RACE AND RACISM IN NINETEENTH-CENTURY ART

RACE AND RACISM IN NINETEENTH-CENTURY ART

The Ascendency of Robert Duncanson, Edward Bannister, and Edmonia Lewis

NAURICE FRANK WOODS JR.

Foreword by George Dimock

University Press of Mississippi / Jackson

The University Press of Mississippi is the scholarly publishing agency of
the Mississippi Institutions of Higher Learning: Alcorn State University,
Delta State University, Jackson State University, Mississippi State University,
Mississippi University for Women, Mississippi Valley State University,
University of Mississippi, and University of Southern Mississippi.

www.upress.state.ms.us

The University Press of Mississippi is a member
of the Association of University Presses.

First printing 2021
∞

Library of Congress Cataloging-in-Publication Data available

LCCN 2021015807
ISBN 9781496834348 (hardback)
ISBN 9781496834355 (trade paperback)
ISBN 9781496834362 (epub single)
ISBN 9781496834379 (epub institutional)
ISBN 9781496834386 (pdf single)
ISBN 9781496834393 (pdf institutional)

British Library Cataloging-in-Publication Data available

For Logie and Terri

In an atmosphere permeated with the poisonous fume of racial prejudice, the sensitive soul is apt to be withered and the spirit crushed. This has ever been the tragedy of the Negro in America, and in the same measure, the tragedy of America.

—*Opportunity: Journal of Negro Life*, 1937

CONTENTS

FOREWORD

Naurice Frank Woods is an important scholar of African American art and African American studies who is best known for his pioneering essays on Henry Ossawa Tanner, the pre-eminent African American artist of the late nineteenth century. He brings his formidable skills as researcher, together with lifelong commitment to nineteenth-century American art, to the task of championing the lives and creative contributions of three African American artists who played pivotal roles in the formation of US visual culture after the Civil War: Robert S. Duncanson, Edward Mitchell Bannister, and Edmonia Lewis. Woods traces, in vivid and painstaking detail, the deforming effects of white racism on the careers and creative opportunities of these three talented and exceptionally courageous artists of color who defied the color line in the Jim Crow era. This timely and accessible book reaffirms a creative achievement and cultural legacy that, to this day, remains too little known by the general public.

Woods produces a clear-eyed account of race prejudice and oppression as deeply embedded, structural components of American visual culture. He documents in comprehensive detail the indomitable will and perseverance it took to create three quite different bodies of work that reflect the visionary imagination, sophisticated humanist learning, and technical virtuosity of the Western fine-arts tradition. Yet each bears the traces of an inimitable African American experience lived at odds with, and sometimes in defiance of, the white mainstream. These three African American artists, each in her or his own hard-won way, gained access to the essential tools of their trade, that is to say, an accomplished studio training based on the protocols of the French and British art academies and a thorough working knowledge of the

dominant visual motifs circulating within American high culture. Yet they also refashioned their techniques, narratives, genres, and subject matter to more adequately, if often obliquely, give visual expression to their far more fractured identities and equivocal experiences as denigrated citizens of a New World social order founded on slavery. Woods's historical and analytic methods are finely attuned to the complexities and contradictions of this all-but-impossible task that was nevertheless carried out to mainstream critical acclaim.

For all their differences, Duncanson, Bannister, and Lewis shared a common fate. All three fashioned prominent careers at a time when African American agency, ambition, and achievement in the fine arts were widely considered implausible, if not unthinkable. It took immense faith, prodigious talent, and indefatigable will to make their marks in an art world organized, like virtually all other aspects of US society, to privilege whiteness. What is perhaps most inspiring, yet also most heartbreaking, about the complex narrative Woods creates in examining these three parallel lives and bodies of work is the overarching affirmation of the Western canons of painting and sculpture as avenues of transcendence and redemption in the face of an ongoing and unremitting history of Black exclusion.

Dr. George Dimock
Associate Professor of Art History
The University of North Carolina at Greensboro

ACKNOWLEDGMENTS

Special thanks go to all those who helped make this book possible—George Dimock, Gerald Holmes, Lewis Tanner Moore, Sam and Harriet Stafford, Tara Green, Michael Cauthen, Logie Meachem, Hewan Girma, and Sadie Bryant Woods.

RACE AND RACISM IN NINETEENTH-CENTURY ART

INTRODUCTION

The "Artistic Ancestors" of Henry O. Tanner

Without question, Henry Ossawa Tanner (1859–1937) [fig. 0.1] could easily lay claim to the title of the most accomplished African American artist of the nineteenth century.[1] His ascent from a modest middle-class background in Philadelphia as the son of Benjamin Tucker Tanner, a future bishop of the African Methodist Episcopal (AME) Church, and Sarah Miller Tanner, an escapee on the Underground Railroad, to the exalted environs of European high art attest to his resolve to surmount the travails commonly experienced by almost all artists who sought such a prize. However, Tanner also bore the additional burden of "racial inheritance" that magnified his quest and severely limited his chances for success. Yet, through sheer strength of will, immense talent, and unyielding faith, he did not allow the impositions of racism to destroy his dreams of being an internationally acclaimed artist.

Having displayed an innate talent for art in his early teens, Tanner tried desperately to find local white artists who would allow him to advance—all rejected him before he developed significantly.[2] Fortunately, he managed to gain entry to the Pennsylvania Academy of the Fine Arts (PAFA), where, under the rigorous tutelage of the principal instructor, Thomas Eakins, he proved himself a worthy and promising student.[3] Racism, however, followed him into the academy, as some of his classmates resented his presence and the level of his skill that ran counter to widely accepted beliefs of Black inferiority.[4]

After leaving the academy in 1885 with the best art education in the country, Tanner quickly discovered that America had little use for a Black artist. He spent several relatively unproductive years in Philadelphia before moving to Atlanta in 1889, where he believed an enlightened population connected

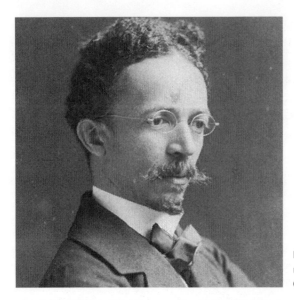

Fig. 0.1. Henry Ossawa Tanner, Photograph by Frederick Gutekunst, 1907.

to several Black colleges there would provide him with much-needed financial support. Unfortunately, this plan failed, and Tanner concentrated on his goal to study and exhibit in Europe, a necessary step for most aspiring artists of the period to gain recognition and reward. He found a few sympathetic benefactors that allowed him to travel to France, where he enrolled in the Académie Julian, a popular private school favored by Americans. Tanner excelled at Julian under the guidance of the noted French academic masters Jean Paul Laurens and Jean-Joseph Benjamin Constant and made rapid progress toward having a work accepted at the Salon, the most prestigious venue of art in the nineteenth century. Before he realized that objective, however, he became severely ill and returned home to recover his health and a depleted purse.[5]

During this time Tanner traveled to Chicago, in the summer of 1893, to present a lecture entitled, "The American Negro as Painter and Sculptor," at the World's Congress on Africa, a symposium celebrating the achievements of people of African descent in America held simultaneously with the World's Columbian Exposition.[6] The text of Tanner's presentation remains lost, but this brief synopsis appeared in the publication *Our Day*: "Professor Tanner (American) spoke of Negro painters and sculptors, and claimed that actual achievement proves Negroes to possess ability and talent for successful

competition with white artists."[7] It is likely that Tanner cited examples of past and present African American accomplishments in art, including works by contemporary Black Philadelphia artists William Dorsey, Robert Douglass Jr., David Bowser, and Alfred B. Stidum. He also certainly mentioned the regionally and internationally celebrated artists Robert Seldon Duncanson, Edward Mitchell Bannister, and Mary Edmonia Lewis—the subjects of this book.

Tanner was familiar with the work of Duncanson, Bannister, and Lewis— he once participated in an exhibition that included a work by Duncanson in a Philadelphia showing of Black artists in 1880, and he personally scrutinized the work of Bannister and Lewis as part of the contingent of American artists that exhibited at the Philadelphia Centennial International Exposition in 1876.[8] In fact, when Tanner departed for Europe in 1891, his original destination was Rome to study sculpture, likely inspired by the success Lewis found there nearly three decades earlier.[9]

As Tanner spoke to his audience at the "Congress," he was the leading African American artist in the country but he knew that his predecessors had played a crucial role in placing him on the path to greatness, one that included finding strategies that surmounted the prohibiting and debilitating effects of racism. He also knew, despite claims to the contrary by many in the dominant culture, that African Americans living in the nineteenth century already had a truncated but verifiable art history.

Tanner went forward from Chicago and eventually found the acclaim and respect afforded to a master nineteenth-century painter, beginning with an honorable mention at the prestigious Paris Salon of 1896 for *Daniel in the Lions' Den*. The next year he medaled at the Salon with *The Resurrection of Lazarus*. Consequently, Tanner's face and reproductions of his award-winning paintings found their way onto the pages of America's newspapers, magazines, and art journals. The press continually acknowledged his ongoing accomplishments for decades, yet his race was usually the foremost part of any report about him coming from popular media. Ultimately, Tanner's confrontations with racism in America were so counterproductive to his personal life and career that he reluctantly chose to live in France for the remainder of his life.

Shortly after his death, *Opportunity: Journal of Negro Life* reflected on Tanner's rise to greatness and how race and racism centrally and severely affected his journey as an artist. The journal remarked:

For many years, the name Henry O. Tanner has been a symbol of the possibilities of the Negro in art. His achievements have been at once the inspiration for hundreds of young Negroes and the answer to those who proclaim the vicious doctrine of racial inferiority. His paintings acclaimed by the great critics of the continent forced the reluctant recognition of American art authorities whose racial antipathies were more acute than their feeling for color and composition and design. Like many other Negro artists, Henry O. Tanner was compelled to seek inspiration and recognition as an expatriate from his native land. Sensitive to the racial ostracism which he knew he would encounter in America, he spent the greater part of his life in Paris and there he died."[10]

Tanner paid an enormous price for achieving artistic freedom, autonomy, and success, but in the end he claimed them as the prizes of a lifetime of struggle and sacrifice. It is highly likely that along his path to international acclaim, he never forgot the courageous Black artists who preceded him and that he was forever indebted to Duncanson, Bannister, and Lewis—his distinguished "artistic ancestors"—for leading the way.

Presently, Tanner remains the most widely and critically studied African American artist of the late nineteenth and early twentieth centuries, while Duncanson, Bannister, and Lewis have received less scholarly attention and public recognition.[11] Yet they, too, sought cultural equality in the fine arts and managed to negotiate the almost impassable social chasm of racism that hindered their opportunities for artistic advancement.

The purpose of this book is therefore to present an in-depth examination of the lives and careers of Duncanson, Bannister, and Lewis to advance the premise that they were masters of nineteenth-century American art and deserve recognition accordingly. Unfortunately, the racism that shadowed them throughout their careers ultimately denied them a rightful place in American art history, as written accounts of this period prior to the late twentieth century rarely, if ever, included their names. Consequently, the following chapters continue the much-needed process of redeeming their memories by stripping away the layers of racially induced neglect and oversight by a dominant culture that has historically prevented full acknowledgment of their contributions to American visual culture. In doing so, common factors that allowed them to excel are given attention, including the level of their talent, the extent of their art education, the systems that supported them, the

type of patrons they attracted, the racial climate in the cities in which they worked, the nature of competition from their peers, and the effects racism had on their development. To accomplish this, I have chosen to use narrative biographies to gauge the overall effectiveness of the strategies they employed to gain prominence in their profession. In addition I punctuate the text with analysis of selected artwork and critiques of events and situations that are relevant to providing deeper insight into the lives of these artists.

Duncanson, Bannister, and Lewis did not live and work in a racially defined vacuum. To compete successfully with their more privileged white peers, they purposefully followed them down a similar path. They sought to attain the same type of advanced artistic training in painting and sculpture, resolutely embraced the popular art styles of the day, socialized with whites when allowed, and, when given the opportunity, shared their work in galleries and public exhibition spaces alongside them. Yet to do so was a constant struggle. For many in the American mainstream, lofty artistic creativity and achievement was the birthright of talented whites exclusively. This belief, of course, was part of a larger national discourse that led many to accept that all people of African ancestry, no matter how long they had resided in America or how much racial admixture they embodied, occupied an inferior position—mentally, physically, spiritually, emotionally, and creatively—to those of white European ancestry. Thus, advocates of Black inferiority and white supremacy remained assured that nothing African Americans said or did could ever elevate them to the level of whites.

Perhaps Connecticut politician Andrew T. Judson best summarized the notion of Black inferiority and the detrimental affect it had on African Americans to become autonomous and upwardly mobile when he stated, "The colored people never can rise from their menial condition in our country; they ought not to be permitted to rise here. They are an inferior race of beings, and never can or ought to be recognized as the equals of the whites. Africa is the place for them."[12]

Likewise, Paul Cameron, one of North Carolina's wealthiest slave owners, remarked, "Four thousand years of wilderness and domination has not materially changed the African. If the race were blotted out today, it would not leave behind a city, a monument, an art or invention to show that it ever existed."[13]

For nineteenth-century African American artists, racism was particularly impactful as they tried to negotiate reaching the upper realms of high art. In

the view of many whites, the creation and appreciation of art, particularly the fine arts, symbolized the ultimate in social cultivation and civility. As a result, Black artists, already perceived largely as unwanted "upstarts," found themselves "victims" of systems of governance and popular opinion that decreed that their African ancestry removed them so far from "white societal norms" that they could expect few, if any, opportunities to demonstrate their abilities as competent art makers.

The fact that the lives of Duncanson, Bannister, and Lewis remain traceable and that a large body of their artistic productions remains identifiable attests to their tenacity to overcome racial barriers. There exists unquestionable evidence that shows that they rose successfully above their prescribed social designation as inferior people and advanced "the race" culturally with works of high aesthetic value. By doing so, they helped reverse, partially, the stigma of racial inferiority that shadowed their lives and careers, and paved the way for other artists of color, like Tanner, to pursue their dreams of self-fulfillment as professional art makers.

CHAPTER ONE

Robert Seldon Duncanson (1821–1872)

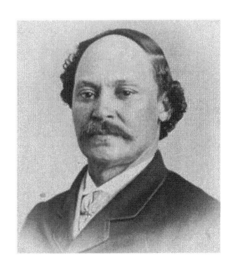

Fig. 1.1. Robert Seldon Duncanson, Photograph by William Notman in Montreal, QC, in 1864, The McCord Museum.

Robert Seldon Duncanson [fig. 1.1] was America's first great painter of African descent.[1] His accomplishments placed him in the first rank of nineteenth-century American landscape artists, but his race created challenging societal impediments in the way he pursued his artistic muse—in his social interactions with whites, in the way he produced his art, in the clientele that patronized him, and on deeply personal levels. As demonstrated here, Duncanson not only survived as an artist of color living in antebellum times but also managed to establish a solid reputation as one of America's finest representatives of the immensely popular Hudson River School of painting.

The Early Years

Information on the early years of Duncanson's life is scarce and often mis-informed. For many years, his biography indicated that he was the son of a white Scottish Canadian father who gave him the middle name Scott—both are incorrect.[2] While it is possible that Scottish blood flowed through his veins, based on the family surname and his noticeable white ancestry, his lineage is traceable to freed slaves from Virginia who migrated to Fayette, New York.[3] Census records there listed his father, John Dean Duncanson (1771–1851), as a mulatto carpenter and housepainter. His mother, Lucy Nickles Duncanson (1781–1854), was also mulatto. Robert was born in Fayette, New York, around 1821. The family settled in Monroe, Michigan, located thirty-five miles south of Detroit, about 1832. John Duncanson likely trained Robert and his four brothers in the family trades of skilled handiwork, thus allowing them to gain useful experience to launch their own careers.

As light-complexioned "mulattoes," the Duncanson family benefited from occasional relaxed rules of social engagement. While they certainly experienced some disadvantages by having their African ancestry documented in census records and known publicly, their physical "blurring" of distinct racial categories often worked to their advantage. By not fitting in completely with either designated racial group, the Duncansons, at times, leveraged their light complexions for social and economic gain. This crossing the "color line" is addressed in detail later in this chapter and acknowledges the complexities many mixed-race families endured in securing a stable and productive position in antebellum society.

The first publicly documented appearance of Robert Duncanson in Monroe was on April 17, 1838.[4] The seventeen-year-old formed a business partnership with John Gamblin, and they advertised their services in the *Monroe Gazette*. Their announcement read, "John Gamblin and R. Duncanson, Painters and Glaziers, beg leave to acquaint their friends and the citizens of Monroe and its vicinity, that they have established themselves in the above business and respectively solicit patronage."[5]Although Duncanson was publicizing his services for house painting and not easel painting, many itinerant house painters of the nineteenth century were often pressed into several artistic services, including portrait painting, carriage painting, and interior wall decorations. There are no known Duncanson paintings from this period, but perhaps he began to experiment with the rudiments of art at the request of area residents.

Duncanson's partnership with Gamblin dissolved the following year. The reason for the venture's failure is unknown. It is possible that competition forced them out of business, or perhaps Duncanson's affinity with art had grown so strong that he decided to develop his talent elsewhere. Ultimately, his decision to embark on a career as a professional artist was almost without precedent for an African American. In fact, although he was probably unaware of any Black predecessors in art, only portrait painter Joshua Johnson (also known as Johnston), active between 1796 and 1824 in the Baltimore area, managed to compile a large body of work by gaining access to the city's upper-class art patrons when many of its African American population remained enslaved.[6]

Thus, Duncanson's decision to enter the field of art is pioneering, but with few opportunities for formal training or steady patronage, his chances for success were infinitesimal. However, he was ready for the challenge and decided to leave Monroe and attempt to establish himself as a creditable and productive professional painter.

Black and White Relations in Cincinnati

Between 1840 and 1841, Duncanson settled in Mt. Healthy, Ohio, located about fifteen miles north of Cincinnati. This small community had a reputation for its abolitionist sentiments and sympathetic treatment of African Americans. It was an ideal place for Duncanson to establish his good character locally, raise the level of his painting skills, and contact people who could benefit his career. In addition, he married a Mt. Healthy resident and former Tennessee-born slave, Rebecca Graham. The two lived with her parents, Reuben and Martha Graham.

Despite the receptive climate of Mt. Healthy, Duncanson sought to move to Cincinnati, where a developing community of artists beckoned. Yet the city teemed with racists and proslavery advocates, making his move potentially dangerous.

The doctrine of African American inferiority was well entrenched in Cincinnati. Dr. Daniel Drake, a local physician, expressed this belief saying that "we do not need an African population. That people . . . are a serving people, parasitic to the white man in propensity, and devoted to his menial employments."[7] A similar position was taken by Charles R. Ramsay, editor of

the anti-abolitionist paper the *Daily Cincinnati Republican, and Commercial Register*. He stated, "The liberal and honorable professions are to him [the African American] forbidden fruit. . . . He cannot even embark in business of any kind other than on a meagre scale. His fate is to toil and drudge for a subsistence. . . . Whether bondsman or freeman, he must be a hewer of wood and a drawer of water. Nature has decreed it and her laws cannot be changed."[8]

A Cincinnati newspaper echoed the idea of racial inferiority when it carried this assessment:

> History informs us that the white skin, from time immemorial, has been of superior order. Civilization and all the arts and sciences have originated with the white race, whilst the blacks have made scarcely any advance from the state of nature. . . . The darker the various shades of color, descending down to the jet black, the lower they descend in the scale of intellect and enterprise.[9]

These statements were indicative of a community with a deep-rooted history of racial oppression that led historian Leon Litwack to conclude that even up to the eve of the Civil War, "the northern Negro remained largely disenfranchised, segregated, and economically oppressed," and perhaps more importantly, "change did not seem imminent."[10]

And while Cincinnati was in the slave-free North, it was located directly across the Ohio River from the slave state of Kentucky. Many of Cincinnati's white citizens prospered from trade with its southern neighbor by supplying farm implements, heavy machinery, furniture, and transportation, thus creating a mutually beneficial climate of social and economic contact. However, an increasing number of fugitive slaves seeking sanctuary in the city led to rising racial tensions, and strong proslavery endorsements spread widely throughout the white community.

By the time of Duncanson's arrival in Cincinnati in 1841, the city had a long history of strained race relations, including a mass exodus of African Americans to Canada in 1829 following a violent race riot.[11] African Americans who remained in the city continued to experience a racially hostile climate. They knew that their survival was dependent upon their ability to endure overt racism without triggering further confrontations with whites. They also realized that the only way to succeed was to suppress their indignation at being treated as socially unacceptable and intellectually inferior and deal with it accordingly. Carter G. Woodson explained: "Negroes were not

welcome in the white churches. . . . Colored ministers were treated with very little consideration by the white clergy, as they feared that they might lose caste and be compelled to give up their churches. The colored people made little or no effort to go to white theaters or hotels and did not attempt to ride in public conveyances on equal footing with members of the other race. Not even white and colored children dared to play together to the extent that such was permitted in the South.[12]

Despite the racism that dominated social contact in Cincinnati, African Americans gradually made some notable progress. Woodson observed, "Undaunted by this persistent opposition the Negroes of Cincinnati achieved so much during the years between 1835 and 1840 that they deserved to be ranked among the most progressive people in the world."[13] For example, 1840 records showed that ninety African Americans were listed in twenty-one skilled occupations such as barbers, carpenters, shoemakers, bricklayers, and coopers.[14] According to Woodson, "It was not uncommon for white artisans to solicit employment of colored men. . . . White mechanics not only worked with colored men but often associated with them, patronized the same barber shop, and went to the same places of amusement."[15] Duncanson was likely aware of these developments.

Despite some advancement, most of Cincinnati's African American population still lived in poverty and faced racial oppression daily. The supporters of racism in the city waged a constant campaign that effectively portrayed Blacks as worthless, dissolute, lazy, stupid, and incompetent.[16] To combat this negative image, many African Americans made a strong, conscientious effort to present themselves as the picture of respectability and self-improvement— a strategy that worked to some extent. James H. Perkins, a prominent white citizen of the city, remarked, "There is no question, I presume, that the colored population of Cincinnati, oppressed as it has been by our state laws as well as by prejudice, has risen more rapidly than almost any other people in any part of the world."[17]

The apparent "renaissance" of African American life in Cincinnati was shattered on August 29, 1841, when a riot erupted between Blacks and whites.[18] This violence, initiated by whites from Kentucky, lasted for several nights as mobs of up to fifteen hundred controlled the nighttime streets. African American homes were attacked, men arrested, and women and children forced to flee their neighborhoods. Another target was the printing press of abolitionist James G. Birney's paper, *The Philanthropist*. Ironically,

a committee of Cincinnati's leading white citizens, including Judge Jacob Burnet and Duncanson's future benefactor Nicholas Longworth, had earlier demanded that the Ohio Anti-Slavery Society cease publication of the paper.[19]

The riot of 1841 further divided Black and white citizens. The few white patrons and friends of the African American community seemed to have abandoned most of their efforts to help.[20] Still, Duncanson's desire to become a professional artist compelled him to risk venturing into Cincinnati and find ways to launch his career.

The Quest to Be an Artist

For Duncanson, the challenge of becoming a successful artist was daunting. There is no record of other African American artists operating in Cincinnati during that period, and it is unlikely that there were any. There was no advanced training he could receive from a member of his race, and he had nowhere to exhibit his work within the Black community. Any assistance Duncanson found to connect with Cincinnati's art establishment would have to come from benevolent whites.

Duncanson may have been enticed to go to Cincinnati because of recent developments in the arts. Prior to the late 1830s, there were no schools for art instruction, and the sales artists realized were usually restricted to individual patrons. The Cincinnati Academy of Fine Arts was established in 1838 with the objective of correcting those shortcomings. The first exhibition featured more than 150 paintings but failed to attract a sizable audience or buyers. Cincinnati was still very much a frontier town, and most of the public lacked sophistication and knowledge to appreciate fine art. That role remained for wealthy patrons to privately support artists. Another art-oriented organization, the Section of the Fine Arts of the Society for the Promotion of Useful Knowledge, appeared in Cincinnati in 1840. Its goal was to allow professionals, artists, and the public to attend lectures on the fine arts, the practical arts, and moral and intellectual philosophy.[21] The group also held art exhibitions and sketching classes.[22]

Cincinnatian Charles Cist wrote of the organization's effort to uplift the cultural image of the city and stated, "The Society for the Promotion of Useful Knowledge has formed the worthy, even if bold, project, of seeking to realize for Cincinnati some of those benefits which seem peculiarly to belong

to cities."[23] Cist noted there were nineteen artists working in Cincinnati the year Duncanson arrived in the city. Despite the small number of practicing artists, Cist was certain Cincinnati would one day gain recognition as the birthplace of a national art.[24]

Duncanson was aware of this dawn of art culture in Cincinnati and decided the time was right to become a part of it, despite the "liabilities" of being African American. His earliest dated work, *Portrait of a Mother and Daughter* (1841), was painted in Cincinnati and reveals much about Duncanson's potential as an artist. The identities of the sitters are not known, but they are white and appear to be of middle to upper class. The work is ambitious even for more skilled painters—a challenging double portrait with accurate attention given to the faces and the textural qualities of the clothing that rivals some of the best limners of the period.[25] As is the case with many of the limners, the mother's seated position seems stiff and forced, due to a lack of proper understanding of human anatomy; but the daughter, who stands relaxed next to her mother and whose arm rests comfortably around her shoulder, displays a great deal of naturalism. More importantly, this portrait highlights Duncanson's ability to be an acute observer of details found in the natural world—a quality that he applied expertly in his future landscape paintings. Therefore, based on his handling of complex compositional elements in this painting, Duncanson, as aspiring artist in 1841, appeared to have all the necessary artistic tools and sensibilities to advance to the next level if only he could find suitable instruction to develop them: a formidable task indeed.

There is no record of Duncanson enrolling in any of the sketching classes at the Society for the Promotion of Useful Knowledge or of him participating in the programs held there. Racial discrimination probably forbade his attendance, but he managed to gain their attention. Surprisingly, he made his formal debut as an artist on June 9, 1842, when the Society for the Promotion of Useful Knowledge presented an exhibition that included his work. Three of his paintings are listed in the exhibition catalog—*Fancy Portrait, Infant Savior,* and *The Miser, a Copy.*[26] Although these pieces remain lost, they obviously indicated that Duncanson's early artistic inclination was not toward landscapes; it appears he was experimenting with several subjects that might find public favor. The exhibition catalog also reveals several local artists showing works in the Hudson River style. These paintings caught Duncanson's attention and perhaps served as a catalyst for his later interest in that genre.

The response to his first public exposure remains a mystery. Yet an African American sharing the same wall space with whites was a major milestone in Cincinnati and in the country, as the occurrence marked one of the rare instances of true egalitarianism during the period. And although he participated in a relatively obscure exhibition held far from the major art centers of the East, Duncanson had at least made a small step toward a sustainable career in art.

Duncanson's talent attracted the attention, and eventually the sponsorship, of many of the region's deeply rooted and well-connected abolitionists—he was good for their cause. They found in him an industrious, intelligent, and talented man of African descent who countered many of the negative stereotypes associated with his race. With their encouragement and occasional commissions, mostly in portraiture, Duncanson sharpened his skills and strengthened his position locally as an artist of note.

Duncanson, like so many other artists living in frontier towns, was mostly self-taught, and it is likely few white artists would associate with him. He therefore developed his skills by observing the works of others, making copies of prints, and relying on his own natural artistic instincts.

One of Duncanson's first paintings to gain public notice was *The Trial of Shakespeare* (1843), a copy of an original work by Sir George Harvey. This was a very ambitious attempt to explore complex compositions that signaled his readiness to compete alongside his established peers. It is possible Duncanson chose this type of painting because historical subjects represented a high level of artistic engagement. Thus, while the painting revealed that Duncanson still had many technical problems to master, such as a rather stiff and awkward handling of the figures, it was a remarkable work for a man with little or no training. One local paper seemed to concur when it ran the following review:

> The canvas that is of such interest is about 30 by 40 inches, and critics deem it a magnificent work. Shakespeare is depicted at trial for poaching before Sir Thomas Lucy. Ann Hathaway, with her child, is close by his side as the game warden testifies. There are eleven human figures, two great hounds and the body of a deer in the painting.[27]

Duncanson explored different types of paintings throughout the decade. Portraiture provided an important source of income. In 1843 he received a

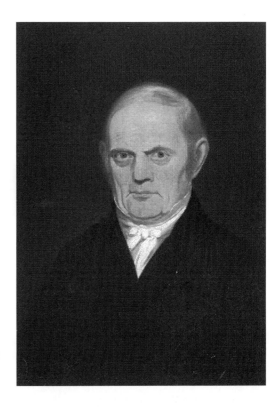

Fig. 1.2. Robert S. Duncanson, *Portrait of James Foster, Jr.*, 1843, Oil on canvas, 28.75" × 24", private collection.

vital portrait commission from James Foster Jr. (1814–1873) [fig. 1.2], an optician and leading Cincinnati businessman.[28] Duncanson's ability to capture a credible likeness, his innate understanding of facial features that are anatomically correct, and his mastery of paint application to achieve subtle shading, highlights, and coloring belie his lack of formal training. This portrait is among the finest he attempted during his developmental years.[29]

Duncanson turned to genre painting in 1845 as he continued to explore styles that sparked interest among buyers. Within the parameters of the style, artists could express charming, lighthearted, and often humorous views of everyday life that addressed issues of ordinary people engaged in common activities. Genre paintings often used narrative or storytelling elements as their central component, and at times they delivered moral messages.

Duncanson's only extant genre painting is *The Drunkard's Plight* [fig. 1.3], a scene that displays a centrally located man, woman, and child confronting each other on a street in a small village. The man, with clothing in tatters, stands with his head bowed as if repentant. A broken jug spilling its

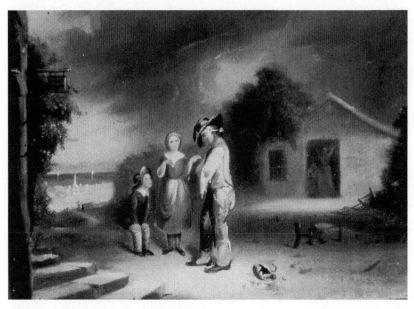

Fig. 1.3. Robert S. Duncanson, *The Drunkard's Plight*, 1845, Oil on canvas, 15 ¼" × 19 ¾ ", Detroit Institute of Arts, Gift of Miss Sarah M. Sheridan.

contents is at his feet. The woman, with quill and paper in hand, appears to be ready to take a signed promise that the man will forfeit his days of heavy drinking. The small boy gazes up, perhaps not fully comprehending the situation. It is likely that this group represents a family that hopefully will find a way to reunite after trying times. In the background a woman and small child standing in a doorway rejoice at the reunion. Cedric Dover's reading of the painting seems to align with this interpretation saying, "But *The Drunkard's Plight* has an unexpected roguish humor which reminds us of the once popular, still pathetic, refrain 'Father, dear father, come home with me now.'"[30] Also, Duncanson paints in the background landscape elements that include detailed trees and a quiet lake with sailboats in the distance.

With this painting, it may have been Duncanson's intention to make a meaningful statement on temperance and the importance of healing within troubled families, thus giving him an easily relatable subject with his viewers. Unfortunately, though competently painted, it appears not to have been followed with another genre painting. It would not be until 1893 and 1894

that a Black artist, Henry O. Tanner, concentrated on genre scenes with his race-affirming genre depictions of African American life with *The Banjo Lesson* and *The Thankful Poor*.

Duncanson further established his notoriety within antislavery circles in 1846 when he drew the attention of the country's leading abolitionist, William Lloyd Garrison. Garrison was obviously pleased to discover paintings by a talented Black artist and recorded these observations in his paper, *The Liberator*: "I had a great treat last evening in the view of some portraits and fancy pieces from the pencil of a Negro, who has had no instruction or knowledge of the art. He has been working as a . . . house painter, and employed his leisure time in these works of art, and they are really beautiful. I saw these works in company with a lady from Nashville in whose family the wife of the artist was reared and brought up a slave."[31]

Duncanson was in Detroit in 1846 for an extended period, soliciting support, perhaps seeking commissions and sales outside a stagnant Cincinnati art market. Cincinnati artist John Frankenstein (white), who eventually left the city because of lack of patronage by the public, supports this supposition. He claimed that the only people in Cincinnati able to buy art were members of the wealthy class that wanted only portraits of themselves, thus stifling creativity and artistic growth.[32]

In Detroit, Duncanson set up a studio.[33] Despite his youth and inexperience, he was soon attracting attention in the city. The *Detroit Daily Advertiser* reported:

> We have intended for some time to call the attention of our citizens to the paintings of Mr. Duncanson, a young artist who has been some weeks here, and has rooms in the Republican Hall, over James Watson's store. Mr. Duncanson has already taken the portraits of a number of our citizens and has designed and finished several historical and fancy pieces of great merit. The portraits are very accurate likenesses and executed with great skill and lifelike coloring. A copy of the "Schoolroom," just finished, from a picture in one of the annuals is full of the spirit and beauties of the original, and a portrait of a young bride, who has recently come amongst us, is one of the most striking likenesses and tasteful pictures we have ever seen from the pencil of so young an artist. Mr. Duncanson deserves, and we trust will receive the patronage of all lovers of the fine arts.[34]

This article revealed several interesting insights into Duncanson's develop-
ment; however, the absence of any mention of his race is notable and will be
addressed later. Obviously, he was on his way to achieving regional recognition
after only four years of exhibiting his work. In addition, he had not yet com-
mitted to landscape painting but continued to concentrate on portraits, and
"fancy pieces" (still-life and flower studies). Also while in Detroit, Duncanson
received several important portrait commissions, including those from Henri
Berthelet, a prosperous Detroit merchant and his grandson, William.

Two paintings from his time in Detroit are noteworthy. Both show that
Duncanson was still attempting to find a comfortable niche in which to grow
his trade and that he was willing to take on a variety of commissions. The
first painting, *Young America* (1846) [fig. 1.4], is a figure study that portrays
a young man dressed in a military uniform waving a large American flag in
one hand and thrusting his sword skyward with the other. He is standing on
a beach, waves lapping at his feet as if to suggest that he is the protector of the
American homeland. The painting has a strong patriotic theme that had the
potential to appeal to a wide audience that grew in the wake of independence
from England, the War of 1812, and the ongoing establishment of a durable
and defensible national identity. In this case Duncanson chose to address
this important aspect of nation building through an allegorical motif—the
young man seems to represent the "newness" of the republic—favored by
many other American artists in visually reinforcing foundational ideals of
liberty and love of country.

The second painting constitutes Duncanson's rare foray into religious
subject matter. Also painted in 1846, *At the Foot of the Cross* [fig. 1.5] depicts
Mary slumped at the bottom of the cross that served in the crucifixion of
Jesus. Her eyes turn downward as she contemplates the crown of thorns
that was instrumental in the cruel act that has recently ended. Duncanson
keeps the perimeters of the composition excessively dark and uses a bright
light from an unseen source to illuminate Mary as if a heavenly spotlight
has fallen upon her. The painting was only recently discovered in the base-
ment of a building at the University of Detroit, Mercy. It has ties to the Jesuit
community at that institution and was likely commissioned to adorn their
building. The suggestion that the Jesuits ordered the work as an internal
commemorative piece is strengthened by the fact that religious paintings
in America received little interest from the public throughout much of the
nineteenth century.

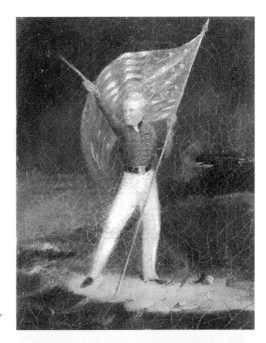

Fig. 1.4. Robert S. Duncanson, *Young America*, 1846, Oil on canvas, 16" × 12 ¼".

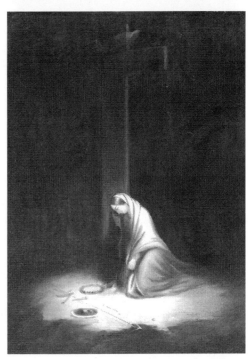

Fig. 1.5. Robert S. Duncanson, *At the Foot of the Cross*, 1846, Oil on canvas, University of Detroit, Mercy.

Duncanson continued to exhibit throughout the Cincinnati and Detroit areas in the late 1840s. He received a "premium" (a prize) in painting at the Michigan State Fair of 1849.[35] His technique and his reputation were rapidly improving, and floral and fruit still-life paintings now became a mainstay in his repertoire.[36] At his peak Duncanson demonstrated technical proficiency, as in *Still Life with Fruits and Nuts* (1848), that resulted in classically composed arrangements of tabletop objects that contrasted rich, varying surface textures that achieved a high degree of naturalism.[37]

The local and regional press began to take notice of Duncanson's ability to render convincing fruit paintings. The *Detroit Free Press* commented, "The paintings of fruit by Duncanson are beautiful, and as they deserve, have elicited universal admiration."[38] Likewise, the *Daily Cincinnati Gazette* proclaimed that Duncanson was "favorably known as a fruit painter."[39] In 1850 Duncanson achieved a small measure of national attention when he sold the American Art Union of New York, the largest and most successful art union in the country, his painting *Fruit*.[40] As part of the organization's subscription-based fundraising and reward system, Duncanson's work was given as a prize to J. D. Warren of Brooklyn, New York.[41]

It was during this period that Duncanson became increasingly interested in landscape painting. His early success and recognition may have gained him wider acceptance within Cincinnati art circles and allowed him to exchange ideas more freely with many of the city's white artists. Within this setting, Duncanson embraced the local preference for painting nature scenes. The predilection for landscape painting by Cincinnati artists can be linked directly to the enormous national popularity of the Hudson River School style.

Working within the Hudson River Tradition

The decades immediately following the War for Independence saw growth in the public's perception of art. Newly acquired European tastes for historical, romantic, and allegorical subjects began to take hold in America, and a few American artists slowly began to shift their attention and talents from the profitability of portrait painting toward other subjects. As a result, many Americans sought to establish an artistic style of their own that was distinct from traditional European prototypes. They felt the new country should

have a national character in its art. In addition, the rapid growth of major cities along the eastern seaboard and the increasing wealth of many of its citizens during the first decades of the nineteenth century helped create a more receptive climate for new and varied forms of art. The first of these new subjects to catch the public's interest was landscape painting.

The beauty of the American wilderness had no parallel in England or the rest of Europe. It was a land filled with spectacular pictorial wonders, waiting for native artists to take up the challenge of capturing it on canvas. In addition, American vistas fit perfectly with the popularity of Romantic art and the aesthetic of the Sublime, which endeavored to capture humans' sense of wonder and grandeur as they contemplated the magnificence of the natural world. In paintings Sublime-inspired imagery sought to provoke the realization that nature inherently proved overwhelming to ordinary, mundane human experiences.

In response to the canons of the Sublime, Thomas Cole (1801–1848) drew upon the work of European landscape artists such as Claude Lorrain, John Constable, and J. M. W. Turner, and began to make sketching trips up the Hudson River and into the Catskill Mountains in 1825. It was there that he captured on canvas a painstakingly detailed interpretation of nature, tempered with a sense of awe and romanticism, and launched a style of painting that coalesced years later under the name Hudson River School—America's first native style of painting.[42]

After Cole's death the popularity of his style continued to grow, and the landscape became the dominant form of painting in America by the 1830s. His immediate successors included Asher B. Durand (1796–1886), Frederic Edwin Church (1826–1900), Jasper Francis Cropsey (1823–1900), John Frederick Kensett (1816–1872), Sanford Robinson Gifford (1823–1880), George Inness (1825–1894), Thomas Moran (1837–1926), the German-born Albert Bierstadt (1830–1902), and Robert Duncanson, many of whom expanded the style westward in America, to Canada, and into Latin America.[43]

For the more adventurous, like the Hudson River painters, there emerged among the public an awakened sense of exploration that stimulated expeditions into the regions rarely viewed by whites. Thus, places like the Rocky Mountains, the Grand Canyon, and the Yellowstone and Yosemite Valleys became "shrines," to the Hudson River painters and their enthusiastic followers. In addition many Americans regarded nature as the most profound expression of the Divine, and many of the Hudson River painters used the

landscape to evoke their moralistic points of view, which often instilled in their viewers the overwhelming grandeur of God's handiwork. There was a strong sense of religiousness in the works of these artists that was reinforced by their use of humans as minuscule appendages that were seemingly incapable of having any significant impact on God's majestic natural wonders. Also, some professed that the work of the Hudson River painters supported the belief in "manifest destiny," the tenet that held that territorial expansion was not only inevitable but also ordained by God.

Once Duncanson chose to master the Hudson River style, he sought to find his own distinctive "voice" within the genre. This decision was made easier because Cincinnati, by its location on the western frontier and abundance of wilderness areas, quickly became a stronghold for landscape painters. Thus, the city had many artists gaining prominence as nature painters by the time Duncanson turned his attention to the subject. Among the most notable of these artists were Godfrey Nicholas Frankenstein (1820–1873), Thomas Worthington Whittredge (1820–1910), and William Louis Sonntag (1822–1900).

There is little evidence to suggest Duncanson had any sustained personal contact with Frankenstein or Whittredge, and it is likely that some local artists would have had nothing to do with him because of their racial prejudices. In a letter written to his friend Junius Sloan, Duncanson indicated that he was at least familiar with the work of Frankenstein and his brother. Duncanson wrote, "Frankensteins are here painting the same green grass Landscapes, they keep them in their rooms for fear they will get eat [sic] by the cows."[44] Sonntag was closer to Duncanson and had a major influence on the development of the young African American artist as a landscape painter. The relationship between the two men is detailed later in this chapter.

Duncanson received a major opportunity to explore landscape painting in 1848. Reverend Charles Avery (1784–1858) commissioned him to paint *Cliff Mine, Lake Superior*, a Michigan site reported to be the largest copper mine in the country. At this stage in his career, Duncanson had not embraced fully the Hudson River style, and in fact he paints the antithesis of its ideals. Although he shows elements of Hudson River—soaring cliffs, detailed flora, and small human figures—Duncanson depicts a strip mine containing many stark white buildings that dominate the foreground, and a landscape decimated by the actions of the miners.

Reverend Avery may have selected Duncanson to paint *Cliff Mine* because of his race. Avery was a well-known abolitionist from Pittsburgh, widely

renowned for his abhorrence of slavery, his support of the Underground Railroad, his founding of Avery College, and his establishing of endowments at other African American schools.[45] Thus, Avery would have been an ideal benefactor for a struggling African American artist. This fact reinforces the premise that Duncanson's early survival was strongly tied to the support he received from abolitionists residing in the region.

In 1852 Duncanson's admiration for Avery surfaced in a very public demonstration. He exhibited a large landscape painting in Pittsburgh entitled *The Garden of Eden* [fig. 1.6]. *Frederick Douglass' Paper* took note and proclaimed:

> From the Pittsburgh papers we learn that Mr. Duncanson, a talented young gentleman of color, of Cincinnati, has for some time past been exhibiting in Pittsburgh, a painting of the Garden of Eden. The picture, says *The Gazette*, "is 7 by 5 feet, exceedingly chaste, and so carefully executed that it looked well at any distance. Mr. D. was offered $800 for it by a gentleman of Cincinnati." Other notices also commend it as the work of genius. At the close of its exhibition in the city, Mr. Vashon, on behalf of the artist, and in the presence of those in the Hall, in a very neat address, presented it to the Rev. Chas. Avery, as a testimonial of respect and gratitude, for his munificent friendship towards the colored people of Pittsburgh and Allegheny. *The Gazette* adds: "Mr. Avery was taken quite by surprise, and seemed for a few moments at a loss what to say; but after a slight demur, he accepted it with warmly expressed acknowledgments for the compliment. Mr. Avery has expended a large amount of money for the establishment of an institution for learning in Pittsburgh, for the benefit of the colored people. And it was in reference to this charity, that this splendid tribute of gratitude was thus delicately paid him, by Mr. Duncanson.[46]

The painting was one of Duncanson's first attempts at depicting idyllic landscapes, a style that would later become a major component of his oeuvre. He likely chose a biblical scene to honor Avery's devout Methodism, rather than celebrate his abolitionist philanthropy. In typical Hudson River fashion, Duncanson rendered a primeval landscape in which Adam and Eve appear small and insignificant amid a lush, expansive, tropical paradise. The painting also resulted in the *Boston Investigator* reporting, "[Rev. James Freeman Clarke] says that he is the best landscape painter in Cincinnati."[47] At this point in his career, it was clear that the energetic abolitionist community in

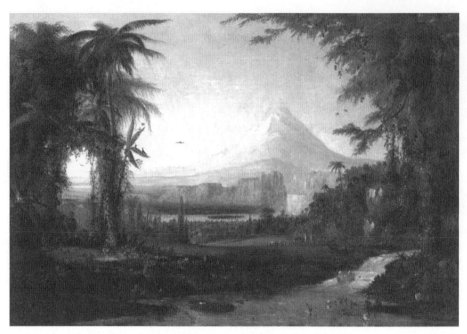

Fig. 1.6. Robert S. Duncanson, *The Garden of Eden*, 1852, Oil on canvas, 32 ½" × 48 ½", Collection of the Smithsonian National Museum of African American History and Culture, Gift of Louis Moore Bacon.

Cincinnati played a major role in launching and supporting Duncanson's career as a painter.[48]

Extant paintings suggest that Duncanson decided to concentrate almost exclusively on landscape painting at the start of the 1850s. William Louis Sonntag, a popular white artist, may have well been instrumental in convincing him to direct all his energy to pursuing that theme. By the early 1850s, Sonntag had established himself as the leading landscape artist in Cincinnati. His career and popularity had grown rapidly since 1847, when he attracted considerable attention through regular exhibitions at the newly founded Western Art Union. This new art institution, established in 1847, emerged to push Cincinnati toward becoming the "American Athens" and the "nourisher of Art."[49] Moreover, the union formed "for the promotion of the tastes for fine arts, and the encouragement of the great body of artists residing in the Western states."[50] According to Taft Museum curator Abby S. Schwartz, the Western Art Union was modeled after the American Art Union in New York and "distributed paintings by lottery to its subscribers. A small yearly subscription fee was taken from members and their money

was used to purchase art works from contemporary artists. The works were displayed for a year, and then dispersed to members by means of a lottery. [Nicholas] Longworth was one of the 'Committee of Ten' appointed to procure subscribers to this new association."[51] The art union was particularly effective in bringing landscape painting to prominence in Cincinnati by its stated purpose of soliciting a "selection of such local and national subjects as may enlist the pride of our country in the support of good taste."[52] Eventually, the names Sonntag and Duncanson featured prominently in establishing the credibility of the organization.[53]

Kathleen Dillon explained how the Western Art Union benefited local artists like Sonntag and Duncanson, and the public:

> Members received a free engraving and the chance to win an original painting. The Art Union exhibit, housed in a four-story building, was open to non-members and was a "subject of just pride" to all as Cincinnatians. Art became accessible and enjoyable. Visiting the exhibit became a form of public recreation. By shrewdly combining business and aesthetics, the art union started an educational process that fueled itself. The union exhibit was convenient and, as its promoters explained, a "very successful mode, of disseminating a taste for the arts and of obtaining subscribers to the Art Union."[54]

Charles Cist, author of several books on contemporary Cincinnati life, attested to Sonntag's popularity in the early 1850s by listing thirteen Cincinnati collectors and many others on the Atlantic seaboard as owners of his work.[55] The circumstances of how and when Duncanson met Sonntag are not known. It is likely the two became acquainted through shared exhibitions at the Western Art Union. Records from that organization for the years 1849–50 indicate Duncanson sold several works of art, including a set of four paintings illustrating the seasons of the year.[56]

Sonntag was apparently able to cast off prevailing racial prejudices and developed a strong friendship and working relationship with Duncanson, although a detailed account of the nature of their interaction remains elusive. In 1850 Duncanson rented a studio next to Sonntag's.[57] The *Daily Cincinnati Gazette* reported, "In the room adjoining Sonntag's, at the Apollo Building, Duncanson, favorably known as a fruit painter, has recently finished a very good strong lake view."[58] In 1851 Duncanson and Sonntag continued their association by traveling on a sketching tour to Yellow Springs

and Clifton, Ohio, areas known for their lush natural beauty.[59] Later both artists contributed works offered for subscribed members of the "Artists' Union of Cincinnati."[60] Duncanson showed four works, including a painting entitled, *River Basin Battle Ground*.[61] Also exhibiting with Duncanson and Sonntag were Lilly Martin Spencer, Thomas Worthington Whittredge, the Frankenstein brothers, William H. Beard, and J. O. Eaton. Clearly, Duncanson was gaining parity with the region's best artists.

During this period Duncanson's work became more focused, and his skill improved quickly. There is little doubt that Sonntag was providing him with excellent instruction. Duncanson readily absorbed his new mentor's example and shifted his art toward romantic, idealized renditions of the American landscape firmly situated in the Hudson River tradition. A survey of Cincinnati artists published in the *Daily Cincinnati Gazette* in the fall of 1852 noted the rapid progress exhibited by Duncanson. The writer stated, "R. S. Duncanson . . . has nearly finished a beautiful landscape of great artistic merit—'the Shepherd Boy.' We discover a decided improvement in Duncanson's last work."[62] Two weeks after the *Gazette* mentioned Duncanson's *Landscape with Shepherd*, the paper ran another article making his connection with Sonntag obvious. The writer observed, "Another landscape of Mr. W. L. Sonntag's is now in Shipley's window, on Fourth Street. We have no authoritative information on the subject, but if we may be allowed to judge by the style, should pronounce the picture in question to be from R. S. Duncanson's easel."[63]

Sonntag's influence on the rapidly maturing Duncanson is evident upon examination of a painting from this period entitled *Blue Hole, Flood Waters, Little Miami River* (1851) [fig. 1.7].[64] Many art historians now recognize this work as one of Duncanson's masterpieces. It embraces fully the ideals of the Hudson River School and incorporates many of its characteristic motifs. *Blue Hole* is an idealized interpretation of a popular wilderness area not far from Cincinnati that Duncanson rendered in a style reminiscent of Sonntag. Duncanson, in characteristic Hudson River fashion, recorded the trees, rocks, and sky with meticulous detail—fragmented and stripped trees litter the background and block the river's natural flow with debris as if to suggest a foregone natural disaster, while a recovered, lush landscape bookends the banks of the water and demonstrates nature's resiliency. A pool of water—the "blue hole"—centers the composition with its mirrorlike quality encompassing the entire scene with a reflectivity that brings the tranquil sky into

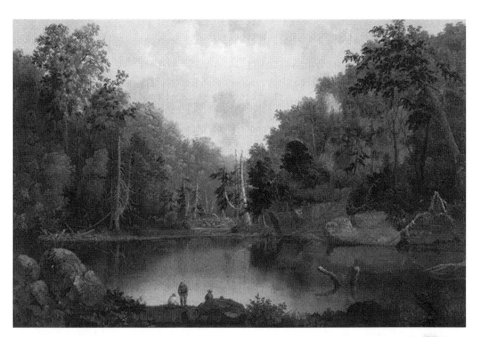

Fig. 1.7. Robert S. Duncanson, *Blue Hole, Flood Waters, Little Miami River*, 1851, Oil on canvas, 29.2" × 42.2, Cincinnati Art Museum.

equilibrium with the pool. Three fishermen—rendered small and inconse-quential to their environment—occupy the immediate horizontal plane at the bottom of the composition and exist, grounded, within the harmonious spirit of nature's bliss. *Blue Hole* captures a convincing sense of deep space combined with the subtle effects of atmospheric perspective, elements miss-ing in his earlier landscapes, and thus establishes him as a rising advocate of the Hudson River style.

Works like *Blue Hole* continued to demonstrate to a skeptical country that African Americans could, if given the opportunity, create impressive art. Recognizing Duncanson's importance to reversing the public's perception of Blacks as incapable of cultural attainment, a reporter wrote in 1852, "Who shall answer to this age and to posterity for the sin and shame of crushing a race, thus gifted with the power of genius, the delicacy of sentiment and the capac-ity for sublime moral development, of which [Duncanson] proves them capa-ble?"[65] That same year in February, Duncanson was again displaying his work in Detroit, this time at the Fine Art Exhibition at the Fireman's Hall, further establishing his regional credibility and keeping his name before the public.[66]

While Duncanson's reputation was on the rise, there is no indication that he generated a steady income from his art. Detroit native and Duncanson patron Henry N. Walker reported that he found the artist in 1849 "living in a state of absolute destitution."[67] According to Walker's widow, her husband gave Duncanson fifty dollars at that time.[68] Following his successful tour of Europe in 1853, Duncanson repaid the debt by presenting Walker with a still life.[69]

Fortunately, Duncanson attracted the attention of a man who was to become his principal supporter—Nicholas Longworth (1782–1863), a Cincinnati lawyer, one of the wealthiest men in America, patron of the arts, horticulturist, and supporter of the downtrodden of all races. Known as the father of American winemaking, Longworth popularized the Catawba grape in the region and produced sparkling wines grown in the Ohio River Valley. He was also a successful real estate investor who channeled his philanthropic interests into aiding those whom many considered to be worthless and of an inferior class.

Two main factors may have enticed Longworth to take an active part in Duncanson's career. First was his interest in aiding the African American population of Cincinnati. The public knew Longworth for his kindness and generosity toward Blacks, helping them establish an orphan asylum in 1844 and a school building in 1858.[70] His desire to aid the oppressed can be gleaned from this response to endless appeals for money. Longworth stated, "Ha! A poor widow, is she? Got a struggling family of little ones? I won't give her a cent. She is the Lord's poor; plenty to help such. I will help the devil's poor, the miserable dog that nobody else will do anything but despise and kick."[71] Most African American citizens living in Cincinnati fell into the category of the despised and downtrodden.

Second, Longworth's love of art made him quick to assist struggling local artists. Worthington Whittredge attested to that fact, stating, "It may be said with entire truth that there was never a young artist of talent who appeared in Cincinnati and was poor and needed help, that Mr. Longworth if asked, did not willingly assist him."[72] Lilly Martin Spencer, an artist to whom Longworth provided financial aid, echoed Whittredge's sentiment when she recalled the first time they met. Spencer said, "A little bit of an ugly man came in . . . he came forward and, taking my hand and squeezing it hard, he looked at me with a keen, earnest gaze. . . . His manners are extremely rough and almost coarse, but his shrewd eyes and plain manner hide a very strong mind and generous heart."[73] Louis Leonard Tucker said of Longworth's contribution

to boost the careers of aspiring local artists, "The available evidence would suggest that he assisted practically every young indigent Cincinnati painter and sculptor of promise; and again, this assistance was provided without attendant fanfare. Knowing of his proclivity for this type of philanthropy, fellow Cincinnatians directed poor, aspiring painters and sculptors to him; and there is not one shred of evidence to suggest that Longworth ever refused to honor such a request. . . . Shobael Clevenger, Robert Duncanson, Hiram Powers, Thomas Buchanan Read—the careers of these and many more artists were instituted through the patronage of Longworth."[74]

Duncanson met both benchmarks for Longworth's support. As the member of the Western Art Union who advised on purchases, Longworth likely watched with intense interest the progress Duncanson was making locally. Many have assumed that Longworth aided Duncanson because of his abolitionist views. Contemporary newspaper accounts, however, reveal that Longworth was a political moderate regarding race relations.[75] It is more likely that Duncanson intrigued Longworth with his talent and his desperate need for financially rewarding commissions.

Around 1850 Longworth decided to enhance the beauty of his Cincinnati mansion by having a series of murals painted on the walls of the entrance hall. This would have been a highly sought commission for any painter. Given Longworth's knowledge of art and his considerable wealth, he could have had his pick of many of the nation's well-known artists. Yet he chose Duncanson for this important project. Longworth's decision to employ the African American artist stands as testament to his faith and confidence in the ability of a painter whose reputation had not extended beyond the region.

The Longworth commission was a daunting challenge given its scale and complexity—several outsized panels located inside the main hall of the mansion. Duncanson was still refining his craft and had not resolved all the technical problems found in his early paintings. Yet the resulting murals at Belmont (now the Taft Museum) [fig. 1.8] show Duncanson as a confident and self-assured artist. He may have sought the advice of Sonntag or other local artists to overcome some of the difficulties he encountered in completing the project, but most of the prodigious amount of painting is probably by his own hand.

For the next two years, Duncanson labored on the murals. When finished they consisted of eight large oil on plaster wall paintings, all more than six and one-half by nine feet high. In addition, Duncanson rendered four

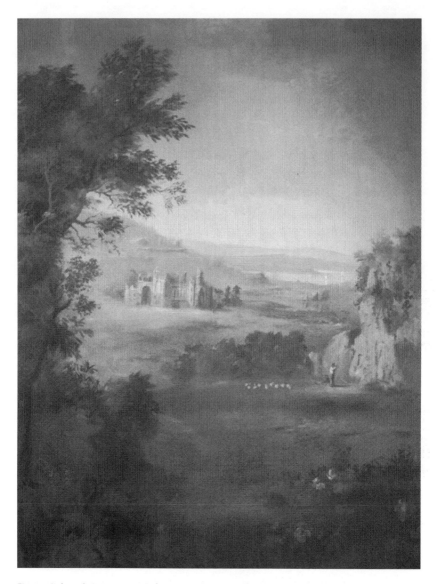

Fig. 1.8. Robert S. Duncanson, *Taft Murals*, Landscape detail, ca. 1850–52, Oil on plaster, 109.9" × 86.7", Taft Museum of Art.

over-door vignettes. Art historian Guy McElroy commented, "The paintings reflect their Hudson River background in their grandness and transposition of the experience of nature into spiritual reverie. They also reveal his European influences, his study of paintings by Nicholas Poussin or even more likely, Claude Lorrain. The softer atmosphere of these paintings relates more to European conceptions than to the sharper more detailed works by contemporary American artists. The excellence of the Taft murals places Duncanson among the most competent of his contemporaries."[76] Duncanson scholar Joseph Ketner proclaimed, "These are the most ambitious and accomplished domestic mural paintings in antebellum America."[77]

Duncanson's new patron may have influenced the style of his new paintings. Longworth owned a considerable collection of paintings and sculptures, evenly divided between American and European works.[78] Duncanson had an opportunity to examine closely European landscape painting and, perhaps, incorporated several of those features in the mural design to comply with Longworth's wishes. In addition, Duncanson drew inspiration from the decorative French wallpaper that was popular in America during the first half of the nineteenth century. These wall-sized prints often featured panoramic vistas and trompe l'oeil frames like Duncanson's Belmont work.

The Belmont murals established Duncanson as one of the major painters in Cincinnati. Furthermore, the completion of the project also established him as the first African American muralist in the country.

By 1850 Duncanson had reached the end of his journeyman period. The mural project had challenged his artistic ability to the utmost and pushed him to a newfound maturity. Many now recognized him as a highly credible artist in the region who was attracting increased critical attention. Hard work and persistence helped erode some of the mark of inferiority associated with his race and allowed Duncanson to continue his ascendency through the ranks of the regional Hudson River painters.

Duncanson relied on a second occupation to supplement his income despite his improving position in Cincinnati art circles and occasional financial aid from Longworth. During the 1840s and 1850s, Cincinnati business directories listed him as a daguerreotype artist.[79] It was not unusual for American artists of the nineteenth century to work in other areas to earn extra money. Even Duncanson's mentor, William Sonntag, reportedly painted circus wagons and dioramas at a wax museum until he could concentrate exclusively on art.[80]

By the early 1850s, Duncanson was associated with James Presley Ball, the African American owner of the largest daguerreotype gallery in the West. Ball was born in Franklin County, Virginia, around 1825 and apprenticed with Boston daguerreotypist John B. Bailey. In 1845 Ball opened a photography studio in Cincinnati, but it failed. He tried again in 1847 and found enthusiastic patrons. *Frederick Douglass' Paper* noted Ball's phenomenal success and reported, "One of the most creditable indications of enterprise, furnished in behalf of our people, is the flourishing business, and magnificent Daguerrean Gallery of Mr. Ball, in Cincinnati. . . . It is one of the best answers to the charge of nature inferiority we have lately met with."[81]

While Duncanson was quietly and tenuously making advances into Cincinnati's white society at this time, patrons, including some of the city's most prominent citizens, actively sought Ball's services. In 1853 he established a lavish studio on Fourth Street between Main and Walnut in the Weed Building that had two large "operating rooms," each twenty-five by thirty feet—one expressly for children and babies. Ball received his patrons in an opulent waiting room that was decorated with flesh-colored wallpaper bordered with gold leaf and flowers and graced with ideal sculptures representing the goddesses of Beauty, Science, Religion, Purity, Poesy, and Music, and the three Graces.[82] He employed nine photographic artists, one of whom was Duncanson, so "visitors are not obliged to wait a whole day for a picture, but can get what they desire in a few minutes."[83] Duncanson's duties in the studio included hand-tinting and retouching photographs, and painting backdrops. Ball's skill as a photographer and Duncanson's tinting ability made their photographs ". . . the town talk. Everyone pronounces them life-like and artistic, and creditable to the skill of Mr. Ball, as well as to the magic pencil of R. S. Duncanson, who does the coloring."[84] As Bridget Ford noted, "White Cincinnatians depended of Ball and Duncanson to envision, create, and represent their respectability. They therefore paid respectable sums for the men's services."[85] One reporter wrote that the photographs "finished by R.S. Duncanson were equal in beauty of finish to the richest paintings on ivory."[86]

The success Ball enjoyed in a city divided by racial tension became an inspiration for Duncanson. The young painter saw that through Ball's ethic of hard work, the obstacles of race could be circumvented and that successful outcomes could be achieved. His relationship with Ball also gave him a new audience for his paintings outside the art galleries of Cincinnati. An article that appeared in *Frederick Douglass' Paper* indicated that six of

Duncanson's best landscapes, including *May Party*, a picnic scene, and *The Shepherd Boy*, hung in Ball's reception room, and that the "depth and tone, the life and beauty of these paintings rank them among the richest productions of American artists."[87] This increased exposure unquestionably aided public awareness of Duncanson. It also helped him gain further acceptance with the city's white population.

During this time Duncanson had an opportunity to use his talents, in association with Ball, to bring increased public awareness of African American life and history. Ball's abolitionist leanings and his desire to openly promote the antislavery cause surfaced when he created, with the assistance of Duncanson and other local painters, an immense panoramic painting consisting of ceiling-high strips of canvas, sewn together and rolled onto a spool.[88] Altogether, the work measured 2,400 square yards of canvas (600 yards in length) and contained fifty-three scenes.[89] Entitled *Ball's Splendid Mammoth Pictorial Tour of the United States, Comprising Views of the African Slave Trade; of Northern and Southern Cities; of Cotton and Sugar Plantations; of the Mississippi, Ohio and Susquehanna Rivers, Niagara Falls, & C.* (1855), Ball gave the public a visual narrative of the Black experience from freedom in Africa, through the Middle Passage, to injustice in America. He first exhibited the panorama in Cincinnati at the Ohio Mechanics Institute and later showed it in Boston's Armory Hall, accompanied with a detailed pamphlet that he composed.

Ball proudly advertised the work as "painted by Negroes."[90] Duncanson may have been the principal artist on the project and painted large parts of it, but there is no record of names or numbers of other Black artists who participated. The United States Census of 1860 does, however, offer a clue. It was recorded that a mulatto man from Virginia named George W. Wilson was living with Duncanson and that James Goings from Ohio resided with Ball.[91] Both were listed as artists. It is highly probable that these men assisted in creating the panorama and suggests that Cincinnati may have had a more vibrant Black art community than one would expect.

It is unfortunate that this prodigious work remains lost and that scholars cannot evaluate its artistic merit. The concept, however, is remarkable given, the racial climate in Cincinnati and the country at the time of its production. In fact, in the narrative pamphlet accompanying the panorama, Ball, writing in the third person, testifies to his struggle in seeking cultural advancement within the race-restrictive environs of American society. He stated, "Had Mr.

Ball been a white man, this triumph (his successful gallery) would not be remarkable, but when we remember that in addition to his poverty, he has had to struggle against, that prejudice of the American people . . . his rise is worthy of remark."[92] Indeed, this declarative statement was one to which Duncanson could readily identify in his own pursuit of artistic and societal equality and upward mobility.

The 1860 census continued to link Duncanson with Ball. By then Duncanson was a highly successful painter owning $3,000 worth of real estate and personal property worth $800, both sizable amounts for African Americans during that time. The census record also indicates that he and his family, along with James P. Ball and his family, lived in a predominantly white neighborhood. They are, in fact, the only Blacks listed on the enumerator's page. The census also identified Duncanson and Ball as mulattoes. It appears, therefore, that in some parts of Cincinnati, a city where pervasive racism still forced well-defined racial restrictions, wealth and public notoriety extended the boundaries of where people of color could reside.[93]

Duncanson's experience with the panorama may have awakened a sense of racial awareness; it contained a section on the Atlantic slave trade and Black life on slave plantations in the South.[94] Yet he apparently did not let those feelings influence his choice of subject matter in his own work. Of all the known paintings by him, only one deals directly with the issue of race.[95] That painting, *Uncle Tom and Little Eva* (1853) [fig. 1.9], is based on the controversial antislavery novel *Uncle Tom's Cabin*, written by Harriet Beecher Stowe.

Although *Uncle Tom's Cabin* had a great effect on the national conscience, it did not stir Duncanson to capitalize on its popularity. Rather, he rendered his painting as a commission for James Francis Conover, a Cincinnati native and, at that time, editor of the *Detroit Tribune*.[96] Conover likely gave Duncanson specific instructions on the passage he wanted illustrated from the novel. Oral tradition passed down in the Conover family stated that the patron spotted a little girl on the street whom he believed to be the embodiment of Eva St. Clare and insisted Duncanson use her as a model.[97]

The resulting painting fails to make an obvious and direct statement denouncing slavery, and only those familiar with the story would comprehend its meaning. Conover chose one of the most moving, though tranquil, episodes in the book, wherein a critically ill Eva expresses her vision of heaven before her faithful slave. Duncanson situated the pair in a lush tropical setting on the St. Clare estate located on Lake Pontchartrain near New

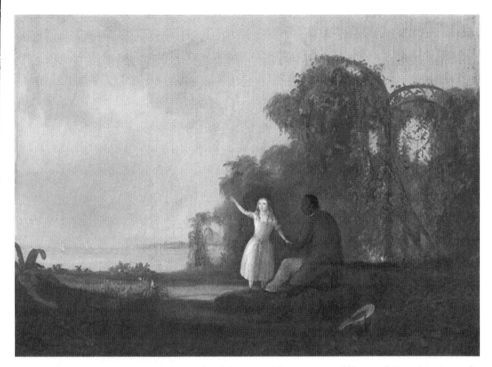

Fig. 1.9. Robert S. Duncanson, *Uncle Tom and Little Eva*, 1853, Oil on canvas, 27 ¼" × 38 ¼", Detroit Institute of Arts, Gift of Mrs. Jefferson Butler and Miss Grace R. Conover.

Orleans. His rendering was remarkably faithful to Stowe's written account and the original illustration by Hammatt Billings, which accompanied chapter 22 in the book. In addition to expanding the vista in which Eva and Tom interact, Duncanson modified the position of Eva from seated to a more dramatic standing pose in which she points to heaven. As A. S. Cavallo noted, Duncanson captured all the details described in the passage with such exacting accuracy that it appeared he painted "with book in hand."[98] Cavallo also commented on Duncanson's virtuosity in his handing of the surrounding landscape in the painting, remarking, "In Uncle Tom and Little Eva, however, the fanciful tropical vines, flowers, ferns and palms seem to be the issue of the artist's own rich pictorial imagination. The touches of the brush in the figures and the background are sure and fresh, and the sunset glow lends charm and warmth to the scene. Mr. Conover's choice of a Negro artist was a happy one: Duncanson must have felt sympathy with the subject."[99]

However, the painting was not without its detractors, especially in Duncanson's handling of the figures. A critic for the *Cincinnati Commercial* wrote:

> Uncle Tom, according to the artist, is a very stupid looking creature, and Eva, instead of being a fragile and fading floweret, is a rosy-complexioned, healthy-seeming child, not a bit ethereal.... Tom has nearly all of her arm in his hand, as if intending to check the projected flight, and appears about to inquire "what goin' dar for?"[100]

Despite any of its shortcomings, this painting provided Duncanson with the opportunity to use popular literature as a source of inspiration, a practice he would make integral in his work in the coming years.

Duncanson apparently painted no other African American–centered subjects after *Uncle Tom and Little Eva*. Perhaps the criticism leveled at him proved a decisive blow to his pride, and he refused to subject himself to those types of comments again. His reputation continued to grow as a skilled painter of landscapes, and he may have felt it was better to remain artistically neutral on racial issues. Duncanson understandably sympathized with the African American cause, but to compete on equal ground with his white contemporaries, he likely decided it was necessary to avoid bearing a label of "black painter of black subjects." He probably felt it safer, for financial reasons based on his clientele, to keep the inhabitants of his pictorial spaces Caucasian. By eschewing Blacks as subjects and keeping the terrain the primary focus, Duncanson aligned with other African American artists of the nineteenth century who rarely depicted Blacks in their works. Landscapes were now Duncanson's established forte, and they had safely gained him a growing measure of success and upward social mobility. Thus, painting Blacks as subjects for moral and emotional discourse was never a viable option.

Travel to Europe and Its Aftermath

The year 1853 was eventful for Duncanson. In April he traveled to Europe accompanied by William Sonntag and landscape painter John Robinson Tait and remained for about eight months. The group made the traditional Grand Tour of major European art centers—a sort of rite of passage for many

American artists of that era that gave them the opportunity to study works by old masters and gauge their own talents comparably. It also allowed them to inject a traditionally accepted European aesthetic into their work that had wide appeal for potential patrons.

Nicholas Longworth and the local Antislavery Society aided Duncanson financially. Longworth's confidence in his ability was apparent in a letter of introduction given to the African American artist for presentation to Hiram Powers (1805–1873). Powers was a Cincinnati native who, with Longworth's support, became one of the most celebrated sculptors in the world. By the time Duncanson set sail for Europe, Powers was operating a successful studio in Florence. Longworth wrote, "This letter will be handed you by Mr. Duncanson, a self-taught artist of our City. He is a man of integrity, & gentlemanly deportment, and when you shall see the first landscape he shall paint in Italy, advise me of the name of the artist in Italy, that with the same experience can paint so fine a picture."[101] Longworth's ringing endorsement of Duncanson indicates that the artist had achieved parity with his American contemporaries and now stood ready to rival the best European landscape painters. As an astute connoisseur of domestic and foreign art, Longworth was fully capable of making such a judgment.

Sonntag's reasons for making the voyage to Europe might give insight into what motivated Duncanson to follow. According to the *Cosmopolitan Art Journal*:

> having amassed a considerable sum as rewards of his incessant toil and study, and having about $5,000 in commissions to execute, he was persuaded to visit Europe for further study, and to obtain fine opportunities to fill his engagements. He went abroad, passing in a kind of flying visit of inspection over Europe, returning home after the brief absence of eight months.[102]

It is likely Duncanson also had several commissions to complete upon his return to Cincinnati. In addition, it is possible that his supporters encouraged him to study the great masterpieces found in the major European museums and galleries, to give his work a new, worldly perspective. Duncanson visited Italy, England, and France on his European sojourn, making sketches and studies that he would later develop into finished paintings.

Duncanson was back in Cincinnati by January of 1854. His European experience encouraged him and convinced him that he could compete with

the best landscape artists in the world. In a letter to his friend and fellow landscape artist Junius R. Sloan, Duncanson reflected on his observations of the English art scene and noted, "My trip to Europe has to some extent enabled me to judge my own talent. Of all the landscapes I saw in Europe (and I saw thousands) I do not feel discouraged."[103] He also found Joseph Mallord William Turner "a Modern Phenomenon in the Art of Landscape," and that English landscapes were "better than any in Europe."[104] However, Duncanson was not pleased with the quality of work done by Americans living abroad. He stated that he was "disgusted with our artists in Europe. They are mean Copyest [sic]."[105]

Upon his return Duncanson executed several paintings based on his sketches done in Italy, including views of Pompeii with Mount Vesuvius in the background that admirers of the detailed Hudson River style found particularly desirable. More importantly, the commissions Duncanson hoped for upon his return materialized. William Miller, a miniatures painter and friend of Duncanson, wrote to Isaac Strohm that he let Duncanson have "another artist's room" and that Duncanson was "executing beautiful Italian compositions" and that "he gives extra-ordinary promise and proves that he made good use of his eyes, in Italy."[106] In addition, Duncanson later indicated that he had an offer of $1,000 for a painting based on John Bunyan's *Pilgrim's Progress*.[107] It is interesting to note that Duncanson viewed this painting, now lost, as a major test of his newfound confidence to execute pictures in the grand European manner. The artist wrote, "I have made up my mind to paint a great picture even if I fail."[108]

Duncanson enhanced his position in the Cincinnati art community after his European trip. Having studied the works of the great masters firsthand, he gained respect as a well-traveled American master. His new paintings reflected an Old World sophistication not found in his earlier work. Duncanson's observations of European landscape painting influenced him greatly and allowed him to elevate his artistic vision.

Another one of the first works he completed after his return was *Classical Landscape with Ruins (Time's Temple)* (1853), an expansive, detailed Italian vista containing the remnants of an ancient Roman temple. Four years later Sonntag painted *Classic Italian Landscape with Temple of Venus*, a nearly identical composition. A close comparison of the two works reveals that Duncanson could more than match the more practiced hand and eye of his mentor.

Interestingly, Sonntag located to New York in 1856. Perhaps he was seeking a wider national reputation and more opportunities for sales outside the limited pool of patrons in the Midwest. In addition, Sonntag's move led to his election as Academician of the National Academy of Design in 1861. And while he was now securing exhibitions at prestigious venues, including the Boston Art Club, the Pennsylvania Academy of the Fine Arts, and the Brooklyn Art Association, Duncanson seemed far from impressed. He remarked, "Sonntag is painting the same old pictures he painted three years ago.[109] This statement speaks volumes about the trajectory of Duncanson's career as a painter and his need to expand his visual vocabulary. He was never content with settling into restrictive "formula" approaches to painting that eventually led to the stagnation of creativity. Instead, he was continually seeking ways that added fresh perspectives to traditional subjects. Landscapes remained the staple of Duncanson's output, but there were new vistas to explore at home and abroad that would allow for stylistic shifts in interpretation, thereby fostering his artistic growth. There was also a wealth of popular literature from which to draw inspiration that would allow his imagination to take flight fully.

Duncanson had now risen from fledging painter to an important regional artist whose skills now rivaled the best of the Hudson River painters, and after Sontag's departure he emerged as the leading landscape painter in Cincinnati. After 1855 Duncanson devoted full time to painting. He continued to enhance his reputation throughout the remainder of the decade, moving between Cincinnati and Detroit to secure commissions. In addition Duncanson married his second wife, Phoebe, a mulatto from Maysville, Kentucky, during this period.[110]

In 1856 Duncanson's identification as a progressive representative of Black achievement found its way into the pages of *The Liberator*, where the paper cited him as one of the enterprising members of the community:

R. S. Duncanson's studio contains many productions from his pencil, both portrait and landscape, well worth the attention of artists and connoisseurs. His most recent composition, "The Land of Beulah," on which he has been engaged for eighteen months, is 4 ½ feet by 6, and is so happy in conception, so admirable in detail and embodiment, that the spectator almost imagines himself actually in the scene it portrays. A plan was in progress for its exhibition and disposal by shares—it being valued at $1000. The friends of the

artist are anticipating a triumph beyond this however, in a series he is about commencing, in which will be blended some of the beauties of the "Garden of Eden," presented by him to Charles Avery, Esq., of Alleghany City.[111]

Duncanson's abolitionist ties remained strong as his career advanced. He donated a painting in October 1855 that was sold to raise funds at the Anti-Slavery Bazaar, and he painted a portrait of Richard Sutton Rust, first president of Wilberforce University and member of the Anti-Slavery Society, in 1858.[112] In addition, Charlotte Cushman, the great American actor and sympathizer of the African American cause, bought a painting from the artist entitled *Western Forest* (1857). The *Daily Cincinnati Commercial* reported, "During Charlotte Cushman's recent engagement in this city, she purchased a picture, entitled 'A Western Forest,' from R. A. [*sic*] Duncanson, our well-known artist. The great tragedienne, on her arrival in England, designs presenting it to her friend, the Duchess of Sutherland. The 'Western Forest' has been much admired by art-critics, and will be, no doubt, a most acceptable present to the lady for whom it is intended."[113] As will be seen, Cushman's close association with the aristocracy of Europe provided Duncanson with an advantageous introduction to art patrons on that continent.

In 1858 Duncanson also painted a life-sized portrait of his friend and benefactor Nicholas Longworth [fig. 1.10]. This gesture indicated that Longworth continued to associate with the Black artist and to provide him with financial assistance. James A. Porter noted that the painting "is a veritable icon of Longworth biography inasmuch as it makes direct reference through the landscape vista in the background, and the grapes and addressed envelope in the foreground, first, to Longworth's wealth of landholding, second, to his vocation of viticulture, and third, to his patronage of Duncanson."[114] Reminiscent of Gilbert Stuart's *Lansdowne* portrait of George Washington (1796) in compositional arrangement, Duncanson portrayed an austere Longworth dressed in a formal black suit standing on a terrace next to a small, cloth-draped table displaying an arrangement of grapes from which he gained his fortune. He also recorded Longworth's eccentric habit of pinning notes to his suit cuffs to remind him of imperative appointments and errands. In the background, a lush valley landscape revealed Longworth's extensive landholdings that allowed Duncanson to add his "signature stamp" to the composition.

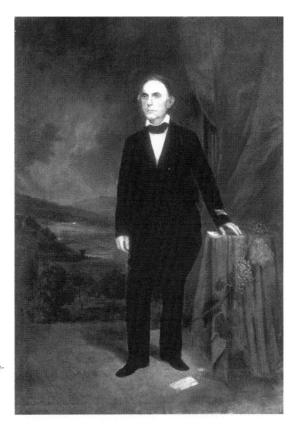

Fig. 1.10. Robert S. Duncanson, *Portrait of Nicholas Longworth*, 1858, Oil on canvas, 84" × 60", Cincinnati Art Museum.

There is no question that Longworth's sustained support of Duncanson proved crucial to his success. Longworth, seated at the top of the patronage structure in Cincinnati, had the ability to make or break local artists. John Frankenstein and painter James Beard both viewed Longworth's dictatorial-like control over successful art production in the city with disdain, as he failed to fully support either of them.[115] For Duncanson, Longworth's assistance was a blessing, and this may explain why, as many artists left Cincinnati to find better opportunities for patronage, Longworth's influence among the city's art elite remained with Duncanson long after his patron's death in 1863.

In the same year, Duncanson painted a full-length portrait of Andrew H. Ernst (1858), a prominent Cincinnati horticulturalist who owned the Spring Garden nursery, reportedly one of the best facilities in Ohio for supplying trees of many types. Ernst shared interests with Longworth—both were successful in cultivating plants locally, both had extensive landholdings, both

were wealthy, and both sought to aid in the plight of African Americans. Ernst's wife, Sarah Otis Ernst, also played a crucial role in the antislavery community in the city by serving as the president of the Cincinnati Ladies Antislavery Sewing Society.[116] It is likely that Longworth recommended Duncanson to Ernst to render his portrait, and he produced a strikingly similar composition to that of Longworth. Duncanson portrayed Ernst—dressed formally in a black suit—standing next to a small, draped table displaying his prized variety of pear. The background, once more, allowed Duncanson to demonstrate his mastery of landscape painting as he filled it with lush, fertile vegetation, rolling hills, and a meandering river. Placed side by side, the two portraits appear as complementary bookends—and indeed they were in their support of Duncanson. Men like Longworth and Ernst were visibly and financially eager to extend their pro-Black leanings to the promotion of Duncanson's career, and their stamp of artistic approval elevated him in the eyes of the art aficionados in the region.

At the end of the 1850s, Duncanson stood as one of the leading artists in the Midwest, despite the fact that pre-Civil War interactions between the races at that time "found most Ohio blacks pariahs, restricted and scorned, living in the state but in no accurate sense citizens."[117] Still, Duncanson managed to overcome many of the negative labels associated with his perceived inferiority and ascended to heights that were unprecedented in the annals of American art. Art historian Wendy J. Katz noted Duncanson's worth as a valued local practitioner of landscape painting by saying, "For African American professionals and entrepreneurs like Duncanson and his sometime collaborator, the African American photographer James P. Ball, Cincinnati's regional ambitions and its related promotion of the refining influence of nature opened opportunities for recognition and participation in art production. Landscapes like Duncanson's emerged as indicators of spiritual and moral depth and as agents of refinement themselves, assisting viewers to literally see beyond their self-interest."[118]

In 1859 the *Cincinnati Daily Press* reported that Duncanson was nearing completion on a painting that he apparently found difficult to resolve. The paper stated, "Duncanson, artist of our city, has been on 'Heaven and Earth' for the last five years. It is a painting, which, in a few more months, will receive his finishing touch."[119] The work remains lost or unidentified.

That same year, Duncanson demonstrated the height of his creative powers when he delivered *The Rainbow* (presently known as *Landscape*

with Rainbow) [fig. 1.11]. The work highlighted his complete mastery of the Hudson River style and made him, unequivocally, the equal of any of his white contemporaries. Duncanson presented a richly detailed pastoral scene wherein a young couple strolls leisurely, under a clearing sky following a fleeting rain shower, along a well-worn path while cows meander passively ahead of them. Vegetation-laden mountains and a mirrorlike lake complete the sense of total tranquility—it is rapidly becoming a perfect day. In addition, a rainbow occupies the right section of the composition and ends directly over a house, presumably the destination of the couple. In this painting Duncanson perfectly captures the human presence as being in harmony with nature and renders a vision of rural America as Arcadia that ranks it among the best in the Hudson River tradition.

The *Cincinnati Daily Press* agreed that *The Rainbow* presented Duncanson as an accomplished artist reaching his zenith. The reporter also gave a critical insight as to how Duncanson assembled his compositions:

> During a recent visit to Duncanson's studio we found he had finished a new picture entitled, "The Rainbow," a composition of studies from nature, which we regard as the most complete and artistic painting he has yet produced. . . . The season is supposed to be September and the hour six in the afternoon. . . . We have our own idea of the rainbow, and of the propriety of any artist, however gifted, attempting to capture its subtle hues, or reproduce its unique semblance on canvas; but we still cannot deny that Duncanson has succeeded very well in this most difficult endeavor. His whole painting is most credible, and must increase the reputation he has earned. All the details are finished, and the painting has more of the true art atmosphere in and about it than we remember to have noticed in any [of] his previous works. About the landscape lies a dreamy, poetic languor that is charming to the sense and refreshing to the spirit. . . . Every feature in his picture is a study from nature, and the whole is but a transcript of fragments selected here and there, most of them from scenery in this vicinity.[120]

As the decade closed, Duncanson likely thought of new worlds to conquer. The great art centers of the East, such as New York, Philadelphia, and Boston, deserved his attention. There also was an international reputation to obtain that would raise his visibility as an artist of impeccable talent and credentials. His initial trip to Europe left him confident that he could compete

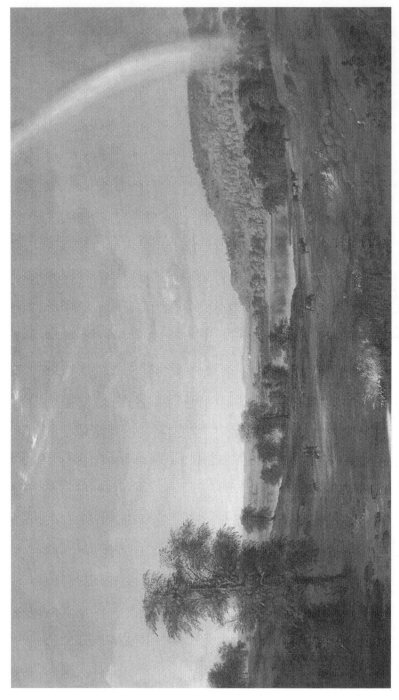

Fig. 1.11, Robert S. Duncanson, *The Rainbow*, 1859, Oil on canvas, 30" × 54 ¼", Smithsonian American Art Museum, Gift of Leonard and Paula Granoff.

equally with anyone at home and abroad. Duncanson's future was bright, but there were political and social issues in the nation that were quickly leading to armed conflict with potential ramifications that could prove dangerous enough to rob him of all he had achieved.

The Civil War and Flight and Fame Abroad

The new decade ushered in troubled times for the state of Ohio and the country. Mounting tensions on the issues of slavery and states' rights drove the South closer toward dissolving the Union. The election of Abraham Lincoln as president in 1860 sealed the country's fate. Many Southerners feared his election would seriously jeopardize a social, political, and economic system based on slave labor. Although Lincoln made it clear during his campaign that he was not opposed to slavery where it existed, South Carolina voted for secession six weeks after his victory. By April of the next year, the Civil War began.

The war had major repercussions for the country's Black population. For free Blacks living in the North, the possibility of a Confederate victory must have been terrifying. They stood to lose what they cherished most—their freedom. Yet Robert Duncanson stood to lose much more. By 1861 he enjoyed increased critical acclaim and financial reward that elevated the appreciation of his art to a level of equality with his white contemporaries. However, the war suddenly threatened to take away all Duncanson had worked so long and hard to accomplish. He and thousands of other free African Americans therefore monitored the progress of the war with great interest and intense dread.

The initial campaigns of the Civil War did not go well for the Union Army. In July 1861 the South won a resounding victory at the First Battle of Bull Run. In August the Second Battle of Bull Run ended in a rout of Northern forces and led to the prospect of a protracted conflict. The wake of these stunning successes caused the citizens of Ohio to fear Confederate attacks launched from Virginia and Kentucky.

Still, Duncanson continued to be productive. In 1861 he exhibited a landscape, *First Tints of Autumn*, at Rickey, Mallory & Co's space in the Opera House Building, that attracted public attention. It was a small painting—about twenty by fourteen inches—but his reputation still made it newsworthy. Its size as much as its "simplicity" of composition seemed to intrigue

the reporter from the *Cincinnati Daily Press*. However, it seemed to lack something expected from a Duncanson painting; "The haziness, the dreaminess he usually throws over his pictures giving such a softness and charm to them is not here, and we miss it much."[121] The reporter concluded, "That he has studied and elaborated the painting there can be no doubt, and we presume his effort has been sufficient compensation for his expenditure of time and application of talent."[122]

If there was any decline in the quality of Duncanson's work, it could be attributed to the fact that he was turning his attention toward something much grander—visual interpretations of popular Romantic literature that eventually emerged from works such as John Milton's *Paradise Lost*, Thomas Moore's *Lalla Rookh*, Alfred, Lord Tennyson's *The Lotos-Eaters*, and Sir Walter Scott's *The Lady of the Lake*. Duncanson's attraction to these subjects came from his involvement with the Cincinnati Sketch Club, a gathering of local artists dedicated to promoting intellectual advancement in the arts, including intergroup sketch challenges often based on well-known works of literature.[123] In this regard, he was falling in line with the growing appeal of imagining ancient civilizations and exotic environs as a means of expressing individual emotions and reverence to nature through escapist imagery.

This was a defining moment for Duncanson and his career, as he transformed himself from a first-rate painter of midwestern landscapes into an artist capable of absorbing innovative high-culture texts and translating them into magnificent narrative images based on an elevated level of intellectual engagement that exquisitely countered the mainstream's acceptance of Black cultural stagnation. As such, Duncanson strategically added impressive literary comprehension to his existing visual vocabulary to further produce art that was, by any credible and objective critique, race equalizing. As Bridget Ford noted of this transition and its eventual deliverance of prestige in regional attainment in the arts, "Duncanson . . . benefited and made use of Cincinnatians' civic ambitions to advance his artistic career. Boosters who sought to make Cincinnati the leading commercial and industrial city of the Midwest patronized the arts in a bid to demonstrate the region's elevated cultural sensibilities and Duncanson's highly stylized works with literary themes delivered a certain cachet."[124]

Despite his growing concern over the war, Duncanson completed his largest work to date, *Land of the Lotos-Eaters* (1861) [fig. 1.12], based on Alfred, Lord Tennyson's (1809–1892) epic poem. The painting depicts a

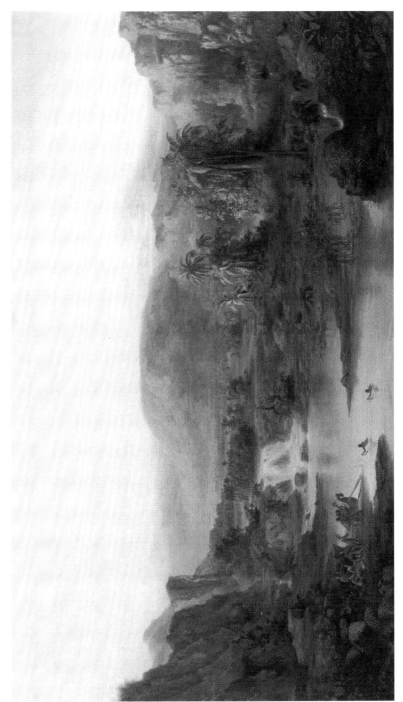

Fig. 1.12. Robert S. Duncanson, *Land of the Lotos-Eaters*, 1861, Oil on canvas, 52 ¾" × 89", Swedish Royal Collection, Stockholm.

lush, tropical island paradise devoid of all conflict and struggle. According to the story, derived from *The Odyssey*, shortly after Odysseus and his crew arrive, he dispatches three of his men to explore their surroundings. These men encounter the Lotos-Eaters and find that they are a peaceful people who do nothing all day except eat the Lotos plant. The explorers ingest the intoxicating food, and it alters them mentally; they forget everything, including their duties, homes, and loved ones. They have only one purpose in life now—to eat from the plant and succumb to its tranquilizing effects. Odysseus later locates the men and forces them to return to the ship against their wishes.

This poem is ripe to see within it a strong antiwar message. The period immediately leading up to the Civil War and its subsequent violent turn of deadly events may have triggered a response from the artist, in allegorical terms, which dealt with a growing sense of concern over the nature of the conflict. In this regard, *Land of the Lotos-Eaters* may directly refer to a restored "paradise" where the horrors of bloody conflict no longer exist and peace reigns supreme. Perhaps Duncanson chose to make a symbolic visual statement that not only eliminates war but also abolishes the divisive issue of slavery—in Lotos Land, all are equal under the mind-altering effects of the food. Therefore, Duncanson may have found a measure of escapist racial coexistence in this and other literature-inspired works in the midst of turbulent times.

While this decoding of *Land of the Lotos-Eaters* remains debatable, there is no question that this was one of the great pictures he anticipated creating after his journey to Europe. Duncanson painted it with such exacting detail and technical proficiency that it immediately rivaled the best work of any Hudson River painter.

Duncanson drew further inspiration to create this monumental painting after viewing Frederic Edwin Church's acclaimed work *The Heart of the Andes* (1859), at Pike's Opera House in Cincinnati in 1860. His choice of subject matter also reveals certain crucial aspects of his development during the early 1860s. His turn toward large paintings based on literary themes indicates that he was striving for a new level of mastery of technique and increased recognition. He was challenging himself to compete on a higher level, perhaps feeling he had outgrown the label of "regional artist" and that an international audience beckoned. The personal threat that the war represented for Duncanson was enough to make him consider retreat to Canada

and Europe for its duration—at least he would be able to continue his career abroad if the Confederacy made major gains, and paintings like *Land of the Lotos-Eaters* would make for a smooth and impactful transition, casting him as a master painter. Duncanson's preference for deriving inspiration from popular works by nineteenth-century authors would also suggest he was looking for an enlightened audience that would better appreciate his artistic vision.[125]

Duncanson's decision to paint from literature possibly did more to dispel the belief of African American inferiority in art than any of his previous efforts. Here was a person of African descent who not only painted as well as most whites but also was intelligent enough to read the contemporary classics and render stunning imaginative visual interpretations.[126] Thus, given Duncanson's accomplishments as a landscape painter of the imagination, racists like North Carolina author Hinton Rowan Helper would be hard-pressed to defend his position on the lack of Black artistic progress in the name of white supremacy after writing:

Has the African ever artistically pictured, upon canvas, anything animate or inanimate? No, no. The Negro can show no masterpiece in landscape, no pattern in portraiture. It is the white man only, who self-supplied with easel and brush, mysteriously seizes the fantastic and flights of the imagination, and then, with steadiness of nerve, deliberately fashions them into substances of wondrous form and beauty. None but white men . . . have gained, and none but white men can gain, meritorious recognition and eminence.[127]

Land of the Lotos-Eaters was an unqualified success and further elevated Duncanson's standing as the region's premier painter of scenic vistas. The *Daily Cincinnati Gazette* announced:

Mr. Duncanson has long enjoyed the enviable reputation of being the best landscape painter in the West, and his latest effort cannot fail to raise him still higher in the estimation of the art loving public. He has not only wooed, but won his favorite muse, and now finds ample repayment for the labor of a lifetime, in the achievement of a more brilliant success than has attended most of his compeers. It did not escape the notice of the public that Land of the Lotus Eaters was drawn directly from Church's *Heart of the Andes*, which had taken the city by storm.[128]

When Duncanson's intention to exhibit *Lotos-Eaters* abroad became known throughout Cincinnati, the *Daily Cincinnati Gazette* predicted, "With Mr. Duncanson, we take it that the acquirement of a most enviable reputation is only a matter of travel and time. Let the art lovers of Gotham view and study the picture, now on exhibition at the Opera House, and they will not hesitate to enroll the name of its author in the annals of artistic fame."[129] It appeared that some in Cincinnati wished to see Duncanson duly rewarded for his standing as a stellar representative of the city's cultural advancement. Matters of race, in this case, seem to have been overlooked for the sake of maintaining regional pride and prominence in landscape painting originating in the West.

Duncanson followed the ambitious literary translation of *Lotos-Eaters* with *The Vale of Kashmir* (1863) based on Thomas Moore's epic work *Lalla Rookh: An Oriental Romance* (1817). Duncanson first envisioned the scene as part of the meetings of the Cincinnati Sketch Club. At this time, Duncanson was an active member along with Henry Worrall, James H. Beard, William P. Noble, Thomas Lindsay, Theodore Jones, and Joseph. O. Eaton.[130]

Although Thomas Moore never visited India, his poem, set in the country, enjoyed wide appeal in Europe and America for its vivid imagery of the distant and mysterious land and its people and customs. Duncanson found within it an opportunity to once more allow for his imaginative interpretation of a key act in an epic poem. Thus, he visually translated the arrival at the "Vale of Cashmere" of Lalla Rookh, the princess of Delhi, to marry Aliris, the Prince of Bukhara. The poem suggests that the destination is an earthly paradise, and Duncanson treated his composition as such. Thus, while the participants of the wedding are centered in the painting, they are rendered small, in keeping with Duncanson's preference for Hudson River aesthetics, while a highly detailed landscape, with a river, waterfalls, lush tropical vegetation, and soaring mountains, transports the viewer to the exotic environs an Orientalist utopia. Consequently, most of those who gazed upon *The Vale of Kashmir* and who were familiar it its source material would instantly recognize Duncanson as an artist of the highest level of intellectual engagement in recasting literature into stunning scenes of mystery, intrigue, and romance.

The poem continued to fulfill Duncanson's growing infatuation with classic Irish, Scottish, and British literature and the possibilities they offered to depict vistas that transported his viewers to imaginative realms. This subject appears to have held particular interest for Duncanson, as he subsequently

rendered several other versions of *Kashmir*, each growing more impressively detailed and polished, as if he continued to search for his own perfect mythical paradise.[131]

Duncanson returned to depicting the human figure as the central focus in some of his compositions during this period. For example, Duncanson's *Allegorical Figure* (1860) depicts a beautiful, exotic woman rendered in the style of a classical European goddess. She seems suspended in midair as her robes flow backward as the wind gently pushes them. Her right hand gestures upward and points to a lone star that glows in the distance. Her flawlessly rendered face, looking contemplative and serene, shows that Duncanson attained a level of technical execution that rivals some of his more academically trained contemporaries.

Joseph Ketner suggests that the figure is a Peri, a "child of air," described in *Lalla Rookh*, from which his *Vale of Kashmir* would spring.[132] I suggest another reading of the figure and see her as a guardian angel. If there is a possibility that Duncanson was inclined to encode antislavery messages in his works, then *Allegorical Figure* can be easily deciphered as a veiled reference to Black liberation in the form of a spirit guide who points to the North Star and the end of enslavement.

Perhaps Duncanson takes his visual metaphors in addressing slavery a step further in *Eve* (1862). He presents a full-length female nude who dominates the composition amid the lush foliage of the Garden of Eden. Duncanson portrayed her clasping the apple from which she has taken a bite. Her other hand reaches back into the forbidden tree as if to repeat her disobedience of God's command not to eat from the Tree of the Knowledge of Good and Evil. Moving beyond a literal biblical interpretation, Duncanson may have chosen Eve to represent symbolically the nation's "sin" of embracing slavery, which now resulted, in the year of the painting's completion, America's "punishment" through civil war.

Duncanson was now reaching the height of his career, but the mounting pressures caused by the Civil War and increasing racial tensions in Cincinnati weighed heavily on him and his future prospects. In fact, a legislative committee issued a report in 1862 that stated, "The Negro race is looked upon by the people of Ohio as a class to be kept by themselves; to be barred of social intercourse with whites; to be deprived of all advantages which they cannot enjoy in common with their own class."[133] This heightened state of racial agitation, coupled with the uncertain outcome of the war and the

rising confidence in his ability to compete on an international level, influenced Duncanson's decision to leave the country as a matter of personal and artistic survival. As a result, Duncanson, traveling with many of his popular paintings, ultimately crossed into Canada.

Duncanson arrived in Toronto in the winter of 1861 and exhibited *Lotos-Eaters* along with a painting entitled *Western Tornado* (1861) at Joseph's Jewelry Store.[134] Apparently, he vacillated between Canada and America while remaining close to the border and painted at a safe distance from the battle lines drawn in the Civil War. He made a lengthy tour of Minnesota and New England and completed works such as *Maiden's Rock, Lake Pepin, Minnesota* (1862) and *Lancaster, New Hampshire* (1862).

At this time Duncanson may have drawn inspiration from the poetry of Henry Wadsworth Longfellow, especially his *Song of Hiawatha* (1855). The popularity of the work and its setting in the American wilderness offered Duncanson the opportunity to reestablish his spiritual affinity with the native rural landscape. As part of his Minnesota excursion, he observed how the land and its indigenous peoples serendipitously coincided with Longfellow's embrace of Native Americans as worthy embodiments of literary romance. Consequently, Duncanson framed his new works *Minnehaha Falls* (1862) and *Minnenopa Falls* (1862) around the presentation of Native Americans as a people intimately and spiritually tied to the natural landscape, in keeping with an important principle of Hudson River aesthetics.[135]

By the summer of 1863, at the height of the Civil War, Duncanson established residence in Montreal.[136] He found the Canadian social and artistic climate so receptive that he apparently decided to remain in the country for an extended period. The racially connected pressures he endured in America were now diminished, and Duncanson historian Edward H. Dwight concluded, "In Canada his color did not prevent his association with other artists and his entrance into good society, as it evidently had in Cincinnati. It may be that because of his light color he was not thought to be a Negro. In any event there was less prejudice in Canada and in Europe, then as now. He was greatly encouraged in Canada and in Scotland and England [and] was treated with consideration. His paintings brought high prices and he lived in style."[137] The *Art Journal* of London reported that during his stay in Canada, Duncanson was at work completing landscapes "nearly the same dimensions as the *Lotos Eaters*."[138]

Duncanson's reputation in Canada was enhanced by his association with that country's most prominent commercial photographer, William Notman (1826–1910).[139] Notman exhibited *Land of the Lotos-Eaters* and *Western Tornado* in his Montreal studio in September 1863.[140] He charged admission for the public to view the works of the American painter. At the same time, Notman was assembling a portfolio of photographic prints of leading Canadian and foreign artists.[141] When he completed the work in December 1863, *Photographic Selections by William Notman* contained reproductions of *Land of the Lotos-Eaters* and *City and Harbour of Quebec*. It also contained this glowing assessment of Duncanson's brief time in Canada: "Mr. Duncanson has been for some time resident in Montreal; where he has met with that success and encouragement in his profession as a landscape painter, which he was entitled to expect as the painter of the *Lotos Eaters*."[142]

During his stay in the country, Duncanson began to shift from epic literary works to more-focused and intimate views of the Canadian wilderness. He had arrived in the country when it sought its own distinctive national identity in art. Following Duncanson's example, several native painters, such as Otto Reinhold Jacobi and Allan Aaron Edson, helped establish the landscape as a major focal point of Canadian art. Apparently, Duncanson's influence on Edson went beyond mere emulation. Evidence suggests Duncanson was Edson's first art instructor.[143] This distinction made Edson the only known student of Duncanson, and his ability as a teacher may be judged by Edson winning an award at the Upper Canada Provincial Exhibition in London in September 1865.[144]

Although some art historians have long regarded Duncanson as a minor regional artist within the Hudson River tradition in America, he provided a major contribution to the development of Canadian art. Allan Pringle stated:

Duncanson was the first established American artist to take up residence in Canada. During his two-year stay he remained near the hub of art-related affairs, most valuable to the aspirations and evolution of a Canadian landscape school. Not only did he actively participate in the events of Canada's earliest art society but he was also among the original interpreters of Canadian subject matter and an inspiration for leading landscape enthusiasts. Viewed in this light, Duncanson's efforts in Canada must be considered among the greatest accomplishments of his career.[145]

Duncanson left Canada sometime before the summer of 1865, bound for Europe to display his *Lotos-Eaters*. He was accompanied by Canadian artists Allan Edson and C. J. Way. The Civil War was now over, but the impact of the newly freed slaves on American society was uncertain. Duncanson may have wished to view these unfolding events from a safe distance, rather than rushing home and suffering the backlash of unsympathetic and agitated whites. His experience in Canada had served to bolster his confidence, and he felt he was now ready for the more sophisticated European market.

Duncanson repeated the success he enjoyed in Canada during his stay in Europe. He exhibited *Lotos-Eaters* in Ireland at the Dublin International Exposition of 1865, where the painting was listed as a Canadian entry.[146] In addition, Edward H. Dwight noted that Duncanson extended his travels abroad, saying, "His work was well received in Glasgow and other cities in Scotland."[147]

In London, Duncanson attracted considerable attention with his talent. The *Art Journal of London* reflected the extent of Duncanson's acceptance abroad when it reported:

> America has long maintained supremacy in landscape art, perhaps indeed its landscape artists surpass those of England. . . . Mr. Duncanson has established high fame in the United States and Canada. He is a native of the United States, and received his art education there; but it has been "finished" by a course of study in Italy, by earnest thought at the feet of the great masters, and by a continual contemplation of nature under southern skies. . . . [*Land of the Lotos-Eaters*] is full of fancy. It is a grand conception, and a composition of infinite skill; yet every portion of it has been studied with the severest care. . . . The sight of it cannot fail to be the source of intense enjoyment. As a transcript of nature, such as nature may be in the land where, even now, all but man is divine, where the loveliest of earth's products are lavished in luxurious profusion, and where the commonest things are the most beautiful—this painting may rank among the most delicious that art has given us but it is also wrought with the skill of a master in the minutest details.[148]

There are few details available on Duncanson's life while he was in Europe, but the Reverend Moncure D. Conway, a Presbyterian minister and Cincinnati resident visiting London, provided an insightful look at an African American artist standing on the edge of international greatness. Conway

reported Duncanson's stunning success back to the people of Cincinnati in the following article:

> In walking through the gallery of South Kensington the other day I met Duncanson, whom some of you remember as one who, a few years ago was trying to make himself an artist in Cincinnati and who already had produced a worthy piece of imaginative art in a picture of Tennyson's "The Land of the Lotos Eaters."
>
> Duncanson subsequently left Ohio and repaired to Canada where his color did not prevent his association with other artists and his entrance into good society. He gained much of culture and encouragement in Canada, retouched his "Lotos Eaters" and set out for England. In Glasgow and other Scotch cities he exhibited his pictures with success.
>
> He has been invited to London by various personages. Among others, by the Duchess of Sutherland and the Duchess of Essex, who will be his patrons. He also received a letter from Lord Tennyson, the poet laureate, inviting him to his home on the Isle of Wight where he will go and take with him the "Lotos Eaters." Think of a Negro sitting at the table with Lord and Lady Tennyson, Lord and Lady of the manor and the mirror of aristocracy.[149]

Conway's conversation with Duncanson confirmed that the African American artist's career was hindered within the art circles of Cincinnati because of his race. Despite all he had accomplished in America, Duncanson was still not permitted to gain full entry into white society. It is therefore not surprising that Reverend Conway challenged his Cincinnati readers to ponder the almost "unbelievable" notion of a person of African descent sitting at the same table with the poet laureate of Great Britain, engaged in an exchange of high culture.

As previously mentioned, Duncanson's association with the celebrated American actor Charlotte Cushman benefited him greatly. Cushman's status as an influential expatriate in Europe and friend of the aristocratic class proved instrumental in seeing that his work received proper introduction overseas. In fact, Cushman secured for Duncanson the purchase of *Lotos-Eaters* while he was still in London. It was she who brought the painting to the attention King Charles XV of Sweden, who subsequently bought it from the artist for display in the Royal Palace in Stockholm.[150]

Finally, the *American Art News* reported that Duncanson had another distinguished European patron, stating that his talent brought him "under the notice of Queen Victoria; she purchased one of his works now hanging in Windsor Castle."[151]

"The Best Landscape Painter in the West"

Despite the success he attained in Canada and Europe, Duncanson decided to return to the United States in 1867. With the Civil War over and Radical Reconstruction policies promising a new era in Black rights and representation, the artist may have felt that doors previously closed to him were now open. He was now an internationally celebrated painter who could command higher prices and a greater measure of respect among the public and his peers. His decision to abandon the more congenial lifestyle outside the country and return to Cincinnati was a gamble, but it soon proved to be the correct choice, as he immediately began to experience increased demand for his paintings. Consequently, he opened a new studio on Fourth Street.

At this stage in his career, the artist was extremely confident in his ability, and enthusiastic audiences embraced him fully, and buyers rewarded him substantially. Perhaps to satisfy his growing list of patrons, Duncanson shifted to painting smaller, more intimate views of nature that he began in Canada, and he employed looser brushwork and softened perspective.

For the next four years, Duncanson remained a popular and financially rewarded artist. As he continued to actively participate in exhibitions in Cincinnati and Detroit, he was "receiving $500.00 for a medium sized canvas."[152] Wendell P. Dabney proclaimed that Duncanson's paintings "produced for him many thousands of dollars, year after year."[153] In addition, Joseph Ketner reported that near the end of his life, Duncanson's paintings commanded astonishing prices for the times, indicating that his *Paradise and the Peri* brought $15,000, and *Ellen's Isle* sold for $8,000.[154]

Edward H. Dwight suggested that he made another trip to Europe between 1870 and 1871 to find inspiration for new work.[155] Even though there is no existing documentation to support this venture, he at least reentered Canada in 1869, where he continued to paint wilderness areas. Around this time, he also completed several works inspired by European scenes—*Storm off the Irish Coast* (ca. 1870), *Dog's Head of Scotland* (1870), *On the Banks of the*

Doune, Scotland (1871), and *Ellen's Isle, Loch Katrine* (1871)—thus adding to the speculation of additional travel abroad.[156]

Duncanson was now in an enviable position at the start of the new decade. His technique had never been stronger, sales were good, and critical response remained positive. The *Detroit Free Press* reflected the admiration Duncanson had achieved with the critics and his viewing public in this review:

> There were placed on exhibit, in the Western Art Gallery, two works by R. S. Duncanson, of Cincinnati. In the foreground is seen Peri (Spirit of Air) standing on a cloud facing the angel at the gate of Heaven. It is an illustration of a portion of Moore's "Paradise and Peri." The atmospheric effects are startling and original. Another picture entitled "Ellen's Isle," from Sir Walter Scott's "Lady of the Lake," is a superb work, and during the first day of the exhibition attracted a great deal of admiration. It represents the island and a portion of Loch Katrine with the sunlight shining full upon the scene. A mountainous background and rich glory of clouds, add a charming effect to the warm and glowing foreground, giving the whole picture a harmony of coloring and graceful outline that cannot fail to please the eye.[157]

Around this time, Duncanson made a sincere gesture to repay the support the abolitionists had given him during the days prior to emancipation. He traveled to Boston with the intention of presenting *Ellen's Isle, Loch Katrine* to Charles Sumner as a "token of the gratitude felt by a colored man for what the senator had done for his race."[158] While Sumner, a noted political leader known for his stand against slavery, was honored by the gesture, he declined the gift. He believed the painting was much too valuable to be kept from the public eye and possible sale. Sumner agreed to hold the work in trust for Duncanson, and it was hung on the senator's bedroom wall.[159] When Duncanson fell ill two years later, Sumner was said to have had the painting appraised for $500, added $100 to the sum, and given the money to Mrs. Duncanson.[160]

The End of His Career

Though his future looked promising, tragedy struck. While he was preparing for another exhibition in Detroit in the summer of 1872, Duncanson suffered

a seizure and collapsed.[161] His family had him committed to the Michigan State Retreat for treatment of a severe mental disorder. For unknown reasons, Robert Seldon Duncanson died on December 21, 1872.

Duncanson's declining mental condition did not adversely affect his ability to paint captivating landscapes, as his artistic production in the year preceding his death—including *Paradise and the Peri* (1871), *Pompeii* (1871), and *Scotch Landscape* (1871)—all measured up to his high standards. In fact, a Cincinnati reporter called *Paradise and the Peri* "perhaps the best effort of the artist's life."[162]

Yet *Paradise and the Peri* may offer a clue as to Duncanson's state of mind shortly before his passing. Once more turning to *Lalla Rookh*, Duncanson chose a passage wherein the Peri, a fantastical, winged, spiritlike creature occupying a position between heaven and hell, having been expelled from Paradise, attempts to regain entry by presenting a gift that is most desirable in the higher realm. It is only after the Peri secures a tear from the cheek of a remorseful old sinner who has witnessed a child praying, that Paradise is finally achieved. Perhaps Duncanson, anticipating his own demise through growing clouded perceptions, metaphorically sought his own entrance to heaven through a painting based on a familiar subject that represented his personal longing for the escape into an eternal paradise.

The official diagnosis of Duncanson's illness contained in the records of the Michigan State Retreat has long since been lost, but there are a few surviving statements regarding some of the symptoms he displayed toward the end of his life. His obituary in the *Detroit Tribune* reported, "He had acquired the idea that in all his artistic efforts he was aided by one of the spirits of the great masters, and this so worked on his mind as to affect him not only physically but mentally."[163]

Even before his death, Duncanson's celebrity status made his mental decline speculative fodder in the Cincinnati press. Perhaps those labeling him a Spiritualist who conversed with the dead somehow lessened their pain of witnessing publicly his growing struggles to maintain his sanity.[164] His family, friends, and supporters were at a loss to competently explain the mounting bouts with hallucinations, sudden mood swings, and violent outbursts that engulfed him.

Another account stated that Duncanson "must have been very temperamental, for his last days were clouded, in Ohio and Michigan, leading finally to his violent insanity, in which, with his great strength, he would tear apart

his confining bars."[165] Henry Mosler, a friend of the artist, described his "moodiness and sudden upheavals," and his throwing away of his brushes, accompanied by "weeping and wild laughter at his imagined mediocrity."[166] In addition, *The Plaindealer* (Detroit) reported that Duncanson "developed the hallucination that he was 'rich, very rich!' and 'had more money than he could ever give away or spend!'"[167]

Finally, a letter by Duncanson's second wife, Phoebe, written just four days before his death presented this painful account:

> I went out today to hear from him. They do not allow me to see him any-more, he was worse after my seeing him the other time. The sister in charge of him said today that he has been entirely unconfined since last Thursday, and is very quiet and natural. His physical health has improved and he eats and sleeps, and walks in the hall with other quiet ones. I had Berta with me for the first time. She thinks it is very nice out there, and likes the sister very much. She thinks a great deal about her papa and worries about him too, and sometimes comes to me and says, "mama I can't help it, I feel so bad for papa, I must cry." When I told her he would like to see her she cried as if heart-broken. One would not expect so much feeling from one so young, and mild as she is. . . . I am so unsettled I cannot do anything now. I had not been to the Retreat for 2 weeks until today. I found that going so often was having a bad effect on me, so I quit. I do not allow myself to have any hope for fear I may be disappointed. I made up my mind for the worst long ago.[168]

Joseph Ketner's research on Duncanson led him to suggest that the physiological cause of the artist's illness was lead poisoning.[169] In Duncanson's case, this affliction may have been the result of long-term exposure to the lead contained in the white pigments he used throughout his career, beginning with the paint he used on houses in Monroe. Ketner speculated that the cumulative, toxic effects of lead "caused a traumatic disruption of his personality."[170]

The press in Detroit and Cincinnati noted the death of Duncanson. The *Detroit Tribune* attested to his ability and character by stating, "He was an artist of rare accomplishments and his death will be regretted by all lovers of his profession who knew him personally or by reputation."[171]

Perhaps the greatest tribute to Duncanson came from an appreciative group of his fellow Cincinnati artists—Thomas S. Noble, John Aubrey, Dwight

Benton, Henry F. Farney, E. D. Grafton, Mr. Knock (likely William C. Knocke), Henry Mosler, Israel Quick, a Mr. Winton, and C. T. Webber—-who published the following resolution, in part in his honor:

> Resolved: That his long life of arduous toil and continuous effort to elevate the aims and use of landscape art command our admiration and though endowed by nature with the highest poetical conceptions and eminently successful in placing his chosen branch of art beyond the plane of the merely imitative, he deserves the greatest appreciation that he never forgot the kindly and generous sympathy for the humblest beginner who sought advice from the rich storehouse of his experience.
>
> Resolved: That while we mourn his departure, and miss from among us the genial soul who cherished malice toward none, at least a measure of satisfaction is that the weary pilgrimage of his life is over and we can believe that his spirit waits not like "Peri at Paradise" but the celestial landscape his imaginative pencil so vainly endeavored to depict is reality.[172]

Duncanson was fifty-one years of age at his passing. Funeral services were held in Detroit, and he was buried in an unmarked grave at the Woodland Cemetery in Monroe, Michigan.

Apparently the admiration shown to Duncanson at the end of his life among his artist friends was not well ensconced in the community's collective memory. In 1875, just three years after his death, the city hosted the Cincinnati Industrial Exposition that included a major art exhibition. On display were dozens of works by European and American artists, including paintings by notable locals, former and present, Sonntag, Eaton, Tait, Beard, Spencer, Duveneck, Webber, and Whittredge.[173] Surprisingly, no work by Duncanson was exhibited in this celebration of Cincinnati's cultural ascendency. Perhaps his race played a factor in his exclusion, and the exposition organizers wished to begin the process of erasing his contribution to the city's art legacy simply as a matter of racial nullification—it seemed that through their efforts he never existed. Also, the manner in which Duncanson died may have contributed to this eradication.[174] Whatever the reason, Duncanson's legacy continued to fade rapidly, and soon only those who knew him intimately or those who owned his paintings could testify to his significant artistic gifts to the region.

Duncanson's Dilemma of Racial Identity and Black Representation

The notion that Duncanson, on occasion, crossed the color line and passed for white has lingered throughout much of the existing scholarship concerning his life and career. In this section I intend to clarify this long-standing debate. In addition this section addresses the ongoing discourse concerning the lack of African American figures in Duncanson's paintings and the possibility that he instead encoded metaphors of "Blackness" in his landscapes.

It was not until 1982 that the first known photograph of Duncanson surfaced, and many questioned whether the seated man holding a palette was actually Black—he appeared phenotypically close to white. However, there was no question that Duncanson's face as now revealed helped clarify certain mysteries surrounding him and choices he made during his career.

African American art historians James A. Porter, James Parks, Guy McElroy, and David Driskell established Duncanson historically as a credible Black artist working within an overwhelmingly white tradition and profession. Art historians Joseph Ketner and David M. Lubin advanced Duncanson's reputation further by writing lengthy treatises on him that, out of the necessity of "race and place" in nineteenth-century America, attempted to gauge him as an artist whose artwork was veneered in his "Blackness."

All these art historians helped rescue Duncanson from undeserved anonymity. Lubin in particular focused attention to Duncanson's race as a central part of his essay.[175] Yet, while these scholars acknowledged Duncanson's biracial background as vital to his acceptance and advancement in art circles dominated by whites, they failed to explore fully the dynamics of a Black artist that could easily move between races whenever it was advantageous. Did Duncanson, in fact, present himself as white on occasion as a means of negotiating a career in fine art? If so, did he leave behind verifiable evidence of this "racial transgression"?

While there is no irrefutable proof that Duncanson passed, the possibility remains as an intriguing explanation for his ability to overcome seemingly insurmountable obstacles that hindered Black advancement in the fine arts. Fortunately, background information exists on Duncanson's family that may shed light on how he viewed crossing the color line and how he approached and resolved certain racial ambiguities that arose during his career.

As stated earlier, Duncanson descended from a family identified as mulatto in census records. Once the Duncansons settled in Monroe, Michigan, matters of race, color, and place began to play an important part in their lives. As will be seen, the social acceptance of Blacks and mulattoes in Monroe offers an interesting study in the disadvantages of acknowledging African ancestry and the advantages of crossing the color line. Robert Duncanson and the members of his family, by their biracial heritage, no doubt experienced both sides of this complex issue.

Historian James DeVries's study of African American life in Monroe indicated that county records of Duncanson family births, deaths, and marriages show the family listed as mulatto or white. Furthermore, Monroe had a small African American population, and the search for suitable mates inevitably brought about interracial bonds. DeVries explained:

> Contrary to what might be expected, race mixing was not unusual in Monroe in the nineteenth century. Even before Michigan's miscegenation statute was struck down in 1882, the Duncanson family was combining with its white neighbors. The community ignored these transgressions. In 1874, for example, both Robert W. Duncanson and his future wife, Mary S. Dennis, were "conveniently" recorded as white in their marriage application. In 1881, John A. Duncanson and Mary L. Sharlow were white in their marriage record, and in the next year Mary Duncanson and Charles Hermann were designated as white on their license. The technical illegality of the union between Nathaniel Duncanson and Phoebe Grobb was overlooked, as was that of Simeon and his second wife, Mary Louisa. It would seem that interracial unions were the norm in the Duncanson family.[176]

Some whites in Monroe tolerated the Duncanson family's "transgressions" because they were close to them in appearance. Another interracial marriage in Monroe caused strong public outcry and disgust, when dark-skinned James Bromley wed white Elizabeth Willett in 1888. According to DeVries, "Monroe never approved of the wedlock and Mrs. Bromley's choice was viewed as a big mistake."[177] Thus, the town of Monroe seemed to hold a double standard when it came to race mixing.

While the white citizens of the community turned their backs on certain interracial liaisons, they were unwilling to give its African American population full civil rights. The only way this could be granted was to further blur

the color line and allow those African Americans light enough to pass for white to renounce their heritage and cross to the other side. DeVries wrote:

> The community obviously believed that it was best to be white. Those who had the physical attributes to pass and who denied their background were permitted to do so and were, in effect, rewarded with the legal appellation "white." Although many in the community might have realized that these people had a "tainted" lineage, the racist ideology allowed the transition as these people were moving in the right direction.[178]

The ambivalence inherent in condoning miscegenation and defining racial identity played out well in Monroe. It is, however, doubtful that this situation was atypical of northern communities. Wherever Blacks and whites lived in proximity, inevitable interracial relationships and subsequent problems surfaced. Robert Duncanson and his family grappled with the sensitive issues of the merging of races. This matter therefore may have affected the way the artist viewed himself, the way the African American community regarded him, and the way the dominant culture accepted him.[179]

As previously mentioned, Duncanson's stay in Detroit in 1846 resulted in local newspaper reports failing to mention his race; this led his early biographer, James Dallas Parks, to conclude that Duncanson was passing for white.[180] Parks offered little support for this position. He stated that neither Duncanson's Detroit newspaper clippings nor his obituary alluded to his African American heritage. Parks believed Duncanson "found it easier to secure commissions for his paintings if he did not reveal his racial identity."[181] However, Duncanson's abolitionist patrons in Detroit knew his race. Whether this knowledge extended to the broader public is presently unavailable but the mainstream press seldom covered African American artists who followed in his wake, like Edward Mitchell Bannister, Edmonia Lewis, and Henry Ossawa Tanner, without mention of their race.

David M. Lubin was also convinced that Duncanson passed physically or as a figurative extension of whites that appeared in most of his paintings. He stated, "Rather than concentrating on Duncanson's paintings as expressions of one particular African American's sense of lack, his desire to pass to the other side, we have regarded them in terms of what we know of the hunger of antebellum African Americans in general, dark-skinned or light, slave or free, to cross over from racial oppression to genuine, meaningful liberation."[182]

Art historian Kirsten Pai Buick countered this sentiment by remarking, "In terms of Lubin's simple formula, the desire to be free is indistinguishable from the desire to be white."[183] While Buick argues that Lubin is forcing a cultural barometer of "veiled" race specificity upon Duncanson through the white subjects that occupy his landscapes, Lubin's overarching point does carry a degree of validity. There is no question that some light-skinned African Americans, given motivation, opportunity, and reward, deliberately slipped into "whiteness" during and after the antebellum period. Options of securing increased autonomy were few among free people of color, given their restricted standing within the mainstream. It is therefore not farfetched to understand how some, especially those capable of passing successfully, could equate their individual liberation with the face that stared back at them from a mirror. Therefore, the question must be asked: "Was passing ever a viable option for Duncanson at any point in his career?"

During the years when no photographs of Duncanson were known, it was impossible to determine whether he could have passed as white, and only written descriptions provided intriguing clues. In a letter of introduction to renowned sculptor Hiram Powers, Nicholas Longworth wrote that the artist was a "light Mulatto."[184] Duncanson's passport issued on April 23, 1853, stated, "Stature 5' 8," Forehead high, Eyes brown, Nose medium, Mouth large, Chin sharp, Hair brown, Complexion sallow, Face oval."[185] This description is important, because Lynda Hartigan noted that the State Department at that time issued Duncanson a regular passport, while traveling Blacks commonly received diplomatic passports, since they were not recognized as citizens.[186] Perhaps he chose, wisely, not to challenge an incorrect assumption.

As photographs of Duncanson began to emerge in the 1980s, they confirmed that his appearance was close to Caucasian and that he could easily pass as white. Yet the existence of photographs identified as the artist seems to support that he did not try to conceal his racial identity, at least while living in Cincinnati. In a photograph taken by local daguerreotypist John W. Winder around 1868, Duncanson appears seated in three-quarters view, holding a palette as an emblem of his profession. Duncanson, at this stage in his career, equated his considerable success with a photographic portrait displaying him as a free, confident, internationally recognized artist. Since an individual's chance of passing successfully is calculated on one's ability to maintain a high level of secrecy, this photo alone demonstrates that crossing the color line for long periods was not part of his agenda for advancement.

Duncanson did have to fend off one documented charge of passing. In a letter written to his son Reuben on June 28, 1871, the artist addressed an accusation about his attempts to cross the color line. Duncanson wrote:

> I heard today, not for the first time, of your abusive language toward me. Reuben I have lived to the age of fifty years, I have toiled hard, and have earned and gained a name in my profession second to none in the United States, and now as God decrees an Angel smiling in the Sun has sent me a friend. A wealthy citizen. I am assured of any amount. My declining years will glide smoothly along. He is of the race that you despise. I despise no being that God has made for he made all good, you have stated that I have all my life tried to pass for white. Shame on you Reuben. Shame!! Shame!! Shame!! Reuben. My heart has always been with the down trodden race. There are colored persons in this city that I love and respect, true and dear to me. It does not follow that because I am colored that I am bound to kiss every colored or white man I meet. Hog's [*sic*] pick their company, and I have the same right. . . . I say here in black and white I have no color on the brain all I have on the brain is paint. I care not for color: 'Love is my principle, order is the basis, progress is the end. Reuben one more step in the course you pursued and you fall. How often we see the total destruction of disobedient and God forsaken children. You have gone far enough in your abuse . . . My conscience does not upbraid me a single nite [*sic*].'[187]

Duncanson explicitly denied that he passed for white, but the charge, coming from a close relative, cannot be easily dismissed. Personal jealously or failure to establish an equally successful career could have triggered such a response from his son, but it was apparently a long-standing "problem" within the family. Still, Duncanson's response to Reuben's accusation implies that his son may have witnessed him in "compromising" incidents concerning his racial identity.

However, Duncanson clearly indicates that Ruben's allegation derives from the artistic social circles in which he traveled—all white. In this case Duncanson had no choice when it came to counting his patrons and courting his potential customers. In fact, all African American artists of the nineteenth century had to rely on whites to maintain extended careers, as there was no suitable or sustainable base of Blacks able to support artists through patronage. Therefore, in rebuking Reuben, the artist directly stated the obvious—if

anything, he was "guilty by association." Duncanson had no choice but to maintain close ties with the race Reuben despised, and gladly and thankfully reaped the rewards of their backing. Duncanson asked of Reuben, "What have the colored people done for me? [O]r what are they going to do for me?"[188] Of course, the answer was, painfully, little or nothing.

Crossing the color line could have been beneficial for Duncanson as it had the potential to lift the burden of racism, allow him access to additional opportunities for advanced study, and broaden his social circles in which to sell his paintings. There was, however, a steep price paid by any African American attempting this ruse. According to Joel Williamson:

> Actually, passing was relatively easy, but the emotional costs of passing were high . . . passing was often very painful. Not only was there the strain of maintaining the fiction of being white, there was also the necessity of cutting away one's roots. For those who passed permanently it was like a voluntary amnesia in which family and close friends, home, and all of the accustomed things of a lifetime were suddenly erased.[189]

If Duncanson successfully passed long term, all knowledge of his past would have been lost. Such a break in racial identity usually had to be complete to prevent unexpected discoveries and unwanted exposure. Yet Duncanson carved a place in history as an African American artist, and members of his race remembered him long after dominant-culture art historians had forgotten his name. He also continued ties with his family in the region, indicating he never intended to pass full-time.

In addition Duncanson maintained a close and highly visible working relationship with James Pressley Ball, the highly successful African American daguerreotypist, and abolitionist circles publicly linked them as shining examples of Black creativity and success. In fact, Frederick Douglass specifically declared Duncanson "a talented young gentleman of color."[190]

Yet how are the omissions of Duncanson's race cited by Dallas Park's biography explained? Could Duncanson, at some level, have allowed others to perceive him as white? If so, was Duncanson always obliged to correct the false impression? Passing is a very complicated issue, with varying degrees as to how one can accomplish this deception. While permanent passing is easily ruled out in Duncanson's case, some African Americans found part-time passing—living a portion of their lives in either racial group—an acceptable alternative. Although

this type of passing also carried risks of exposure and retribution, mobile Blacks like Duncanson could, for example, live in their own communities but work in distant locations as white without raising suspicion. Passing in this manner often was undertaken to secure better-paying jobs or privileges and, if needed, the opportunity to return to "Black life" was readily available.

This level of passing may explain the nature of Duncanson's journey to the mountains of western North Carolina in August 1850 for a sketching trip. During his expedition to the slave-holding state, revelation of Duncanson's identity would have put him in a very unsafe position, particularly considering the forthcoming Fugitive Slave Act of 1850. Duncanson was also aware of how precariously the South viewed its free Black population. When the artist arrived in North Carolina, state officials were continuing a practice of intensifying "Black Codes" that led to increasing restrictions on its free African American population. State law dictated that "free Negroes" could not enter the state, that recently manumitted slaves had to leave the state within ninety days, and that locally established free Blacks could not interact with whites or slaves. In fact, there was a growing movement throughout the South to return all free African Americans to slavery. "This problem," according to Kenneth Stampp, "would remain unresolved until all Negroes and mulattoes were not only presumed to be slaves but were in fact slaves."[191] It is unlikely Duncanson would risk his freedom merely to observe new scenery for his paintings, and it is therefore quite possible that Duncanson sketched along the French Broad River confident that his racial identity would not be disclosed.[192]

Duncanson was accompanied to North Carolina by Cincinnati painter A. O. Moore. Perhaps Moore had ties to the region's mountain communities and assured his companion that his safety would not be compromised by journeying to an isolated part of the state that had a minuscule Black population and few slaves.[193] The two artists spent an extended amount of time traveling throughout the scenic mountains selecting choice spots for recording future compositions and counted Warm Springs (now Hot Springs), Black Mountain and Hickory Nut Gap as interesting stopping points.[194] The *Asheville Messenger* noted that Duncanson "appears to be a fine Artist and has shown us a number of very pretty sketches. We hope he will be amply paid for his trouble, and if he has them engraved, we have no doubt that but a large sale will be made of them."[195] The article concluded that "we wish him abundant success" and that "we are proud that Artists are beginning to appreciate [Western North Carolina scenery]."[196]

The fact that Duncanson openly circulated through the region as an "outsider" artist (revealing his name and city of origin) and submitted himself to scrutiny by the local press who failed to note his race suggests that he had grown comfortable in not having his African ancestry questioned. Therefore, it is highly plausible that Duncanson passed as white to explore picturesque wilderness areas that largely escaped the attention of his northern competitors.

Two extant paintings from this venture are identified. The first, *View of Asheville* (1850, Greenville County Museum of Art), taken from the vantage point of Beaucatcher Mountain, overlooks an expansive vista of the city below.[197] James W. Patton (1803–1861) of Asheville owned the work and probably acquired it as commission and had it shipped to Asheville after its completion in Cincinnati.[198]

The notion that Duncanson passed at this time is further strengthened in light of Patton's position within a family of slaveholders—his brother James was the second-largest slave owner in Asheville—a fact of which Duncanson likely was aware.[199] In addition, if Duncanson and Moore stayed in Warm Springs, they probably took rooms in a hotel operated by the Pattons.[200] Thus, if Duncanson's race was known to the Pattons, it is highly unlikely that he would have been so well received as either a guest or a professional artist and would have been subjected to the full force of anti-Black state laws.

Duncanson painted another work at this time also presently entitled *View of Asheville* (1850, Museum of Fine Arts, Houston) [fig. 1.13] that appears to have been taken from the same location and is nearly identical in composition. The key differences in the latter painting are two gnarled, bare trees that bookend the foreground and two men (replacing two women and a child found in the previously mentioned work) that stand centered between them observing the view.

Also during his southern journey, Duncanson ventured into the slave state of Tennessee to compose *Short Mountain, Hawkins County, Tennessee*. This act of potential racialized calamity also indicates he must have felt a certain level of security concerning safe passage through dangerous territory.

Thankfully, Duncanson apparently returned to Cincinnati from the South unscathed and the risk seemed worth the effort in gaining further public attention when he exhibited his new paintings at Western Art Union in 1851. One reporter exclaimed, "One of R .S. Duncanson's best pictures— we like it better than any landscape he has in the Gallery . . . is a view on the

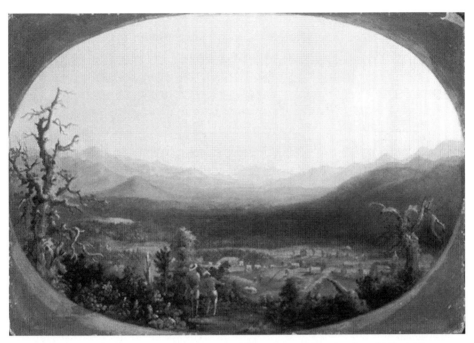

Fig. 1.13. Robert S. Duncanson, *View of Asheville*, 1850, Oil on academy board, 13" × 18" ¾", oval format, Courtesy of The Museum of Fine Arts, Houston; museum purchase with funds provided by the Susan Vaughan Foundation in memory of Susan Clayton McAshan.

French Broad (River), North Carolina . . . the picture is one which pleases all who examine it."[201]

In regard to Duncanson passing to achieve active membership in Cincinnati's art community, it is evident he did not. As discussed earlier, Duncanson first entered the city's art environment by appealing to antislavery groups for support and slowly gained acceptance in white-dominated local art organizations as distinctly African American. Even the outsider Francis Blackwell Mayer, a prominent genre painter from Maryland, quickly learned that an African American was operating on the level of the city's white painters after a visit to the Western Art Union in 1851. Mayer noted of Duncanson's race in his diary, "The artists of Cincinnati, and this city has been peculiarly prolific in men of this class, are mostly the uneducated votaries of art, i.e. so far as academic instruction is concerned. The tendency of the school is good, self-reliance and constant reference to nature, regardless, perhaps too much, of the great canons of art. The painters are mostly landscape artists and the

beautiful country by which they are surrounded supplies them with ample material for study and subject. The most eminent in landscape is Sonntag ... Whittredge [and] Duncanson (a Negro), also paint good landscapes."[202]

And while some of the white artists may have refused to associate with him because of his ancestry, enough of those with solid reputations and leadership positions included him as one of their own. Fellow artist Charles T. Webber succinctly remembered him this way: "Duncanson's landscapes were, on account of their peculiar poetical conception, much prized not only in this country but in England and Scotland. Among the friends of the colored Americans (for Duncanson, a most genial gentleman, as well as an accomplished artist, was a light quadroon) they were in especial demand finding favor with such cultured critics and outspoken believers that negroes have souls as Charles Summer and his illustrious compeers in Europe."[203]

Beyond the speculation on Duncanson's decision to physically pass for white, several art historians have attempted to imply that within the absence of African Americans in his paintings, there is, nonetheless, a racial undertone that reinforces his Black identity. As a result, Ketner and Lubin take Duncanson's lack of a Black presence in his landscapes a step further and suggest that he, because of his race, was obligated to embed "Blackness" in his paintings. Ketner, in his biography of Duncanson, stated, "Duncanson was the first African American artist to appropriate the landscape as part of his cultural heritage and as an expression of his cultural identity."[204] Lubin advanced the idea of intrinsic, race-based codification, much like those inherent in Negro spirituals that allowed slaves to secretly plot escapes or express dissatisfaction with their captivity, and extended it as a plea to judge Duncanson's landscapes differently from other Hudson River artists because he was so "unlike" his peers. From their perspective, Duncanson had to deliver nuanced subliminal messages as a reflector of his race and the African American condition even in the way he approached painting a waterfall, a tree, or an ancient temple. According to art historian Wendy J. Katz:

> Joseph Ketner, in his invaluable monograph on the artist, finds a parallel between Duncanson's denial of concern with racial issues and his landscapes that conform to mainstream Hudson River School aesthetics. Ketner, for example, suggests that Duncanson's 1852 *Garden of Eden*, which is based on a painting by Thomas Cole, reveals that his apparent adherence to conventional artistic ideals veiled an African American perspective; paradise with

its palm trees might also be the promised land of slave songs. David Lubin, in a thoughtful study of the theme of passing in the artist's life and work, also finds a double consciousness operating in Duncanson's paintings, positing that they may have contained hidden allegories on racial themes whose meanings were available only to certain audiences.[205]

Even Sharon F. Patton, in her award-winning textbook *African-American Art* (1998), continued this line of reasoning by finding escapist Black themes in Duncanson's idyllic landscapes, such as his celebrated *Blue Hole, Flood Waters, Little Miami River* (1851). Patton discerned:

> Works dated before 1865 hold a double coded meaning, one for whites, another for Blacks, which revises the old formulaic comprehension of the 'magisterial gaze' (as an evolutionary movement from wilderness to civilization) to one about slavery and emancipation. The tale of the slave George Washington McQuerry, who escaped in 1849 and eventually settled in a small community in Miami County, Ohio, was well known among Blacks in the region. Therefore, *Blue Hole, Flood Waters, Little Miami River* could be understood as not just a bucolic fishing scene, but a tribute to Black life and freedom.[206]

There is no evidence to support what these scholars suggest is fact. Such loose interpretations of hidden messages seem merely an attempt to amplify the level of his "Blackness" to offset an apparent lack of "authenticity" he displayed in his work as a representative of his race in a domain claimed by whites. Perhaps art historian Margaret Rose Vendryes best summarized this forced need to unlock some racial overtones in the work of an artist who felt it best to remain racially neutral at all levels for the sake of measuring up equally to his competition.

> The basic, problematic argument offered by Ketner and Lubin is that nineteenth-century black American artists, because they experienced America differently than whites, would have been unable to engage with the nation's landscape in the same aesthetic language as their white contemporaries. Like Duncanson, they would have created, consciously or not, landscape paintings that consistently operated as hidden allegories on racial themes. Both writers agree that Duncanson's work exhibits what Ketner called an "undercurrent of meaning" specific to African Americans, and both forwarded the opinion that

Duncanson's art, based on what can be recovered of his life, was primarily shaped, physically and psychologically, by his race.[207]

In conclusion, Duncanson's light complexion provided him a level of privilege in art advancement that allowed him to obtain opportunities that reached far beyond most African Americans. Consequently, he may have leveraged this "advantage" to navigate both black and white worlds, and, as such, he often straddled the fine line of identity and acceptance. He may have found it necessary to walk in the shadows of both worlds, but he never found passing to be the ultimate solution to achieve stability in his life and career. Even after his death, some continued to remember him as distinctly African American. In 1883 a book of local history entitled *Picturesque Cincinnati* listed Duncanson as "a man of color, as well as a colorist, who was a landscape-painter having a high imaginative power."[208] In addition, in 1915, Traxel's Art Store in Cincinnati prominently displayed several of Duncanson's paintings in an exhibition that "aroused more than ordinary interest in local art circles since the artist, a negro, was one of the first artists to settle here."[209]

Given this widespread knowledge, it is remarkable that on many occasions, local and regional presses, touting Duncanson's impressive accomplishments, intentionally failed to cite his racial identity and instead reported on him as a distinguished master. It appears that despite the societal odds against his success, Duncanson was able to transcend many racial disqualifiers through the high quality of his art.

There may have been rare occasions when Duncanson deliberately chose not to reveal the full nature of his racial background to help him overcome impassible racially constructed obstacles that blocked his progress. But in the end, his "crime" was minor and forgivable, and his Blackness ultimately prevailed.

CHAPTER TWO

Edward Mitchell Bannister (1828–1901)

Fig. 2.1. Edward Mitchell Bannister

In 1876 the nation staged the Centennial International Exposition in Phila-delphia, its first world's fair, to celebrate the one hundredth year of inde-pendence and to stake a claim as an internationally significant industrial power. The Centennial, for many, signified the "common destiny of the world's people and a symbol of unity among workmen of all nations."[1]

The exposition also highlighted the best in American ingenuity and pro-ductivity in multiple areas. One particularly strong source of national pride centered on Memorial Hall, a $1,500,000 ornate structure designed to house the finest native and foreign works of art.[2] The building was designated to display more than one thousand American paintings; landscape art garnered

the greatest approval, and these works accounted for over half of the exposition's awards for merit.[3] One of the prizewinners at this, the largest art exhibition ever held in America, was Edward Mitchell Bannister [fig. 2.1], an African American landscape painter. This award not only put his name before a nation quick to embrace its leading artists as major celebrities in the forging of a national identity in the arts but also helped establish, once his race was known, that it was possible that African Americans could triumph at the highest levels of the fine arts. Thus, only four years after Robert S. Duncanson's death, another Black landscape painter demonstrated that race held no natural barriers to artistic success.

The Early Years in Canada

Like Duncanson, Edward Mitchell Bannister rose from humble beginnings to achieve artistic prominence. He was born on October 4, 1828, in St. Andrews, New Brunswick, Canada. His father, Edward (?1832), likely immigrated there from Barbados. His mother, Hannah Alexander Bannister (?1844), was of unknown racial/ethnic identity.

From an early age, Bannister showed a strong inclination for drawing. This proclivity often came at the expense of his schoolwork. Citing his mother's support of his fledgling talent, Bannister stated, "The love of art in some form came to me from my mother, who was born within a stone's throw of my birth place, on the banks of the St. Croix River. She it was who encouraged and fostered my childish propensities for drawing and coloring. She helped me with my lessons, which I was prone to neglect for the more congenial work of drawing."[4] His schoolmates acknowledged Bannister's sketching ability before he was ten, and they predicted he would become a great artist.

After the death of their mother, Bannister and his older brother, William, became orphans. Harris Hatch, a lawyer and farmer formerly from Boston, took Edward into his home. Undoubtedly, young Edward found adjusting to this new environment difficult, yet he managed to maintain an affinity for art. According to Carter G. Woodson, "In the home of Mr. Hatch he found two faded portraits of which he made lifelike copies. He also practiced reproducing pictures from the family Bible."[5] Edward soon decorated the walls of his foster family's home with his drawings, much to the disgust of the Hatch women. The locals could also view young Bannister's renderings

publicly, as "the results of his pen might be seen on the fences and barn doors or whatever else he could charcoal or crayon out rude likenesses of men or things about him."[6]

When Bannister reached adulthood, he decided to broaden his horizons. Although he apprenticed to a cobbler in his youth, he obviously found the profession unsuitable for a lifetime of work. Like many young men who grew up in proximity to the ocean, he sought adventure on the high seas and possibly served as a cook on a northeast trading ship.[7] This early experience instilled in Bannister a lifelong love for sailing and served as a constant source of inspiration for many of his paintings.

Life in Boston

Bannister abandoned life at sea and settled in Boston by 1848–49. He went there to seek formal art instruction and a career as an artist. According to T. Thomas Fortune, the editor of the *New York Age*, when Bannister left St. Andrews, "his brain was fired with the ambition to reproduce on canvas the glowing pictures of the wild coast life and sylvan loveliness that had filled his childhood hours with never ceasing wonder."[8] He obviously viewed Boston as the place where he stood the best chance for success. Like Duncanson, Bannister knew that his eventual acceptance as an art maker came predicated on a well-established base of support that championed Black social advancement. Boston was such a city. Despite an overwhelmingly white population, Boston achieved an inspiring reputation for its strong abolitionist activism, and as a refuge for fugitive slaves. It was here that William Lloyd Garrison published *The Liberator*, the leading antislavery paper in the country. Boston was also the home of the New England Anti-Slavery Society, an organization founded not only to end slavery but also to aid in bringing about better living and working conditions for free African Americans. Black Bostonians strongly demonstrated their abhorrence to slavery by forming their own abolition societies and holding antislavery conventions. Even Frederick Douglass chose Massachusetts as a place of sanctuary following his escape from Maryland and eventually became a prominent member in the New England Anti-Slavery Society.

The constant pressure for civil rights exerted by these groups helped spotlight the plight of African Americans for white Bostonians and, in many

instances, helped stimulate better racial understanding. African Americans in the state had long enjoyed the right to vote, and Boston's public schools, after years of constant protest, became legally desegregated in 1855. However, this measure of racial tolerance did not bring about full racial equality. While Black Bostonians experienced better race relations than many of their northern counterparts, color prejudice was still well entrenched in the city. One Boston native admonished those who held to the belief that "because we have the right to vote, and enjoy the privilege of being squeezed up on an omnibus, and stared out of a seat in a horse-car, that there is less prejudice here than there is farther South."[9]

Despite Bannister's education, reserved demeanor, and aspirations for upward mobility, these traits, for many whites in Boston, had no bearing on how he was received and treated among many in the city's dominant culture. Historians James and Lois Horton summed up the racial conditions endured by Black Bostonians during the antebellum period:

> Blacks were segregated into a few highly concentrated areas of the city, restricted to "Jim Crow" accommodations on public transportation, isolated in schools that were rapidly deteriorating and scholastically inferior, excluded from juries, and seated apart in white churches, lectures halls, and places of entertainment. They held the worst jobs at the lowest pay. Friends were rare among the white elite and working classes, native and foreign. Crude racial insult and injury often passed over into subtler forms of condescension and contempt in more polite circles. Black Boston faced incredible obstacles with little more than faith to sustain it.[10]

According to Carter G. Woodson, Bannister encountered this climate of racial oppression shortly after he arrived in Boston, and he quickly found out that the color of his skin created undesirable outcomes. Woodson noted, "Thinking that he could find a better opportunity elsewhere, Bannister went to Boston, but there he discovered that his color prevented him from becoming an apprentice in a studio."[11] This may be the incident to which T. Thomas Fortune was referring when he claimed Bannister's early desire to create landscape paintings was dashed by "contact with narrow, prejudiced minds" that "threw a pall over these bright hopes and turned his mind from nature to the contemplation of man."[12] Still, Boston was as good a place as any in America for Bannister to begin making inroads to becoming a professional

artist. James Horton explained that the city "never matched its reputation for racial egalitarianism, yet compared to most other northern cities, largely through the efforts of dedicated white abolitionists and the black community, Boston was a racially tolerant place. If blacks did not find complete racial equality there, they did at least find opportunities for education, employment, and community."[13]

And while Boston was a major art center, many of the city's residents were not ready to see an African American artist counted among their creative elite. William Wells Brown noted, "At last he turned his steps towards Boston, with the hope that he might get a situation with a painter, never dreaming that his color would be a barrier to the accomplishment of such an object. Weeks were spent by the friendless, homeless, and penniless young man, and every artist had seen his face and heard his wish to become a painter."[14] Many years later Bannister caustically remarked that members of the race who once "refused to receive him for instruction because of his color, would fill his room as pupils at the first sign of consent."[15] Bannister's early encounters with racial prejudice in Boston must have come as quite a shock. Unlike Blacks born in America who constantly received reminders of their inferior status, Bannister apparently grew up in an environment where race was of little consequence. An article written about Bannister in 1893 seems to support this statement. T. Thomas Fortune stated:

> At that early day there were not many colored people in St Andrews, and so thoroughly free from race prejudice were the inhabitants that "colored" was rarely heard among them. It was not until he became ambitious to develop his artistic powers, and consequently left his native town, that he was made to feel the distinction between white and brown. While at home in St. Andrews he lived in an atmosphere of British fair play, where character and not race made the man, consequently his individuality was that of an enterprising "down-Easter." The presence of African blood in his veins had no power to make him accept a prescribed course, or be other than what his environment made him. Few people in this country seem to understand this. It is a common mistake to think that a man must act "colored" for no better reason than because he is called "colored," and because his complexions suggest a descent of American slavery. This apparently trifling sentiment has blasted the hopes and stood as a barrier to the development of many a promising Afro-American child. It is so marked that the entire race has been affected.[16]

Therefore, Bannister's abortive efforts to find proper art training forced him to take menial jobs and he worked as an assistant to a photographer and spent time as a barber.

It is not certain how much support Bannister received from the city's anti-slavery organizations—there is no evidence that they sponsored exhibitions for him—but like Duncanson, and later Edmonia Lewis, he realized that any chance of success ultimately rested in networking through abolitionist circles. And while their encouragement did not necessarily translate into sales for unknown and inexperienced Black artists beginning their careers, Bannister, nevertheless, forged ahead and finished his first commissioned work, *The Ship Outward Bound*, in 1854.

William Lloyd Garrison's paper, *The Liberator*, quickly noted Bannister's potential as an artist. Referring to him as a "Colored Genius," journalist and abolitionist William Cooper Nell stated:

> Calling in, a few evenings since, at the study of Dr. J. V. De Grasse, (whose practice, by the way, we are happy to record as in the ascendant,) our attention was directed to a beautiful oil painting, executed by Mr. Edward Bannister. Its subject—*The Ship Outward Bound*—for fidelity in design, coloring, and shade, reflects much credit on the young artist. It is safe to predict for him, at no distant day, that encouragement which should reward such self-taught exertions.[17]

Some abolitionists like Nell and Garrison were quick to identify and promote African Americans who demonstrated the capacity to advance their race through extraordinary feats of intellectual achievement. Frederick Douglass, with his gifts of public speaking and authorship, stood above others and perfectly symbolized not only a need for immediate emancipation but also a need for full civil rights and social acceptance. With Black artists like Bannister, abolitionists found similar ground in forwarding these principles and used them to challenge the beliefs of skeptical whites who viewed high art as existing well beyond the intellectual grasp of Blacks. Openly demonstrated Black artistic progress therefore helped alter many of the dominant culture's opinions on race matters through highly visible and easily comprehendible creations amounting to the level of "genius."

At this time Bannister also rendered a portrait of Dr. DeGrasse, thus further establishing him as one the earliest patrons of the artist.[18] Bannister

completed a pastel portrait of his wife, Lucretia Cordelia DeGrasse, around 1854, and for more than a decade he listed his services as a portrait painter.

While Bannister struggled to launch his career in art, he channeled some of his creative energy into other areas. He possessed a marvelous tenor voice and participated actively in church choirs. He was also a member of the Attucks Glee Club, a musical group that played an important role in the first observation of the Boston Massacre, staged on March 5, 1858, in Faneuil Hall. They sang an original composition, entitled "Colored American Heroes of 1776."[19]

Bannister also acted as a member of the Histrionic Club, an organization described by his close friend George W. Forbes as being "composed of the moving spirits among Boston colored people at that time."[20] According to Forbes, the club presented plays in Boston and the surrounding area, such as *Love at Sight* in 1857 and *The Indian's Visit* the following year, which won praise in the local press.[21] Among the members of this troupe was Christiana Carteaux (1822–1902), a striking young woman with distinctively Native American features.

Madame Carteaux, as she was known, was a member of the well-known Babcock family of Boston, was born in North Kingstown, Rhode Island, and was rumored to be a descendant of a Narragansett Indian chief. She was a successful businessperson who owned and operated several of Boston's most popular hairdressing salons. The 1853 Boston city directory listed Bannister as a hairdresser operating in Carteaux's salon. The Histrionic Club also held rehearsals in her establishment, and it was through these affiliations that Edward fell in love with Christiana.[22] Bannister married her on June 10, 1857 (he was about thirty and she was thirty-seven), and this union allowed him the luxury to, again, turn his attention to art.[23] Apparently, Christiana was completely supportive of Edward's ambition to become a professional painter, and "the canvas, the paint, the easel, and the pallet [*sic*] were brought in, and the hair-dressing saloon was turned into a studio."[24] This was Madame Carteaux's second marriage.[25]

Years later Bannister acknowledged the contribution his wife made to his success. He said, "I would have made out very poorly had it not been for her and my greatest successes have come through her criticisms of my pictures, or the advice she would give me in the matter of placing them in public. She has always had a host of friends, and it's no wonder, for she's such a grand woman."[26] Bannister was as devoted to his wife as he was to his art, and he honored her by painting her portrait [fig. 2.2]. That work showed fully the

range of Bannister's ability as a portrait painter, as he presented Christiana seated in a comfortable chair, three-quarters view, and arm resting on a side table. Through her husband's sharp eyes and practiced hands, she appears confident and elegant—the epitome of Boston's elite African American middle class. Her face, with hair parted in the middle and drawn back in a braided bun, hints perfectly at her multiethnic background and fully reveals the essence of her beauty. It was, indeed, a praiseworthy attempt at capturing a credible likeness, expressing his unbridled admiration and demonstrating his growing confidence as a portrait painter.

The Bannisters: Prominent Boston Abolitionists

Boston was the epicenter of antislavery publications, lectures, and protest rallies, and the Bannisters were at the forefront of crusading for racial justice and equality. Though less known presently than their more illustrious peers such as Frederick Douglass, William Wells, Brown, William Cooper Nell, and William Lloyd Garrison, the couple played a highly visible role in the local community for causes advocating emancipation and Black welfare.

It is likely that Christiana encouraged Edward to become more active in matters of abolitionism and civil rights. Her brother, Charles, married Cecelia Remond, one of the owners of a prosperous wig shop in Salem, Massachusetts, and a member of the Black abolitionist family that included Charles Lenox Remond and Sarah Parker Remond. In addition Edward Bannister's relationship with Christiana allowed him greater access to Boston's African American elite, including its impressive list of white anti-slavery supporters, as potential patrons of his paintings.

The Black community in Boston soon recognized the Bannisters as social leaders. For two years they assisted former slave and abolitionist Lewis Hayden in the operation of Boston's Underground Railroad while living in his home, which some referred to as the "Temple of Refuge."[27] On May 23, 1859, Edward played a pivotal role in a meeting held at the Twelfth Baptist Church "for the purpose of sympathizing with the persons in the Oberlin Rescue case and devising ways and means to assist them and their families."[28] Bannister served the organizing committee as secretary, and William Wells Brown presided as chairman.[29] Committee member William C. Nell read a series of resolutions that included, "Resolved, that our hearts have been

Fig. 2.2. Edward M. Bannister, *Portrait of Christiana Carteaux Bannister*, n.d., Oil on canvas, 35 ½" × 28", Newport Art Museum.

warmed by their (the Rescuers) daily and constant exhibition of patience in suffering, their unflinching adherence to principle, in fact their martyr-like spirit, under unwarrantable and tyrannical inquisition of the slave power of this nation."[30]

In August of that year, Bannister served on another committee at the Convention of the Colored Citizens of New England, organized to "consider the best means of promoting their moral, social, and political elevation."[31] His activism against slavery continued in 1862 when he helped organize a lecture by Charles Lenox Remond entitled, "The Duty of the Colored People in Relation to the Current Crisis" at the Twelfth Baptist Church.[32] As news of the plight of refugee slaves in the South seeking aid from Union regiments reached Boston, Bannister served as recording secretary of the Association for the Relief of Destitute Contrabands to help ease their suffering.[33] John S. Rock served as chairman.

Bannister was among the huge crowd gathered under the auspices of the Union Progressive Association at Boston's Tremont Temple on January 1, 1863,

to await word that Lincoln's final Emancipation Proclamation had gone into effect.[34] More than a mere spectator, the artist held an important position as recording secretary. Bannister documented the stirring speeches delivered by noted African American leaders such as William C. Nell, William Wells Brown, John Rock, and Frederick Douglass.

For the next year's Emancipation Day celebration in Boston, Bannister once more played a critical role in organizing the event.[35] When Bannister was not directly involved in committee work, his name appeared publicly in the press on petitions advocating for emancipation. William Wells Brown said of Bannister's political engagement, "Mr. Bannister has a good education, is often called upon to act as secretary to public meetings, and is not by any means a bad speaker, when on the platform."[36]

Bannister also found time to devote to church activities outside the antislavery crusade. For example, Bannister spoke, along with Reverend Leonard Andrew Grimes, at a celebration for the Sunday School of the Twelfth Baptist Church on January 1, 1865.[37] Even after slavery ended, he continued to work for the betterment of "the race." He served on the board of the American Baptist Missionary Convention and helped organize their twenty-sixth anniversary meeting held at the Ebenezer Baptist Church, Richmond, Virginia, on August 17, 1866.[38] The board's appeal was to "the Baptist ministers and churches, and friends of the missionary work and education among our people at the South and our brothers in Africa."[39]

Christiana Bannister was also a prominent activist among Black women's organizations in Boston. After John Brown's unsuccessful raid on a government arsenal at Harpers Ferry, Virginia, in 1859, she was instrumental in establishing aid for the widows of the "colored American heroes" lost in the attack.[40] She also worked to see a public monument erected to their memory.[41]

During the Civil War, Christiana crusaded in support of the African Americans who fought for the Union Army. When she found that newly recruited Black soldiers were receiving less pay than whites were, Mrs. Bannister led a protest that ended in a personal meeting with the governor of Massachusetts. From this meeting, Mrs. Bannister received permission to organize a fair and auction, sponsored by the Colored Ladies Sanitary Commission of Boston, that aimed at raising funds to aid the African American troops and their families. The civic function attracted many of the city's elite. The *Liberator* reported:

The fair of the colored ladies of this city, for the benefit of the sick and wounded soldiers of Massachusetts, opened at forenoon at Mercantile Hall in Summer Street. The hall has been beautifully decorated, and the tables were filled with useful and ornamental articles, grab boxes, guessing cakes, a post office. . . . There is a fine piano made by Chickering, one of Mason and Hamlins's Cabinet Organs, and a portrait of the lamented Col. Shaw, valued at two hundred dollars, executed by the young colored artist Edward M. Bannister to be disposed of by raffle.[42]

Abolitionist Lydia Maria Child reported that she attended the fair and saw a full-length portrait of Robert Gould Shaw, the slain white leader of the 54th Massachusetts Colored Regiment, painted by Bannister.[43] Child wrote, "Over it was the touching and appropriate motto, 'Our Martyr.' My eyes moistened as I looked upon it. To me there is something very beautiful and pathetic in these efforts of a humble and oppressed people to canonize the memory of the young hero who died for them."[44] With this comment, Child revealed a patronizing and maternalistic attitude toward African Americans seeking cultural advancement that cast them as unsophisticated amateurs grasping at complex concepts only fully comprehended by "superior" whites. As will be seen, Child's similar view of Edmonia Lewis's potential as a sculptor nearly cost her any chance of success.

Bannister's portrait of Shaw eventually hung in the State House in Boston.[45] Moreover, one account suggests that a year earlier, Mrs. Bannister presented the colors to Colonel Shaw and the Massachusetts Fifty-Fourth before they marched off to fight in the South.[46]

The Quest for Recognition

Despite Bannister's apparent rapid improvement as an artist, he seems to have been reluctant or unable to make it a profession. Although he had listed himself as a painter in the Boston city directory since 1859, few whites had taken notice of his talent, and few Blacks could afford his services. Bannister no doubt sought to supplement his income. He may have gone to New York during 1862 to learn and work in the photography trade.[47] Bannister likely used this period to gauge his standing as a painter in a new locale. Little is known of him during this time, particularly how and if the New York art establishment received him.

Bannister was back in Boston the next year and listed his profession as a "Photographist," perhaps realizing that photographs offered a less expensive and time-consuming alternative to sitting for a painted portrait.[48] While he had not become a self-supporting artist, he continued to paint, and many members of the African American community gradually took note of his promising potential. In 1863 William Wells Brown offered the following glimpse of the artist in transition:

> Mr. Bannister possesses genius, which is now showing itself in his studio in Boston; for he has long since thrown aside the scissors and the comb, and transfers the face to the canvas, instead of taking hair from the head. His portraits are correct representations of the originals, and he is daily gaining admirers of his talent and taste. He has painted several pictures from his own designs, which exhibit his genius. "Wall Street at Home," represents the old gent, seated in his easy chair, boots off and slippers on, and intently reading the last news. . . . A beautiful landscape, representing summer, with the blue mountains in the distance, the heated sky, and the foliage to match, is another of his pieces. It is indeed commendable in Mr. Bannister, that he has thus far overcome the many obstacles thrown in his way by his color, and made himself an honor to his race.[49]

Brown also described Bannister's appearance and intellectual preferences, stating, "Mr. Bannister is spare-made, slim, with an interesting cast of countenance, quick in his walk, and easy in his manners. He is a lover of poetry and the classics, and is always hunting up some new model for his gifted pencil and brush.[50]

Bannister's persistence to succeed as an artist, despite his early encounters with racism, led him to enroll in night classes at the Lowell Institute around 1863. By doing so, he became, perhaps, the first African American to obtain formal art training in America. This achievement was unprecedented for a Black artist, as enforcers of white supremacy in the fine arts usually kept "lowly Negroes" from enrolling in advanced art schools.

Bannister received instruction in life drawing and anatomy from noted artist and physician William Rimmer (1816–1879). Rimmer may have approved Bannister's admittance because they were both former British subjects.[51] Rimmer's teaching method was simple but effective. In an essay published on Rimmer, Jeffrey Weidman provided clear insights into the kind of lessons Bannister absorbed under Dr. Rimmer's instruction.

In his lectures Rimmer used a human skeleton, lifesize colored charts of the human body, a cast of Houdon's *Ecorche*, and during the 1860s, his own *Falling Gladiator*, and *Hawk Headed Osiris*. Most of all he relied on a large blackboard and a piece of chalk. Equipped with these simple items, Rimmer first analyzed the separate parts of the body and their functions and then presented their synthesis in complete figures and compositions. He also discussed the functions of the human mind as manifested through expression, and offered ethnological and typological comparisons.

Male and female students copied individual drawings into their sketchbooks. Rimmer would criticize these separately, or a student would draw on the blackboard and Rimmer would discuss the student's drawing for the benefit of the entire group. Eventually, advanced students would work from a nude model.[52]

Bannister's progress at the Lowell Institute may be measured by the report that he ". . . showed such indications of genius that he soon attracted the attention of all the professors laboring with Dr. Rimmer. In this way he became associated with some very choice spirits."[53] Bannister realized his early artistic promise by socializing with those able to help advance his career.

John Nelson Arnold (1834–1909), a prominent Providence portrait artist and Bannister's classmate at the institute, revealed interesting insights into the character of the Black artist and the cause of his acceptance within the Boston art community. Arnold observed that several members of their class went on to achieve notoriety, but Bannister became the most popular among Boston's artists.[54] He attributed this to a "genial, kindly, courteous nature which followed him through life."[55] Arnold first encountered Bannister after another artist suggested a visit to his studio to see the remarkable level of his talent. Arnold recalled, "My friend was desirous that I should know Mr. Bannister and see his talent in the same light he did. Our visit to the artist's room in the Studio Building, Tremont Street, is among my most pleasant memories, and upon leaving I assured my friend he had made no mistake in his estimate of Bannister's work, for it bore the undoubted hall-mark of genius, an opinion which all these years I have seen no reason to change."[56]

As students at the Lowell Institute, Arnold joined Bannister and others, including Martin Milmore, Edwin Lord Weeks, and William Norton, in an effort to draw from the live male nude in the evening class.[57] The students prevailed, and Bannister and Arnold forged a lasting friendship.

Thus, Bannister found approval in the company of his art associates based on his ability rather than his color. Given the racial climate in Boston, this was a major accomplishment. While Bannister was attending Lowell Institute, he also shared a studio with several white artists on Tremont Street. This fact, along with his newfound acceptance, indicates that Bannister was personally integrating a once racially closed portion of Boston society.

Bannister seems to have tried to insulate himself, as best he could, from the distracting and distasteful sting of color prejudice. While in Boston, he apparently did not seek many relationships with whites outside the art and abolitionist communities. This may have been particularly true in his dealings with people who measured a man by racial heritage. According to T. Thomas Fortune, "Bannister's . . . first experience as an art student made him very slow in the formation of friendships outside of the realm of art, and the majority of his associates of today resulted from the old student contact in Dr. Rimmer's classes."[58] Bannister, without question or fault, surely felt more at ease moving in circles, mostly white, where he had gained and enjoyed acceptance, recognition, and respect.

At a time when most young American art students were scrambling to further their education in the great art centers of Europe, Bannister seems to have reconciled that he would never embark on that journey during his formative years due to monetary limitations. Later in his career, he wished to view European art firsthand. Juanita Holland disclosed, "He planned a trip to Europe in 1881 but had to cancel when his financial backing fell through."[59] Charles Walter Stetson recalled of the failed venture, "Yesterday afternoon, as it was so dark I could not paint, I called on Bannister. He was blue enough. He had not heard from certain parties upon whom he was somewhat dependent for his European trip, and things had gone awry considerably. I tried to cheer him up."[60] This statement may be related to an account John Arnold gave of the artist's failure to travel to Europe. Arnold said after Bannister's death, "It is too late to speculate upon what he might have done had he accepted the generous offer of a few of his admirers to give him an opportunity to study abroad."[61] Perhaps the initial offer was rescinded for unknown reasons, but whatever the case, Bannister never journeyed abroad. Incidentally, Bannister's classmates from Lowell—Milmore, Weeks, and Norton—all reached Europe and benefited greatly from the experience.

John Arnold also stated, "Bannister from the first followed no master nor any school—nothing but his own instincts."[62] Bannister likely adopted this

position from the realization that his limited experience with Rimmer had not properly prepared him to obtain all he sought from art. The *Providence Sunday Journal* confirmed the limitation of Bannister's art training, stating, "After leaving Lowell Institute, Bannister continued to take private lessons for two years under this great teacher. This embraces all the art instruction he ever received."[63] Consequently, finding additional training in other areas of art instruction may have been an insurmountable obstacle because of his race.

Additionally, lack of further instruction seems to have forced Bannister into situations where he could not resolve certain technical issues in composition, and he often reacted negatively. Arnold recalled that on such occasions, "he felt his limitations which were purely technical, and when the fervor of inspiration was at its height the uncertain command of his material through which he strove to embody his ideal frequently annoyed and hampered him; and I have known him to obliterate in an hour the labor of weeks."[64] Bannister revealed his frustrations to his close friend George Whitaker saying, "All I would do I cannot . . . simply for the want of proper training."[65] Consequently, Bannister was the only major African American artist of the late nineteenth century who developed his talents without the benefit of direct European exposure or instruction.

Nevertheless, Bannister continued to follow his own muse as his skills grew, and he relied on his instincts to guide his brush. And while training in France or England would have strengthened his technique, it may have dampened his inherent creativity. Study abroad also gave aspiring artists the opportunity and honor of having their work criticized by acclaimed academic masters. Yet Bannister was, according to John Arnold, "his own severest critic."[66] In the end, however, many of his critics and peers in America rewarded his self-motivated desire for perfection with respect and praise.

Through perseverance Bannister managed to overcome many of the racial and technical difficulties placed in his path and achieved a conspicuous place among Boston artists of the mid-1860s. However, it is almost impossible to gauge fully the technical proficiency Bannister must have gained in less than a decade, since few works from that period have survived. Still, in early works like *Moon over a Harbor* (ca. 1868), Bannister emerges as a confident painter, recording nature in a sensitive and convincing manner. The Boston press began to notice Bannister's improvement as an artist, and in 1866 a reporter from the *Daily Evening Transcript* entered his studio and observed a landscape that "displays great talent for one who has had so little practice."[67]

Bannister's decision to pursue art full-time has several versions. George Whitaker confirmed that when Bannister obtained criticism for his painting entitled *Christ Coming before Caiaphas* (lost) from Francis Bicknell Carpenter, he received positive comments. Carpenter had risen to fame for his antislavery painting *The First Reading of the Emancipation Proclamation* (1864), which hung in the United States Capitol. Upon seeing Bannister's religious painting, Whitaker reported that Carpenter advised him to become a full-time artist.[68]

Another version of how Bannister came to commit himself to the full-time business of art came after he supposedly read an article in an 1867 issue of the *New York Herald* that stated, "The Negro seems to have an appreciation of art while being manifestly unable to produce it."[69] His reaction, according to this account, was to intensify his artistic output to disprove the statement.

Bannister's choice to devote the rest of his life to the fine arts may not have emerged from a single incident but instead came from the culmination of a career goal that started in his youth in St. Andrews. Whether the article in the *New York Herald* contributed to his decision remains unconfirmed. Yet Bannister read and heard similar accounts or viewed overtly racially stereotyped images that littered nineteenth-century popular culture, all reinforcing the notion that African Americans had no place in high art.

Early in his career, Bannister, as had Duncanson, attempted several types of subject matter. While landscapes appear to have always been of great interest to him, he also indulged in painting portraits, religious scenes, still-life, and genre subjects. African American themes, especially those dealing directly with the African American experience, were noticeably absent. Portraits of Boston's celebrated Black abolitionists would have been welcomed in the community, but they were apparently not forthcoming. In fact, Bannister's only known portraits that connected with the local abolitionist movement were of whites—Colonel Robert Gould Shaw and William Lloyd Garrison.

It would seem Bannister arrived at the same conclusion as had Duncanson that African American artists of the nineteenth century were best served if they painted racially neutral subjects. Many have often attributed this decision to the belief that a limited number of patrons desired Black subjects; however, nearly every major American genre painter of the nineteenth century rendered paintings of African Americans and found a lucrative market. Such popular white artists as William S. Mount, Eastman Johnson, and John George Brown even devoted a large number of their works to depicting Black life.

Yet Bannister, who was positioned to paint African Americans from a unique personal perspective, failed to deliver them. If art truly was the "ultimate form of social cultivation," it meant that most Black artists had to assume a different outlook on their social standing and mobility. Since they were allowed to move in circles previously occupied only by whites, they enjoyed privileges that set them apart. They were, in essence, becoming "New Negroes" well before the term gained traction in the 1920s. Having this stamp of approval enabled Black artists like Bannister to become social pioneers as their own status was elevated through increasing public acceptance of their work. Perhaps Bannister's feelings during this period echoed those of a member of Boston's Black elite who stated, "While our sympathies tend to unite us with the Negroes and their destiny, all our aspirations lead us toward white."[70]

In fact, the business of creating art in the nineteenth century moved all African Americans toward "white," whether they encouraged it or not. Bannister therefore likely kept most of his work racially neutral to avoid crossing ill-defined social boundaries that could threaten all that he had gained.

Consequently, only a few of Bannister's extant paintings deal directly with Black subjects. Only the portrait of his wife and those of Dr. DeGrasse and his wife remain identifiable as African American. Some art historians have suggested that his well-known *Newspaper Boy* (1869) [fig. 2.3] is, in fact, a mulatto, but there is no conclusive supporting evidence, and the painting carries no overt message of social commentary regarding Blacks.[71] Only *Hay Gatherers* (c. 1893) [fig. 2.4] features African Americans—women and children loading hay onto a cart—as integral participants in a landscape setting; but they are rendered small and ill defined.

Bannister seems to have devalued the Black presence in his work based on economics—few African Americans could offer him sustained support.[72] He knew that African Americans could not buy his paintings in numbers necessary to afford him a comfortable living. This fact was emphasized by Henry O. Tanner when he told W. E. B. Du Bois, "I have never been able to sell one of my pictures to a colored man."[73]

African Americans also could not direct Bannister to many important social contacts outside his small circle of abolitionist friends or open the doors to prestigious art galleries. Only by the beneficence of whites was he allowed to further his career. Thus, Bannister, along with his fellow "accepted" Black artists of the nineteenth century, was bound creatively to paint for a white audience and deliver subject matter that met with their approval.

Fig. 2.3. Edward M. Bannister, *Newspaper Boy*, 1869, Oil on canvas, 30 ⅛" × 25 ⅛", Smithsonian American Art Museum, Gift of Jack Hafif and Frederick Weingeroff.

Bannister and Other Black Artists in Boston: A Matter of Competitive Advantage

Bannister's ultimate acceptance placed him in a precarious position. Having ascended in Boston's art community, he was compelled to do all within his power to stay there. Prior to devoting his attention to landscapes, Bannister, as previously mentioned, advertised his services as a portrait painter, and

Fig. 2.4. Edward M. Bannister, *Hay Gatherers*, ca. 1893, Tempera on panel, 45.72 cm × 60.96 cm, private collection.

he apparently had some success, although there is no large body of these works that would indicate the level of his patronage. However, other African American portrait painters chose to operate in the city, thereby putting themselves in direct competition with Bannister. One, Nelson Augustus Primus (1843–1906), actively sought Bannister for encouragement and assistance in advancing his career with less-than-desirable results.

Primus was born in Hartford, Connecticut, and developed a love of art as a child. After he graduated from grade school he apprenticed under George Francis, who had some formal art training, in the carriage-making and sign-painting trade. With the encouragement of Francis and local art instructor and portrait painter Elizabeth Gilbert Jerome, who studied at the National Academy of Design, he cultivated his talent and won a medal for drawing in 1859 from the State Agricultural Society.[74]

In 1864 Primus apparently realized the limited opportunities for a Black artist in Hartford and moved to Boston to further his art education formally and to establish himself as a portrait painter. Primus wrote, "If I study

hard and tend strict to my profession, I hope to reach the height of my ambition."[75] According to George Forbes, "Though nominally only a carriage painter Primus had larger ambition than the drudgery of the profession and manifested this ambition by both study and practice at every opportunity."[76]

Bannister was, at that time, enjoying a growing reputation among the art elite of the city. Quite naturally, Primus approached him for assistance in securing commissions and perhaps personal instruction, and hoped to share in his success. At first Primus wrote home, "I am a getting along finely with Banester [sic]."[77] However, three months later, Primus saw his relationship with Bannister differently and wrote to his mother, "Mr. Bannister, I think, is a little jealous of me. He says that I have got great taste in art, but does not try very hard to get me work. Mr. Bannister has got on with the white people here, and they think a great deal of him. He is afraid that I would be liked as much as himself."[78]

Primus obviously thought the Boston art market was large enough to accommodate another African American artist. Bannister apparently did not welcome the competition. His rationale for not aiding Primus is not known, since he left no record of this situation. Yet Primus's comment that jealousy was a significant part of the rebuff suggests Bannister may have perceived him as capable of becoming a more accomplished artist, and therefore a threat to supplanting him in the favor of his established patrons.

Primus eventually found an art instructor in Charles E. Stetfield, who worked in the same building as Bannister.[79] Primus perfected his craft by copying works done by other artists; however, none from this early period in Boston have been located. The few paintings by Primus that have survived indicate he was extremely talented and that he eventually made inroads with some white patrons, including some with fame and prestige. His portrait of popular actress Lizzie May Ulmer (1876) [fig. 2.5] received the "highest praise" from the critics of Boston.[80] It is a beautiful painting that far exceeds Bannister's known portrait work. In fact, based on other surviving portraits by Primus, including three paintings he rendered for the prominent Gibson family of East Boston, he demonstrated exceptional ability that ranks him as a first-rate portraitist, especially given his lack of extensive formal training.[81] He also painted a portrait of F. J. Allen, proprietor of the Astor House in New York, and the press "highly complimented him."[82] In 1882 Primus was confidently advertising his services as a portrait painter in the *East Boston Advocate*.[83]

Fig. 2.5. Nelson Primus, *Portrait of Lizzy May Ulmer*, 1876, Oil on canvas, Connecticut Historical Society.

While it may seem almost inexcusable for one successful African American not to assist another, it is quite understandable in Bannister's case. He earned, through hard work and perseverance, a position that was unique among his fellow African Americans. He enjoyed the fruits of his labor at a time when most Americans would not believe a person of African descent could even comprehend the fine arts. Art was Bannister's profession, and he had to stay in a position to maintain his acceptance and respect to earn a living. Yet it is possible he was not secure with this success because he felt it was fleeting given the fluctuating social conditions in Boston. Unfortunately for Primus, Bannister may have not wanted to risk seeing his standing usurped and have someone else "getting on" with the white people. He knew his best years as an artist lay ahead, and he could not afford to see his career and livelihood jeopardized by a more talented Black artist. In addition, in 1867, Primus wrote of the effects a major economic depression had on him and his ability to sell his work. In January 1867 he wrote, "Boston has been very dull for this season of the year. The trouble is business is flat & money scarce, therefore people do not spend it [un]necessarily."[84] Bannister may have experienced similar financial challenges that culminated in a move to Providence, Rhode Island, in 1870.

It is difficult to fault Bannister for his actions. Mainstream society dictated a rigid system of racial oppression that kept African Americans from sharing in matters of cultural refinement. Bannister's potential patrons may have been willing to tolerate one upwardly mobile Black artist at the upper levels of Boston's art circles, but they could view additional African American art makers as constituting a movement toward equality in the arts. If whites truly believed in the inherent inferiority of Blacks, they could never allow their gallery walls to display a growing number of superior works of art by a supposedly inferior people. Bannister gained the favor of whites, and he likely decided to protect his "exclusive domain." It was simply a matter of survival.

Without Bannister's assistance and failure to gain sustainable support from Boston's art patrons, Nelson Primus never realized his full potential. He desperately wanted to leave the country and study abroad, knowing that a European stamp of approval would greatly enhance his opportunity for success in this country. He wrote in 1867, "Oh, I wish that I had money so I could go to Europe to study a couple of years and then I would ask the odds of none of the artists. I do not suppose that I shall be able to go."[85]

While Primus never saw the great art schools of Europe, he viewed the work of celebrated European artists in local museums. In particular, he greatly admired two paintings by Mihály Munkácsy—*Christ in Front of Pilate* (1881) and *Golgotha* (1884)—that were shown in Boston in 1887. He was so impressed by the former painting that he produced a copy that measured 12 by 8 feet and exhibited it in Boston at the old Horticultural Hall on Tremont Street in 1891, and at the Jordan Marsh Art Gallery in 1894.[86] George Forbes noted, "Both experts and others who had seen the original claimed for the copy a merit hardly second to the first painting."[87] From this account it appears that Primus's technical mastery of painting approached the level of a highly acclaimed and formally trained professional artist. In 1895 Primus exhibited work at the prestigious Cotton States and International Exhibition in Atlanta, thus giving him exposure outside New England.[88]

Primus left Boston in 1895 with the intention of traveling throughout the country exhibiting *Christ in Front of Pilate*. He journeyed west and resided in Seattle before moving on to San Francisco, where he settled in Chinatown. Primus continued to paint portraits, genre scenes of the local Chinese community, and religious subjects. However, as in Boston, he attracted little attention, achieved little financial reward, and ultimately supported himself by working in a delicatessen. Unfortunately, many of Primus's paintings were

destroyed in the 1906 earthquake in San Francisco. Although he managed to continue to identify himself as an artist, he died in obscurity to the larger American art scene on May 29, 1916, of tuberculosis.

The predicament of Primus reveals an important side of the struggle of nineteenth-century African American artists trying to gain a foothold in the art world. Other African Americans realized that they possessed the spark of creativity and sought to bring it to fruition. Often, they suffered Nelson Primus's fate. While natural talent played a crucial part of the success of Black nineteenth-century artists, it was often not enough to overcome the crippling effects of racism. Bannister's proper social contacts, being in the right place at the right time, and a great deal of luck were critical to his artistic attainment as he continued to move beyond his perceived inferior status.

If Bannister perceived Primus as a potential threat to his position among Boston art circles, he apparently did not share that sentiment during his formative years. Before 1860 Bannister became acquainted with another local Black artist, William H. Simpson (1818–1872).

William Wells Brown identified William H. Simpson and wrote about him enthusiastically in his landmark book *The Black Man, His Antecedents, His Genius, and His Achievements*.[89] His information on Simpson provides almost all that is known about an early African American who, from Brown's description, was a man of remarkable talent as a portraitist. Brown indicated that Simpson was a native of Buffalo, New York, who in the process of his early education received severe punishment for drawing instead of completing his lessons. Apparently, Simpson had a natural gift for art, and upon leaving school he became an errand boy to London-born portrait painter Matthew Wilson (1814–1892). Wilson immigrated to the United States in 1832, lived in Philadelphia, studied with Edouart Dubufe in Paris in 1835, and traveled throughout America completing portrait commissions. Wilson discovered that Simpson had the potential to be a portraitist and took him on as an apprentice.

They moved to Boston in 1854, where Simpson mastered his craft. According to Brown, Simpson studied and greatly admired the works of Titian, Murillo, and Raphael and took them for his masters. Brown said, "The Venetian painters were diligent students of the nature that was around them. The subject of our sketch (Simpson) seems to have imbibed their energy, as well as learned to copy the noble example they left behind."[90] Apparently, Simpson's absorption of their technical merits was satisfactory, as he was able

to open his own studio and secure patronage. Boston city directories from 1860 to 1866 list Simpson as an independent artist who operated studios at 42 Court Street and, later, 130 Tremont. While the depth of their engagement as artists is not known, Simpson and Bannister did spend time together as members of the Attucks Glee Club.[91]

Although Wilson stated to Brown that he "never had a man who was more attentive or more trustworthy than William H. Simpson," these qualities did not insulate him from prevailing prejudices because of his race.[92] Simpson faced them and vowed not to let racism prevent him from reaching "the highest round in the ladder."[93]

Brown continued his assessment of Simpson saying, "The organ of color is prominent in the cranium of Mr. Simpson, and it is well developed. His portraits are admired for their life-like appearance, as well as for the fine delineation which characterizes them all. It is very easy to transcribe the emotions which paintings awaken, but it is no easy matter to say why a picture is so painted as that it must awaken certain emotions. Many persons feel art, some understand it, but few both feel and understand it. Mr. Simpson is rich in depth of feeling and spiritual beauty."[94] Brown also indicated that Simpson was so skilled at painting likenesses that patrons often invited him to render whole families, and that no one was more adept at painting children. While the level of his patronage remains unknown, Brown recorded that his portraits were "scattered over most of the Northern States and the Canadas. Some have gone to Liberia, Hayti, and California."[95]

It would seem that Simpson was highly successful, but few of his works remain identified. Brown remarked on a portrait Simpson completed of John T. Hilton, which was presented to the Masonic Lodge, saying "The longer you look on the features, the more the picture looks like real life. The taste displayed in the coloring of the regalia, and the admirable perspective of each badge of honor, shows great skill." Brown also stated that Simpson answered a request to have Senator Charles Sumner sit for him and that the results were "signally successful." In fact, Sumner posed in Simpson's studio at 42 and 44 Court Street. George Forbes stated, "There went Charles Sumner in his day of glory at the suggestion of a friend who desired the statesman [sic] likeness painted by the Black artist, and in that little studio was painted a Sumner profile which was never excelled by those who in after years tried their practiced hands.[96]

Simpson's completion of the Sumner portrait may provide evidence that he had strong ties to Boston's abolitionist community and used his artistic talent to aid in the cause much as Bannister had done with his Shaw portrait. This observation is strengthened by the fact that the Ladies Ministerial Aid Society presented Simpson's portrait of Reverend Leonard Andrew Grimes (1815–1874), an African American abolitionist and Underground Railroad conductor living in Boston, before the public in 1860.[97] In 1864 Grimes presented an unspecified painting by Simpson to Governor Andrew of Massachusetts. The *Christian Recorder* noted, "Mr. Simpson, a young man, who executed the painting, is a first-class painter, and deserves a great deal of credit. We are glad to find that Boston has first-class painters among the colored people, as well as Philadelphia."[98]

Two of Simpson's surviving works are part of the Howard University art collection. They portray Jermain Loguen, a bishop in the African Methodist Episcopal Church, and his wife, Caroline Loguen, and attest to Simpson's skill as a confident portrait painter who presented African Americans in a dignified manner. Forbes remarked, "Simpson seldom aspired to other than the portrait branch of his art."[99]

William Wells Brown concluded his overview of Simpson by saying, "Mr. Simpson is of small figure, unmixed in blood, has a rather mild and womanly countenance, firm and resolute eye, is gentlemanly in appearance, and intelligent in conversation."[100]

The level of talent as portrait painters displayed by Primus and Simpson may have contributed to Bannister's gradual withdrawal from the field, as few formal portraits by his hand are extant after their emergence in Boston. Although he still listed himself as a portrait painter in 1864, Bannister continued to grapple with technical problems in painting, perhaps in rendering the human face and body to his complete satisfaction.[101] Clearly, Primus and Simpson were far superior to him in delivering high-quality portraits to their limited pool of patrons in the city.

On at least one occasion, Bannister seems to have put aside his competitive spirit and formed a partnership with another Boston artist, named Asa R. Lewis. They appear in the 1868 *Boston Directory* as "Bannister & Lewis," located at 228 Washington, and list their profession as artists.[102] Unfortunately, nothing is known presently of the nature of this joint venture, and Lewis seems to have left no significant art legacy. However, by the next year, Bannister, as stated earlier, moved to Providence, Rhode Island, indicating

that their efforts met with little success. Lewis remained in Boston until at least 1873, where the *Boston Directory* still listed him as an artist.[103]

Influence of the Barbizon Style

Bannister began to focus his artistic endeavors on landscapes during the mid-1860s. This came, in large part, by the growing popularity of an imported style of French art called Barbizon. Vermont native William Morris Hunt (1824–1879) championed this new style in the New England region. In 1852 he journeyed to Barbizon, a small area nestled in the great Forest of Fontainebleau, to live and study with Jean-François Millet as part of a group of painters who left their confining studios in search of more intimate relationships with nature and the native peasants. Among their number were such noted French artists as Jean-Baptiste Corot (1796–1875), Theodore Rousseau (1812–1867), Charles-François Daubigny (1817–1878), and Constant Troyon (1810–1865).

Art historian Rachel Keith noted, "Although the members of the Barbizon school shared no set doctrine or credo, and their styles varied significantly, they were united in their common desire to experience nature directly and to present it individualistically and poetically, employing painterly techniques that emphasized the subjectivity of the artist through effects of light and atmosphere."[104]

When Hunt returned to America in 1855, he brought many paintings by Millet, as well as works by Rousseau, Corot, and Daubigny. As he settled back into life in this country, Hunt began to urge acquaintances, collectors, and art patrons to purchase Barbizon art. This was particularly true in Boston, where he moved in 1863. Referring to Hunt's influence as an effective tastemaker, Russell Lynes commented, "Bostonians were taught to know and appreciate the painters of the Barbizon School before the French became interested in them, and paintings by Millet, Corot, Courbet, Rousseau, Diaz, and others hung on the walls of Boston parlors before they hung in comparable bourgeois parlors in Paris."[105]

Some suggest that Bannister came under the influence of Barbizon art because he saw these works on gallery walls in Boston, possibly at the Boston Athenaeum, which showed them in the 1850s. While this may have been true, Bannister had a more personal introduction to the style. In 1863 Hunt moved into the Studio Building on Tremont Street.[106] At that time there were

twenty-six artists, including Elihu Vedder and John La Farge, and eleven architects sharing working space and fellowship. Bannister was one of these artists. Therefore, it is highly possible that Bannister, barring any kind of overt racism on Hunt's part, received firsthand exposure to Barbizon art in this environment. In addition Bannister viewed Barbizon exhibitions held in the Studio Building in 1866 and 1867 that "showcased work by Millet, Gustave Courbet, Camille Corot, and their American pupils."[107]

Bannister found the Barbizon style a perfect complement to his poetic view of nature. Unlike the studio-bound Hudson River School style, which remained popular, Barbizon painting allowed Bannister to work directly on site (en plein air), to loosen his brushwork, and to exercise more liberal application of pigment. Instead of enslaving him to the minute detail adopted by the Hudson River painters, Barbizon art freed him to be expressive and imaginative in his interpretation of nature. More importantly, Bannister's embracing of the Barbizon style allowed him to connect personally with unspoiled states of nature that he translated into visual metaphors of his own relationship with the Divine.

At times Bannister rendered paintings utilizing tonalist qualities that many American artists, including George Innes and James Whistler, derived from the Barbizon style as a mood-setting device.[108] As Bannister's embrace of Tonalism grew, he began to emphasize atmosphere and shadow effects while concentrating on warm undertones and cool overtones with priority given to middle values from his palette: soft greens, a muted range of grays and blues, warm browns, and gossamer yellows that combined to yield a prevailing tone. And while cows and sheep often punctuated his pasture scenes and rural environments, his occasional use of a lone figure added a touch of reverence and silent meditation that speaks directly to humble insights into the gentler qualities of the human spirit. Consequently, Bannister's landscapes carried no narrative declarations; rather, he imbued his viewers with more intimate emotional and spiritual visual engagements. John Arnold stated Bannister's immediate affinity with the imported style, and his ability to make it his own:

> Bannister from the first felt the impulse of the Barbizon School, and without imitating any one artist, his trend of mind and his sympathies were all in that direction. His aim, like theirs, was to give expression to the breath, color and atmosphere, without the dry, detailed, formal composition that had heretofore dominated American art.[109]

George Whitaker recorded Bannister's enthusiasm on a visit they shared to a New York gallery featuring Barbizon art. Whitaker said:

> Here my friend was in his element. As we walked from picture to picture talking more earnestly than we were aware, we noticed we were being followed by a stately old gentleman of the old school who soon introduced himself, giving his name, and saying he was an officer of the Metropolitan Museum, and would we after doing up this exhibit be his guest at the Museum? I am sure he had been attracted by Mr. Bannister's talk and actions—namely with hands, feet, body, and head, so enthusiastic did he become. We accepted and were royally entertained.[110]

The Mature Years

Perhaps Edward Bannister's dedication to his career led to a strain in his marriage, as the city directory indicates that he and his wife lived apart from 1866 to 1868. They were back together in 1869 and decided that a change of venue was necessary. Post–Civil War Boston was not the same place that had nurtured him. Many former slaves who had sought refuge in the city sent for family and friends to join them in the North. The new influx of African Americans created hostilities between Blacks and whites over issues of jobs and housing. There was also a great deal of uncertainty about the future among educated and refined Blacks, like Bannister, who worried over the social and political consequences of the migration of their uneducated brothers and sisters from the South. The swelling population of Black refugees created growing tension among Boston's well-established elite and Bannister may have sensed that the supportive environment in the city was diminishing.

Bannister may have also become frustrated by the lack of inclusivity that Boston artists outside his small circle of white friends extended to him. If so, it was likely that he felt his career in the city had stalled and that a change of location was necessary to advance his sustainability as an artist. In addition, Boston art markets were becoming flooded with Barbizon art. Consequently, the Bannisters moved to Providence, Rhode Island, in 1870. However, Christiana maintained her Boston salon through 1872.

Perhaps, too, Rhode Island reminded Bannister of his home in Canada and afforded him a slower-paced lifestyle and closeness to nature that eluded

him in the hustle and bustle of metropolitan Boston. The region offered a landscape painter countless vistas of choice subject matter. The smallest state in the nation attracted many of the country's leading artists to record the intrinsic beauty and character of the land. Among their numbers were John F. Kensett, Martin Johnson Heade, Thomas Worthington Whittredge, and John La Farge. They had not come to Rhode Island to paint the spectacular features of its topography. Rather, as Lloyd Goodrich noted, "what it did have was the ocean, the bay and the seashore. Its landscape was not grandiose: rolling hills, meadows and pastures sloping down to sandy beaches and rocky coasts—and the light and color of the sea and shore."[111] Goodrich's observation of these early Rhode Island artists seems to speak directly to what became important elements in Bannister's art. Goodrich continued, "They paid as much attention to weather, season, time of day, atmosphere and light, as to the solid earth. Their firsthand visual observation captured accurately the climate of Northeast America with its clear air, brilliant sunlight, and high cool skies. . . . They were never afraid to picture the short-lived beauty of sunsets and afterglow, avoided by a later generation as sentimental and corny."[112]

The region's beautiful bays and harbors were a sailor's delight. Bannister spent many hours on his small yacht, *Fanchon*, observing the water and the clouds and making notes for future canvases. George Whitaker remarked, "These were the days when his cup of joy was full."[113]

Bannister once again could concentrate on his art and opened a studio at 14 Westminster Street. Christiana operated a salon on Burrill Street that opened in 1870. Their household, according to the 1870 census, had grown to include nineteen-year-old Estelle Babcock (listed as "housekeeper"), Estelle's mother (Christiana's sister-in-law), and fifteen-year-old William Bannister, likely Edward's nephew.

The Bannisters purchased a house on Swan Street and lived there from 1871 to 1876. In 1883 Christiana established a new hairdressing firm on Westminster Street. The next year the Bannisters bought a new home at 93 Benevolent Street and remained there until 1898.

Bannister quickly attracted attention as an artist in Providence. Perhaps the novelty of his race drew inquisitive residents to his studio. Soon the local media began to cover him, with the *Providence Press* commenting on his recently completed portrait of William Lloyd Garrison and his excellent figure study *The Newspaper Boy*.[114] The reporter also mentioned that Bannister had begun painting several landscapes.[115]

At this time Bannister's landscapes, usually devoid of anything but foliage, water, sky and an occasional boat or building, began to include more animals, as in *Untitled (Man with Two Oxen)*, (1869) [fig. 2.6]. Perhaps this was his response to the growing popularity of animal studies in Europe and America derived largely from the work of Barbizon artist Constant Troyon and the renowned French *animalière* Rosa Bonheur (1822–1899). Bannister effectively placed sheep and cows in their natural environment, thus adding another dimension to his portrayal of God's tranquil blessings to the world much in line with George Inness's belief that "everything in nature had a corresponding relationship with something spiritual and so received an 'influx' from God in order to continually exist."[116]

When Bannister chose to incorporate human figures in his Barbizon-inspired compositions, they remained humble appendages to their natural surroundings; they are shown as no more important than a tree or cow as all exist freely and purely in pristine rural environments. In fact, Bannister seems to have painted few human figures interacting within an urban setting. For him, the human presence in his landscapes celebrates the nobility of human life as it sympathetically intertwines with all living things in perfect equilibrium. Thus, unlike the earlier appeal of the Hudson River painters where humans occupy a subordinate position to the grandeur of nature, in Bannister's world all elements operate on the same level of importance.

One thing Rhode Island did not offer Bannister was a strong, organized community of artists. Although the state had produced painters like George Whitaker and Charles H. Davis, who both studied at the Académie Julian in Paris, there was little formal interaction among local artists to create a more conducive art-responsive environment. In addition, local collectors, prior to the 1880s, had shown little interest in the work of the French Barbizon painters despite William Morris Hunt's presence in the state. Providence art dealer Seth Vose began to introduce French Barbizon art into the region as early as 1852, becoming the first American commercial importer of this new style.[117] Vose maintained galleries in Providence and Boston, but he had little initial success selling Barbizon art to his Rhode Island patrons.

Thus, Bannister left a city quickly awakening to the spirit of Barbizon for one that was slow to respond to its virtues. This would seem to be quite a gamble for an artist who still had not made a major mark on the regional art scene. George W. Forbes noted that the change of location did wonders for his friend's artistic output. He stated, "Freed from the overshadowing

Fig. 2.6. Edward M. Bannister, *Untitled* (Man with Two Oxen), 1869, Oil on canvas, 16" × 24 ¼", Smithsonian American Art Museum, Gift of Dr. Peter A. Pizzarello.

influence of the Boston throng, Bannister's brush took unto itself wings for a loftier flight, and henceforth with his larger self-confidence he gave some of the best creations to an admiring world."[118]

During Bannister's early years in Providence he refined his technique, matured as an artist, and painted some of his finest landscapes. Another indication of Bannister's growing maturation as a landscape artist came in 1872, when he received an Award of Premium at the Rhode Island Industrial Exhibition for a painting entitled *Summer Afternoon.*[119] His confidence must have soared as he now gained conformation that an African American artist could compete successfully against the elite white artists in the region.

Despite his relocation to Providence, Bannister did not lose his activist spirit. Having long championed the fight for Black civil rights and political attainment, he was extremely pleased when he attended a dinner hosted by William Still in Philadelphia in honor of congressional representative John R. Lynch of Mississippi in 1875.[120]

The culmination of this period of rapid growth came in 1876 when Bannister completed a large painting entitled *Under the Oaks*. He first displayed it at the Massachusetts Centennial Art Exhibition at the Boston Art Club, where it was warmly received. A reporter exclaimed that the painting was one of the two best in the exhibition and that it was "the greatest of its kind that we have seen from an American artist."[121]

Bannister was buoyed by the reception of *Under the Oaks*, but he had larger plans for it. He next submitted the painting to the prestigious art exhibition held as part of the Philadelphia Centennial International Exposition. Bannister felt that acceptance here would catapult him to a level of achievement and recognition that surpassed that of many of his more successful white contemporaries. However, despite all the gains to his career that would come from inclusion at the Centennial, Bannister hesitated over submitting his painting. According to George Whitaker, *Under the Oaks* was "sent with many misgivings to the art committee with nothing but a signature attached."[122] Bannister would have naturally been apprehensive about having his ability judged against the best artists in the country, hence one possible misgiving. Yet the fact that he entered his picture with only his name as a qualifier suggests something much more serious.

Given the opportunity to gain national prestige and recognition at the Centennial, it may be assumed that nearly all the artists submitting to the exhibition included, along with their artwork, an impressive listing of their accomplishments. They did this to sway the jurors and increase their chances of garnering awards. While Bannister had made only modest gains in art, it would have been to his advantage to mention his rise in the Boston and Providence art communities. Yet he remained silent. He was apparently unwilling to jeopardize the likelihood of his selection out of fear that knowledge of his race would negate the chances of success. A space on the wall of the Centennial signified the best America could produce in art. It was highly unlikely, given the spirit of the times and the inherent belief of racial inferiority, that the jurors were willing to raise the work of a Black man to so lofty a position. Such a move would essentially say to the world that a Negro—an African—was the cultural equal of America's greatest artists.

The Centennial jury selected *Under the Oaks*, submitted with only the name of Edward Mitchell Bannister, to hang among some the greatest works of art in the world. This painting was included with the Massachusetts entries. George Forbes's recollection of Bannister's participation at the Centennial

supports the notion that he wished his racial identity to attract little attention. Forbes wrote, "Only a few of the better informed even of the Massachusetts exhibitors knew the painter's identity. In the Art building therefore while all admired the picture none could give the identity of its creator, or had other thought than that he was of the regulation type. The painting caught from the first the eyes of the judges as well as those of the spectators. Accordingly when the day for bestowing the prizes came around 'Under the Oaks' was unanimously granted the gold medal."[123]

Bannister had actually received a first-place bronze medal and certificate of award for a painting described as "quite a startling representation of a grove of old gnarled oaks, beneath which a shepherd watches a small flock of sheep browsing on the slight declivity which leads to a quiet pool in the foreground. These trees are painted with such wonderful closeness to nature as to fairly stand out from the gray-and white background of the sky as though in relief."[124] Although *Under the Oaks* is now lost, a similar work painted the same year, *Oak Trees* [fig. 2.7], gives a close approximation of Bannister's masterful painting.

By winning the award, Bannister had almost single-handedly advanced the cause for people of color to aspire to the fine arts in this country. In addition, his stunning achievement thrust him from an obscure regional landscape painter to an acclaimed national figure.

Once informed, Bannister quickly left Providence for Philadelphia to receive his medal. He was fortunate that the judges had not discovered his race and, thus it played no part in a triumph that came based solely on merit. Bannister, however, soon found out that his decision to maintain a low profile was correct. When he arrived at Memorial Hall to verify that he had been the recipient of an award, an unexpected turn of events transpired. As reported by George Whitaker, Bannister recalled what happened next:

> I learned from the newspapers that "54" had received a first prize medal so I hurried to the committee room to make sure the report was true. There was a great crowd there ahead of me. As I jostled among them many resented my presence, some actually commenting within my hearing in a most petulant manner, "What is that colored person in here for?"
>
> Finally when I succeeded in reaching the desk where inquiries were made, I endeavored to gain the attention of the official in charge. He was very insolent. Without raising his eyes he demanded in the most exasperating tone of voice, "Well, what do you want here anyway? Speak lively."

Fig. 2.7. Edward M. Bannister, *Oak Trees*, 1876, Oil on canvas, 34" × 60 ¼", Smithsonian American Art Museum, Gift of H. Alan and Melvin Frank.

"I want to inquire concerning '54.' Is it a prize winner?" "What's that to you?" said he.

In an instant my blood was up: the looks that passed between him and the others were unmistakable. I was not an artist to them, simply an inquisitive colored man. Controlling myself I said deliberately "I am interested in the report that 'Under the Oaks' has received a prize; I painted the picture."

An explosion could not have made a more marked impression. Without hesitation he apologized, and everyone in the room was bowing and scraping to me.[125]

Had Bannister accomplished nothing more in his career than defusing a myth of racial inferiority, he must be viewed as a successful artist. Yet his achievement at the Centennial carried greater implications. Bannister's award denoted, to a national audience, that works of art created by people of African descent stood up to the highest standards of the period. Accordingly, Bannister "found his way through the crowd and stood before his masterpiece, with his heart bounding with joy."[126] It was a moment for him to savor a great accomplishment. On that day at the Philadelphia Centennial Exposition of 1876, Bannister carried the hopes and aspirations of "his people's" quest for a measure of equality admirably. Thus, hanging on the wall of Gallery 28 was not just a painting but also a symbol that talent and perseverance could overcome overt racism.

It is understandable how members of a society largely bent on the oppression of African Americans and keeping them in a place of inferiority would have serious misgivings about letting Bannister's triumph stand. Therefore, it is not surprising to learn that "when the judges found that they had given the prize to a colored man, they attempted to change their decision."[127] Apparently, only the protests of his fellow artists, who threatened to withdraw from the exhibition, allowed Bannister to keep his medal.

Bishop Henry McNeal Turner of the AME Church, a Georgia resident and confirmed Black nationalist, later condemned the North, particularly the Centennial organizers, for showing none but the faintest interest in Black advancement in any area. He acknowledged that Bannister had received a premium at the Philadelphia Centennial of 1876, but "the only position other than that, as far as I could learn, filled by a colored person was attending the toilet rooms and bringing water to scrub some of the floors at night."[128]

The Centennial award boosted Bannister's confidence and convinced him that he could be competitive with anyone. Bannister said, "I was and am proud to know that the jury of award did not know anything about me, my antecedents, color or race. There was no sentimental sympathy leading to the award of my medal."[129]

Bannister's triumph received glowing attention in the Black press. Robert Douglass Jr., an African American painter from Philadelphia, commented on *Under the Oaks* for the AME *Christian Recorder* and described it as "a quiet pastoral scene, a Shepherd and sheep beneath a fine group of oaks. It is much admired, and it gave me great pleasure to find that it is one of the really meritorious works that have gained a medal. To me it recalls some of the best efforts of Constable, the great English Landscape painter."[130]

Professor John P. Sampson, a leading educator and AME minister, also writing for the *Recorder*, gave specific details of the work. He said:

> It has attracted great attention. The press speak of it in the highest terms, and declare it to be one of the finest paintings in the Department. Mr. B is a colored gentleman of modest bearing and general intelligence; he comprehends fully the importance of competing in the world of art and takes a just pride in his picture. He has been awarded one of the four prizes to be given for the four best pictures and will no doubt take rank at once among the best American artists. It is a four by six feet picture, representing in the foreground, a herd of sheep along the branch, while further on the back-ground is a beautiful ascent, with a

cluster of oaks, wide spread in their branches, like a great shed; and beneath this shelter can be seen numerous cows, and sheep taking shelter from the storm.[131]

John Duff of Chicago bought *Under the Oaks*, before it received an award, for fifteen hundred dollars. Duff's niece stated that her uncle sat before the painting "for twenty minutes before breakfast each day and looked upon the peaceful scene that his mind might be sweetened for his day's work."[132]

Bannister returned to Providence a hero. No local artist had ever received so great an honor. And while Bannister's trajectory as a local artist continued to rise, Madame Bannister labored to improve the lives of the Black citizens of Providence. She and other civic-minded Black women actively raised money locally to establish a much-needed rest home for elderly African American women, providing them with relief from advanced age, poor health, and poverty. The facility opened under the name Home for Aged and Colored Women, located at 45 East Transit Street. It remains today as the Bannister House Nursing Care Center.

Respected Providence Artist

Rhode Island nurtured Bannister with the beauty of the land and sea and the embrace of his fellow artists. He produced many of his best works in this environment, such as *Five Cows in a Pasture* (ca. 1882), *Sabin Point on the Narragansett Shore* (1885), and *Approaching Storm* (1886). The spirit of Barbizon encompassed Bannister, yet his mature works pushed the boundaries of that style, and he arrived at a method of working that was uniquely his own. His paintings were not merely observations of nature; they were transformative experiences. They eloquently and poetically captured bucolic landscapes rich in texture and heavy on atmospheric effects. As he loosened his brushwork, his command of his subject grew along with his "visionary eye." He did not desire to render accurate depictions of his environment. Rather, he permeated his canvases with a deeply personal sense of his own devout spirituality—God's hand is present in all his landscapes. Simply put, Bannister believed that nature provided a kind of perfect spiritual state and that his art served as a direct channel to the Divine.

Although he occasionally rendered a painting based strictly on a biblical theme, as discussed later, the ultimate manifestation of his religiosity surfaced

in every tree, meadow, and wave that appeared on his canvases. A letter written to his friend George Whitaker around 1895 reflected this aspect of his development. Bannister said, 'With God's help, however, I hope to be able to deliver the messages instructed to me.'[133] In addition Bannister, no doubt using himself and his work as the primary example, said of God in art, "He becomes the interpreter of the infinite, subtle qualities of the spiritual idea centering in all created things, expounding for us the laws of beauty, and so far as finite mind and executive ability can, revealing to us glimpses of the absolute idea of perfect harmony."[134]

Whitaker reflected on Bannister's spiritually driven purpose for art creation by saying, "Our friend was a spiritually minded man and from the beginning of his art career to its close, he felt deeply that the Ideal was the real. This ideality obtains in all his canvases making them poems of peace. Mr. Bannister's thoughtful contemplation embraced the beautiful, the fanciful and the weird. He draws us from the hard realities of life, and by his deep interpretation, touches the soul, clearly representing the invisible in the visible."[135]

Bannister played an integral part in Providence's quest to become an established regional art center. With the prestige of his Philadelphia Centennial award casting new light on the area and a growing number of younger artists settling in the state, Bannister felt the time was right to form an official art organization in his newly adopted city. In February 1878, George Whitaker, Frederick Batcheller, and Charles W. Stetson met with Bannister in his studio to begin discussions on how to stimulate the interest of collectors, dealers, and the public in their work. In addition they sought to provide mutual support among its members, increase exhibition opportunities, and offer art-related lectures. Other meetings followed and their efforts culminated on February 12, 1880, in the studio of sculptor Eimrich Rein. There, sixteen men and women gathered to sign a charter forming the Providence Art Club. They elected James S. Lincoln as president of the organization, and he was the first to place his signature on the official founding document. Bannister signed next, followed by Stetson and Whitaker.[136] The Providence Art Club would go on to sponsor a prestigious annual exhibition for many years to come. Bannister participated in most of them until 1900.

The Providence Art Club proved to be a success in its advocacy for artist support in the city. However, in 1885 several members of the club formed

an offshoot social group known as the A. E. Club (reportedly a fanciful reference to a popular waitress Ann-Eliza, who served them and to whom they all claimed to be married). Perhaps in response to the Providence Art Club's growing lack of formal and challenging intellectual engagement, the new organization provided a forum for stimulating criticism on a variety of art topics. On April 15, 1886, Bannister delivered a lecture, "The Artist and His Critics," to the A. E. Club. The lengthy talk showed that he was astutely engaged in nuancing philosophical and critical rhetoric that formed the basis of the relationship between art makers and the public. He framed his talk at the beginning by stating that he presently stood artistically "between the period of knowing nothing of Art and an awakening appreciation of its value as a teacher and its importance as a means toward lifting us out of the low atmosphere of sordid gain and narrow selfish ambition into one more ethereal and spiritual."[137] Thus, Bannister placed himself formally as a conduit, an artist operating between the material world and the spiritual realm. This viewpoint aligns Bannister with the philosophical approaches espoused by the Transcendentalists, particularly Ralph Waldo Emerson and Henry David Thoreau, whose works he likely read (Boston being the epicenter of the movement). As such, Bannister found commonality with the Transcendentalists' embrace of the American landscape as a spiritual setting wherein they "praised the individual spirit and the lush beauty of the natural world. To them, divinity was everywhere, within each individual and especially in nature."[138] Bannister may have personally identified with the words of Emerson when the poet wrote: "What is man born for but to be a Reformer, a Re-maker of what man has made . . . a restorer of truth and good, imitating that great Nature which embosoms us all, and which sleeps no moment on an old past, but every hour repairs herself, yielding us every morning a new day, and with every pulsation a new life?"[139] Thus, Bannister also challenged art critics to consider this fundamental relationship in judging the value of the artist's personal vision:

> Aside from his recognition of good or bad technical qualities in the artists' work, the critic in order to be fully up to the demands of his assumed position, should, we repeat, so be able to place himself in rapport with the artist as to know if he had in any degree succeeded in expressing what he intended, in formulating the central idea that possessed him, understanding that idea, and the limitations of art expression.[140]

Bannister also cited his admiration for Millet, calling him the "profound-est, tenderest, most sympathetic artistic spirit of our time."[141] Overall, this lecture defined Bannister in the manner he likely wished to be remembered—a "reformer" and a "remaker" of the American landscape, whose profound spirituality fueled the bounty of his artistic output. It also demonstrated that the artistic production of an African American could be grounded in theory rather than springing from some racially induced imitative response to the works of whites, as some racists would have it.

For his engaging intellectualism, George Whitaker referred to Bannister as the "Artist Laureate," and in 1891 he delivered an impassioned speech to the A. E. Club praising the Black artist for his significant accomplishments and profound artistic vision. Whitaker also suggested that Bannister had not received proper acknowledgment and appreciation and admonished the members, "Is it rightful that a man of such power should be allowed to slip through our community without due recognition?"[142]

In November of 1880, Bannister participated in a unique group exhibition—all the artists showing were African American. Organized by the Working Men's Club of Philadelphia, according to the *People's Advocate* this was "the first enterprise of this kind ever started among people. The exhibits are all works of colored artists and some of them are very creditable."[143] Hanging on the walls alongside the work of Bannister were paintings by Robert S. Duncanson in addition to Black Philadelphia artists William Dorsey, Robert Douglass Jr., David Bowser, Alfred B. Stidum, and the very young Henry Ossawa Tanner.[144]

Bannister gained broader acclaim, nationally and internationally, when the prestigious *Magazine of Art* cited him. The *New York Globe*, quoting from the magazine, reported, "The May *Magazine of Art* in speaking of the Providence Art Club says, 'The most prominent landscape painter of the city, it is hardly necessary to say, is Mr. E. M. Bannister, whose excellent broad work receives some extraneous interest from the fact that he is a Negro.'"[145] The magazine writer understood that race was still an overarching factor in the public's engagement with Bannister's art, for better or worse.

Bannister maintained a studio in the Woods Building at Number 2 College Street from 1877 to 1898, working alongside admiring peers, including John Arnold, James Lincoln, George Whitaker, Sidney Burleigh, and Charles Walter Stetson. Evidently, one of the keys to Bannister's success was his ability to surround himself with kindred spirits who saw his color as no barrier to guiding

them in their common quest for artistic perfection. Charles Stetson's admiration of Bannister as mentor and friend, for example, is reflected in his dairies, and they reveal a very close working relationship. Stetson wrote, "He was my only confidant in Art matters & I am his."[146] He later journaled, "The only person that seems to understand my Art and ideas is Bannister: and I say more to him of my art feelings than to any other man."[147] They also shared a mutual distaste for Impressionism, with Stetson saying, "Mr. Bannister and I stood on the sidewalk talking art—particularly the "impressionists," which he dislikes as much as I."[148]

The *Providence Sunday Journal* provided a brief glimpse of how Bannister maintained his studio, stating that "the fourth floor, known as the 'artists' floor,'" also housed the studios of Sidney Burleigh, John Arnold, James Lincoln, and Frederick S. Batcheller. Bannister's easel was directly under the skylight, which flooded his studio with light, and he stacked sketches and paintings along the walls. Hung on the walls were his wife's portrait and his paintings depicting scenes from Spenser's *Faerie Queene*; he kept a vase of dry grasses and autumn leaves before him as he worked."[149] He also taught Saturday art classes.

Artist William Alden Brown, a student of Bannister and collector of his work, recorded an interesting account of his studio and his intellect:

> As a boy, I visited Bannister's studio in the old Woods Building where later I was to become his pupil. On my first visit to the studio, Bannister moved an easel covered with drapery out from the gloomy depths at the rear of the studio. He wished my mother to see his large canvas of *Christ in the Garden of Gethsemane*, a canvas on which he worked intermittently for years. Both Mr. Bannister and his wife were honored members of the Elmwood Avenue Baptist Church where my parents belonged. So at church and on Saturdays in his studio, I saw much of Bannister. His was a mind far above the ordinary and his art was in keeping with his brilliant mind. He was thoroughly conversant with the Bible, Shakespeare, English literature, classic themes and mythology.[150]

The mention of the size of *Christ in the Garden of Gethsemane* and the extended period Bannister spent perfecting it indicates that religious themes remained an important and personal part of his creative endeavors. As previously mentioned, *Christ Coming before Caiaphas* appeared earlier in his career and proved to be a significant work in gaining him favorable criticism at a crucial stage in his professional development.

Unfortunately, *Christ in the Garden of Gethsemane* remains lost, so no direct assessment is available to determine how he chose to approach the composition. However, Christ placed in a garden setting would allow Bannister to continue his passion for landscapes while adding a deeply personal reflection of his own religiosity.

It is surprising, given Bannister's devout Christian nature, that there are few references to other biblical paintings. Charles Stetson recollected Bannister beginning a work featuring Herodias, the infamous woman who desired the head of John the Baptist. He wrote, "This morning I gave half an hour or so to calling on Bannister. . . . He . . . showed his sketch for Herodias. She is sitting contemplating with the head of John, Baptist before her. The pose is excellent. It is a profile."[151] In 1887 Stetson also recalled seeing two more religious works by Bannister: "Before going to mother's I called on Bannister [for] a few minutes. . . . He also showed me two scriptural pieces that he had sketched on canvas: one, Christ inviting humanity—I should call it, just drawn on the canvas in charcoal, a dignified promise surely, the other, Jesus & the daughter of Jairus himself & wife. The latter is in color & promises much."[152] These works, if ever completed, remain lost.

Therefore, only three extant works by Bannister reveal direct references to biblical subjects. Bannister's rendering of a portrait of *St. Luke* (n.d.); *Salome Receiving the Head of John the Baptist* (1890), an apparent preparatory study; and *Jesus Christ, Messiah* (n.d.), showing Jesus walking along a path, offer little insight into what motivated his choice of Bible-related work. Of course, without an explanation from the artist or numerous works that define a clear direction of his religious vision, it is difficult to measure Bannister's intent as a biblical delineator.

Nevertheless, his *Christ in the Garden of Gethsemane* and *Christ Coming before Caiaphas* suggest that he had some affinity for visually engaging the Passion of the Christ, and perhaps there were others that extended this narrative. Bannister's profound level of faith makes it easy to imagine that religious works should occupy a more extensive portion of his visual output; perhaps they existed and now remain to be discovered. Therefore, without further evidence of other works, *St. Luke*, *Salome*, and *Jesus Christ, Messiah* remain as interesting footnotes in his career. It would not be until the emergence of Henry Ossawa Tanner, several decades in the future, that an African American artist would build a sustainable career based on interpretations of stories from the Bible.[153]

At the height of his career, Bannister's work was much in demand by New England galleries and collectors. He continued to exhibit regionally at exhibitions of the Boston Charitable Mechanics Association in 1878 (bronze medal), 1881 (bronze medal), and 1884 when he received a silver medal for *A New England Hillside*. In addition, his contribution to the growth of Providence art culture expanded when he sat on the original board of the newly created Rhode Island School of Design in 1878.

Bannister also remained of great interest in the Black press, as his Centennial triumph still resonated as a matter of high artistic achievement as practiced by Black hands. A reporter for the *Christian Recorder*, stopping in Providence while returning to Philadelphia, said of Bannister:

> A few hours on our return from Boston, we had the good fortune to meet our friend E. M. Bannister, the artist. Nothing gave us more pleasure than the inspection of the pictures, which grace his studio. Since his triumph at our Centennial he has been equally successful both in New York and Boston. The picture he purposes sending to New Orleans [A *New England Pasture*] is one of exceptional merit, and must win new laurels for him.[154]

In 1885 Bannister exhibited *A New England Pasture* at the Cotton Centennial Exhibition in New Orleans and demonstrated fully that he was an artist who had reached maturity of style. The *New York Freeman* reported:

> Mr. E. M. Bannister's art exhibition and sale has largely been attended the last few days. His landscape pictures are fine, especially the New England hillsides. It shows a sloping mountain with all the beauty of nature around it. It must be remembered that this picture took first prize at the Massachusetts fair in Boston last November. Mr. Bannister sent a picture to the New Orleans Exposition, the canvas being 6×4 ½ feet and styled the "New England Pasture." This picture also [won] first prize in Boston in 1883. Another of his handsome pictures is "Spring Morning," with the bright rays of the sun streaming through the new grown foliage. As an artist, Mr. Bannister is not excelled in Providence. Students are taught at his studio in Ward's [sic] building, corner of College and South Main streets.[155]

Bannister could not withhold his racial identity when he sent *A New England Pasture* to New Orleans. The recognition he received from the

Philadelphia Centennial made that impossible. Thus, fair organizers designated him as a Negro artist—fortunate to be included in the exhibition, virtually ignored by the critics, and segregated from his fellow art makers in the Negro Building. Despite the high quality of *A New England Pasture*, New Orleans Exposition officials obviously deemed it an inferior work. George Forbes, quoting from the *American Baptist* of Louisville, Kentucky (June 11, 1885), wrote that "probably because of the environments of the place of exhibit, such as the bitter and intense race feeling with which the whole atmosphere was surcharged there, the painting got little or no official recognition. Not even did it get regularly listed with the other American artists."[156] This racial slight may have convinced Bannister that as long as his race was connected to his paintings, he stood little chance of receiving fair and equal recognition outside New England. The *American Baptist* article seems to have acknowledged this when it concluded, "It may have been from this cause that we find no more instances of exhibits being sent by Bannister from home."[157] It is therefore little wonder Bannister chose to work and exhibit almost exclusively in the New England region, where his friends respected and accepted him as a man and an accomplished artist.

In 1886 the *New York Freeman* noted that Bannister was "represented at the Art Club's Autumn exhibition by a picture entitled 'Southeaster on the Coast,' thus placing him once again in the more race-friendly confines of his hometown."[158] Also that year Charles Stetson wrote that he and Bannister still maintained their close relationship and that he still valued the older artist's criticism: "Mr. Bannister came—a rarity. Pleasant chat. I showed Bannister the things I've been doing lately. He does not seem in sympathy with my more fanciful & ideal work—that is with my compositions generally. But he expressed himself very strongly and favorably regarding my portraits. He said, 'You struck the right thing this time!'"[159]

Bannister also delivered in 1886 a painting many art historians now consider a masterpiece—*Approaching Storm* [fig. 2.8]. Unlike most of his landscapes, with human figures coexisting peacefully with nature, this work shows man at odds with it. Bannister displays a lone figure struggling forward as the wind from an oncoming storm impedes his progress. At its most basic interpretation, the work is about conflict, which makes it ripe for some to view as a metaphor for the stagnation of Black progress during the post-Reconstruction era or his efforts to resist declining sales due to changes in artistic tastes. And while these interpretations may be valid, they cannot be

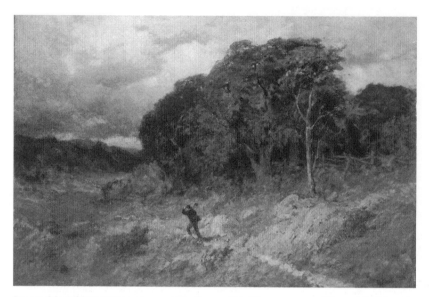

Fig. 2.8. Edward M. Bannister, *Approaching Storm*, 1886, Oil on canvas, 40 ⅛" × 60", Smithsonian American Art Museum, Gift of G. William Miller.

confirmed. What is left is what Bannister said about his art in the same year when he delivered his lecture to the A. E. Club and the inherent optics of the painting. *Approaching Storm* represents Bannister at the height of his creative powers and all he synthesized over the years as a landscape painter. His depiction of the environment—the windblown trees, the darkening sky in the background, the fleeting sunlight in the foreground, and the richly textured groundcover—saturates nature with a sense of dramatic energy and urgency. More importantly, Bannister locates the man, shown mid-stride walking along a well-worn path with an axe slung over his shoulder, in the center of the composition to focus attention on how he reacts to the deteriorating weather conditions, and making his presence as important to the painting as the imposing landscape that surrounds him. Ironically, the man-made object he carries—the axe—offers no protection against the elements in this instance, although it may symbolically represent the human potential for destroying the pristine environs that Bannister honors in his work. Thus, Bannister creates within the composition a dichotomy between the envisioned spiritual and physical relationships that give his work its vitality. In this case nature has the potential to be overpowering, but humanity has the potential to endure.

When he was not formally engaged in teaching or working on commissions, Bannister often spent time traveling in the state for dual purposes—a pattern that seems to be his preferred method of producing art. As the *New York Freeman* explained in 1887, "The Summer is the time to prepare work for Winter, so Mr. E. M. Bannister has gone to Newport on a sketching tour combined with pleasure."[160]

Bannister showed a collection of his paintings in 1887 in Providence in the "art parlors of a firm on Westminster Street."[161] A newspaper critique proclaimed, "He always sees the picturesque side of nature and the strong atmospheric qualities. Sympathetic and conscientious rendering of nature has given him a distinguished position among New England artists."[162] In 1891 he had a major showing of his works at Providence Art Club, along with those by Whitaker, J. Baxter, and Stetson. Thirty-three of his paintings composed the largest grouping of his career and provided viewers with the opportunity to experience decades spanning his development. That same year Bannister seems to have relaxed his position on showing outside of New England—but not in the South—and expanded his reputation nationally when he showed *September on the Palm River, Massachusetts* in the First Annual Exhibition of American Art, held at the Detroit Museum of Art. He was the only African American artist the museum included.[163]

In 1890 Bannister still appeared to maintain an active lifestyle when the *New York Age* reported, "Sculptor W. C. Noble has gone to Providence and will accompany Artist E. A. [*sic*] Bannister on board his yacht."[164] However, his artistic output started to diminish, and his exhibition participation dwindled. Toward the end of his distinguished career, he abandoned his beloved strolls out in the country to select scenes to paint, because "of his sudden and frequent attacks of illness."[165] John Arnold described his deteriorating condition, including the onset of dementia, saying, "With a mind clouded and bewildered, a hand that had lost its cunning, [he was] mentally and physically a wreck."[166]

It was perhaps fitting that this fervent Christian died on January 9, 1901, while offering a prayer at his church during a Wednesday evening service. Earlier that day, he had complained of shortness of breath, but because of his devout nature, he insisted on worshiping with his congregation. Bannister's last words were, "Jesus help me."[167] Heart failure was the listed cause of death. He was seventy-three years old.

The outpouring of sympathy and respect for the fallen artist was remarkable. His lengthy local obituary, which contained a large photograph,

recounted his rise to prominence and praised his accomplishments. Although the headline referred to him as a "Well-Known Colored Artist," there was no intention to suggest inferiority. Through an inspiring work ethic, laudable talent, and an affable personality, Bannister had earned adoration and respect from his white peers that, on occasion, seemed to transcend race.

Another fitting obituary circulated in the Black press and extoled Bannister's virtues as a "Great Colored Artist" to pronounce him a hero of "the race."[168] In fact, the obituary exudes pride of race and denotes his level of high artistic achievement as a significant qualifier of racial equality. The article said that Bannister:

> was an artist of rare ability, having had the distinction of being the best land-scape painter the state of Rhode Island has ever had. This is only another instance which demonstrates that we have as a race within our ranks men who can and do successfully compete with all other nations in every depart-ment which makes up life. . . . Lovers of art or anyone desirous of the won-derful imagination of a practical student of nature's beauties will certainly be well paid with a visit of productions of our lamented artist, Edward M. Bannister, whose name must be placed in history [as] one of the celebrities of our race.[169]

Bannister's funeral drew "more than a score of the prominent artists of the city and several from Boston, who, by their presence, testified to the esteem in which they held the deceased. There were other mourners who came to pay their respects, not because they knew the deceased, but because they knew of his works and merits and their value to the community."[170]

The Providence artists moved quickly to make sure Bannister's memory remained ingrained in the art-spirit of the community. His friends at the Providence Art Club, led by George Whitaker and John Arnold, organized a major retrospective exhibition of his work. This event began on May 14, 1901, and included 101 of Bannister's paintings. His widow loaned only two paintings for the showing. The rest, ninety-nine cherished paintings, came from his patrons and admirers. Also displayed among Bannister's art were his awards that included "three from the Massachusetts Charitable Mechanics Association, in 1878, 1881, and 1884, the certificate from the Centennial Commission, with the bronze medal, September 27, 1876, and a diploma from the Rhode Island Industrial Exhibition, September 1872."[171]

A catalog from this exhibition contained the following tribute to Bannister:

He early came to this city, and for thirty years was prominent in the Providence group of artists. His gentle disposition, his urbanity of manner, and his generous appreciation of the work of others, made him a welcome guest in all artistic circles. . . . He was par excellence a landscape painter, and the best one our State has produced. He painted with profound feeling, not for pecuniary results, but to leave upon the canvas his impression of natural scenery, and to express his delight in the wondrous beauty of land and sea and sky. Had his nature been more self-reliant and adventurous, and had early opportunity been more kind, he might easily have been one of America's greatest landscape painters; it was his lot, however, to pursue his humble path among us, and to gently lead us into that greater love of art which only the fine man and fine artist can inspire.[172]

Later that year a meeting held at the studio of Sydney R. Burleigh commenced to fund a monument erected to Bannister's memory.[173] In November of 1901, his friends and admirers placed over his grave a ten-foot-high block of Rhode Island granite bearing the inscription "E. M. Bannister 1828–1901, Erected by Artists and Friends." The marker also bears a bronze plaque inscribed with a poem that reads in part, "This pure and lofty soul . . . who, while he portrayed nature, walked with God." A photograph taken during that ceremony best summarized how Bannister overcame many of the obstacles of race [fig. 2.9]. It showed a group of eleven men, all white, standing next to the massive grave monument they erected lovingly and respectfully to the memory of a Black man. George Forbes was acutely aware of the significance of the moment when he observed, "There is probably not another instance where color was lost so completely in merit and achievement as in this of Bannister, and unstinted homage so freely paid to genius."[174]

John Arnold sought to put the work of his friend Bannister into historical context. He said, "It is too early to determine his position as an artist, but my opinion is that his work will be thought more of in 50 or 100 years than now. Our work is to do him honor, and in so doing we shall do ourselves honor."[175]

George Whitaker also attempted to ensure the preservation of Bannister's memory by framing his work as the product of a gifted intellectual, perhaps to deflect the uniqueness of his race as the defining qualifier of his successful career. Whitaker wrote, "He conversed with more than ordinary intelligence

Fig. 2.9. Bannister grave marker dedication, November 1901, Department of Rare Books and Manuscripts, Boston Public Library.

on the principal topics of his day, and all deemed it a privilege to be in his company. His opinions were of a decided nature."[176]

Christiana Bannister had a difficult time reconciling Edward's death, and it caused her to suffer a complete breakdown. In September 1902 she entered the rest facility she helped establish. She remained there briefly before the caregivers decreed that she was "violently insane" and placed her in the state asylum in Cranston, where she died on December 29, 1902. She was buried beside her husband in the North Burial Ground, Providence. Estate records indicated that at the time of her death, she was impoverished. According to Juanita Marie Holland, Madame Bannister's assets included only "a few paintings and belongings valued at approximately one hundred dollars."[177] Given the short time between her passing and that of her husband, it is likely that Edward, after selling hundreds of paintings, had been in a likewise dire financial situation. This may explain why Bannister returned to Boston in 1898 and opened a studio.[178] Christiana Bannister was inducted into the Rhode Island Heritage Hall of Fame in 2003, and her bust now resides in the Rhode Island State House.[179]

American art history has yet to clearly define Bannister's importance, long after his death. His legacy, however, reaches far beyond that of a nineteenth-century art maker. Bannister showed that an African American living in that period could take control of his destiny and successfully forge a path where few of his race had ventured.

Although Bannister did not leave behind a detailed account of his journey to greatness, it is obvious that racism was a major obstacle he had to overcome. He perhaps spoke for all the African American artists of his century when he said, "I have been sustained by an in-born love for art and accomplished all I have undertaken through the severest struggles which, while severe enough for white men, have been enhanced tenfold in my case."[180] The E. M. Bannister Gallery at Rhode Island College now stands as a testament to his memory and achievements.

CHAPTER THREE

Mary Edmonia Lewis (ca. 1844–1907)

Fig. 3.1. Mary Edmonia Lewis, Augustus Marshall, photographer, Carte-de-visite, ca. 1864, Albumen silver print on card, 3 ¾" × 2 ¼."

As has been seen, Edward Mitchell Bannister realized his greatest artistic triumph at the Philadelphia Centennial International Exposition of 1876. However, he was not the only artist of African descent represented at that prestigious event. A startling marble sculpture, entitled *The Death of Cleopatra* (1876), was also on display and drew considerable attention from art critics and the public. The fact that its creator, Mary Edmonia Lewis [fig. 3.1], enjoyed so lofty a position among the art makers of the nineteenth century was remarkable given the prejudices experienced by members of

her race and gender at that time. Indeed, her path to the Centennial was the most improbable of all the exhibiting artists', and her rise to prominence as an internationally celebrated sculptor stands as one of the most unique and intriguing stories in the annals of American art.

The Early Years

Information on the early years of Mary Edmonia Lewis remains scarce. Her biography, as she espoused to the press once she attained considerable attention in America and success in Europe, centered on her claim that she was biracial—African American and Native American. Yet she provided few verifiable details about her origins—just enough to stamp her as having ascended through the artist ranks from the humblest of circumstances as experienced by two oppressed groups. Even the date and place of her birth remain in doubt.[1] However, recent research has shed more light upon her beginnings. According to Lewis scholar Kirsten Pai Buick, Edmonia, her preferred designation, embellished the background of her mother. While Lewis insisted that her mother was "a full-bloodied Indian," Buick claimed that she was of "mixed African American and Ojibwa parentage."[2] Buick noted that Lewis's mother was Canadian born and that she was the daughter of an escaped slave named John Mike and an Ojibwa woman named Catherine.[3] Buick explained:

> Catherine lived with her parents on the Credit River Reserve, now known as the city of Mississauga, on Lake Ontario. The Indians living on the reservation were entitled to annual government payments. However, because membership derived from the father and Mike was black, the council elders voted to exclude him and the children from a share in the government grants. Although the council had no authority to enforce its ban, it did bring pressure on the family to leave."[4]

According to that account, the Mike family moved to Albany, New York, and there one of their daughters, whose name is unknown, married a Black man of West Indian origin named Lewis. She was likely Edmonia Lewis's mother. Lewis, whose account of her background often diverges from facts known presently, described her mother as being from the Chippewa (Ojibwa) tribe, a "wild Indian . . . born in Albany, of copper colour, and with straight

black hair."[5] She described her father as a "negro" and "gentleman's servant."[6] Lewis reported that her mother grew restless in the marriage and sought life among more familiar surroundings. "My mother," she said, "often left home, and wandered with her people, whose habits she could not forget, and thus, we her children, were brought up in the same wild manner."[7] In fact, Buick concludes that the Lewis family left Albany, moved to Newark, New Jersey, and remained there until 1844, before settling in Greenbush, New York.[8]

The first child of the Lewises was Samuel W. Lewis, born on May 19, 1832, in the West Indies—likely in Haiti.[9] One source on the life of Samuel stated, "When as a child his parents moved to the United States and located at Newark, New Jersey."[10] If this is the case, could this possibly indicate that both her parents were born outside America? More likely, Edmonia Lewis's mother was her father's second wife. Samuel's obituary cites that his mother died in 1844. Edmonia listed July 4, 1844, on a passport application as her date of birth, but she had vivid recollections of her mother.[11] Furthermore, while no photograph of Samuel exists presently, a description of him contained in his obituary states, "Although he was generally known as 'the colored barber' Sam Lewis was very much of a white man. He was white in his entire make up—physically, socially, intellectually, morally—and the best citizens of Bozeman were his firm friends and constant patrons."[12] If Samuel Lewis had no physical resemblance to his sister, whom a report in 1870 insisted was "without a drop of white blood in her veins," then there is a strong possibility that his father's second wife, to whom Edmonia was born, was the daughter of John and Catharine Mike, thus making Samuel Edmonia's half-brother.[13] This accounting adds more credibility to her own publicly stated recollections.

Despite the perplexing contradictions in Edmonia Lewis's early biography, noted abolitionist Henry Highland Garnet verified the overarching nature of her biracial heritage in a speech given in 1878 and even claimed that he knew her as a child. He said:

> Her mother was a Chippewa Indian, and her father an African. She has gone forth to rescue both races from the inferior position in which they have been placed by her skill in her chosen field of art. She was born in Greenbush, near Albany. I have seen much larger women than she is now, but she was a little girl when she first came to see me, and, looking up into my face, said, "I am going to become an artist."[14]

Lewis scholars have long suspected that she exaggerated parts of her life story to cater to an audience that best viewed her as exotic and unique. That strategy, as will be seen, worked to her advantage, but until researchers uncover more details about Lewis's origins, her own version of events as she reported to the press remains the best source of understanding her struggle to advance in the fine arts.

From the moment she was born, Lewis had three strikes against her that individually could have nullified any chance she had of making significant contributions to high art. First, she was partly Black and therefore assigned by the mainstream to a position of inferiority and degradation. Second, she was partly indigenous and therefore a member of an oppressed and conquered people whom the dominant culture also deemed as inferior. Last, she was a female and living in a time when even white women had little or no civil rights or opportunities for social, political, and cultural advancement. Given the societal norms of the period and the enormous obstacles placed upon her because of her race, gender, and social status, Lewis, from the beginning, stood practically no chance of success.

After the deaths of her parents, Lewis's maternal aunts assumed the duties of raising her.[15] Based on her account, she grew up as an Ojibwa and experienced their hunter-gatherer lifestyle that provided her with a happy childhood, wandering throughout the countryside, fishing, swimming, and making moccasins and beaded baskets that sold in the towns in the region. Lewis stated, "My Indian aunts took care of me; the tribe moved away to Canada, but they sometimes came down as far as New York City to buy beads and such things."[16] Lewis claimed that her Native American name was Wildfire, a moniker that seems appropriate considering her indomitable spirit.

After his father's death, Samuel Lewis took an active part in Edmonia's well-being, providing "a home for his sister with a Capt. S. R. Mills, paying her board and also her tuition while in attendance at day school."[17] Here again this information diverges from Edmonia's story and neglects to mention anything about her Indian upbringing.

Samuel Lewis left his sister and traveled until 1852, when he settled in San Francisco and opened a barbershop. He then moved to Sierra County, California, where he started another barbershop and found success mining gold. Sending money back home, he continued to fund his sister's formal education, and in 1856 she entered New York Central College, an abolitionist school located in McGrawville, New York. Lewis later claimed that she

ran into a bit of trouble when she apparently lived up to the name Wildfire. Lewis said, "I was sent to school for three years in M'Graw but was declared to be wild—they could do nothing with me. Often they said to me, 'Here is your book, the book of nature; come and study it.'"[18] Lewis also said of her education, "I was delighted to learn—very eager. I had never learned anything. The 'black robes' taught us a few prayers—that was all."[19] Once more Lewis seems to be reducing herself to near savagery in an obvious effort to give reporters what they expected from her "Native upbringing" and their want of a sensational story that made her climb to Rome even more unlikely. Actually, while she attended Central College, she obtained a quality education and earned good marks in conduct. Based on school records from 1856 to 1858, Lewis excelled in arithmetic, composition, and even Latin and French. She also received a grade of 100 in a drawing class.[20]

Lewis also stated, "I felt the strangest sensation putting on dresses. I had never worn anything but blankets. (Laughing) You see I had good opportunities for studying the nude."[21] This comment furthers the contradictions that Lewis continued to make in crafting her biography before the public throughout her career where fiction overlaps fact. Of course she wore more than blankets. In fact, the Ojibwa in their native environment wore clothing they received in trade from whites or made clothes from animal hides. Women of the tribe often wore deerskin dresses, leggings, moccasins, and undergarments woven from natural fibers. Again, Lewis delivered to the public an early biography that shrewdly achieved maximum impact in making her uniquely intriguing. In this case it seems she had the last laugh in convincing the reporter of her sincerity.

Oberlin College

With further assistance from her brother, Lewis enrolled at Oberlin College in 1859. The school, located in northern Ohio, from the outset allowed men and women to gain an education together, sharing academic and spiritual growth on equal terms. When discussions of slavery and abolition became pressing issues in Ohio during the mid-1830s, the officials of Oberlin College stepped to the forefront of this heated debate and in 1835 admitted students "irrespective of color." In doing so Oberlin distinguished itself as the first college in the United States to give African Americans equal educational opportunities.

School officials placed Mary Lewis, as she was known at that time, in the college's Preparatory Department, where she completed her high school courses. She pursued Oberlin's liberal arts curriculum along with some thirty other students of African descent.[22] It is possible that during this time she developed a deeper love for art. Students of the Ladies Department could choose a course in Linear Drawing. It may have been in this class that Lewis produced her only extant student drawing. The work, given the title *The Muse, Urania* (1862), revealed a remarkable level of proficiency. She copied the drawing from an engraving of a classical sculpture and presented it as a wedding gift to one of her classmates, her closest friend, Clara Steele Norton.[23] Lewis later attributed her creative gifts to her mother, who she claimed was well known for inventing new patterns for embroidery. Lewis said, "Perhaps the same thing is coming out of me in a more civilized form."[24]

Mary Lewis was by all accounts an average student who made friends easily among the white coeds. Samuel Lewis provided his sister with a measure of comfort that approached the level of Oberlin's more affluent students, "even anticipating every want of hers, after the style and manner of a person of ample income."[25] Thus, Lewis secured a room in a respectable boarding house that a dozen other young women occupied—all white. The Reverend John Keep, a member of the college's board of trustees, and the man who in 1835 cast the deciding vote to admit African Americans to the school, owned the house.

Lewis became an acquaintance of two fellow Keep House boarders, Maria Miles of Vermillion, Ohio, and Christina Ennes, of Birmingham, Ohio. On January 27, 1862, the white women decided to accompany two men on a sleigh ride to Ennes's hometown, located nine miles from Oberlin. Before leaving they informed Lewis of their plans, and she reportedly invited them to her room for a hot drink to protect them from the cold of winter. Lewis supposedly prepared a mixture of wine, allspice, and sugar and poured it into three glasses. She took a sip of the drink and declared it unpalatable. Her white friends consumed the contents of their glasses and soon left to greet their callers. At this point all parties were guilty of violating Oberlin's strict policies on the consumption of alcohol and having unchaperoned dates.

Well into their journey to Birmingham, Miles and Ennes experienced almost simultaneous severe stomach pain. After arriving at the small town, locals placed the women in bed and summoned the doctor. Christina Ennes immediately proclaimed that Mary Lewis poisoned her.[26] An examination by

two doctors allegedly confirmed this diagnosis, and they declared the women to be in a life-threatening condition. News of this unfortunate incident traveled quickly back to Oberlin.

Oberlin law officials did not immediately take Lewis into custody or charge her with a crime. This lack of legal action is remarkable for the time, considering that it appeared that a Black woman had deliberately sought to harm whites. While the citizens of Oberlin were understandably shocked and outraged by this turn of events, there seems to have been little immediate public outcry for justice. According to historian Geoffrey Blodgett, Oberlin's mayor, Samuel Hendry, "looked into the case, but apparently took no decisive action."[27] Nor was any type of action taken by the college. The officials of Oberlin, the college and the town, chose to treat this case in a most delicate manner, wishing not to tarnish its reputation for racial tolerance or incite the wrath of those who would frown upon a negative outcome without overwhelming evidence of Lewis's guilt. The spirit of Oberlin still lived despite this impending crisis.

The services of African American lawyer John Mercer Langston (1829–1897) were secured for Lewis's defense. Langston, the mulatto son of a Virginia plantation owner and one of his slaves, was a graduate of Oberlin College, receiving his BA and MA degrees in 1849 and 1852.[28] Despite his education, he found it impossible to gain admission into a school of law. Undeterred, Langston learned the legal profession from abolitionist attorney Philemon Bliss of Elyria, Ohio. Although the Ohio bar did not allow Blacks membership, Langston gained admittance in 1854 through an interesting peculiarity in state law that decreed a "nearer white than black" mulatto was entitled to the rights of a white man.[29]

The public began to grow restless as the weeks following the alleged poisoning passed. No charges came against Lewis, even though her alleged victims were still reported near death. Convinced that this was not an airtight case, Langston used this time to make a trip to Birmingham to gather additional evidence.

While Oberlin was an apparent mecca of racial harmony, it was not without prejudice. A few citizens who viewed the town's law enforcement officials as neglecting their duties concerning the Lewis matter decided to take the law into their own hands. On a cold night in the dead of winter, Lewis encountered vigilante justice. According to Langston, "One evening, just after dark, as she was passing out of the back door of the house in which

she still roomed, she was seized by unknown persons, carried out into the field lying in the rear, and after being severely beaten, with her clothes and jewelry torn from her person and scattered here and there, she was left in a dark, obscure place to die."[30]

When locals discovered that Lewis was missing, the town's warning bell sounded and people flooded the streets. A search party quickly organized and found her brutally beaten. Her "injuries were very serious, so crippling her that she was confined to her room for several days and then was not able to move about except as she did so on crutches."[31] Law officials never identified her attackers.

This ruthless incident seemed to spark immediate action in the case, and officers arrested Lewis within a few days of her beating. The impending trial caused a sensation throughout the region, with several Ohio newspapers carrying pertinent events as they unfolded. Oberlin's paper, the *Lorain County News*, remained oddly silent on the matter. Henry E. Peck, the paper's editor, finally broke the silence on February 19, 1862, when he wrote, "We have hitherto refrained from speaking of the matter because we have supposed that the ends of justice would best be promoted by our silence. We speak of it now to make occasion for correcting the impression, which we hear is entertained by many friends of the young ladies who are said to have been poisoned, that the people of Oberlin are not willing to have the case brought to a trial."[32] Peck assured his readers this was not the case, but that Lewis (whom he never mentioned by name) was subjected to extreme prejudice because of her color.

As the date of the trial approached, Langston believed the town was equally divided on the issue. Surprisingly, many of Oberlin's Black population were convinced of Lewis's guilt and tried to convince her lawyer not to take her case. Langston, however, was determined he could win. On February 26 the trial of Mary Edmonia Lewis began.

The first step in deciding Lewis's fate involved a preliminary hearing to determine whether she should receive an indictment. Two men, a Mr. Chapman of Birmingham and Charles W. Johnson, a prominent Elyria attorney who was also well versed in medicine, opposed Langston.[33] The hearing lasted two days and included testimony from Maria Miles, Christina Ennes, the men who accompanied them on the sleigh ride, and the two doctors who initially examined the women. The physicians stated that they found evidence of internal poison that they believed had come from cantharides, or Spanish

fly. Many have long regarded this notorious substance, made from a species of European beetle, to be a powerful aphrodisiac that may have had toxic side effects. The motivation, according to the prosecution, was revenge for rough teasing the white women had subjected Lewis to before the incident. They concluded that Lewis had acted either to encourage sexual activity between the women and their dates or to murder them.

Friends carried Lewis, still suffering from her injuries, to the courtroom, where Langston decided that she should not testify in her defense. Rather, he built his case around the fact that there was insufficient evidence to link his client with a crime. His trip to Birmingham, Ohio, had yielded the crucial fact that no medical examination had been made or specimen taken from the women's stomachs or bowels. Langston moved to have the case dismissed without calling a single witness, claiming that corpus delicti had not been proven. In the end, thanks to her lawyer's brilliant strategy and eloquent summation, Lewis won exoneration.

Many of the citizens of Oberlin were relieved that justice prevailed. The town's image was preserved, and African Americans of the region learned that there was a measure of fairness for them in the courts. The truth in this sensational case remains inconclusive. Whether Lewis drugged the wine remains shrouded in mystery. It appears that all the major participants and observers, except the young white women (who dropped out of the college) and Lewis (who bore the scars of this traumatic experience for the rest of her life), moved quickly to put the tragic incident behind them.

Lewis had a difficult time adjusting to college life after the scandal. Although she was "fully vindicated in her character and name," her class-mates viewed her in a skeptical and suspicious manner. Whenever her name came up in some conversations, some students would remark, "Look out for Spanish Flies."[34] Obviously, some Oberlin coeds never accepted Lewis's inno-cence and likely subjected her to repeated episodes of hazing and racial slurs. It is not surprising to find that whites, in letters written home, referred to Blacks as darkies or "Niggars."[35] This type of attitude and general resentment may have resulted in Lewis being excluded from a newly formed student skating club that she wished to join. According to one observer, she reacted with such a "tantrum" over her rejection that a request was made of an official to "invite the wench, but I'm blamed if I would have done it in his place."[36]

Lewis's troubles did not end with that incident. Someone later accused her of stealing brushes and paints from a professor's office and of taking a picture

frame from a local store.[37] To answer these charges, Lewis stood before one of the same justices of the peace that had heard her poisoning case. Once again, they acquitted her because of insufficient evidence, but her once exemplary character received further tarnishing. Whether she had taken the items or had been a victim of vindictive students was no longer an issue. Rather, Lewis was becoming an embarrassment to the college. Marianne Parker Dascomb, the principal of Oberlin's Female Department, saw fit to carry out disciplinary actions against her. Consequently, she prevented Lewis from graduating. One student felt this gesture would "humble her some."[38]

In May of 1863, Lewis was again in trouble with the law. A grand jury indicted a man named Burdett for burglary and charged Lewis with "aiding and abetting" in the crime. According to the *Lorain County News*, rather than face another trial, she left town.[39] At this point, many people, including some of her staunchest supporters, no doubt, were happy to see her go.

The debacles Lewis faced at Oberlin and the press coverage she received attracted outside attention. In one instance Lewis entertained visitors at the school who were concerned about her future and offered her some life-altering advice.[40] A reporter for the *New National Era and Citizen* wrote, "In the Spring of 1863 we remember conversing most earnestly and encouragingly with the above mentioned young lady [Lewis], then a student at Oberlin, with regard to art. She had exhibited some signs of talent in drawing and painting; had evinced such enthusiasm for the art which adorns and ennobles that, from a kindred artistic love, we were led to advise her to seek the East, and by study prepare herself for work and further study abroad."[41] If this recollection is correct, Lewis left Ohio with a plan to maximize her potential, and Boston was her destination.

Launching a Career among Boston's Abolitionists

When Lewis found her way to Boston, she had little money and no place to stay.[42] Fortunately, the city's abolitionist community came to her rescue, and one of the antislavery giants, William Lloyd Garrison, directly provided her with assistance. When Lewis met with Garrison, she informed him of her interest in learning sculpture. He then directed her to local artist Edward Brackett (1818–1908), an African American sympathizer who had executed neoclassical portrait busts of the martyred John Brown and abolitionist

senator Charles Sumner. Lewis later said of her willingness to work with Brackett, "I thought the man who made a bust of John Brown must be a friend to my people."[43]

There exists a widely published account of Lewis's first encounter with monumental public sculpture soon after her arrival in Boston. According to the story, she became captivated with a statue of Benjamin Franklin. She did not know what to call the "stone image" but was inspired to exercise her artistic abilities in a like manner. "I, too, can make a stone man," she was reported to have said."[44] Soon after, she sought out Garrison, who explained to her the "nature of sculpture."[45]

It is not known if this anecdote was invented by the reporter or given by Lewis. Had this story come from her, however, it did no justice to her or her people and merely served to reinforce old stereotypes. While the magnificence of Boston's public sculptures impressed her, they were viewed through the eyes of a young woman who had come close to becoming one of the country's first Black college graduates and one who almost flawlessly rendered a drawing of a classical sculpture. She may not have been worldly sophisticated when she arrived in Boston, but she knew what to call a statue.

By the time Lewis came under the influence of Brackett, she was using her middle name, Edmonia, perhaps to distance herself from the Oberlin scandals. Brackett gave her a piece of clay and a model of a foot and instructed her, "Go home and make that. If there is anything in you it will come out."[46] Her new mentor rejected her first effort, but she continued to work diligently to learn the art of sculpting. She apparently made rapid progress under Brackett's guidance and soon moved to attempting a copy of a bust of Voltaire.[47]

Lewis did not remain with Brackett for long—perhaps he was not moving her along at her anticipated pace—-and soon left to open her own studio. Her first attempt at rendering a portrait bust was that of Dr. Nathaniel Bowditch, the Boston physician and prominent Christian abolitionist.[48] She also began modeling portrait medallions of contemporary abolitionist leaders such as William Garrison and Wendell Phillips. On January 29, 1864, Lewis placed an advertisement in *The Liberator* for her newly finished medallion of John Brown: "The subscriber invites the attention of her friends and the public to a number of Medallions of John Brown, just completed by her, and which may be seen at room No. 89, Studio Building, Tremont Street."[49]

While those aware of her early accomplishments generally praised and encouraged her, Lewis believed the public should not single her out for merit

simply because she was "a colored girl."⁵⁰ Evidently, even at this early stage in her career, she wished to be judged on the same level as whites. However, Lydia Maria Child (1802–1880), a woman whom Lewis regarded as one of her greatest supporters, dampened her initial enthusiasm as an artist quickly gaining recognition for possessing commercially viable abilities.

Child was unquestionably one of the most active and influential abolitionists of her era. At one time she served as editor of the *Anti-slavery Standard*, the official organ of the American Anti-Slavery Society. She also campaigned actively for the civil rights of Blacks and women, and took great interest in the efforts of women who sought advancement in the fine arts. Child first encountered Lewis at a reception hosted by antislavery proponents in Boston in 1864, and she was initially impressed with what she saw and heard from the young artist. Child said:

> One of the most interesting individuals I met at the reception was Edmonia Lewis, a colored girl about twenty years of age, who is devoting herself to sculpture. Her frank, intelligent countenance and modest manners prepossessed me in her favor. I told her I judged by her complexion that there might be some of what was called white blood in her veins. She replied, 'No; I have not a single drop of what is called white blood in my veins. My father was a full-blooded negro, and my mother was a full-blooded Chippewa.'⁵¹

Lewis then proceeded to give Child the details of life among the Ojibwa, a story that she would continue to tell for the remainder of her career with varying degrees of truthfulness. In this scenario Lewis emphasized just how far she had come from the wilderness to Boston. When Child asked if she liked life among the Indians, Lewis stated, "Oh, yes I liked it a great deal better than I do your civilized life. . . . I would not stay a week pent up in cities, if it were not for my passion for Art."⁵² Even before she sold her first work of art professionally, Lewis was laying the foundation for presenting herself to the public in a manner in which she appeared to have ascended from an almost savage existence to the rarified realms of high art. It proved to be an effective strategy that gained her pity, sympathy, and support from those who counted her thrice cursed by the dominant culture.

Child was attracted to Lewis for several reasons. Her unique racial admixture made Lewis a natural curiosity. Child was well familiar with and intrigued by black/white mulatto types, having written a short story, "The

Quadroons" (1842), and served as editor for biracial Harriet Jacobs's slave narrative, *Incidents in the Life of a Slave Girl* (1861). But Lewis was a different kind of mulatto, and Child, also a supporter of Native American rights, saw Lewis's arrival in Boston as a convenient way to glean deeper, personal insights into subjects she found especially fascinating.[53]

Once Child learned of Lewis's desire to pursue art as a career, she was more captivated with her and the possibilities of how far this unlikely tale of aspirations in high art by one so racially "cursed" would play out. However, despite Child's public persona as a champion for the rights of Blacks and Indians, she saw Lewis, in private, as a "project"—a short-term social experiment—that came with low expectations that would yield unsatisfactory returns.

Nevertheless, Lewis was willing to accept Child as a mentor—she had few options at this time—and needed her desperately to steer her through Boston's abolitionist community as a means of launching her career. Each woman had something to gain from their early relationship, but Lewis would soon learn that Child was willing to draw racial lines that prohibited her growth as an artist once her success seemed imminent. As so many people of African and Native descent learned in the nineteenth century and beyond, attempting to leave one's designated place of subordination in the dominant culture often came with strong rebukes or worse.

Thus, Child eventually revealed a condescending, racist attitude toward Lewis in her correspondence with her friends and associates, wherein she cast Lewis as a perpetually childlike figure possessed with inferior qualities that limited her ability to function credibly without "proper" guidance. In a letter written to Sarah Shaw of Boston, Child related that she believed Lewis had no spark of creativity. She wrote:

> With regard to Edmonia Lewis, I partly agree with you, and partly I do not. I do not think she has any genius, but I think she has a good deal of imitative talent, which combined with her indomitable perseverance, I hope might make her something above mediocrity, if she took time enough. But she does not take time. . . . I think it is a pity that she has undertaken to be a sculptor; and when she first told me of her design, I tried hard to dissuade her from it.[54]

Child continued, "I agree with you that, looked at in the light of *Art*, nothing she has produced is worth a second glance; but I am more disposed than you seem to be to give her time for a fair trial. If she will only take the time!"[55]

Here, more "time" equates to more professional training, and this was a luxury Lewis did not have in Boston.

This was a major impediment that Edward Bannister encountered in his quest to be a painter in the same city, and only through strict adherence to self-improvement was he able to advance. Like Bannister, Lewis was eager to proceed in art creation at an accelerated pace, and she grew more impatient with the career-stagnating barriers that Child placed before her. She was ready to move forward, even if it meant taking on risky projects that challenged her developing skills—like most artists, Lewis was willing to learn from her mistakes in order to improve her technique.

However, in Child's view Lewis showed only minimal promise as a sculptor, when she was copying the works of others. This notion seems notoriously close to the conviction held by the supporters of African American inferiority that Blacks had an innate ability to mimic certain aspects of white behavior while lacking initiative and imagination of their own. This line of reasoning put Child on the side of Hinton Rowan Helper, the previously mentioned white southerner who published a scathing racist treatise, *Nojoque; A Question for a Continent* (1867), that denigrated all Americans sharing the slightest trace of "African ancestry."[56] In support of his argument, Helper turned to the arts as conclusive proof that Blacks, uniformly, failed to measure up to white standards of plastic expression and aesthetic comprehension and execution. As to the potential for people of African descent to handle the creation of three-dimensional art forms, he asked:

> Can the African hew out of stone, cast of metal, or make of any other solid substance whatever life-like representation of men? Beasts? Birds? Where or when has the Ethiopian executed an admirable statue of any hero? Demigod? Or other renowned personage? Is the Negro a clever modeler in plaster? A cunning carver in wood? An expert chiseler in marble? Has he ever, of granite, of bronze, or of oak, formed famous images of the lion? The horse? The dog? White men only . . . have been known, and none but white men can be known, as highly-gifted and accomplished.[57]

Thus, while Child found Lewis's medallion of John Brown, modeled after the work by Brackett, and her reproduction of the Voltaire bust acceptable, she deemed the medallions of Garrison and Phillips, done from life, "horridly vulgarized."[58] Consequently, Child was totally opposed to the idea of

Lewis pursuing a career in the fine arts. Rather, she saw the potential in Lewis's hands to be only utilitarian—a comfortable and racially safe place in her mind for Black plastic expression—in the form of working "in stucco-molding for architects, which I have been told employed a good many hands in Europe. . . . She might, meanwhile, keep trying her hand at statuary during after hours, and if, in the course of years produced something really good, people would be ready enough to propose to put it in marble for her. I have also thought of wood carving as a means of subsistence for her."[59] Child, like many other so-called proponents of Black advancement beyond slavery, saw "the race" as existing in a state of cultural infancy that could be remedied only by a protracted process of structured guidance by whites like her.

Historian George M. Fredrickson asserted that Child's seemingly contradictory perceptions of Blacks (she once observed that Frederick Douglass was an "atypical colored man") were related more to class and culture than to race and should not be viewed as racially supremacist.[60] From whatever perspective Child approached her relationships with African Americans, her insistence that Lewis abandon her plans to be a sculptor could only have bruised an already fragile ego. However, Child was not trained as an artist or an art critic, and her suggestions to Lewis lacked authoritative credibility. Lewis's intimate reaction to these suggestions is not known, but she valued Child as a confidante. Thus, any criticism directed against Lewis struck a blow to her self-esteem, but she never allowed it to deter her ambition to reach the upper limits of nineteenth-century sculpture.

While Lydia Child found Lewis's sculpting technique wanting, she was impressed with her "indomitable perseverance." This characteristic led Lewis to continue to refine her craft. In 1864 and 1865, Lewis maintained a studio in the same building on Tremont Street that Edward Bannister occupied. Also working in the building was Anne Whitney (1821–1915), another female sculptor with dreams of broadening her horizons abroad.[61]

Despite Child's harsh criticism, Lewis was undaunted. She finally confronted Child, saying, "I don't want you to go to praise me. Some praise me because I am a colored girl. I don't want that kind of praise. I had rather you point out my defects, for that will teach me something."[62] Lewis expressly rejected acceptance and approval as a sculptor from anyone who simply perceived her as a racial curiosity deserving of fleeting attention, rather than carefully measuring her potential as an artist despite her initial flaws in practice. Instead, she was willing to accept constructive criticism if it

would help advance her career. There was, however, a fine line that she had to negotiate in determining who among those in Boston's abolitionist community sincerely wanted to guide her properly. Lewis reached the conclusion that she, alone, would have to move forward according to her own agenda for attaining public acclaim and eventual success abroad. To achieve these goals, she would have to produce a work that would capture the public's imagination and demonstrate to all that she was capable of progressing exponentially.

Hence, Lewis's most ambitious undertaking while living in Boston was a portrait bust of Robert Gould Shaw (1837–1863) [fig. 3.2]. Colonel Shaw, as stated in the previous chapter, became a martyr for African American freedom and the abolitionist cause after he died in South Carolina leading the all-Black Massachusetts 54th Volunteer Infantry Regiment during the Civil War. In 1863 Massachusetts Governor John Andrew chose Shaw, the son of a prominent Boston abolitionist family, to raise and command the first regiment of Black troops organized in a Northern state. The formation of the regiment carried with it the opportunity for Blacks to prove that they had the intelligence and physical skill needed to serve as effective combatants despite contrary widespread mainstream beliefs. Once properly trained, Shaw, in the lead on horseback, paraded his troops through the streets of Boston on May 28, 1863, on their way to the dock to depart for duty in the South. In addition to the dignitaries who observed the proceedings were runaway slave Harriet Jacobs and Edmonia Lewis. Lewis recalled while working on the bust, "I thought, and thought, and thought how handsome he looked when he passed through the streets of Boston with his regiment."[63]

After Shaw's death many of the state's residents approached the preservation of his memory with almost religious fervor. Any artist attempting to capture his likeness in tribute also had to capture a measure of his spirit. The public would not accept a less-than-credible image; consequently, anyone attempting to immortalize Shaw in a work of art so soon after his death faced a precarious challenge. This was particularly true for Lewis, who had been sculpting for little more than a year. When Child found out that Lewis was thinking of creating a bust of Shaw, she tried to stop the project. Child felt that Lewis's lack of training and her "handicap of race" could never do justice to the memory of Robert Shaw.[64]

Lewis proceeded with the undertaking despite Child's objections. She exhibited the finished piece at the National Sailors' Fair in November 1864

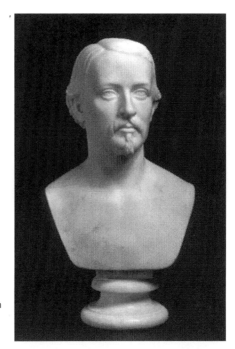

Fig. 3.2. Edmonia Lewis, *Portrait Bust of Robert Gould Shaw*, 1864, Marble, Museum of African American History, Boston & Nantucket.

to much acclaim. Critic Henry T. Tuckerman described the level of success Lewis attained with the sculpture:

> A young woman, of mixed Negro and Indian blood, excited much interest during the Union war, by exhibiting, at the Soldiers' Relief Fair [*sic*] in Boston, a bust of Colonel Shaw . . . ; it seemed like an inspiration of grateful homage, that so authentic a likeness and pleasing a work should have emanated from the unpracticed hands of a dusky maiden.[65]

Quaker poet John Greenleaf Whittier also praised the bust in a letter to Child stating, "I saw the bust of Col. Shaw that thee spoke to me of at the colored fair. It struck me as very excellent. I am not perhaps a judge of such matters, but it seems to me that it is a success."[66] In addition Lewis displayed her medallion of Wendell Philips. The *New Orleans Tribune* reported, "A life-like medallion of Wendell Phillips, with some other sculptures, attest the talents of Miss Edmonia Lewis."[67]

Lewis also exhibited the Shaw bust publicly at the Thirty-First National Anti-Slavery Subscription Anniversary meeting held in Boston on January

25, 1865. The reporter for the *National Anti-slavery Standard* stated, "Among the newest objects present were Johnston's crayon likeness of Mr. Garrison done with fine spirit, and Miss Edmonia Lewis's beautiful bust of the late Col. Shaw, of the Massachusetts 54th regiment."[68]

Lewis's achievement on the Shaw bust was remarkable considering she had only a few photographs of him from which to work. Even the doubting Lydia Child could no longer deny that Lewis did have talent. When she went to Lewis's studio to see the work in progress, she admitted, "But when I went to see the bust in clay, I was very agreeably surprised. She had indeed 'wrought well with her unpracticed hand.' I thought the likeness extremely good, and the refined face had a firm yet sad expression, as of one going consciously, though willingly, to martyrdom, for the rescue of his country and the redemption of the race. As the clay needed moistening, she took water from a vase nearby and reverentially sprinkled the head. The sight of that little brown hand thus tenderly baptizing the 'fair-haired Saxon hero' affected me deeply."[69]

Lewis revealed to Child that she firmly believed that another source guided her hand. "If I were a Spiritualist," she said, "I should believe he (Shaw) did help me make this bust; for while I was moulding it, I had such a strong feeling that he was near."[70]

Once Lewis completed the Shaw bust, Child reversed her earlier praise and found fault in the work. Citing Lewis's skills as lacking to finish the work properly, Child altered the bust to make it look more pleasing. She wrote:

> I bought one of the busts of Robert; and, wishing to make it look more military, I sawed off a large portion of the long awkward-looking chest, and set the head on a pedestal again, in a way that made it look much more erect and alert. When she [Lewis] saw it, she did not seem displeased, but said, "Why didn't you tell me of that before I finished it? How much you improved it!"[71]

Noted American sculptor and pioneering feminist Harriet Hosmer (1830–1908), newly arrived in Boston from her studio in Rome to exhibit her monumental work *Zenobia* (1859), saw the bust of Shaw and pronounced it "finely moulded."[72] Robert Shaw's family deemed Lewis's work an excellent likeness and thus helped legitimize her aspirations of becoming an artist. They had the work photographed by Augustus Marshall and gave Lewis their blessing to sell copies of it for antislavery causes. Even the local press took note of her success and offered its praise and encouragement. The *Commonwealth* reported:

Edmonia Lewis, a young colored woman of mixed African and Indian descent, has modelled a bust of Col. Robert G. Shaw. She had never seen him, and could work only from photographs and from the deep feelings in her own heart, towards the man who had so nobly laid down his life for her race. Considering her youth and experience, and that she had not life to work from, the bust is a remarkable success, both as a likeness and as an ideal work. We will not wrong her by one word of exaggerate praise; the path to success is steep and rugged, and she has but just entered upon it. She has shown that her dark skin is no bar to the possession of the highest artistic powers. She must prove by her fidelity that she can do them full justice. We believe in a great future for art in this country, and that the sensitive and aesthetic Negro race will contribute very largely to its wealth.[73]

Praise also came from Anna Quincey Waterston, a member of a prominent Massachusetts political family, who in 1864 published a poem entitled "Edmonia Lewis (The young colored woman who has successfully modelled the bust of Colonel Shaw)"in the *National Anti-slavery Standard*. In her poem Waterston applauded Lewis, showed great admiration for her bust of Shaw, and commented on the appropriateness of her having the talent and racial background to create such a tribute. Anna Waterston and her husband, Rev. Robert C. Waterston, also played a role in helping Lewis secure the funds for the first pieces of marble from which she carved in Rome. Around 1866 Lewis carved a small marble bust of Anna Waterston as a commission or as an acknowledgment of her kindness.

Lewis had nearly one hundred copies of the Shaw bust cast in plaster and sold them for fifteen dollars each.[74] The positive reaction to the work must have convinced her that she was ready to embark on a new phase of her art training—study abroad. To that end Lewis completed a medallion of President Lincoln and a bust of abolitionist William Wallace Hebbard. *The Liberator* announced the projects calling the Lincoln portrait a "marked success" and saying, "All who are familiar with the peculiar features of Dr. Hebbard pronounce this work a decided success, and it is in consideration, we learn, to have it done in marble."[75]

By this time Lewis appears to have cut all ties with Edward Brackett. She initially referred to him as "very rough," and perhaps friction between the two increased.[76] In a letter to her sister, sculptor Anne Whitney noted, "Edmonia is engaged on a bust of Col. Shaw. Brackett has given her up apparently—&

she wants to salaam me as her teacher![77] Whitney suggested several other local instructors, but it seems Lewis did not study with any of them. Perhaps more revealing in Whitney's letter are her personal feelings about Lewis and why she refused to aid in training her further. In a condescending tone that carried over to their shared experiences later in Rome, Whitney said, "Edmonia is very much of an aboriginal—spiteful, vengeful, a little cunning and not altogether scrupulous about the truth when dealing with those she doesn't love, open, kind, and liberal with those she does—I like her in spite of her faults and will help her all I can—I wish she were a little less of an aborigine about the ordering of her wigwam."[78]

Showing much the attitude displayed by Lydia Maria Child, Whitney seemed willing to "assist" Lewis in overcoming her "perceived ignorance" and stereotyped racial inheritance for the sake of upholding the veiled layers of maternal abolitionist duties, while refusing to give Lewis the respect she deserved as a fellow female sculptor trying to gain a foothold in a profession dominated by white males. Whitney condescendingly assigned to Lewis negative personal characteristics based on distorted racial beliefs and used the term "the ordering of her wigwam" to suggest that she wished for Lewis to remain in a subordinate place to her socially and professionally. Referring to her as "aboriginal" further reduced Lewis, in Whitney's eyes, to bordering on the savage.

Although Lewis's thoughts now turned to Europe to advance her career, the journey was extremely expensive. Not only did she have to pay for her transport, but she also had to factor in the costs of room and board, studio rental, and art materials. Perhaps to supplement her income from the sale of her medallions and sculptures, Lewis and her friend Adeline T. Howard responded to a call for teachers to go south and assist former slaves in their transition to freedom.[79] An article originally published in the *New York Tribune* confirmed, "Miss Edmonia Lewis, the colored sculptor, who so beautifully executed the bust of Col. Shaw . . . has been in Richmond the past month teaching school." [80] The *Tribune* article also mentioned that Lewis had become the victim of a theft, stating that "her trunk containing a large and elegant wardrobe has been stolen . . . the loss has been a heavy one."[81] Yet even in the continued praise Lewis received for her remarkable tribute to Shaw, some would find a way to degrade her on racial terms. The *New Hampshire Statesman* noted, "Edmonia Lewis, a 'female nigger' at Richmond, has just made a marble bust of the heroic and ill-fated Col. Shaw."[82]

Justice of the Peace (and public notary for Suffolk County) Jonathan Amory signed Lewis's passport application on August 21, 1865. Of particular note, he listed her height as "4 feet."[83]

With her proceeds from the Shaw bust, her medallions, her small salary from teaching, aid from abolitionist supporters, and the assistance of Mr. M. Perry Kennard of Boston (who handled her finances, arranged for her passage, and provided her with traveling instructions), Lewis departed on August 26, 1865, bound for life among the world of neoclassical sculpture production.[84] Her chances of success were buoyed by the fact that she carried the promise of several commissions—a request from Robert Gould Shaw's sister to have his bust transferred into marble; one to render a portrait of Diocletian Lewis, a practitioner of homeopathic healing; and one from "some gentleman from Boston" to create a memorial to the emancipation of the slaves.[85] A report in a Boston newspaper also claimed that Lewis was "soon to leave for Italy to complete her education, at the same time chisel-ing busts of Abraham Lincoln, Horace Mann and others, for which see now holds orders."[86]

Lewis's destination was Rome. Art historian Melissa Dabakis described the importance of that decision, saying, "Until 1876, Rome served as a central destination for American artists, journalists, social reformers, and tourists who were enchanted by Italy's mythic Arcadian past and fascinated by its classical legacy. Artists held center stage in the Eternal City, respected and admired by prominent people of the day, from statesmen and authors to businessmen and royalty. 'Rome is the very home of art,' one American writer espoused. . . . If a young artist cannot succeed here, he must be destitute of talent.'"[87] Lewis, full of hope but lacking much experience, decided to take on the challenge of life among the celebrated sculptors of Rome, where she counted on using her novelty and talent to get access to career-defining opportunity.

The Neoclassical Tradition and the Struggle for Women to Pursue It as a Profession

By the second decade of the nineteenth century, America produced a few native-born artists with the talent and ambition to seek European training in sculpture. Most traveled to Italy and became immersed fully in the neoclassical experience and created works modeled from the "classical" art and culture

of ancient Greece and Rome. Centering mainly in Florence and Rome, they found reasonable expenses, willing nude models, pure white Carrara and Seravezza marble, expert criticism, antique sculpture from which to draw inspiration, and a labor force of skilled stone cutters able to flawlessly carve marble from clay or plaster models.

Horatio Greenough (1805–1852) became, in 1825, the first in a long line of young American artists seeking to master the neoclassical aesthetic. Greenough spent most of his life in Florence, producing portraits and figure groups on demand. By the 1840s the classical revival in sculpture peaked in America. The public had slowly brought itself to accept mythologically based allegories and the necessity of having female nudes embodied in white marble. Without question, the most popular American sculptor of that period was Hiram Powers (1805–1873), who, like Robert Duncanson, had been the beneficiary of support from Cincinnati millionaire Nicholas Longworth. Powers arrived in Florence in 1837 and quickly became the "world's greatest sculptor of busts." His bust *Proserpine* (1844), of the goddess of agriculture, was described as the "most favored single piece among Powers' work and it was copied more times than any other work produced by an American sculptor."[88] However, his immaculate *Greek Slave* (1843) awakened America from its puritanical art slumber and brought the sculpted neoclassical nude to public respectability.

A second generation of American sculptors followed Greenough and Powers to Italy. Included in this group of artists were many independent-minded women who sought liberation from the social and educational obstacles that confronted them in America. Many in this male-dominated culture assigned women, like African Americans, to a specific place of inferiority in nineteenth-century American society. In general, women, regardless of color, had to do little more than marry, raise children, and maintain the home. Thus, any woman with the drive and ambition to advance beyond her perceived "place" faced a monumental task. This was particularly true for female sculptors who sought a career in the fine arts. The very idea of a woman carving a massive block of stone conjured up images, in the typical male mind, of a masculine, unladylike, trouser-wearing, and discontented creature.[89]

By midcentury, a colony of women neoclassical sculptors had gathered around the noted actor and lecturer Charlotte Cushman (1816–1876) in Rome.[90] All of them were dedicated to competing equally with their male counterparts. Henry James (1843–1916), the expatriate American writer,

referred to these women condescendingly as "that strange sisterhood of American 'lady sculptors' who at one time settled upon the seven hills in a white, marmorean flock."[91] The first and most successful of this group was Harriet Hosmer (1830–1908).

The life and career of Hosmer represents a milestone in the American feminist movement. Her pioneering efforts in self-determination served to energize the concept that women should and could achieve their full artistic potential. She found her way to Rome as the first American woman to seek formal training in neoclassical sculpture.[92] In November 1852 Hosmer entered the studio of John Gibson (1791–1866), the dean of all English-speaking neoclassical sculptors in Italy, and demonstrated her considerable ability to 'breathe life' into blocks of marble.[93]

Within ten years after she arrived in Rome, Hosmer was overwhelmed with commissions. She then operated one of the city's most magnificent studios completely as her own business enterprise that was staffed by a small army of laborers and stone cutters working directly under her command.

The novelty of her gender added to her great appeal. However, this did not endear her to many of her male counterparts. They considered her a woman doing a man's job, and therefore entirely out of her element. Joseph Leach expressed this sentiment:

> Working at Gibson's elbow, the lone female among Rome's coterie of bearded American artists, Hosmer quickly discovered that they felt nothing for her but scorn and amusement. American sculptors like William Wetmore Story, Paul Akers, Randolph Rogers, and Thomas Crawford—all neoclassical artists like Gibson and herself—presented friendly smiles to her face. But behind it, they scoffed at her hopes to play their game. Story wrote his friend James Russell Lowell, "If Harriet Hosmer displays any true creative talent, will she not be the first woman?"[94]

Noted sculptor William Wetmore Story (1819–1895) openly endorsed the misguided notion that women had no creative powers and merely imitated the work of men. This widely held belief followed Hosmer throughout her career, and because of it prejudices against her as a competent art maker remained strong. According to John Carlos Rowe, "William Story's patronizing judgment of Hosmer betrays his own fears that Hosmer's achievements and talent might be superior to his own, as most modern art historians agree they were."[95]

The enormous obstacles Lewis had to overcome to become established as a sculptor carried a double burden. Not only did she have to overcome the limitations imposed on her by race, but she also had to deal with pervasive gender inequality. While it had been hard for Harriet Hosmer to blaze the trail to Rome, she still had the advantages of caste, class, and color to smooth the way. But as a woman of color containing the blood of two oppressed races, Lewis's path to the Eternal City was filled with career-threatening pitfalls. Still, Lewis and Hosmer were kindred spirits, both pioneers advancing the cause for all women to determine their destinies despite the objections of overly prideful and resentful men.

Other women seeking to make their mark as sculptors followed Hosmer to Rome. Among them were Louisa Lander (1826–1923) in 1855, Emma Stebbins (1815–1882) in 1857, Margaret Foley (1827–1877) in 1860, Florence Freeman (1825–1876) in 1861, Edmonia Lewis in 1865, Anne Whitney (1821–1915) in 1867, and Vinnie Ream Hoxie (1847–1914) in 1869. Charlotte Cushman became a mentor for many of them and assisted in finding suitable studios and artisan laborers. She also allowed them to board in her large apartment complex.

All these women severely challenged the prevailing notion of the "Cult of Domesticity," an ideology that surfaced in the nineteenth century among white, Protestant males of the upper and middle classes in Great Britain and the United States that fashioned an idealized view of women and womanhood that centered on work and family. Within its parameters, men left the home to face the harshness of the world to support their families, while women, assigned the role of weak, timid, and fragile creatures, remained steadfastly bound to hearth and home. Thus was born the concept of the "True Woman," whose duties within her limited sphere of influence consisted of four characteristics that ensured her acceptance by men and her place in "proper" society—piety, purity, domesticity, and submissiveness.

In this line of reasoning, women maintained the spiritual nature of the home, staunchly protected their virginity until marriage, managed the household, dutifully tended their children, remained passive observers to the doings of men, and yielded to their demands without question. More importantly, the "True Woman" knew her place and stayed there and relied on men for protection and guidance. Of course, the women sculptors who ventured to Rome "violated" most of these principles by their audacity to move beyond their designated "place" and actively challenge men who could never imagine or tolerate female intrusion into their "hallowed," safely off-limits profession.

As such, these women artists dared to work in clay and marble in the heart of the neoclassical movement in direct competition with their male counterparts; cast off their physically restrictive clothing in favor of practical, functional, and liberating attire; operated studios in which they supervised men; set aside marriage and family bliss for the sake of extended careers; and, for some, entered into same-sex relationships ("Boston marriages") that shook the foundation of societal norms.[96] Women who were progressive in any form threatened the essence of nineteenth-century manhood, along with its perceived superior qualities; thus, these female sculptors likely topped the list of all possible transgressors.

In addition, foreign women seeking careers in Rome as sculptors were exposed to views from the outside that placed them under intense scrutiny. Jacqueline Marie Musacchio wrote:

> But the women in this group of expatriate artists generated the keenest interest, not least because they had to negotiate a delicate path in their public and private lives to maintain respectability. Wealthy travelers who visited their studios abroad to examine and purchase art also scrutinized their behavior, and a wide variety of writers reported on their activities with both curiosity and a certain degree of voyeurism. But the experience of living abroad and studying original art for any length of time was worth the risks it entailed, and female artists with the opportunity and means to travel to Europe did so.[97]

When Lewis sailed from America, she faced enormous obstacles in realizing her dreams. Yet she possessed an unwavering commitment to become an internationally recognized sculptor, and a willingness to endure whatever challenges she faced from prejudiced minds that measured her race and gender as untenable attributes on her road to success. Lewis was indeed a very courageous woman as she moved ahead into a great unknown—the true measure of potential greatness.

Life and Work in Italy

Lewis arrived in Florence, Italy, in the fall of 1865. She was determined to advance her artistic vision and hoped that racism remained on the other

side of the Atlantic. However, she quickly learned that color prejudice was not limited to America.

Reverend Marsh, a Boston minister living in Florence, received Lewis. She carried a letter of introduction from an acquaintance, Mrs. Annie Adams Fields, which she was to present to her sister. Mrs. Fields wished that this should be one of the first contacts Lewis made in Florence, and hopefully her sister would provide good advice for a young woman in a strange land. However, when Lewis arrived at the home of Mrs. Fields's sister, she found she was not welcome. The sister rejected the letter, and they did not exchange a word.[98]

This incident was the focus of a letter written from Lydia Maria Child to Annie Adams Fields on November 25, 1865. Child enclosed with the letter "several documents from Florence" that apparently described some act of racism perpetrated against Lewis.[99] While these documents have not been located, their nature is easily deduced. Child wrote, "There has been an unpleasant misunderstanding, and Edmonia is evidently much excited; but that is not to be wondered at, considering the trying position in which she is placed by her complexion."[100] Child made it clear that repeated episodes of racism against Lewis would severely limit her chances of finding success abroad. Despite her initial reservations of Lewis entering the fine arts, Child seems to have given in to her desire to find fame in Italy. Child continued, "I hope the artists in general will be able to divest themselves of American prejudice as to give Edmonia a fair chance to make for herself such a position as she may prove herself entitled to. Of course, any attempt to force her, or anyone else, above the level of their nature will prove unavailing, but assuredly all obstructions ought to be removed."[101] Child seems supportive of Lewis despite her best efforts to hold her back as an artist. One has to assume that this was merely an attempt for Child to save face once Lewis had defied her wishes and had now embarked on her journey in Italy.

This incident apparently caused quite a stir within the Boston abolitionist community. The Commonwealth published an explanation that tried to appease those appalled by Lewis's reception:

The explanation is as follows. "There are two houses on Lung' Arno of the same number; the letter was sent to the wrong place, and unceremoniously returned to Miss Lewis. The lady addressed was entirely unaware of the whole matter until she received a letter from Boston, requesting an explanation of the report circulated here. A most kind and generous note was instantly

written by the lady to Miss Lewis, explaining the mistake, and assuring her that letter of introduction had never reached its destination, offering to Miss Lewis every attention, artistic and social, and welcoming her cordially. We are very glad to hear this explanation, and make record of it.[102]

Whether the clarification was true or not, the response it generated assured Lewis that many of her supporters back home remained vigilant in seeing that she made a good start in Italy. When she arrived at the Florence home of Thomas Ball (1819–1911), she had a positive experience. The noted sculptor treated her like "an old friend" and made her "some nice tools."[103] Ball's wife wrote her a letter that helped her secure a place to stay.[104] She was also introduced to Hiram Powers. Lewis said, "Mr. Powers was very kind to me—that dear, good man. He showed me how to fix the wires so as to keep the clay from settling when I modelled."[105] She also noted that Powers had given her "some things," including a molding-block to assist her in launching her career.[106]

Despite the encouragement of these great artists and the appeal of the working conditions in Florence, Lewis remained vigilant in launching her career in Rome. She may have realized that Rome attracted more American tourists and offered her a broader range of those who might appreciate her talents and buy her works. More importantly, Lewis knew Charlotte Cushman was there providing for the needs of struggling female sculptors.

Sometime in late 1865 or early 1866, Lewis arrived in Rome. Cushman received her and decided to take her on as a personal project. Cushman obviously felt a great deal of sympathy for this "poor little soul, who has more than anybody else to fight."[107] Lewis also reacquainted herself with Harriet Hosmer, who helped her acquire the former studio of Antonio Canova.[108] While Hosmer's correspondence is strangely silent concerning the newly arrived Lewis, her biographer, Dolly Sherwood, reported that she was "cordial and friendly" to Lewis.[109] Lydia Child gave additional insight into Lewis's early relationship with Hosmer. Child quoted Lewis as saying, "A Boston lady took me to Miss Hosmer's studio. It would have done your heart good to see what a welcome I received. She took my hand cordially, and said, 'Oh, Miss Lewis, I am glad to see you here!' and then, while she still held my hand, there flowed such a neat little speech from her true lips!"[110]

Lewis indicated that Hosmer would call on her and that they met frequently.[111] She also confirmed that Hosmer occasionally made constructive

comments about her work in her studio. Lewis recalled, "I have been greatly indebted to Miss Hosmer for advice. I was making a model of a soldier. Miss Hosmer came in to see it. She said, 'The legs of that are not long enough.' I saw it the moment she pointed it out. Now Professor Tadolini, of the University of San Luca had seen it, and he failed to note the error, although he is a great art connoisseur."[112]

Lewis's presence in Rome quickly attracted attention. Soon after her arrival, the *Anti-slavery Standard* reported:

> A correspondent writes from Rome, "An interesting novelty has sprung up among us, in a city where our surroundings are of the olden time. Miss Edmonia Lewis, a lady of color, has taken a studio here and works as a sculptress in one of the rooms formerly occupied by the great master Canova. She is the only lady of her race in the United States who has thus applied herself to the study and practice of sculptorial [*sic*] art." [113]

That same year, the Black-owned *Christian Recorder* informed:

> Many of our readers will remember Miss Edmonia Lewis as a poor, unknown colored girl, a few years ago, and then a little later as giving evidence of the highest order of genius, by her models of the busts of distinguished men, which she wrought in Boston.
>
> We saw last winter one of these, the exact likeness of Wendell Phillips. It is in the possession of Richard Greener, a colored student at Harvard College, and is highly prized as a work of art. Miss Lewis will soon take rank among the greatest masters of the art, who transfer life's glow to the pale marble.[114]

With several commissions in hand, Lewis could anticipate extending her stay in Rome. She began work on the bust of Diocletian Lewis. Lewis said, "After I got there I began work. I went into Canova's old studio in Rome, and began to work on my American orders. I had several valuable ones. I made a bust of Dio Lewis, the reformer. He said he would pay me $100 extra if I should do the subject justice. After I had sent it back he refused to pay this, but my friends there made him do it."[115] If Dio Lewis was not completely satisfied with the finished work, the *Christian Recorder* gave this favorable report, "It is not only an accurate likeness, but she has given the attitude and expression of the physical educator most happily. This is the

first work of the kind sent from Europe to America from the hands of a colored artist."[116] She also indicated that she would soon begin work on the clay model of *The Marriage of Hiawatha* and quickly received an order for a marble version from Mrs. Mary Pell of Flushing, Long Island, for which she was paid $400.[117]

In addition, Lewis worked on small portrait busts that either fulfilled other commissions from her supporters or served as mementos of her gratitude. She also she completed *Preghiera* (1866), a work that likely held significant personal meaning. Translated from the Italian, *preghiera* means "prayer," or more specifically, a short instrumental musical composition in devotional mood. She composed a woman on bended knee, hands clasped in the praying position, and eyes looking to heaven. The work immediately draws comparisons to the abolitionist emblem "Am I Not a Woman and a Sister?" in that they share an almost identical pose. Thus, Lewis linked the work to William Lloyd Garrison's adaptation of the image for the Ladies Department of *The Liberator* in an obvious sign of respect for work he led to free her people.[118] Perhaps more importantly, Lewis may have created a visual metaphor that symbolized her own escape from racial oppression in America and deliverance to Italy to fulfill her potential. By adding the musical reference to her statue, Lewis may have evoked Negro spirituals that often spoke of liberation from bondage and subjugation.

Of course, Lewis was anxious to begin moving on to compositions that were more ambitious and having them carved in marble. However, that transition was expensive due to the cost of the material. Neoclassical sculptors had long favored Carrara marble found in quarries located in Italy's provinces of Massa and Carrara, but the most desirable, unblemished specimens came at a hefty price. For this reason and the fact that she decided to carve her own sculptures (discussed later), Lewis's early work was small and contained some veining in the marble.

Lewis's early initiative was derived from her shrewd business strategy to fill the lucrative niche market among those antislavery advocates still celebrating Black emancipation, and she produced her first group piece, entitled *The Freedwoman, on First Hearing of Her Liberty* (1866, location unknown). The work was described as that of a woman who "has thrown herself on her knees, and, with clasped hands and uplifted eyes, she blesses God for her redemption. Her boy, ignorant of the cause of her agitation, hangs over her knees and clings to her waist. She wears the turban which was used when at

work. Around her wrists are the half-broken manacles, and the chain lies on the ground still attached to a large ball."[119]

Even if the individuals portrayed in this work resembled Greeks more than the descendants of West African slaves, Lewis's gesture was a purely symbolic effort to represent a major event in African American history and to attract the attention of patrons still basking in the spirit of abolitionism. More importantly, the work provided her the opportunity to acknowledge "the race" on visual terms. Lewis remarked that the subject was a "humble one, but my first thought was for my poor father's people, how I could do them good in my small way."[120] She also stated, "Yes, so was my race treated in the market and elsewhere."[121]

Lydia Maria Child was again convinced that Lewis was moving too fast in her pursuit to be an artist. She viewed *The Freedwoman and Child* as "disagreeable."[122] While she found the face of the sculpture to be good (perhaps in its whiteness), Child stated that the figure was "shockingly disproportionate."[123] Obviously, Child was still skeptical of Lewis's talent and chances of success. She suggested that Lewis spend several years modeling in clay and plaster to overcome her shortcomings in anatomy. Lewis, however, had her own agenda and pressed on honing her craft in marble.

The American neoclassical sculptors in Rome had never seen a work like *The Freedwoman* because they never directly addressed American slavery in their art. Despite its flaws, the piece delivered the plight of African Americans to the heart of Rome's art community. For those who thought themselves distanced and insulated from America's racial problems, the arrival of Lewis and her Black subjects must have come as a shock. Finally, an African American had finally added social commentary about racial matters and heritage to the Roman art community and American art patrons. Thus, while Duncanson and Bannister did not create many Black-themed images, Lewis seemed almost obligated to produce them.

Travelers to Rome were astonished to discover Lewis's presence and profession. In less than two years after her arrival, her incredible story began to gain international attention. Although many saw her as merely a curiosity, Lewis used that perception to her advantage; there must have been a sense of awe for those who saw her dark hands manipulating the pure white marble. Thus, to own a work by her was to have something unique. Possessors of her sculptures had a genuine conversation piece, since one could count the number of Black, Indian, female neoclassical sculptors in the world on one finger.

Had Lewis heeded Lydia Child's advice to proceed in a more traditional fashion to gain the public's consideration, she would have languished for years struggling to perfect her technique and to attract buyers in an already highly competitive field. To survive, she needed immediate recognition and quick sales. She apparently gambled that her distinctive background, exotic nature, and innate talent would make her famous—and it did.

In 1866 Lewis's unique position gained her the attention of Frank Leslie, the publisher of a major American periodical, *Frank Leslie's Illustrated Newspaper*. He reprinted an article on her that originally appeared in the *London Athenaeum* that detailed her rise to Rome and exposed her to a wider audience. A year later Leslie traveled to Italy shortly after he attended the International Exposition in Paris and met Lewis. She said, "While I was working in that studio Frank Leslie found me, drew a picture of me and published it. This was my first public introduction with the world of art. That gave me notoriety and helped me in my course."[124] The article that followed in the newspaper portrayed Lewis at the beginning of her career. It read in part:

> In her coarse but appropriate attire, with her black hair loose, and grasping in her tiny hand the chisel with which she does not distain—perhaps with which she is obliged—to work, and with her large black, sympathetic eyes brimful of simple, unaffected enthusiasm, Miss Lewis is unquestionably the most interesting representative of our country in Europe. Interesting not alone because she belongs to a contemned and hitherto oppressed race, which labors under the imputation of artistic incapacity, but because she has already distinguished herself in sculpture—not perhaps in its highest grade, according to the accepted canons of art, but in its naturalistic, not to say most pleasing, form.[125]

In 1868 Leslie continued his interest in Lewis and printed a large engraving of her portrait—now there could be no question that she was, indeed, a woman of color doing remarkable things abroad. Accompanying her likeness was this assessment: "Considerable interest is manifest in the progress of Miss Lewis, partly because she exhibits good promise of success in her difficult profession, and partly because the African blood in her veins renders her conspicuous as one of a race that rarely ventures into the domain of high art."[126]

Lewis's increased exposure through the Leslie publications made her studio in Rome more attractive to Americans traveling abroad. Whether she

liked it or not, her reported story made her a must-see attraction. Soon her studio became a necessary stop on the Grand Tour of the European continent. Thayer Tolles, the curator of American paintings and sculpture at the Metropolitan Museum of Art, explained the benefits of this increased traffic:

> Travel guides featured artists' studios as tourist attractions, bringing prospective patrons—eager for souvenirs of their European sojourns—right to the sculptors' doors. On view in the studios were plasters of imaginative "ideal" subjects—themes from literature, mythology, and history. These works, considered to be a sculptor's most worthwhile and creative endeavor, were available for prosperous Grand Tourists to commission for translation to marble (artists generally produced several marble replicas of the same composition to maximize potential income). Or clients may have sat for portrait busts—the backbone of any sculptor's business—modeled in clay, and later carved in marble and shipped to their homes in the United States. Indeed, the productions and achievements of American sculptors in Italy were closely followed in American newspapers and journals and incorporated into novels and travel recollections.[127]

The attention Lewis garnered back in America through the initial Leslie publication and similar reports also caught the eye of some residents back in Oberlin. The *Lorain County News* questioned if this new artistic celebrity was the same as the "infamous" Mary Lewis who absconded several years earlier: "The papers are noting the advent in Rome of a young colored artist and sculptor—Miss Edmonia Lewis, who is creating something of a sensation in the Eternal City. Report hath it that she is none other than Miss Mary E. Lewis, who had her brief notoriety here—and for other than artistical [*sic*] efforts—a few years since. If Miss Mary E. is none other than Miss Edmonia, she is indeed enjoying a checkered career."[128]

In 1867 Lewis created another African American–themed work entitled *Forever Free* [fig. 3.3], formerly known as *The Morning of Liberty*. During her first years in Italy, her artistic vision did not include typical neoclassical subjects drawn from mythology or ancient history, but demonstrated her independence and acknowledged her ethnic identity. The execution of *Forever Free* also revealed, as she had done with *The Freedwoman*, that Lewis was unafraid to take on complex group subjects. Most neoclassical sculptures were either single, full-length figures or busts. Groups were rarer because

Fig. 3.3. Edmonia Lewis, *Forever Free*, 1867, Marble, 41 ¼" × 11" × 17", Howard University Art Gallery.

they created the problem of achieving multiple viewing angles and therefore presented greater challenges for the artist. Usually all but the most confident of masters avoided these types of work—but not Lewis.

With *Forever Free*, Lewis returned to African American liberation that she explored in *The Freedwoman*. The title suggests a commemoration of Lincoln's Emancipation Proclamation, which stated that as of January 1, 1863, "all persons held as slaves within any State, or designated part of a State, the people whereof shall then be in rebellion against the United States, shall be then, thenceforward, and forever free."

Compositionally, *Forever Free* featured a nearly exact reproduction of *Preghiera* by retaining the kneeling pose of a prayerful woman. She added a standing young man whose position and gesture reflect thankful triumph, reinforced by the broken shackles he holds aloft to the world. Lewis's interpretation of the news of emancipation therefore centered on the immediate physical and spiritual agency of its recipients and negated the commonly depicted view of them as passive witnesses to a gift bestowed by Lincoln, the "great white father" of emancipation.

Lewis sent Lydia Child a photograph of *Forever Free* hoping for a positive response. She likely viewed the new work as demonstrative proof that her

skills were rapidly improving and that she was living up to the promise of artistic maturation that her supporters envisioned. Child, however, continued her discouragement of Lewis's pursuit. In a letter Child wrote to Sarah Blake Sturgis Shaw, she claimed the limbs of the statue "were like sausages" and emphatically insisted, "I do not think it wise or kind to encourage a girl, merely because she is colored, to spoil good marble by making it into poor statues."[129]

Lewis also sought criticism from her trusted supporter Maria Weston Chapman and sent her photographs of her progress.[130] Lewis was determined that *Forever Free* be presented to William Lloyd Garrison, "who has done so much for the race."[131] She indicated to Chapman that the cost of the sculpture was one thousand dollars and asked for assistance in securing five hundred dollars "to get the work so far advanced as to be able to send it to Boston in time to be presented to our much valued friend on the first day of January 1868."[132] By August of 1867, Lewis had remodeled her "Freedman" based on Chapman's input and noted, "I have made a much better work of it."[133]

Funds for the project materialized slowly. Undaunted by this lack of progress, Lewis apparently borrowed the money needed to finish the statue and shipped it to the United States with the hope that the financial arrangements could be worked out. According to Lydia Child, Lewis sent *Forever Free* to Boston without prior notice, accompanied by the bills.[134]

Once the sculpture reached Boston, Lewis lost track of it. She wrote to Maria Chapman asking for its whereabouts and whether any payment from its purchase was on its way to Rome, declaring, "I am in great need of the money. What little money I had I put all in that work.[135]

Lewis's friend Elizabeth Palmer Peabody, a pioneering educator, better understood the importance of *Forever Free*, despite any flaws attributable to a novice. She wanted to see that the work found a proud home within the Black community in Boston. During a visit to Lewis's studio in Rome, Peabody said:

> The thing that excited my interest most was the group—"Forever Free"; the history and destination of which, by her own heart, clothed it with so much sacredness that it perhaps made a cold critical analysis impossible. It went to my heart, as it came to hers. To reach the destination she especially desired, it must be purchased by the colored people only, and I am glad to learn that at the present moment measures have been taken to secure its being purchased by those of Boston and vicinity for the purpose she desired. It will be, I hope and presume, seen for a week or two by others at the Fraternity rooms.[136]

Some have often criticized Lewis for placing the freedwoman in a lower position than the man, thereby relegating her to a subordinate position. They would have wanted the two portrayed on equal terms, especially since Lewis intended many of the women in her compositions to be strong and independent. But Lewis was not immune to the hierarchy of gender roles in the nineteenth century, and the positioning of her figures may reflect that societal assignment; at least it would have more appeal to male patrons who felt that way.

Art historian Kirsten Pai Buick also connected a similar hierarchy within the Black family structure saying, "If we reexamine Lewis's statue as a representation of the birth of the African-American 'family' after slavery, the freedwoman's posture can be seen to reflect the qualities ascribed to the 'True Woman'—submission, piety, and virtue."[137] Thus, for the fiercely independent Lewis, it may have been her intention to use the kneeling position of the woman to show symbolically that men still dominated, overshadowed, and restricted women during her lifetime.

Lewis's treatment of the faces in *Forever Free* is more Eurocentric than African American; only the curly hair of the male figure hints at his ethnicity. In this case she seems torn between racial pride and the neoclassical tradition. Neoclassical aesthetics embraced idealized white imagery. The physical features of Blacks did not fit this criterion; thus, a truly discernible West African–derived image appears to be nonexistent in the genre. Could Lewis have believed that "Black features" were not aesthetically pleasing? Or was she simply dedicated to adhering to strict principles of well-established European traditions? Whatever the reason, Lewis appears to have made no serious attempt to present "uncontestable Blackness" in her sculptures. Lewis may have anticipated that her buyers would be whites with strong ties to the abolitionist movement that preferred to see a reflection of their service in her work. Clearly, she chose not to challenge, at this time, traditional neoclassicism which prevented her from fully realizing a more emotional representation of emancipation. Therefore, the cold whiteness of the marble and the Eurocentric faces removed much of the "soul" from Lewis's sculpture.

Despite Lewis's inability to easily achieve a new level of emotionalism and realism in her early work, the significance of her African American groups should not be underestimated. These were pioneering efforts that infused the entire neoclassical genre with direct social and political commentary on the African American condition that was sorely lacking in artistic productions done in Rome.

Lewis was ready to explore more of her Native American heritage in her art by 1866, and she wrote Lydia Child for information on Pocahontas. Child appeared accepting of Lewis's appeal, apparently willing to allow her to express her "authentic" Native side because of past experiences. Child wrote, "I complied with her request, and told her I thought it would be a good subject for her, because she had been used to seeing young Indian girls, and could work from memory, and with her heart in it, for her mother's sake . . . I think she would make a statue of an Indian better than anything else."[138] No reference exists to indicate that Lewis completed the work.

Many of Lewis's fellow nineteenth-century artists shared her interest in Native American subjects. Indians had long been a popular subject in both European and American art, and artists often incorporated them in paintings and sculpture of the eighteenth and nineteenth centuries as allegories representing the New World—neoclassical artists found them to be a kind of noble savage, worthy of careful study and uniquely representative of America. The sculptural treatment of Indians varied from the untamed attacker of white women found in Horatio Greenough's *The Rescue* (1851) to Thomas Crawford's heroic *Dying Chief* (1856). Artists most often portrayed female Native Americans as vulnerable American princesses—innocent nymphlike creatures far removed from the savage nature of the male, and at times the beneficiaries of Christian civility.

Lewis's treatment of Native American themes was comparable to her portrayal of African Americans in their stylistic elements. She preferred to sculpt groups instead of individuals and carefully avoided any hint of racial stereotype or grandiose romanticizing of Indian culture. She drew early inspiration from Henry Wadsworth Longfellow's popular epic poem *The Song of Hiawatha* (1855), from which she produced *The Wooing of Hiawatha* (1866) (also known as *The Old Arrow Maker and His Daughter*) and *The Marriage of Hiawatha* (1866) (also known as *Hiawatha's Marriage*).[139] An early description of these works follows:

> Her first (sculpture) "Hiawatha's Wooing," represents Minnehaha seated making a pair of moccasins and Hiawatha by her side with a world of love and longing in his eyes.[140]
>
> In marriage they stand side by side with clasped hands. In both, the Indian type of features is carefully preserved and every detail of dress, etc., is true to nature; the sentiment is equal to the execution. They are charming bits, poetic,

simple, and natural; and no happier illustrations of Longfellow's most original poem were ever made than these by the Indian sculptor.[141]

The San Francisco newspaper *The Elevator*, long a vocal supporter of Lewis, announced, "Photographic copies of two groups of statuary, entitled 'The Wooing and Wedding of Hiawatha,' executed in Rome by Miss Edmonia Lewis, a colored artist—For sale at this office."[142] By circulating photographs of her work, Lewis increased her visibility and created a sense of excitement among potential buyers who might wish to subscribe to a copy. Perhaps her brother Samuel was actively supplying the photographs to media outlets in the West to aid in her promoting her sculptures.

Charlotte Cushman and other supporters of Lewis presented the *Wooing of Hiawatha* to the Boston YMCA in 1867.[143] Cushman may have seen Lewis as a standard bearer of "the race" in their quest for recognition in art and sought to promote her as such. *The Elevator* printed a letter that she wrote on May 1, 1867, about the sculpture:

> Sir: —A number of Americans who have passed the last winter in Rome, and in whose name I write, have had occasion to know of the praiseworthy efforts at improvement of a young colored artist, Miss Edmonia Lewis, established here, in her profession as a sculptor. Taking an interest in her success, and in the hope of making her better known at home, they ask leave to offer to the acceptance of the Young Men's Christian Association, of Boston, the little group of her's [*sic*] in marble, which she entitles the "Wooing of Hiawatha," and which will soon follow this note. Trusting that it will be received, not as a work of high art in itself, but as the first fruit of a talent capable of development and assuring proof that a race which hitherto in every country has been looked upon with disfavor, may not only be alive to the pleasures which come from refined pursuits, but capable even, under favorable circumstances, of producing work worthy the admiration of cultivated persons. May I ask your friendly interest in presenting this matter acceptably to your association?[144]

The Elevator also printed the response from the YMCA. At its regular meeting on December 5, 1867, a committee at the Boston branch resolved:

> That the thanks of the Boston Young Men's Christian Association be returned to Miss Charlotte Cushman and others, citizens of the United States resident

Fig. 3.4. Edmonia Lewis, *The Wooing of Hiawatha* (also known as *Old Arrow Maker*, modeled 1866, carved 1872, Marble, 21 ½" × 13 ⅝" × 13 ⅜", Smithsonian American Art Museum, Gift of Joseph S. Sinclair.

at Rome, for the gift of statuary, entitled the "Wooing of Hiawatha," by Miss Edmonia Lewis. It is not only prized by us as being a beautiful work of art, but also as being the production of one who represents the race hitherto looked upon as incapable of artistic culture.[145]

With *The Wooing of Hiawatha* [fig. 3.4], Lewis depicted from the epic poem (chapter 10) Minnehaha seated next to her father "plaiting mats of flags and rushes." The old man shapes arrowheads for hunting. A newly killed deer, a gift from the unseen Hiawatha, lies at their feet. The face of the man, surprisingly, suggests strongly his Native ancestry while the young woman retains European characteristics. However, Lewis gives special attention to finely detailing surface textures that lend a touch of authenticity to items such as the moccasins, animal hides they wear as clothing, and the animal claw necklace that rings the neck of the old arrow maker. She wished to show the other side of her heritage in a naturalistic manner that was devoid of many of the typical neoclassical clichés found in other interpretations of Native Americans. Her patrons would have viewed her work as culturally accurate, which only added to her mystique and appeal.

The Marriage of Hiawatha continued the narrative that Lewis established with *The Wooing*. In it she presents the moment in the poem when Minnehaha

and Hiawatha exit the wigwam, hand in- hand, gazing lovingly into each other's eyes, thus sealing the peace between Hiawatha's tribe, the Ojibwa, and Minnehaha's tribe, the Dakota. The work seems fitting to represent symbolically, in the wake of Civil War, a uniting of warring factions and the move toward amenable coexistence. Unfortunately, Lewis's voice remains silent as to any underlying meanings associated with this work. As with *The Wooing*, Lewis injects a strong element of naturalism—the clothing, headdresses, accessories, and hairstyles—that further separated her style from conventional neoclassical treatments. The face of Hiawatha shows a semblance of Native physiognomy, particularly in the nose and cheekbones. The face of Minnehaha, again, reflects Lewis's preference for females to look European.

The success of Lewis's works based on the Longfellow poem allowed her to meet a growing demand for copies. At least five versions of *The Wooing* survive, and six versions of *The Marriage* are extant. In obvious reaction to the popularity of her Longfellow-inspired works, Lewis created small, individual busts of *Hiawatha* (1868) and *Minnehaha* (1868) for sale, thus providing less expensive options for those wishing to own this "genuine" part of her artistic output.[146]

Another work by Lewis that addresses Native American life is *Indian Combat* (1868) [fig. 3.5]. With this sculpture she becomes more daring in her compositional structure and presents three Native Americans engaged in fierce hand-to-hand battle. Lewis scholar Marylyn Richardson described the work:

> The 30" high marble group shows three American Indian men engaged in combat. One figure grabs another by the hair with one hand and wields a knife with his other. A third man has fallen and struggles to pull himself up or to pull one of the other warriors to the ground. A long arrow and a battle-ax lie on the ground. The dynamic and complex composition leads a viewer to circle slowly to sort out the tangle of limbs and loincloths. The sculpture . . . is signed and dated "Edmonia Lewis/ Fecit A Rome 1868."[147]

Lewis handled the figures with a sense of dynamic tension that moved dramatically away from the stoic, undeviating classic approaches found in the work of most of her peers—this further added to her uniqueness. Elizabeth Bolande of the Cleveland Museum of Art wrote of the work that "virtually no other work exhibits such a complex integration of multiple protagonists. Conceived fully in the round, *Indian Combat*'s dynamic composition

Fig. 3.5. Edmonia Lewis, *Indian Combat*, 1868, Marble, 30" × 19" × 14 ⅜", Cleveland Museum of Art.

encourages the viewer to circumnavigate the piece in order to discover the details of the action. Having carved the marble herself—without the use of assistants that was the custom at the time—Lewis rendered a wide variety of complex textures, which can be seen in the moccasins, animal hides and loin cloths worn by the figures."[148]

Continuing her attempts to translate the words of Longfellow in visual terms, *Indian Combat* appears to draw its inspiration from a wrestling scene found in *The Song of Hiawatha*, although it diverges from the text in number of combatants and seems to be a more imaginative extrapolation of the theme. Still, the sculpture affirms Lewis's confidence to take on the complexities of multifigure compositions, and it stands as, perhaps, the best work of her career.

Lewis's decision to address Native American themes, particularly those drawn directly from Longfellow's poem, was a combination of perceptive business acumen and pride of race. She realized that the broad popularity of *The Song of Hiawatha* and celebrity status of its author would easily translate into sales, and she became perhaps the first American sculptor to produce marble sculptures from the narrative for public consumption (others like Augustus Saint-Gaudens in 1874 would follow her lead.) And since Longfellow had given Hiawatha an Ojibwa identity, the resonance with Lewis was instant and undeniable.

In 1868 Lewis completed a sculpture, *Hagar*.[149] Lydia Maria Child, in her usual discouragement of Lewis's attempts to advance, wrote to Sarah Shaw after viewing a photograph of the work, "I think it better than the *Freedman and His Wife*, but I do not think it worth putting into marble. It looks more like a stout German woman, or English woman than a slim Egyptian, emaciated by wandering in the desert.[150]

Lewis's decision to attempt the biblical character was a well-calculated endeavor to portray someone with whom she could identify strongly and to make a broader statement about the current condition of women. It also indicates that Lewis was quick to embrace Hosmer's manner of choosing strong-willed women from literary sources as subject matter. Hagar, as noted in the Old Testament (Genesis 16), was the Egyptian handmaid of Abraham's wife, Sarah. Because she was barren, Sarah gave Hagar to her husband so that he would produce an heir. However, Sarah became jealous, and Hagar and her son, Ishmael—the offspring of Abraham—fled into the desert to escape her wrath.

Hagar reveals an interesting choice made by Lewis in how she should approach the handmaid's appearance. Although the Bible identifies Hagar as Egyptian, and therefore African, Lewis, again, followed neoclassical aesthetics, making her essentially a white woman—Child's letter confirmed that the face was more European. Lewis would never break from this treatment of women when dealing with subjects of African descent.

Lewis's creation of *Hagar* also carried an additional underlying meaning. Referring to the work, Lewis said, "I have a strong sympathy for all women who have struggled and suffered."[151] This statement confirms that she was addressing the plight of nineteenth-century women in her art and the predicament of African American women specifically, thus demonstrating that Lewis imbued some of her figures with political and social subtexts. However, Hagar represented much more to Lewis. It also contains a strong autobiographical element. No American female sculptor had struggled and suffered as she had, particularly when racism was factored in. Lewis had this work cut in marble in 1869.

The Honorable C. D. Robinson, the publisher of the *Green Bay Advocate*, visited Lewis's studio in Rome in 1869 and found her with the newly completed *Hagar*. His assessment of the work was in complete contrast to Child's observation. He wrote, "She has now finished a life-sized figure of Hagar, which I think is pronounced by those who are judges as the work of genius

as well as skill. It is rarely that there can be found in Rome a figure which invokes such immediate admiration, and which grows upon the sympathy the more it is studied."[152] Robinson also revealed that she was struggling financially because she had purchased such a large block of marble for the project. He said, "From some conversation with her about her affairs, I was sorry to hear that she is in straightened circumstances; that she has had no order for several months, even though Rome is unusually full, especially with Americans. She desires to sell her *Hagar*, reserving the right to exhibit it, in which case she will come with it personally to the United States."[153]

Fellow sculptor Anne Whitney, writing her sister Sarah in 1869, commented on her impression of *Hagar*. Whitney had a less-than-favorable opinion of Lewis and the quality of her work, believing that the art-buying public would soon grow tired of her "inferior" creations.

> She made last year a statue life-sized which she called Hagar—had I thought it possible to counsel her I should have been thankful to save her from peril— color-indulgence and it must be said the dreadful ignorance of a large class of buying have led her on—but there is a limit somewhere to such things and now it seems she has involved poor ——. But this is also marked Private. Poor creation—what will she do if this work gives out.[154]

Despite the end of slavery, Lewis seems to have retained the support of the abolitionists, and they created a much-needed source of income; a group in Boston bought *The Freedwoman*.[155] However, early recognition and an occasional commission did not translate into financial reward. In 1868 Lydia Child expressed in a letter written to her close friend Harriet Sewall that Lewis was "very poor."[156] Child blamed her condition on her inability to understand the concept of budgeting money—a fact she attributed to Lewis having grown up a poor Negro and a wild Indian—and her insistence to sculpt in expensive marble. Child wrote of Lewis that "neither her mind or her hands are yet educated enough to work in marble."[157] She was concerned that Lewis was becoming too eager to send expensive pieces back home (with added shipping costs) without a buyer. She wrote, "I don't believe that Charlotte Cushman has taken Edmonia 'under her protection'; for if she had, she would never have allowed her to run in debt for marble, on the mere supposition that Mr. Garrison's friends would raise money to pay for it."[158] Child thought that this effort would never come to fruition and that

Lewis should immediately find another means to earn a living.[159] It must have come as quite a shock and a bit of a humbling experience when Child learned five years later that Lewis was actually making notable inroads in the art community in Rome. Child once again underestimated the potential and determination of Lewis.

Lewis's decision to work directly with marble was an expensive venture. The reasons for this choice linked directly to her race and her sex. She knew she had to prove to a skeptical dominant culture that any sculpture bearing her name was unquestionably by her hand. To ensure that no one ever accused her of being a fraud, Lewis resisted any type of prolonged instruction while in Rome. While this decision ultimately deprived her of gaining much-needed technical knowledge, she obviously felt it was necessary to ensure her integrity. Anne Whitney explicitly defined her position regarding this issue in a revealing letter written in 1868. Whitney visited Lewis's studio and found her possessing a "very elementary knowledge of the art."[160] She believed that Lewis would advance only with proper instruction and suggested that she have a "good artist" come by once a week to offer advice. Lewis rejected the idea. According to Whitney, Lewis was "haunted by . . . a fear that people will say she didn't do her own work."[161] Lewis consequently was extremely careful to avoid the accusations that had even plagued Harriet Hosmer in her quest to gain acceptance as a sculptor.

Rumors concerning the authenticity of Hosmer's work emerged as soon as she began to receive notoriety and praise in Rome. The widely accepted notion that the process of producing marble sculpture was a task of which females were physically incapable was part of the problem. For those who were not familiar with the time-honored procedure of creating a neoclassical work, the rumors were quite understandable. Carving marble was a demanding and time-consuming job. Within the accepted tradition, the primary creator of the work usually delegated this job to skilled laborers. Hosmer's mentor, John Gibson, taught her the process of creating a neoclassical piece, and she followed it closely, as did most of her peers. The first step in the process was the formation of an idea, or *concetto*, followed by the roughing out of the idea in a clay model, or *bozzetto*. Once the sculptor was satisfied with the model, studio artisans built a skeleton of wood and metal to support a full-size clay composition, or the *modello grande*. The laying on of clay to the skeleton was next, and it was drudgery, particularly if the work was large. When the mass of clay began to take on human form,

the artist would proceed to "bring the work to life." This process of refinement could take months. Once the sculptor was pleased with the results, the laborers took over and covered the work in plaster to make a pattern for the marble carvers. The transferring of the pattern was purely mechanical. They took precise measurements from every conceivable angle to ensure a highly accurate translation on the artist's original design. The last step in the process was to polish the sculpture to give it a smooth, delicate finish. Some sculptors were actively involved in the carving process, but most were not. Some made final touches to the work of the craftsmen, but most, including Hosmer, felt that once the creative part was completed, it was time to move on to other projects.

This manner of working allowed women to compete as equals with men. It was the accepted and practiced method employed by the great neoclassical sculptors since Canova. Yet there were those who could never accept the idea of a woman, specifically Harriet Hosmer, creating artistic masterpieces. For others, Hosmer became the source of intense professional jealousy, and they attempted to discredit her. Rumors suggested that her work was done by her teacher, John Gibson. When Hosmer completed her crowning achievement, the colossal figure of *Zenobia*, her critics attacked her in print by stating that her work was "really executed by an Italian workman in Rome."[162] Fortunately, Hosmer defended her reputation with threatened lawsuits and the support of strong character witnesses.

Lewis would not allow similar charges against her to surface. While she was financially unable to hire skilled laborers during her early years in Rome, she probably would not have used them had they been available. She knew that if a celebrated white woman like Hosmer could receive such negative treatment, an unknown Black woman would face similar or worse attacks. Thus, Lewis willingly endured the physical hardships of building up clay and carving marble to prove, beyond any doubt, that she was the sole creator. A reporter addressed her success in avoiding any charges of relying on outside help:

> Miss Lewis is one of the few sculptors whom no one charges with having assistance in her work. Everyone admits that whether good or bad, her marbles are all her own. So determined is she to avoid all occasion for detraction, that she even "puts up" her clay; a work purely mechanical, and one of great drudgery, which scarcely any male sculptor does for himself. It is a very hard

and very fatiguing process, for it consists in piling up masses of wet clay into the vague outline of a human figure, out of which the sculptor brings the model into form and beauty."[163]

Another article echoed the same description of Lewis's sculpting habits. It read, "She performs every part of her art without any assistance, even putting up her clay, which is a task of great drudgery, and forming therefrom more original designs than any of her sisters are equal to."[164]

Lewis's admiration for the renowned Henry Wadsworth Longfellow and his poetry of Native Americans resulted in her sculpting a portrait bust of the famous bard. Initially she tried to create the likeness based solely on glimpses she caught of him during a visit to Rome in 1869.[165] She later managed to get Longfellow's brother Samuel to come to her studio and see what she had done. Lewis's modest attempt impressed Samuel, but he felt that the nose of the sculpture needed work. To remedy this situation, Samuel convinced the entire Longfellow family to visit her. The great poet then posed for Lewis and commended her for achieving a better image than most of her fellow art makers.[166]

Despite her financial situation, Lewis's growing celebrity continued to attract visitors to her studio, and she pressed on. In 1868 some relief came when Prince George of Prussia ordered a statue of Clio, the muse of history, perhaps intrigued by Lewis's novelty and improving skills.[167]

C. D. Robinson offered some unique glimpses into Lewis's demeanor and the large number of sculptures that filled her studio.

I think that few of our countrymen know that there is in Rome an American girl only twenty-two years of age, who is commencing a career as a sculptor which promises to be a brilliant one. . . . When I called she was in her working dress—an overfrock of tow cloth—and busy with the chisel; but she received me with a very pleasing and natural grace, with an absence of any affectation which was quite charming; I do not know what she commenced upon; she has found some English patrons, who took her first works.[168]

Robinson mentioned seeing "*Hiawatha's Wedding*, another one of an Indian fight, several other Indian figures, a clay bust of Longfellow, and some half dozen or so in marble of ladies, which have been ordered. . . . There were other small works. . . . A head of Charlotte Cushman is also a good one."[169]

As Robinson concluded, he eloquently framed the importance of all that he had witnessed and made race central to his experience. "There is rare beauty in all this, but it could not be, had it not first existed in the mind of the little negro woman. You cannot gather grapes from thistles. She did not come here and launch away at Venuses and Adonises, but with innate and true beauty, remained, even in fancy, with her kindred the Indians and the bond people."[170] Finally, Robinson revealed the complex balance most artists must endure to maintain a steady supply of product while relying on sales to keep moving forward. In Lewis's case, she may have overextended herself without sufficient financial return. Robinson observed, "From some conversation with her about her affairs, I was sorry to hear that she is in straightened circumstances; that she has had no order for several months, even though Rome is usually full, especially with Americans. She desires to sell her Hagar, reserving the right to exhibit it, in which case she will come with it personally to the United States. I hope some one of the many men of wealth who are now traveling through Europe, and who, when at home, talk much of the race we have oppressed so long, and of our duty to encourage in all ways their development in intellect, will buy her beautiful marble, and send her on her way rejoicing."[171]

Lewis continued to improve her technique and achieve notoriety at the dawn of the 1870s. She solidified her position as "unquestionably the most interesting representative of our country in Europe."[172] Although few considered her the most talented of the neoclassical sculptors, her exotic nature and credible skill made her studio at number 8 Piazza di San Nicola di Tolentino a popular tourist attraction. It was to Lewis's advantage that her work did not look like most neoclassical sculptures that surrounded her. Her style was more personal and readily identifiable—charming and refreshingly distinctive from the masses of nearly identical Greco-Roman marble bodies emerging repeatedly from Italian studios.

It was during this decade that Lewis finally reaped her greatest financial reward. She broadened her artistic vision, rendering a copy of an antique Roman bust entitled *Young Octavian* (1873), and Michelangelo's monumental *Moses* (1875). Such works served as a substitute for direct instruction, allowing her to learn from the masters through imitation. They also served as a good source of income. In fact, many considered her *Young Octavian* to be the finest copy available in Rome.[173] Still, because of the widely accepted stereotype that people of African descent were merely imitative of whites,

Lewis had to be careful in balancing the sale of her reproductions with her own original works.

She also tried her hand at conceits, or fancy pieces that were extremely popular with collectors. These table-sized, marble sculptures usually took the form of children, often portrayed as sprites or cupids. Lewis may have decided to produce conceits based on the success Harriet Hosmer achieved with her *Puck* (1856) and *Will o' the Wisp* (date unknown). Hosmer created at least thirty replicas of *Puck*, and it proved to be her most profitable venture. Following this example, Lewis rendered *Poor Cupid* (ca. 1872–76) and a matched pair of figures entitled *Asleep* (1871) and *Awake* (1872) that she would exhibit to public acclaim in a triumphant return to America in 1872.

Around this time Lewis completed two portrait busts of Abraham Lincoln, in keeping with a growing number of visual tributes calculated to capitalize on his death in and out of former abolitionist's circles. By doing so Lewis joined several members of the enclave of female sculptors in Rome who combined honoring Lincoln's memory with profit-making marble memorials.

Harriet Hosmer, for example, envisioned a grand monument to Lincoln. As talk of monuments to Lincoln grew and she learned of large sums of money being collected for that purpose, Hosmer proposed a grandiose, tri-level, pyramidal design to honor the slain leader entitled "Freedman's Memorial to Lincoln" (1866). In the end, however, Hosmer's design proved impossibly expensive to execute, and interested parties abandoned their plans.[174]

In the wake of Hosmer's failure, some now had a completely different perspective on how monuments to Lincoln should emerge. A reporter from the *Boston Daily Advertiser* did not question that such a monument be built if that was how the Black community wanted to show their gratitude for their emancipation, but he or she was adamant that all the financial burden be shouldered by them exclusively.[175] The reporter objected to any white participation and quoted from an article that appeared in the *Freedmen's Record* that the monument should be "emphatically the work of freedmen and yet their friends should assist them." Although the *Record* reported that freedmen had subscribed $20,000 toward the project, the *Advertiser* reporter doubted that a largely impoverished population could meet those subscriptions and that "it will not be a freedmen's monument however emphatically it may be called so."[176] Citing Harriet Hosmer's proposed Lincoln memorial, the reporter noted that her plan "is not of necessity the only one which they can follow. A monument costing fifty thousand dollars of their own money

would be far more honorable of them than one costing a million."[177] For the project to be an exclusive Black expression of remembrance, the reporter suggested, "Why may not Edmonia Lewis or some other colored artist make a model of a monument a sum that would be within reasonable limits for the blacks to raise among themselves? Then it would be emphatically a freedmen's monument."[178]

While this proposed memorial eventually came to fruition in the hands of Thomas Ball, with his *Emancipation Group* in 1876, one wonders whether Lewis actively sought the commission.[179] Nevertheless, she chose a more practical route and joined the growing number of artists paying tribute to Lincoln. Again, as a matter of acute business acumen, Lewis realized that she could easily reproduce busts on demand and eventually rendered at least two life-size portraits of the president that survive, one in 1868 and the other in 1872. The earliest version of Lincoln was a head study with a partial view of his shoulders in typical neoclassical fashion, although she eschewed clothing him in classical robes. The second was much more elaborate in execution. The head was identical to the first, but she added a base that contained four small, surrounding, full-figured African Americans.[180] Kirsten Pai Buick identified the 1872 piece as the *Central Park Lincoln* and suggested that Lewis incorporated stylistic elements found in Harriet Hosmer's proposed memorial into the composition.[181]

Of the quality of the likeness captured by Lewis, one critic pronounced it "the most perfect likeness of the martyred President ever carved in marble."[182] After a fire destroyed much of the Central Park Museum in 1881, where her Lincoln sculpture resided, a newspaper account specifically mentioned that Lewis's bust of the president was saved.[183]

Another "flock" member, Vinnie Ream [Hoxie], secured one of the most coveted commissions for a Lincoln memorial when she obtained a much sought after $10,000 congressional committee commission for a life-size statue of the president to reside in the United States Capitol Building.[184] Thus, in 1866, at the age of 18, Ream became the first female artist commissioned to create a work of art for the United States government. Once selected, however, Ream was the center of controversy.[185] Many politicians turned their prejudices against her gender and age to launch spirited opposition and a campaign of slander.[186] Despite the disapproval, Ream unveiled her statue of Lincoln in January 1871. The audience at the event received the work

warmly and marveled at its natural appearance. Ultimately, Ream proved to be a talented sculptor, and much of the resistance against her faded upon the completion of the Lincoln statue.

Still, many of her fellow sculptors—nineteen had sought the commission—felt slighted and continued to vent their frustration of losing out to such an inexperienced woman then barely out of her teens. And some, including the women sculptors of Rome, assumed that Ream, extremely attractive and alluring, had somehow wooed influential men to her side, thereby gaining the commission unfairly in the absence of an impressive portfolio.

The controversy over Ream's Lincoln statue was not lost on Lewis, and she joined the outcry over the younger artist's portrayal of the deceased president. During an interview given in 1873, she offered some critical insights on the subject. When the reporter asked how her fellow sculptors in Rome felt about Ream and her Lincoln statue, Lewis indicated that most found it flawed. Lewis said, "All the English and French sculptors and critics who saw it in Rome used to laugh at it."[187] More importantly, Lewis cited Harriet Hosmer's reaction: "Miss Hosmer felt very much mortified about it, because it might seem to indicate that American artists, and especially the women, were not able to produce anything better than that."[188]

The *New National Era and Citizen* was aware of the negativity surrounding Ream and Lewis's reaction to her saying, "Artists have never been noted for their generosity toward each other; on the contrary, their jealousies have rather been prominent. We are not surprised, then, that Miss Lewis should have indulged in some sharp criticism of her fellow craftswoman—Vinnie Ream. Miss Ream's friend, 'R.J.R.,' above referred to, comes to her rescue gallantly, but by no means discourteously."[189]

Perhaps Lewis had forgotten how much she had to learn when she was just starting out as a sculptor at about the same age as Ream and how some criticized her fledgling efforts. Whether this eventually resonated with Lewis is not known, but when questioned upon her later arrival in San Francisco, she "refused to gratify the reporter's curiosity regarding Miss Ream."[190]

Ironically, Hosmer, Lewis, and Ream shared a patron identified as "Mrs. Crosby" of California. The *Boston Daily Advertiser* reported that "the sisterhood of which Miss Hosmer, Edmonia Lewis, and Vinnie are the prominent members, have a valuable reinforcement in the person of an obscure lady residing in the state."[191]

For those who did not have the good fortune of seeing Lewis at work in her studio, the following description offers the impression she made on one of her supporters, Laura Curtis Bullard:

> Edmonia Lewis is below medium height, her complexion and features betray her African origin; her hair is more of the Indian type, black, straight, and abundant. She wears a red cap in her studio, which is very picturesque and effective; her face is a bright, intelligent, and expressive one. Her manners are child-like, simple, and most winning and pleasing. She has the proud spirit of her Indian ancestor, and if she has more of the African in her personal appearance, she has more of the Indian in her character.[192]

Once more, no matter how well intentioned by the author to offer a fair assessment, Lewis fell victim to a report that devalued her ability as an artist operating at the level of high art and instead focused on the "child-like" qualities and the simplicity of ways expected by many in the dominant culture of Blacks and Indians.

Having assumed the role of active sculptor in charge of her own Roman studio, Lewis was definitely not the fragile, delicate, and hapless creature most men came to expect, even though she was petite. In the studio she wore clothing not considered appropriate for women, partly out of a need to demonstrate her uniqueness but mostly for the freedom of movement. Layers of petticoats and tight-fitting corsets had no place in the sculptor's workspace, especially when she had to negotiate large piles of clay and blocks of stone. She also hammered out her own marble, an act of creating art that demonstrated a remarkable physical prowess that few neoclassical sculptors, male or female, were willing to employ for long periods. Thus, it is not difficult to imagine that some writers assigned her and her female peers masculine personas.

Lewis continued to enhance her reputation as one of Rome's most versatile sculptors by including more religious works in her growing list of accomplishments. She received some much-needed financial assistance in 1870 when the Marquis of Bute purchased one of her works for use as an altarpiece.[193] The *Boston Advertiser* reported, "There is a Miss Lewis here, a sculptress of merit. . . . In common with several score brothers and sisters of the craft, she has been without orders this season, or, if with an order or two, without ready money. A sculptor has to pay rent for a studio, wages for

workpeople, and immense sums for marble which sometimes turns out good for nothing when cut. . . . The Marquis has not only ordered a Madonna from Miss Lewis, to be a copy of one now in the workmen's hands, but also paid her promptly for it, and so relieved the poor girl from embarrassment."[194]

Reports stated that the Marquis purchased the work for $3,000 and built a shrine especially for the sculpture on the Isle of Bute.[195] *The Revolution* reported that it was a "fine group of the Madonna with the infant Christ in her arms, and two adoring angels at her feet."[196] The patronage of royalty served as a kind of official endorsement for the quality of Lewis's work, and others of nobility followed, including art collector Lady Ashburton (the lover of Harriet Hosmer) with *The Old Arrow Maker and His Daughter* and Lady Ophan with *Hiawatha's Marriage*.[197] Such a stamp of approval also endeared her to the American public and enhanced the possibility of future sales from this added exposure.

Lewis's interest in Christian subjects coincided with her reported conversion to Catholicism in 1868. Anne Whitney wrote home that year and informed, "Edmonia Lewis has turned Catholic and her reasons for it are better than her Catholicism."[198] Of course, Whitney was implying that Lewis's conversion was one calculated to gain more potential customers, rather than for deeply personal religious reasons. The true nature of the change remains unknown and open to speculation. Albert Boime saw this switch as a "need to overcome her sense of isolation," which "also raises interesting questions about the pressures of race and class in her new surroundings."[199] Still, Lewis's conversion was genuine and heartfelt in the long term, as she confirmed "the Virgin Mary is very dear to me."[200]

If Lydia Child's condescending attitude toward Edmonia could be attributed to the differences in culture and class, it is easy to imagine that her white associates in Rome could not completely divest themselves from the prevailing prejudices of the day. Some in Cushman's circle likely treated her differently and excluded her from many of their intimate activities. Lewis, as a woman who was unabashedly proud of her dual ethnicity, on occasion ruffled some of the feathers of the "marmorean flock." Her growing notoriety sparked jealousy among them, especially those who saw her work as inferior to theirs and her success based solely on the novelty of her race. In this case some may have readily agreed with Henry James, who noted of Lewis, "One of the sisterhood, if I am not mistaken, was a negress, whose color, picturesquely contrasting with that of her plastic material, was the pleading agent of her fame."[201]

The growing patronizing attitude among some of Lewis's peers may explain an account given by the niece of Horace Greeley, and her attempt to meet the now-famous Black sculptor:

> While we were in Rome four or five years ago . . . I heard much talk about [Edmonia] from her brother and sister artists. I intended at one time to visit her studio and see her work, but several sculptors advised me not to do so; she was, they declared, "queer," "unsociable," often positively rude to her visitors, and had been heard to fervently wish that the Americans would not come to her studio, as they evidently looked upon her only as a curiosity. When, therefore, I did see her for the first time (last summer), I was much surprised to find her by no means the morose being that had been described to me, but possessed of very soft and quite winning manners. She was amused when I told her what I had heard of her.[202]

From this description it appears that some of Lewis's fellow artists circulated reports of negative qualities about her in order to disrupt her career. All previous accounts of those visiting her studio found her cordial and welcoming. In addition Lewis was in no position to turn away any potential customer, and she had always counted on her uniqueness to stimulate interest in her work. Her fierce independence and an unwillingness to allow racist and distracting behaviors directed against her to make her retreat from a profession she had every right to pursue certainly created problems within her social circles in Rome. However, her critics could not control or easily manipulate her. From all indications Lewis refused to be a passive "Negro" when they expected it from of her, and according to Boime she "disregarded the proprieties of upper-class society that still marked the lifestyles of her more advantaged white counterparts."[203]

Thus, Boime's observation that she was isolated seems valid. As the only Afro-Indian, surrounded by white women of privilege in a distant land, she was naturally set apart from the others. This was a detachment based not just on skin color but on class and caste as well. The very nature of Lewis's work helped fuel this feeling of isolation, since she created works that drew from experiences none of her white friends could completely identify with or understand. Therefore, Lewis may have turned to the Catholic Church to find a sense of belonging that had eluded her for most of her life. Further, her

close association with the church gave her an additional source of potential patrons wanting artifacts expressing their devotion.

Perhaps as part of embracing Catholicism, Lewis drew closer to Isabel Cholmeley, an English expatriate living in Rome, of whom Anne Whitney stated that Lewis "looked upon as her best friend."[204] Besides being a devout Catholic, Cholmeley was a sculptor of small portrait busts and rendered one of Lewis that she displayed publicly in 1870. The bust received attention in an article published in the *London Art Journal* and noted that it captured Lewis's racial admixture where "on one side of the head the hair is woolly, her father having been a negro; on the other, it is of the soft flaccid character which distinguishes the Indian race, from which her mother sprang."[205] It would be interesting to know how Lewis felt about this imaginative treatment of signifying her biracial background. Conceivably, Cholmeley intended it to be a visual pun for the amusement of Lewis, given the closeness of the two. The sculpture is presently lost.

As a capstone to her conversion, Pope Pius IX visited her studio and blessed her work.[206] It was also reported that the pope was "kind to her."[207] This may have given some her white compatriots, with Anne Whitney in the lead, another reason to shun her. The facts that Lewis's studio was fast becoming a desirable stop for those making the Grand Tour and, consequently, that her commissions multiplied, likely caused further tension between some of the white women, as their own sales paled in comparison. Whether the other members of the "flock" liked it or not, Lewis had eclipsed all of them in public attention, except for Harriet Hosmer.

Return to America

At some unknown point in her career, Lewis decided to become an expatriate. Although matters of race never vanished fully while she was in Rome, the social climate there was much less racially restrictive. However, Lewis returned to America on several occasions to visit family and friends, and to sell her work. She was in Boston in June 1869. The *Christian Register* reported, "She has returned to this country, after a sojourn of four years in Rome, where she has been busily engaged in the practice of her art. She has completed several works in marble—among them figures of 'Spring' and

'Hagar'—and has made excellent busts in plaster of Charlotte Cushman and Henry W. Longfellow."[208] By July some of Lewis's supporters tried to have the Longfellow bust transferred to marble and presented to Harvard. According to the *Christian Register*, the plaster bust remained in her studio in Rome, but the readers were assured that all who had seen the work considered it "to be a fine specimen of art, as well as a most excellent and truthful likeness of her subject."[209] They proposed that a subscription be started to raise about seven hundred dollars necessary to complete the project.[210] Lewis stated that if any group raised one hundred dollars toward the goal, she would present the organization with a terra-cotta copy of the Longfellow bust.[211]

The Elevator ran a lengthy article on Lewis that succinctly delivered the message of how important she was to "the race" as a successful artist:

> Edmonia Lewis, the young colored sculptor visited our sanctum a few days since. She has just returned from Italy, where she has been pursuing her art several years. One need but look into her large, thoughtful eyes, and bright sparkling face, to know that she is a girl of rare genius. We well remember the admirable bust she made of young Colonel Shaw just before her departure, so much admired by all who saw it. Not having seen her late works we cannot judge of the late progress we hear she has made. As we sat talking with her we thought of all the trials and disappointments she had known, because both of her sex and race, and wondered why our earthly rulers could not be as impartial in granting privileges, as the Good Father has been in bestowing gifts. Proud as we feel at every great achievement of any woman, we always feel doubly so, when one of this oppressed race, by her gifts, commands a place among the favored few of earth's children and proves that genius has no sex or color.[212]

Also during this trip, Lewis presented *Forever Free* to Rev. Leonard Grimes (instead of Garrison) at the Tremont Temple in Boston.[213] Lewis sometimes sent unsolicited work to America with the expectation that her friends and supporters would find a buyer, probably counting on them preferring this to paying shipping costs for a return to Rome. Fortunately, Samuel E. Sewall, an abolitionist lawyer and a close friend of Garrison, took charge of trying to pay for the statue. He decided that because of Reverend Grimes's contributions to African American liberation, he should receive the work and that subscriptions could offset its cost.[214]

Therefore, it is understandable how *Forever Free* represented the ideals Grimes worked so hard to achieve; it was the apt expression of the abolishment of slavery in this country—a masterful blend of gratitude and self-empowerment. The *Christian Register* recounted that the power of the work moved those in attendance that day at Tremont Temple. The reporter wrote, "No one, not born subject to the 'Cotton King,' could look upon this piece of sculpture without profound emotion. The noble figure of the man, his very muscles seeming to swell with gratitude; the expression of the right now to protect, with which he throws his arm around his kneeling wife; the 'Praise de Lord' hovering on their lips; the broken chain,—all so instinct with life, telling in the very poetry of stone the story of the last ten years."[215]

Lewis's supporters gave her a reception at the Phillips Street Baptist Church on November 23, 1869, to "signify their regard for her, as she is about to leave for Rome for professional purposes."[216] *The Elevator* article continued:

> Mr. George L. Ruffin presided. Rev. Grimes spoke in complimentary terms of the professional skill and personal qualities of Miss Lewis. Addresses of a friendly character were also made by Mr. Ruffin, Wm. Craft, J. B. Smith, and others. In the course of the evening Miss Lewis was presented with a purse of money and a handsome ivory mallet. The latter it is proposed she shall use in fashioning in marble the bust of Mr. Grimes, which she has already wrought in plaster. The presentation address was made by Miss N. Smith. A piece of statuary, the production of Miss Lewis, occupied a prominent position in the church.[217]

Although Lewis continued to secure some commissions, she used her profits to purchase more materials. She at times created works in marble that she fancied with the hope that they would attract buyers without prior consent. At this point in her career, her profits, if any, could barely sustain her. Concerning the fate of *Forever Free* as a new source of income, Lewis wrote her friend Maria Weston Chapman, an aide to Garrison, pleading anxiously for a solution to her financial dilemma.

> It seems almost, I was going to say impossible, that not one of my many kind friends have not witen [*sic*] to me some word about the group Forever Free. Will you be so kind as to let me know what is to become of it? And has Mr. Sewall got the money for it yet or not? I am in great need of money. . . . Dear Miss Chapman, I have been thinking that maybe you have met with some

who think that it will ruin me to help me, but you may tell them that in giving a little something towards the group—they will not only aid me but will show their good feeling for one who has given all for poor humanity. . . . Unless I receive this money from home I will not be able to get on this year.[218]

Before Lewis's return to America, Elizabeth Palmer Peabody visited her studio and became aware of Lewis's financial distress. Peabody thought that she had a solution to alleviate the situation. She also noted the incredible amount of attention Lewis was drawing to her studio:

While I was in Rome I went frequently to the studio of Edmonia Lewis being very much interested in the first colored artist sent by America to Europe; and was pleased to find, in cards on her table, how much interest she has excited among Europeans; for it was covered with such an array of names—very many *titled*—as showed that there the color was rather a cause of attraction than of neglect. There were fewest American names, I am sorry to say, and most German ones. From German artists, too, she had received most sympathy and instruction. . . . Miss Lewis has a chance of getting an order for the colossal head of Longfellow, for the Harvard library. Several leading gentlemen have already subscribed, and others will do so doubtless, who can see the photograph at Fields, Osgood & Co.'s, and elsewhere. No patronage of Miss Lewis could be more valuable to her than this, because as Longfellow is the most known and most popular American author all over Europe. She will have a better chance of selling copies of his head than of any other; more especially if it has the recommendation from America of having been ordered, after being seen, for Harvard University.[219]

Lydia Child criticized Lewis sharply for going into debt from making unsolicited marble sculptures and ordered her to stop.[220] Child wrote to Sarah Shaw that Lewis's business practices were not done because of vanity, but because of her "restless energy, which makes her feel competent for any undertaking, coupled with her want of education and experience, which makes her unconscious as a baby of the difficulties which lie in her way."[221]

Some equated Lewis's increasing visibility and public notoriety with financial success even when she still struggled to maintain her career. For example, the *Bangor Daily Whig & Courier* proclaimed, "Edmonia Lewis, the American colored sculptress at Rome is said to have made a large fortune already by her

genius."[222] Another source stated that Lewis received two $50,000 commissions.[223] This amount seems highly exaggerated, as it would have made major headlines in the European and American press and would have resulted in massive sculptures. Still another account reported that Lewis was "overwhelmed with orders for statues from British sympathizers."[224] Of course, there was no validity to these articles, or they were greatly overstated. Such claims suggest some reporters created false accounts to "enliven" their stories. Yet they all aided in a growing construction of Lewis in the public eye as a remarkable American success story based on unimaginable circumstances and the attainment of phenomenal rewards—if nothing else, it made interesting reading and extended the perception of her as a highly successful artist. This would also explain how accounts of Lewis's background continued to change as her reputation grew, with or without her input.

While in America, Lewis visited friends in Ohio and won a commission to render a life-size sculpture of a seated John Brown that she was to complete in the spring of 1871 for the Union League Club of New York City.[225] *The Revolution* reported that when she returned to Rome, she was "just putting up the clay, for, unlike most other sculptors, she will not allow even this mechanical part of her work done by another's hand. Even the tongue of malice cannot say Edmonia Lewis' work is not all her own."[226] The fate of the piece is not known.

Lewis was also in Chicago in September 1870 with her statue *Hagar*. She charged the public twenty-five cents admission to view the work and eventually sold it for $6,000.[227] A "Col. Bowen" was identified as the purchaser.[228] Anne Whitney confirmed this lofty price when writing home, "You know that the enterprising daughter of Africa's Sunny fountains raffled off her Hagar for $6000. Probably she had that business in her eye . . . when she went to America."[229] Once more, Whitney, out of continued jealousy of Lewis's growing fame and ability to find buyers for her work, reductively placed her on the level of a "clever" inferior based on her African ancestry—backhanded praise indeed.

During this visit, Lewis posed for six *cartes de visites* in the studio of the city's leading portrait photographer, Henry Rocher. She appears seated, wearing a stylish jacket, a necktie, and, in some, draped in a covering and wearing a tasseled beret. Her face displays confidence and at times slips into pensiveness, as if she is contemplating her next project. Rocher therefore recorded Lewis as a celebrity artist just as American interest in her was peaking and her future seemed highly promising.

Gwendolyn DuBois Shaw saw within one of the portraits a unique quality. She stated, "The photograph embodies what philosopher Walter Benjamin has called a 'spell of personality' with its representation of Lewis as a worldly woman, independent and liberated, artistic and original."[230] Whether Rocher was aware of the historical importance of taking Lewis's image is not known, but he nevertheless captured a landmark moment in the annals of African American art—the first female sculptor of color in full command of her identity and her craft.

In an interview with Lewis taken in Rome in 1873, the reporter provided a detailed account of her creative space with works finished and yet to be completed.

> You enter and see a few rude beginnings before you, which makes you at once turn to the right, where a small room contains some busts and a number of statuettes. You easily recognize Horace Greeley on one side, Longfellow on the other, and make out without difficulty the costume of Hiawatha and his beloved, who stand multiplied in various sizes before you. Here are two children in one group, asleep, in another awake; and there are four busts representing the four seasons. As you look and examine you feel somewhat bewildered; for there are traces of genius in these sculptures you cannot doubt for a moment, and yet the execution seems so imperfect, and the expression of the fancy busts so peculiar, that you feel you are in the presence of art, but of art in its early beginnings.[231]

The unidentified reporter then noted Lewis's entrance and that she immediately informed that it was payday for her workers, always a difficult time because of her finances. She also praised Greeley and Charlotte Cushman "for the goodness they have shown her." She next explained that she made small pieces for those with "slender purses," because "we must sell our work if we want to live."[232]

The reporter then began a pattern of observations that seemed to accompany almost all interviews with Lewis as if they all were trying to find a "special quality" within her that could explain her ascent to Rome.

> You have, of course, known that Lewis is black but you are hardly prepared to see so few traces of the Indian blood of which you were told she had in her veins, and you look in vain for the signs of genius which spoke so eloquently

from the countenance of the artists you have seen before. As you look more closely, you notice that her eye is bright and glowing with a subdued fire, but her hand is large and uncouth; then you understand at once why her works show much originality in conception, but possesses little virtue of execution. You see, also, why she is particularly happy in capturing a likeness, but not so successful in giving life and softness to marble.[233]

Once more Lewis received oblique praise in the mainstream press for coming this far in the profession. The reporter struggled to see beyond the perception of negative Black stereotypes in an effort to glean some clue as to her ability to create meaningful art. In the end, however, the reporter could not divest preexisting prejudice and found her racially incapable of achieving high aesthetic qualities in her work that measured up to her white peers'.

Lewis arrived in America on June 7, 1872, making landfall in New York City. Still feeling a sense of deep appreciation for the work done by the abolitionists, she soon journeyed to the home of Gerrit Smith in Peterboro, New York, on August 23 and remained until September 3 to begin work on a sculpture of him that was commissioned by his friends. Smith, a noted social reformer and philanthropist, once provided financial backing for the anti-slavery crusader John Brown, and this alone would have made him a heroic figure to Lewis. For some reason, however, Smith proved a reluctant model. He wrote in his diary, "Edmonia Lewis of Rome, Italy comes to take the first steps in putting up my statue in marble. I am surprised and not pleased by it."[234] After the project stalemated, Lewis instead made a cast of the clasped hands of Smith and his wife as a symbol of their undying affection.[235] Lewis translated the cast into marble upon her return to Rome.[236]

Lewis decided to make an exhibition tour of the West during her time in America; she was now a very perceptive businesswoman. She felt the citizens in that region would be more open-minded and receptive to her unique nature and that the area offered less competition than the overcrowded art centers of the East. She said, "Here they are more liberal and as I want to dispose of some of my works, I thought it best to come West."[237] Her brother may have encouraged her to exhibit in San Francisco in particular, since he once lived there and still maintained banking interests in the city.

The celebrity status that Lewis enjoyed in Boston and Chicago followed her to San Francisco, where in preparation of an exhibition, "Mayor Alvord and a Committee of the San Francisco Art Association have generously

granted her the use of their rooms, No. 311 Pine St., between Sansome and Montgomery."[238] The reporter for *The Elevator* noted, "We hope she will be liberally patronized, as she is the only colored professor who ever attained eminence in this department of the fine arts."[239] The reporter also stated that one of the sculptures that accompanied Lewis had received a gold medal at the National Exposition of Paintings and Sculpture, Academy of Arts and Sciences, Naples in 1872.[240] This recognition placed Lewis as the first African American/Native American to garner an international award for high art and solidified her position as a top-ranking sculptor working in Rome.

On August 27 Lewis was introduced to the audience following a lecture delivered by "Bishop Ward" in the hall of the Young Men's Union Beneficial Society. Lewis opened her display on the first of September at the Pine Street Exhibition Hall of the San Francisco Art Association with five pieces, *Poor Cupid, Hiawatha's Marriage, Asleep, Awake,* and her bust of Lincoln. Lewis set her prices lower than usual, for quick returns. Two of her pieces sold quickly, one being *Hiawatha's Marriage* to Mrs. C. L. Low of San Francisco for $550. However, a critic for the *San Francisco Chronicle* did not find her works so appealing and expressed mixed feelings about their quality:

> All the pieces give evidence of considerable artistic taste . . . still there is so much labored finish to them that very little expression is left. The chisel has been used with too much mechanical nicety, and even if the conceptions were originally beautiful, the over careful manner in which they have been carved out would prevent them from ever taking a high rank in art. Miss Lewis is a skillful manipulator of marble and the polish she gives it is very fine, but compared with the works of Powers and other eminent sculptors her efforts make a poor show. It cannot be denied, however, that she has acquired a certain excellence in art.[241]

An article appearing in *The Elevator* was quick to defend Lewis against this charge of artistic inadequacy.

> The "carping critic" of the Chronicle "damns with faint praise." He intimates that from the fewness of the number of pieces of sculpture ("only five") they are "not calculated to impress the general beholder." We have been taught to consider one painting by a great artist as sufficient in itself to form an exhibition. When Vanderlyn's "Caius Marius on the ruins of Carthage" was exhibited

alone in New York, "The Temptation" by Paul de la Roche drew crowds, as did also Landseer's "Twins" and Powers' "Greek Slave." Five pieces of sculpture or paintings by one artist are more than generally exhibited at one time.

The critic shows his prejudice by finding fault with the "labor finish" of Miss Lewis' statuary. That is alone merit. He doubts their originality. Every piece in the exhibition is we believe the original conception of the artist. He says "compared with the works of Powers and other eminent sculptors her efforts make a poor showing." We say compared with any sculptors her efforts make a good show. Powers had been nearly twenty years at work before he produced his chef d'oeuvre, the "Greek Slave," and that is almost a plagiarism of Canova's "Venus." The attitude is the same, only the position is reversed. The expression is similar, the difference is the "Greek Slave" is looking down, and the "Venus" is looking direct. Of one, the right hand is pendant; the other left. The attitude of neither is natural. The attitudes of Miss Lewis' statues are natural and graceful.[242]

The article also cited the intrinsic beauty of Lewis's work:

They all exhibit originality of conception and of beautiful finish. There are no rough nor neglected points; as much care has been spent on the reverse as on the obverse sides. The pose of "Hiawatha and Minnehaha" is perfectly natural; there is an ease and gracefulness which is really charming. The adjuncts are also in keeping: the wampum belt, the fringe on the robe, the quiver and arrows, the wild flowers on the ground; the whole tout ensemble carry out the idea and illustrate Indian life.

The other works are equally as elaborate, and as highly finished. "Caught Cupid" represents the little god of love caught in a trap while in the act of stealing a rose. The idea is also original. The position is natural. The expression of pain on the face of the little pilferer is exquisite.[243]

Another critic applauded the remaining two sculptures:

The two pieces, "Asleep" and "Awake" are very beautiful, perfect creations, and establish Miss Lewis' claim to the high rank as an artist. The little children seem to have fallen asleep while sitting up, the little girl having her arm around her brother. The features are beautiful and extremely natural . . . and we were struck with the wonderful expressive features of the little girl in

"Awake" on half opening her eyes and beholding her dear little brother still asleep, resting on her arm.[244]

Lewis, always a shrewd promoter of her work, sometimes set up her exhibits in booths fashioned as wigwams to capitalize on her Native American identity.[245] She did this during her California tour, seemingly willing to endure the embarrassment of racial stereotyping to maximize attention to her unique origins. When she exhibited three of her unsold works at the City Market Hall in San Jose, more than sixteen hundred visitors came to see them, many perhaps attracted to catch a glimpse of the mysterious Black Indian who lived and worked among the greatest neoclassical artists in Rome. A week later in the same city, she showed her work at the Catholic Fair. A fundraiser secured the Lincoln bust as a gift to the San Jose Public Library, and Sarah Knox-Goodrich, the organizer of San Jose's first Women's Suffrage Association, purchased Awake and Asleep, thus making Lewis's return a great success.[246]

At this time another reporter alerted readers to the enormous progress Lewis had made since leaving for Rome: "Ten years have passed, and the half-Indian maiden has gained a reputation which many artists might envy; but has not, we trust, reached the highest round of the ladder which it has been her good fortune to climb. She is now revisiting her native land, bringing with her some of the works of her chisel. These are now on exhibition in San Francisco, and have received the praise of all art critics in that city."[247]

The reporter verified that Lewis suffered from those wishing to see her fail as an artist solely because of her race. Likely speaking of some of the resentful members of "the flock," among others, who grew increasingly jealous of her success and widespread positive press coverage, the reporter wrote, "We are aware that, in Italy Miss Lewis has enjoyed some advantages on account of the accident of complexion; has met encouragement, where she would not had she been white. We know that this was the case in Boston; but we are still painfully aware that, she has suffered many discouragements at the hand of her own fellow countrymen and women, which have tended to cripple her energies and clip the wings of her progress."[248]

Lewis's exhibition in California was a triumph. The sale of her work eased some of the burden of financing future work, and her notoriety in the region greatly expanded her visibility in the land of her birth. Moreover, the writer of a pamphlet entitled How Edmonia Lewis Became an Artist seemed to come close to deciphering the "enigma" of Lewis and what it took for her to

come so far in the highly competitive realm of high art, saying, "God's gift to Edmonia Lewis is unconquerable energy, as well as genius; and these two combined enable her to rise above all prejudices of race or color, and command the respect and honor of all true lovers of art."[249]

It is likely that Lewis visited her brother during her westward journey. Samuel Lewis was living in Bozeman, Montana, where he operated a barbershop on Main Street. In November, Lewis stopped in St. Louis, where she was the guest of James Peck Thomas and his wife, Antoinette. James Thomas was a noted African American barber and businessperson, who amassed a small fortune by investing in real estate in St. Louis, built and renovated apartments, and invested in railroad and insurance company stock.[250] Antoinette Thomas was also wealthy independently, having inherited more than $60,000 from the estate of her mother, Pelagie Rutgers.[251]

As a family of "colored aristocrats," the Thomases could travel extensively abroad. In June 1873 James Thomas embarked on the Grand Tour of Europe, with Rome as his final destination. He likely sought out Lewis for possible commissions. Whether they met in Rome is debatable, as Lewis may have already embarked on a tour in America around the time of his arrival in the city. Fortunately, Lewis definitely met with Thomas upon his return. The primary request from Thomas and his wife was for the creation of an elaborate, marble cemetery memorial to rise above the grave of Antoinette's mother. The memorial, entitled *The Virgin Mary at the Cross*, was to feature a five-foot figure supported by a three-foot marble pedestal adorned with flowers. Lewis also incorporated into her design a garlanded cross in a crown of thorns and roses.[252]

Thomas also asked Lewis to sculpt portrait busts of himself and his wife. Thus, either Lewis had reference photographs made of her subjects or executed clay studies that she shipped back to her studio in Rome, where she completed the commission in marble in 1874.[253]

While Lewis was in St. Louis, a reporter came to the Thomas house to interview the celebrity sculptor. He first requested her background, and she provided him with her now-familiar story of her rise from Native life, her start in Boston, and her arrival in Rome. She listed some of her major commissions and sales, including her recent success in California, and revealed that she employed four artisans for "preparing the marble for her statuary."[254] Lewis also "expressed her earnest sympathy with the colored people in their aspirations for the attainment of intelligent progress."[255]

Before her departure for Rome, the Grant and Wilson Club held a lavish reception in Lewis's honor at the residence of Peter S. Porter in New York City, on January 13, 1874.[256] Lewis proudly wore a gold medal that she received in Italy for a work of art presented by a committee, "composed of the nobility and artists in sculpture, of which King Emmanuel is the head."[257] Many prominent members of the African American community were in attendance, including Henry Highland Garnet.

While Lewis resisted any studio help during her early days in Rome, the same reporter stated that she now had twenty men at work for her (quite a jump from the four she reported in St. Louis).[258] In either case Lewis had become a successful and important figure rivaling the status of some of the best sculptors in Rome. In fact, the reporter claimed that she now "pursue[d] her calling in a manner as Powers, [Erastus Dow] Palmer, and other of America's great geniuses."[259]

Additional commissions came from cemetery monuments. In 1873 she finished two important statues erected over the gravesites of Lynch Blair at Graceland Cemetery in Chicago and Dr. Harriot K. Hunt (1805–1875) in Mount Auburn Cemetery in Cambridge, Massachusetts. Hunt, one of the first women to practice medicine in the United States, requested a statue of Hygeia, the goddess of good health. Also, the Lincoln Club in New York City promptly ordered a copy of her bust of Horace Greeley.[260]

Lewis was now a major representative of American prowess in sculpture at home and abroad. She was for African Americans aware of her accomplishments much more—a source of intense racial pride. Therefore, the Black press was quick to announce her triumphs and stress her importance as the representative of "the race" in high art. *The Elevator* published an article that elucidated that point while equating Lewis's recent triumph in the West with its perception of the growing upward mobility and acceptance of Black mechanics and artisans by the dominant culture when her exhibition was still running in San Francisco:

> It is not only the mechanical branch to which we would call to the attention of the rising generation, but we would have them excel also in the fine arts. The world of the arts is—cosmopolite [*sic*]—it is universal. It is confined to no race, nation, or color. The schools of Music, Painting, and Sculpture are open to all who possess inclination for the study and practice of those arts. Italy, Germany, France no longer claim a monopoly of those arts. While the facilities

for study and practice are greater in those countries than elsewhere, and students can find associations more congenial to their tastes and habits. . . .

We have now in this city an evidence of the progress which can be made in the highest and most difficult of the fine arts in the person of Miss Edmonia Lewis, the celebrated Sculptress. This young lady, having an intuitive feeling that she could accomplish certain things, applied herself to the task, and finally by perseverance and study has become equal to the great artists of ancient and modern times, and the emanations of her mind and productions of her chisel will compare favorably with the works of Praxilities [sic], Canova, Powers or Harriet Hosmer.

What Edmonia Lewis has done, others may likewise do. If all cannot arise to the same eminence, and occupy as high a niche in the temple of fame, everyone can learn some useful trade or profession.[261]

William Wells Brown further acknowledged Lewis's rise in stature within the African American community when he included her biography in his book *The Rising Son; The Antecedents and Advancement of the Color Race* in 1873. He concluded that section by saying, "The true poetical mind of Edmonia Lewis shows itself in all her works, and exhibits to the critic the genius of the artist."[262]

Now Lewis was eyeing an upcoming venue that had the potential to gain her an undeniable place among the top rank of American sculptors. The Philadelphia Centennial International Exposition of 1876 was still nearly three years away, but she realized that to guarantee a spot at that prestigious event she would have to sculpt something spectacular. However, Lewis was not convinced that in the years she had been away from America, racial prejudice had lessened. Consequently, her strategy to get her work shown aligned with that of Edward Mitchell Bannister, who was also contemplating having a work accepted at the Centennial. Lewis explained, "I intend to make a beautiful statue, as beautiful as I can, and send it to the Philadelphia Exposition anonymously. I do this in order that it may be judged fairly and without favor or prejudice. If it is a success, so much the better for me, when I claim my work before the world. If it is not a success, I shall bow before the public verdict."[263]

In 1875 Lewis received an unexpected monetary boost when she learned of the death of Lizzie Williams, a resident of Bozeman, Montana. Williams was one of the few African American women who lived in Bozeman. She

Fig. 3.6. Edmonia Lewis, *Hagar*, 1875, Marble, 52 ⅝" × 15 ¼" × 17 ⅛", Smithsonian American Art Museum, Gift of Delta Sigma Theta Sorority, Inc.

ran a restaurant in the town and owned commercial buildings. She was also close to Samuel Lewis, once sharing a residence with him and selling him land for his barbershop.[264] Although the full nature of their relationship is not known, she chose Samuel Lewis as the executor of her estate. In her will she left half of her estate to her daughter, Rebecca Brown of St. Louis, and half to Edmonia Lewis.[265] It is likely that Edmonia used this newfound income to expand her vision for her anticipated centennial masterpiece.

The same year, Lewis completed the extant version of *Hagar* [fig. 3.6], as previously mentioned. It appears she improved her original design, if Lydia Maria Child's earlier criticism has any validity. The face of the Egyptian servant girl is expressly appealing in a European sensibility as Lewis continued to eschew imbuing nonwhite subjects with recognizable ethnic features, despite African American and abolitionist readings of Egypt as decidedly "Black."[266]

Stylistically, Lewis depicted Hagar in the standard neoclassical manner, standing erect in a moment of prayer, hands clasped and eyes lifted to heaven, either as she asks God for deliverance from her plight in the desert or immediately after her salvation. This gesture is reminiscent of her

use of the prayerful women in *Preghiera* and *Forever Free*. Lewis included an overturned water pitcher on the base of the work as symbolic of her physical distress in the wilderness but failed to include any reference to Ishmael, who is almost always portrayed in similar treatments of the subject. Lewis's predilection for rendering sculptural groups makes this depiction seem somewhat at odds with her previous work unless she remained focused on illustrating allegorically the plight of women in society, as she stated years earlier.

This work may have provided a clue as to what Lewis was contemplating for the upcoming Philadelphia Centennial Exposition—the use of a historically significant female who references Africa in its linkage to the strength and power of Black women.

The Death of Cleopatra

As has been demonstrated, Lewis's unique background as an Afro-Indian neoclassical sculptor had its own advantages, and her printed struggle to reach Rome and the success she enjoyed there provided readers internationally with a story that almost defied comprehension. Her skill, some might suggest, did not rank with the best of the more celebrated neoclassical artists, but her time spent in Italy gave her increased proficiency, and her work approached their more educated and practiced level. Consequently, her exotic nature, increased coverage in the press, and the respect shown her by some in the American expatriate community in Rome may have led John W. Forney, the commissioner of the Philadelphia Centennial Exposition, to call upon Lewis in her studio in Rome in the summer of 1874.[267] Forney regarded her as an artist of merit whose works offered proof of American prowess in sculpture and extended to her the opportunity to exhibit at the centennial—thankfully, there was no need for her to withhold her racial identity. Although Lewis drew most of her clientele from wealthy Europeans, she used this invitation to increase her visibility in the United States and to attract additional patrons. She decided to capitalize on this advantageous opportunity by investing in a huge block of marble from which to carve what she hoped to be her most important work to date. Upon its completion in Rome, Lewis arrived home in July of 1875 to prepare for the unveiling of *The Death of Cleopatra* [fig. 3.7] at the Centennial Exposition.[268]

Fig. 3.7. Edmonia Lewis, *The Death of Cleopatra*, 1876, Marble, 63" × 31 ¼ × 46", Smithsonian American Art Museum, Gift of the Historical Society of Forest Park, Illinois.

Once back in America, Lewis continued to solicit support for her sculptures. She quickly went to work seeking buyers for smaller pieces that she brought with her from Rome. As was her custom, she reached out to former champions of emancipation, feeling that many wanted keepsakes of their long, hard-fought battle. On July 29, 1875, Lewis wrote to William Henry Johnson, a Black physician and longtime leading civil rights activist based in Albany, New York, to inquire if he would be interested in acquiring a bust of the recently deceased Sen. Charles Sumner.[269] She also indicated that she had already sold several copies of the bust and noted that it was "highly spoken of."[270] In addition, she informed him that she was willing to launch a subscription campaign to meet her price of $200.[271]

Johnson replied to Lewis favorably and concluded his response by acknowledging profound respect for her, saying, "To simply say I would be

delighted to be the possessor a life-size bust of the dead Senator, and to assure you that I would be proud to know that that work of art was the creation of your talent and labor, would but faintly express my true feeling; still language at my command is inadequate to express more."[272]

A testimonial was held to honor Johnson for his distinguished career on August 25, 1875, at the African Methodist Episcopal church in Albany. As part of the lavish ceremony, Lewis was present to unveil the Sumner bust.[273]

On August 5, 1875, a committee met in Cincinnati, composed of Peter H. Clark of Ohio, W. G. Brown of Louisiana, and R. W. Arnett of Pennsylvania, to "procure from Miss Edmonia Lewis a work of art to be placed in the centennial exposition, in the name of the colored women of America."[274] The *Christian Recorder* provided more details of the effort to help Lewis financially:

> The following gentlemen have been appointed by the Editorial Convention at Cincinnati for the State of Indiana to raise funds for the purpose of aiding the Centennial enterprise by encouraging Miss Edmonia Lewis in her art work. Said amount of money when raised to be forwarded to Bishop Payne, viz., Wm. H. Howard, John B. Lott, Alfred Carter, Alexander Moss, John Carter, Henry Stepp, W. J. Sismore, J. S. Hinton. I trust the above gentlemen will be successful in raising the necessary funds to aid in this matter for the colored men and women of America cannot afford to be silent in this great enterprise.[275]

Once delivered to the exposition, art officials placed *The Death of Cleopatra* in Gallery K of Memorial Hall. It weighed a monumental 3,015 pounds and sat beneath a brightly colored canopy of Oriental design to enhance its visibility. Lewis reportedly wished to sell the work for $30,000.[276]

Despite the exposition's preference to highlight the best in American talent and inventiveness, jurors selected only 152 American sculptors out of 673 participants. According to one report, Lewis later recalled how she felt when *Cleopatra* appeared before the Centennial judges:

> She lingered about within earshot of the committee room. . . . She had seen, with trembling for the fate of hers, work after work rejected by the committee. At length the box containing the "Dying Cleopatra" was brought in and opened. "I scarcely breathed," she said. "I felt as though I was nothing. They opened the box, looked at the work, talked together a moment, and then I heard the order given to place it in such and such a position." The Indian

stoicism gave way. Miss Lewis swallowed her sobs for the moment and went home and had a good cry all by herself.[277]

While Lewis was the only Black sculptor represented at the Centennial, she was not the sole female participant. Also included were her compatriots Anne Whitney, Vinnie Ream (Hoxie), Florence Freeman, and Margaret Foley.

Lewis's sculpture received a mixed response from the mainstream. Artist William J. Clark found *The Death of Cleopatra* to possess a strange balance of praiseworthy and questionable features. He remarked:

> This was not a beautiful work, but it was a very original and very striking one, and it deserves particular comment, as its ideal was so radically different from those adopted by Story and Gould in their statues of the Egyptian Queen. Story gave his Cleopatra Nubian features, and achieved an artistic if not a historical success by so doing. The Cleopatra of Gould suggests a Greek lineage. Miss Lewis, on the other hand, has followed the coins, medals, and other authentic records in giving her Cleopatra an aquiline nose and a prominent chin of the Roman type, for the Egyptian Queen appears to have had such features rather than such as would more positively suggest her Grecian descent. This Cleopatra, therefore, more nearly resembled the real heroine of history than either of the others, which, however, it should be remembered, laid no claims to being other than purely ideal works. Miss Lewis' Cleopatra, like the figures sculptured by Story and Gould, is seated in a chair; the poison of the asp has done its work, and the Queen is dead. The effects of death are represented with such skill as to be absolutely repellant—and it is a question whether a statue of the ghastly characteristics of this one does not overstep the bounds of legitimate art. Apart from all questions of taste, however, the striking qualities of the work are undeniable, and it could only have been reproduced by a sculptor of very genuine endowments. . . . The real power of her Cleopatra was a revelation.[278]

Another critic, J. S. Ingram, also found the statue commendable despite some reservations. He wrote:

> The most remarkable piece of sculpture in the American section was perhaps that in marble of *The Death of Cleopatra* by Edmonia Lewis, the sculptress and protégé of Charlotte Cushman. The great queen was seated in a chair, her

head drooping over her left shoulder. The face of the figure was really fine in its naturalness and the gracefulness of the lines.

The face was full of pain, for some reason—perhaps to intensify the expression—the classic standard had been departed from, and the features were not even Egyptian in their outline, but of a decidedly Jewish cast. The human heads, which ornamented the arms of the chair were obtrusive, and detracted from the dignity which the artist succeeded in gaining in the figure.[279]

Likewise, another critic ascertained of *Cleopatra*:

There is a great deal that is good in this piece, and much that is defective, both in work and conception. Cleopatra is represented as dead or dying, with the asp still in her hand, and apparently inserting its fangs in her arm. This is not in accordance with the usually accepted manner of Cleopatra's death, which was for the serpent's bite on the bosom. Aside from this there are many archeological inaccuracies in the work; the ornamentation of the chair is not at all consonant with the Egyptian style as we are made acquainted with it in history. The face of Cleopatra, too, evinces anything but a refined conception of the woman's feature and character, which we are assured by historians was one full of beauty, strength, and intellect. Miss Lewis makes it a coarse, masculine, unattractive visage.[280]

Critics like Clark and others who found Lewis's depiction of Cleopatra far from idealized in the popular conventional neoclassical sense were, in fact, mystified and dismayed by her dramatic shift to a more realistic treatment of the subject. Perhaps such a bold move from a woman and a person of color exposed their deep-seated prejudices and thus allowed for less-than-favorable observations. However, another critic came close to deconstructing the inevitable racist and sexist biases that surrounded the maker of *The Death of Cleopatra*, stating, "Some odd features of the show attract considerable attention, among them the annex of Edmonia Lewis, the colored sculptor, who is exhibiting her 'Cleopatra' and receiving any amount of rudeness and insult from boors who will not believe that such a beautiful creation could come from colored fingers. They should learn to think more of the article and less of the epidermis."[281]

Lewis's choice of Cleopatra was compelling in theme and execution. Visual interpretations of the Egyptian queen remained popular in the

mid-nineteenth century, and viewers and artists alike found the legends of her beauty, power, sensuality, regal splendor, and dramatic suicide captivating. In this period of extreme public fascination with Egypt, the sexual allure of Cleopatra, always a predominant feature of her myth, eventually intersected in America with questions of her racial identity. At no time in the past had race been so strategically scrutinized so that a person's ethnic origins, either contemporary or historic, were assigned to a hierarchy that defended racial purity and asserted white superiority. In this process many reexamined Cleopatra and her lineage to prove her greatness or offer racial explanations for her failings and downfall. Thus, contemporary artistic creations of Cleopatra inextricably linked with the problems of race in the United States. White critics and admirers saw her as Caucasian when stressing her nobility, leadership, and ideal beauty. They saw her as Egyptian, African, or Jewish when her sexual and violent nature was unleashed. Nineteenth-century author and reformer Edward Everett Hale agreed with the latter view when he noted, "A little jet of Greek blood, which Ptolemy brought into this dynasty three centuries ago, is the smallest fraction of this Egyptian's life.... A line of Egyptian mothers for ten generations have made her wholly Egyptian—in this raring hot blood of hers; in this passionate temper; and in the whole quality, even, of her mind."[282] If some like Hale considered Cleopatra to be an exotic being of mixed race, it resonated for American viewers with all the stereotypes of mulattos, quadroons, and octoroons, including their inevitable self-divisions and tragic alienation from white and Black society alike.

Acceptance of Cleopatra as Black, even partially, was unthinkable to some. Ten years before Lewis's African queen was unveiled at the Centennial, the discussion of her Black ancestry led one ethnologist to comment:

> Was Cleopatra a negress? Impossible! The refined, delicate, beautiful and fascinating Queen of Egypt a black negress? If so, is it not passing strange and unnatural that she should have captivated and held in thrall the noble, literary, and epicurean Mark Anthony—a descendant of Japheth? Impossible! Were all the great, the rich and noble of Egypt negroes? The millions of mummies lately exhumed and exposed to view "give the lie to the base slander."[283]

If one is to trust the observations of author Nathaniel Hawthorne, one of the major supporters of Cleopatra's African heritage was William Wetmore Story, whose own sculptural representation of Cleopatra was widely lauded

by critics as the best available during the mid-nineteenth century. Hawthorne visited Story's studio in Rome shortly after the sculptor began his *Cleopatra* in 1858 and came away so impressed that he followed its progress and used the statue as a key motif in *The Marble Faun*, an 1860 novel about an American sculptor in Rome. Although a work of fiction, Hawthorne's description of Story's work in the novel negated historical accounts of the Egyptian queen as being Macedonian and instead envisioned a Black monarch.

Lewis would have been aware of Story's *Cleopatra*, either through firsthand observation before the Centennial or through photographs. Lewis, as an avid admirer of Henry Wadsworth Longfellow, would have also been aware of *The Marble Faun* and read it prior to traveling to Rome to begin her career. Thus, Lewis's reading of Story's *Cleopatra* as distinctively African keeps alive the suggestion that she, too, envisioned an African queen that once sat on the throne of Egypt.

It is understandable that many of the viewers of *The Death of Cleopatra*, knowledgeable of Story's work, would likely draw comparisons between the two sculptures. As such, the fact that Story's *Cleopatra* was nearly twenty years old at the time of the Centennial failed to diminish its power to link Oriental exoticism with deep psychological exploration. Story portrayed Cleopatra slumped lethargically on her throne, solemnly contemplating suicide. Story, like Lewis, was interested in the morbid nature of the subject and the emotional excitement it generated. Instead of portraying the queen close to death or dead, Story depicted Cleopatra entertaining forbidden and abhorrent thoughts in the last moments of her life. His version thus preserved the nobility and decorum inherent in the neoclassical tradition, rather than rendering her "gruesome" demise.

In her more fatalist approach, Lewis took Story's brooding queen a step further by showing the immediate effects of her final act. While much has been made of the shocking qualities of Lewis's version, this interpretation stems largely from the two previously mentioned critiques by William C. Clark and J. S. Ingram. Clark's use of the words "ghastly" and "absolutely repellent" and Ingram's use of the phrase "The face was full of pain," have been echoed in numerous descriptions of the sculpture, but, in fact, Lewis's *Cleopatra* never strayed far from accepted neoclassical aesthetic conventions. The face is not displeasing or upsetting. Rather, the abhorrent effects of the poison quickly sending the queen to oblivion manifest in a tranquil death-sleep. Her body remains at peaceful repose; the right arm, still entwined by

the snake, lies draped across her lap while the left arm hangs lifeless at her side. Her head turns to the side and tilts slightly backward, suggesting that her life's struggles are finally at an end. Lewis's portrayal of the African queen seems remarkably like the following description of a dying Cleopatra from an 1852 issue of *Graham's Magazine*:

> Her hands were folded in her lap, the fingers unconsciously playing with a chain of mingled strands of golden thread and dark, auburn hair. Her face was very pale, and cold, and almost stern in its passionless rigidity. . . . All was composed, silent, self-restrained grief.[284]

A more detailed and revealing description of Cleopatra appeared in the *People's Advocate*, a Black-owned press. It provides insights into the power of the work as audiences viewed it in Memorial Hall:

> In this marble statue the posture is sitting, the Queen's head, turned towards the left, reclines upon the back of the chair—her lips apart—eyelids almost closed, and swollen—right hand laying [*sic*] upon her lap—left arm hanging with all the expression of perverseness, outside of the arm of the chair—features, Egyptian—costume "set out in all the royal ornaments."
>
> The first idea suggested is that the queen is in a profound sleep—closer scrutiny discovers that avoiding the hideousness of wide-open glaring eyes and rigid muscles, Miss Lewis has succeeded in making the eye and left arm tell you that the voluptuous queen is dead, and that she has this moment died.
>
> The treatment is historic and the conception though not original is nevertheless a decided improvement upon any previous portrayal of this event. . . .
>
> Except "The Forced Prayer" by Guanerio, "The Death of Cleopatra" excites more admiration and gathers larger crowds around it than any other work of art in the vast collection of Memorial Hall.[285]

Albert Boime read into Lewis's unorthodox handling of Cleopatra "an embodiment of feminist power" that suggested her "alienation from the neoclassical circle in Rome and gives evidence of anti-feminist feelings turned against herself."[286] There indeed seemed to be some powerful underlying message in the work. Perhaps Lewis used Cleopatra as an allegory of her own ongoing acts of resistance to personal attacks leveled by envious men and women who wished to see her fail publicly and have her finally excluded

from their ranks as praiseworthy neoclassical sculptors. Likewise, the work may symbolize the freedom that she ultimately achieved in rightfully choosing her own destiny.

The innovative power of Lewis's *Cleopatra*, and what must have shocked some of its critics, was not any extraordinary violation of the neoclassical ideal, but rather Lewis's bold decision to render her suicide, an act viewed by the Protestant and Catholic Churches as a grave and mortal sin. The harshness of Cleopatra's death, as depicted by Lewis, cannot be easily explained on prevailing neoclassical terms as an unexpected accident, a fatal disease, or a blissful passing to the "other side." It is a carefully contemplated, self-inflicted departure from the physical world.

Some may assume, perhaps correctly, that Lewis's *Cleopatra* was influenced by ongoing debates over the Egyptian queen's ethnicity and the cultural politics of affirming African contributions to the rise of Western culture. Lewis's familiarity with the "Blackness" of Story's *Cleopatra*, as mediated by Hawthorne's writings, reinforced her own Africanist interpretation. Consequently, she may have embraced the viewpoint of some abolitionists who wished to bolster their arguments for liberation that often included African Americans as part of a highly civilized, noble, ancient race by citing biblical linkages to Egypt and Ethiopia. This ideal was openly vocalized by her close friend, clergyman and abolitionist Henry Highland Garnet, who counted Cleopatra as one of his Black ancestors in his quest to claim a stake in modern culture. In 1848 Garnet wrote, "Ham was the first African," and, "Egypt was settled from an immediate descendant of Ham. . . . Yet in the face of this historical evidence, there are those who affirm that ancient Egyptians were not of pure African stock."[287] Ultimately, Lewis's choice of Cleopatra as the subject of her most ambitious sculpture exhibited at the most prestigious American art venue connected advantageously with the hope that she would produce something memorable "in the name of the colored women of America," a reference establishing the linkage of the statue's "African nature" to Blacks in this country.

Lewis's encounters with other portrayals of Cleopatra may have left her feeling that male sexual fantasies of a long-dead queen undermined any positive ethnic and spiritual ties to an ancient African civilization. The eroticism of Cleopatra, as fleshed out by most nineteenth-century male interpreters, inherently connected with prevailing Orientalist visions of the East where powerless female slaves and concubines surrender to the sexual advances

of white men. It is therefore likely that Lewis deliberately decided to sculpt Cleopatra at death's door to strip away her legendary sexual allure and replace it with messages of strength, dignity, and resistance.

Lewis also seems to have been keenly aware of a growing public fascination with images of sickness and death among women. While this movement would peak toward the end of the century, the popularity of works of art centered on the act of dying began to gain momentum around the time she conceived *The Death of Cleopatra*.

The fascination with death in the Victorian age was reflected not only in art but in literature and poetry as well.[288] While most in the nineteenth century accepted that death was a natural and inevitable consequence of life, the fact that life expectancies were increasing helped focus attention on those who failed to achieve longevity, particularly children and beautiful young women. Written or visual narratives of an untimely or unexpectedly tragic death held audiences of the period entranced by portraying the process as a metaphysically and religiously transformative act. Many sculptors of the mid-nineteenth century capitalized on the public interest and rendered works in keeping with the theme, many times envisioning the act of dying as a kind of tranquil, everlasting sleep.

Lewis's *Cleopatra* also has important parallels with Harriet Hosmer's first major work, *Zenobia*. Standing nearly seven feet tall, the statue champions another heroic and tragic queen. Zenobia was the queen of Palmyra (now Syria), who conquered Egypt and much of Asia Minor. She was defeated and captured by the Roman emperor Aurelian in AD 272 and then forced to march through Rome in chains. Hosmer depicted the Palmyran queen as heroic and resolute even in her hour of despair and intended the chains that bound Zenobia to be directly associated with the oppression suffered by slaves and women in America.[289] The reaction to Hosmer's work in America was overwhelmingly enthusiastic among viewers and critics, and she was regarded as one of America's most exemplary representatives in the world of neoclassical sculpture. The success of *Zenobia* must have served as precedent and benchmark for Lewis, and her *Cleopatra* seems a worthy successor to the Palmyran queen. In addition to its massive scale, *The Death of Cleopatra* shares with *Zenobia* the theme of a defeated, captured royal resigned to a tragic fate imposed upon her by her conqueror. Lewis's work, like Hosmer's, proclaims the dignity and grandeur of a woman in crisis.

Lewis was determined to make her presence known at the Centennial. At times she remained vigilant beside her *Cleopatra* to remove any doubt that a woman of color was capable of crafting such an impressive work. This, unfortunately, exposed her to verbal and physical abuse—she was struck once—from racist skeptics who deemed her an intrusive impostor.[290]

She was also troubled by the lack of attention paid to her by wealthy, educated African Americans despite the recognition *The Death of Cleopatra* gathered from the art critics and the press. She may have counted on *Cleopatra*'s success to gain her new patronage among the Black cultural elite of Philadelphia and beyond. John P. Sampson, a leading educator and African Methodist Episcopal minister wrote on her behalf for the leading African American paper, the *Christian Recorder*:

Standing before this magnificent work of art, wrapped in admiration, and wonder, I asked a bystander some questions in regard to the design and the nativity of the artist, when I was reminded that this was the work of an American colored lady. I said, "Oh yes, I have heard of her, and this is what I have been wanting to see," but really I was so much interested in the work itself that I had not thought of her. Just then a very ordinary looking colored girl (as I thought) offered very kindly to show me other statues carved by the same lady. She took me to another department where I saw several beautifully carved statues of Sumner Giddings, a group of infants &c., all of which seemed to be the center of attraction,—in the class of statuary in which they were found. I am no critic in aesthetics and yet I could see that her works, took the popular eye. I was more surprised when I found that my guide, a plain and unassuming young woman was the veritable sculptress herself. After some conversation, I soon found Miss Lewis to be a downright sensible woman; a young lady of no foolishness, a devoted lover of her race, a woman courageous in the faith of her final triumph and the fullest recognition of the equal brotherhood of the race she so successfully represents. She spoke of her trials and said she rested under the burden of two despised races, the Indian and the Negro. Some of her own people who had been more favored in point of opportunity, gave her no encouragement but came to criticize her work, of the merits of which they knew nothing; it was presumptuous; she had no time for them; and instead of fooling her with our people aping the prejudices of the whites. "I am going back, to Italy, to do something for the race—something that will excite the admiration of the other races of the earth."[291]

Sampson's interview revealed a deeply personal side of Lewis that rarely appeared in her statements to the mainstream press. She mentioned her dual heritage as always, but this time she spoke directly to her African American ancestry and her love for "her people." However, she was extremely disappointed that her love was not returned by African Americans in positions to aid in her perpetual struggles to remain a viable and self-sustaining artist. It is clear that some did not share her artistic vision or her stylistic approach to her work. Perhaps it was her long absence from America that caused her to believe many Blacks had lost interest in her. Or maybe she believed that some criticized her because they saw her art as being devoid of significant statements regarding issues of race. Or maybe they simply saw Lewis as a fading relic of old art traditions who was now more European than American. The rebuffs, whatever their origins, led Lewis to feel rejected and ill prepared to deal with Black prejudiced minds. Her only solution was to reestablish her ties to and reputation within the Black community by rendering something undeniably race affirming. Unfortunately, Lewis never disclosed what she had in mind for "the race," and it appears she never realized this major project. Most of her work done after her return to Rome consisted of portrait busts and religious subjects connected to Catholicism.

In addition to *Cleopatra*, Lewis exhibited other sculptures in the Memorial Hall Annex—marble versions of *Asleep*, *Hiawatha's Marriage*, and *The Old Arrow Maker and His Daughter*. She also sold terra-cotta busts of Henry W. Longfellow, Charles Sumner, and John Brown to fairgoers for eight dollars each.[292]

Despite the high standards to which Lewis set her *Cleopatra*, some attendees to the Centennial objected to the nudity contained in the sculpture. Lewis responded, "The Americans are queer people. Don't you think a lady—a rich lady, too—came to me and said, 'Miss Lewis, that is a very beautiful statue, but don't you think it would have been more proper to drape it. Clothing is necessary to Christian art.' Said I, Madame, that is not modesty in you. That is worse than mock modesty. You see and think of evil not intended. Your mind, Madame, is not as pure, I fear, as my statue."[293]

The triumph of Lewis's Centennial showing was short lived and not a financial success. While living in Philadelphia during the Centennial, Lewis wrote Gen. Samuel Chapman Armstrong, the head of Hampton Institute, a freedman's school in Virginia, for support.[294] Although she failed to mention *Cleopatra*, she did offer Armstrong the opportunity to own copies of the

busts of Brown, Sumner, and Longfellow. She also informed Armstrong that she was poor, perhaps referencing the enormous financial outlays entailed by the creation of the massive statue.

This effort was part of a strategy Lewis used to appeal to African American colleges and universities for their potential as sources of income. She was successful on at least one occasion, when Fisk University in Nashville, Tennessee, purchased a set of her terra-cotta Centennial offerings—John Brown, Charles Sumner, and Henry Wadsworth Longfellow.[295]

Before returning to Rome, Lewis traveled to St. Paul, Minnesota, in October to display her work and seek buyers.[296] According to the local *Daily Globe*, no one initially came to see her sculptures. The paper claimed that it was through their recognition of her "genius" that they were "the first to discover and draw attention to her wonderful work."[297] The paper also noted that she sold two sculptures during her stay and that she helped lead the way for the city to become more active in the promotion of the fine arts.[298]

The Final Years

By the 1880s Americans were rapidly losing interest in the neoclassical style, and they began moving on to art forms that reflected a modern aesthetic. Ironically, *The Death of Cleopatra* closely coincided with the death of American neoclassicism. All great movements in art eventually fall from vogue, and most artists firmly entrenched within an older tradition fail to make the transition to new ways of art making. This was the case with many of the neoclassical sculptors, including Lewis. Consequently, Lewis's presence, public and private, during the remaining years of her life soon faded from the historical record.

However, fragments of information remain on her activities after the Centennial Exhibition. Former President Ulysses S. Grant sat for a portrait in Rome in 1878, emphasizing that she managed to retain her celebrity status for a while. During a stop in Indianapolis that year to exhibit her work, Lewis said, "Gen. Grant sat for his bust in my studio last February. The General came there with McMillan, the consul general. That is the bust I have with me now. I shall see if the church people don't want to subscribe enough to buy it. It would cost anybody else $300, but I will let them have it for a good deal less."[299] When the reporter asked her if Grant was pleased with his portrait,

Lewis remarked, "Oh, yes, but he didn't say much; he is such a quiet man. He is the only president we have ever had who doesn't talk much. He will be the next president. I don't know who is any better fitted for that position. I was invited to the grand reception given him, and I went."[300]

During this interview, the reporter described her as "rather small in stature, with the regular features of her race, and in color is a little lighter than the ordinary negro. Her eyes, however, are large, brown and sparkling, her forehead is broad and high, and her hair is allowed to fall over her shoulders untrammeled by bow or ribbon. She is a charming conversationalist, using the choicest language, shows a wonderful enthusiasm in her work, and speaks freely of her past life and future prospects. . . . 'My features . . . I take from my father, but my spirit, my industry and perseverance I get from my Indian mother.'"[301]

When the reporter asked Lewis about the remunerative side of her career, she responded in a manner that sounded like a blueprint to overcoming all obstacles, including matters of race and gender. She said, "I have supported myself ever since I made entrée into its circles. Sometimes the times were dark and the outlook was lonesome, but where there is a will there is a way. I pitched in and dug at my work until now I am where I am. It was hard work, though, but with color and sex against me I have achieved success. That is what I tell my people whenever I meet them, that they must not be discouraged but work ahead until the world is bound to respect them for what they have accomplished.[302] Perhaps more importantly, when the reporter pressed Lewis on the issue of race, she responded with a resounding statement as to why expatriation was her ultimate salvation. She said, "Why, I am invited everywhere, and am treated just as nicely as if the bluest of blue blood flowed through my veins."[303]

Earlier, Lewis was in Chicago, where she exhibited *The Death of Cleopatra* at the Chicago Interstate Industrial Exposition. Once more it drew considerable attention. Lewis said, "I came here to exhibit my statue of the death of Cleopatra at the fair in Chicago. It took me a long time to finish it. I worked for four long years on it. It was visited by 30,000 people in Chicago, and I believe it was pronounced a success."[304] She concluded, "The Chicago people have my Cleopatra still and want me to come back next year and exhibit it again. I may come back—I would like to, and perhaps I will."[305]

However, it appears Lewis did not return, and she was unable to find a buyer. In addition, shipping the massive piece back to Rome proved to be too expensive. Thus, the regal queen remained in storage in Chicago for years.

In addition to her showing of *Cleopatra* in 1878, Lewis secured an order from the St. James Church in the city for her *Madonna and Child*, as well as a statue of St. Joseph.[306] Prior to her departure for Rome, she continued her associations with the Black community. In December 1878 she was in New York to attend a "grand reception" given in her honor at the Shiloh Presbyterian Church. There she unveiled a life-size marble bust of John Brown and presented it to Rev. Henry Highland Garnet for his contributions to "the race."[307] In Garnet's remarks on the occasion, he said of Lewis:

> Were I able physically I could talk to you at greater length, for my heart and mind are full to-night of things that this occasion calls up. We have with us a young lady who has honored us at home and abroad. By a peculiar arrangement of Providence, she has in her veins the blood of the only two races that have been outraged and persecuted by the white man. Her mother was a Chippewa Indian, and her father an African. She has gone forth to rescue both races from the inferior position in which they have been placed by her skill in her chosen field of art. She tells me that she has executed nine busts like this of John Brown, and I notice with delight that she chooses for her subjects, men who have been heroes, and who have suffered martyrdom for freedom."[308]

Even at this date, long removed from the struggle to end slavery, Lewis continued to reach out to the "old guard" for support based on the extended memory of those who venerated the champions of liberty and wished to have a tangible reminder of their greatness.

Lewis's success and celebrity drew the attention of the *New York Times* during her brief stay in the city. A lengthy article published in the paper perfectly framed her struggle to circumvent the obstacles of race she encountered in her career by simply headlining, "Seeking Equality Abroad." The reporter, notably, offered a very different version of how Lewis was motivated to become a sculptor, claiming that she had visited Boston as a child and, upon an encounter with a statue by William Wetmore Story, decided on the spot to pursue art with a "passion."[309] Whether Lewis had once more adjusted her origins to intrigue and entice her audience is not known, but she did find an opportunity to state openly how racism forced her into expatriation. Lewis said, "I was practically driven to Rome, in order to obtain the opportunities for art culture, and to find a social atmosphere where I was not constantly reminded of my color. The land of liberty had no room for a colored sculptor."[310] Lewis

concluded that even though Rome allowed her some relief from oppressive racism, she still endured unwanted responses to her color. She said "They treat me very kindly here, but it is with a kind of reservation. I like to see the opera, and I don't like to be pointed out as a negress."[311]

In 1879 Lewis made news in America, but it was not concerning her latest exhibition or the unveiling of a new public work. Rather, Lewis was involved in a lawsuit in which James Peck Thomas forced her to take legal action. As mentioned earlier, Thomas commissioned Lewis to sculpt a cemetery monument for the grave of his wife's mother. Lewis complied but Thomas and his wife were displeased with the final product. Lewis charged $2,600 for the statue, *Virgin Mary at the Cross*, and agreed to installment payments. However, she failed to receive her last payment of $600. According to a newspaper report, Thomas and his wife declared the work "a botched job" and "not a work of art."[312] The case went to trial in St. Louis Circuit Court, and representatives from both sides presented their evidence; Lewis remained in Rome. The *St. Louis Globe-Democrat* stated that "the contract was to make a figure of the 'Virgin Mary at the Cross,' in accordance with a clay model shown to Mrs. Thomas, and enthusiastically approved by her."[313] The testimony of art experts was contradictory. An Italian artist, Lefano Maisit, stated that "the statue was of the finest marble and made in strict accordance with the clay design, and was artistically executed."[314] Other experts supported the plaintiff, including George W. Harding, who claimed "the chief value of a statue was the 'original design.'"[315] Another witness testified that the work was "an elaborate piece of art" but admitted that one arm of the Virgin was shorter than the other.[316]

Thomas's lawyer countered that the work was not perfectly executed and that the base was hollow and so top-heavy that it was susceptible to falling over from a strong gust of wind. In addition, some "St. Louis men" who worked in a local marble yard testified that Lewis's work was a "patched up job."[317] Also, Thomas's lawyer claimed that Lewis had rendered the crown of thorns out of wire instead of marble and that she omitted the roses altogether.[318] Other alleged defects emerged from testimony including the fact that the statue was only four feet eight inches tall instead of the agreed-on five feet, the Virgin and the cross were separate pieces and attached by a clamp, and that the posts were solid plaster instead of marble.[319]

Although defining what is and is not art remains a debatable subject, the case rested upon whether commissioners of a piece of art have the right to

refuse it if it does not meet their expectations. In his ruling the judge awarded Lewis $600 and, on the counterclaim, he awarded the defendants $599, leaving an amount due on the statue of one dollar. Thomas did not take possession of *Virgin Mary at the Cross*, and its location remains unknown. Almost five years later, an article appeared that stated that a judge ruled against Lewis on appeal and awarded Thomas and his wife $2,200.[320]

Also in 1879 Lewis finished a work entitled *The Bride of Spring*. At four feet tall, the sculpture served as an allegorical representation of the season, showing a young woman in a standing position with the lower part of her body ringed in roses and other flowers that add to a sense of renewal and restoration. A wreath of flowers also surrounds her head. Lewis may have drawn inspiration for the work from classical depictions of Flora, the Roman goddess of flowering plants. The work suggests that Lewis was gaining more confidence in her sculpting ability and challenging herself to move from more familiar and comfortable techniques. Italian sculptors often attempted veiled figures to demonstrate their expertise at carving marble. In this regard Lewis drapes the figure in a veiled effect that covers the figure and wraps around it sensuously from head to ankle. She skillfully treats the face to give the impression that the covering envelopes it, yet through the illusionary translucency of the veil, it manages to soften the delicate features that lie beneath its surface.

Lewis exhibited *The Bride of Spring* in New York in October 1879.[321] She also showed it in Cincinnati in the same year, at a Ladies' Bazaar held to help relieve the indebtedness of Archbishop Purcell. According to a newspaper account, "The venerable prelate visited Miss Lewis at her studio in Rome, and secured her a great deal of patronage, and as a token of her gratitude she unveiled this piece of work."[322] A hospital in Cincinnati later purchased the statue.

Lewis also rendered a bust of Bishop Daniel Payne of the AME Church in 1880 to strengthen her connection with the Black community, but for unknown reasons she decided to delay the unveiling. A reporter described it as "a great disappointment to quite a number of persons who were anxious to view the work of a colored sculptress."[323] Perhaps she was not satisfied with the likeness or found the financial arrangements not to her liking, but she eventually completed the work for presentation in Philadelphia. Poet and scholar Melba Joyce Boyd noted that "the bust was officially unveiled and dedicated to his memory, [Frances Ellen Watkins] Harper read her poem, 'To Bishop Payne.'"[324]

Further evidence of Lewis's celebrity came in 1882 when author Phebe A. Hannaford included her in *Daughters of America; or, Women of the Century*, an expansive volume of biographies that honored women's achievement in the country's first century. Hannaford quoted directly from a published report on the artist that appeared earlier in the *Christian Register*. However, the fact that the author included Lewis attests to her wide notoriety and her importance to the advancement of women's causes in the nineteenth century. In this book Lewis received equal treatment along with other female artists living in Rome, including Anne Whitney, Emma Stebbins, Margaret Foley, and Harriet Hosmer.

Lewis still managed to receive commissions during the 1880s, most connected to the Catholic Church and its members. In 1884 Lord Bute requested another work, this time of the Virgin Mary for one of his chapels. He paid Lewis $3,500.[325] In 1886 she completed *Adoration of the Magi* and installed it at St. Mary's Chapel in Baltimore.[326] Her strong Catholic faith and her continued interest in religious subjects remained evident. A description of the work follows:

> *Adoration of the Magi* is a large, semi-circular bas-relief marble sculpture about 5 feet in diameter. Its style is similar to the 1874 panels of Lewis' *Hygieia*. The three wise men are on the [proper] right, facing baby Jesus, who appears on the [proper] left with Mary and Joseph. The wise men are depicted as Caucasian, Asian, and African, with the African wise man most prominent.[327]

Unfortunately, fire destroyed the church in 1947, resulting in the loss of *Adoration of the Magi*.

Also in 1886, Lewis completed a marble bust of Reverend W. F. Johnson, the superintendent of the Howard Colored Orphan Asylum in New York.[328] As part of the unveiling ceremony, she also sent the marble sculptures *Ruth, Abraham Lincoln, Hiawatha,* and *Minnehaha,* and a medallion of the Johnson's daughter, Florence. Johnson arranged an exhibition of these pieces at the orphan's fair during Thanksgiving week.[329]

Frederick Douglass wrote of Lewis in his diary during a European honeymoon in January 1887. He noted that he encountered Lewis while strolling on the Pincian Hill overlooking Rome.[330] She served as guide and interpreter for Douglass and his wife, although her constant use of Italian had "somewhat impaired her English."[331] Lewis accompanied the couple to a museum to see

"the pictures and statuary and many objects of interest taken from the ruins of Pompeii and Herculaneum."[332] Douglass said of Lewis's life in Rome, "Here she lives and here she plies her fingers in her art as a sculptress. She seems very cheerful and happy, and successful."[333]

Lewis remained relevant to African Americans as a symbol of success and potential well into the 1880s. An essay entitled "Women of the Race: Their Practical and Creditable Progress," circulated throughout the Black press in 1887 listing the notable achievements of contemporary Black women. Lewis was the first featured, with the writer declaring, "Probably the colored woman who has achieved the most marked success is Miss Edmonia Lewis, the sculptor."[334] In July of that year, the *Cleveland Gazette* reported, "Miss Edmonia Lewis the colored sculptress, is at work on a new piece of statuary at her studio in Rome, Italy, which bids fair to eclipse all her former efforts."[335] Unfortunately, the reporter did not identify the nature of the piece—perhaps it proved to be too much of an undertaking and Lewis abandoned it. However, Lewis did complete a statue of Saint Charles Borromeo, the former archbishop of Milan, whom many venerated as a saint of learning and the arts in 1888.[336] The *Milwaukee Daily Journal* described the work as follows:

> Miss Lewis' statue represents him standing in an attitude of silent prayer, a crucifix in his right hand, the rope of penitence around his neck, and his eyes raised to heaven in eloquent supplication. The purple cassock is exquisitely wrought; so is the short Roman stole, with the crown and motto "Humilitas," which St. Charles substituted everywhere for the family arms.
>
> This first statue is the property of Mr. Richard Dixon of Brooklyn. A larger copy of the statue will probably be ordered by Father Ward, rector of the Church of St. Charles Borromeo, in Brooklyn.[337]

The Death of Cleopatra resurfaced at the old Exposition Building in Chicago in 1891 during an orange carnival and exhibit. It was not part of the festivities, and attendees who caught a glimpse of the great statue did not realize its significance. A reporter covering the exhibit, however, immediately recognized "the African queen" and wrote:

> Not connected with the orange show, but in a dusky and dusty corner of the same part of the building is an object to be glanced at casually and wonderingly. It is the Carrara marble "Cleopatra" of the little sculptress Edmonia

Lewis. The figure is not by any means a wonderful production, but certainly good enough to deserve a little better treatment than to be hidden in the dust of this particularly dirty locality. The marble is so begrimed that it scarcely is recognizable as marble, the end of the tapering sandal is broken, several fingers and toes are missing, and after a few months more of such usage, there would be a chance for restoration as of a veritable antique. Perhaps the Exposition managers are planning for such a result, and expect to bring the work before the public again. . . . Her ignominious position among the oranges is not the lowest place to which the mighty has fallen, for at the 'fat-stock' show she could be found hustled off among the boxes and stalls. The proud daughter of the Ptolemys seems to be claimed by no one, and one wonders whether even Miss Lewis has lost all interest in her.[338]

As *Cleopatra* became a distant memory, Lewis took up a new challenge to make one more impressive showing in America. She turned her attention to the upcoming World's Columbian Exposition, a major world's fair held in Chicago in celebration of the four hundredth anniversary of Columbus's arrival in the Americas. Some members of the Black community tried to ensure her presence. A group of Black women from Allegheny County, Pennsylvania, solicited Lewis to create a work "for the purpose of furthering the race's representation at the world's fair."[339] They wished for her to create a life-sized bust of Phillis Wheatley, the slave poet from Boston, in commemoration of Black women's achievement. This newspaper account also confirmed that Lewis was now living in Paris.[340] She may have been drawn there as "American Neoclassical sculpture began to decrease in popularity as a style by the mid-1870s, when its tenets of nuanced sentiment and ideal form were superseded by the pulsing surfaces and expressive realism of the Paris-based Beaux-Arts aesthetic."[341] Thus, Lewis may have relocated to adapt her style to changing artistic tastes and, consequently, continue to make a living as a sculptor.

Lewis's response to the group appeared in print, thus offering a rare glimpse of her mind-set during this time.

Dear Miss McCandless—I have just received your communication of Jan. 10th. In the first place allow me to thank you for your efforts in behalf of the colored women of your city. They should be represented at the World's Fair, and I think a life-sized bust of Charles Avery, as suggested, would be a

touching tribute. You say that not more than $300 can be raised by them. My price for a life-sized bust in bronze or marble is always from $500 to $600.

But I will not stand on price now after so many years of my life are passed and never before have colored people given me such recognition, so you must know that I did feel proud when I read in the paper you sent me, the Commercial Gazette, the article "Action taken." I will therefore execute in bronze the life-size portrait bust of Mr. Avery for the agreed price of $300, and will begin work as soon as I receive your order. Send me good photographs or engravings, front view and also profile. Forward them immediately as there is no time to be lost. I will guarantee good work or not any.

May I trouble you to send me the names of the women who are doing this? I want them for myself. This is indeed a little history and always to be remembered. Thank them all for their appreciation of me.[342]

Upon further reflection, the group decided to change their request from Avery, the white abolitionist who fought against the Fugitive Slave Laws, gave sums of money to help found Liberia, and created educational facilities for Blacks, to someone more representative of the cause of black women, deciding "that if they were to raise the fund and Miss Lewis was to make the tribute, the tribute should represent the most gifted lady of the race—Phillis Wheatley, the poet, instead of Mr. Avery, the deceased benefactor (white)."[343]

With the anticipation that she would have the opportunity to exhibit her sculpture, Lewis committed to the great expense of shipping several of her works to Chicago. The *Cleveland Gazette* reported, "Miss Edmonia Lewis, the sculptress, has shipped her art collection from her studio at Rome to America to be placed on exhibition at the world's fair."[344] The *Huntsville Gazette* echoed, "Miss Edmonia Lewis our colored artist of Rome who will soon set sail for home with studio and effects to attend the fair, is the executor of the beautiful bust of Longfellow which is first on the right, as one enters the great Memorial Hall at Harvard."[345]

Organizers at the World's Columbian went to great lengths to prominently display fine art productions, especially those done by Americans at home and abroad. However, they conspired to downplay the role of women as leading artists and, after loud protests, compromised by agreeing to display their work in the separate Women's Building. It was here that Lewis showed several "statuettes" placed there by her supporters.[346]

Although Lewis became a participant at the World's Columbian, other African American contributors to American progress met with almost total exclusion. In their zeal to show American advancement since the time of Columbus to the world, fair organizers promoted white males as the major contributors to significant American accomplishment and culture. Anything "Black" at the exposition was restricted mostly to ethnological exhibits, assembled by renowned anthropologist Franz Boas, of "lesser" cultures from around the globe. Fair officials displayed Africans much like zoo animals and depicted them as savage creatures clinging to the lowest rung of civilization. Notable and attributable contributions by African Americans to the country's growth were ignored or erased. Prominent pro-Black leaders such as Ida B. Wells, Frederick Douglass, Albion Tourgée, and newspaper publisher Ferdinand L. Barnett quickly recognized and denounced these slights, and a great public outcry from the Black community led to the organizing of the symposium, Congress on Africa. This "counterevent" was held in Chicago simultaneously with the World's Columbian, and it was from this "pulpit of racial enlightenment" that Henry O. Tanner delivered his lecture on African American art that surely included the achievements of Edmonia Lewis.

Dr. William H. Johnson of Albany, New York, loaned Lewis's bust of Charles Sumner to the Cotton States and International Exposition held in Atlanta in 1895. As with a small world's fair, the organizers sought to increase trade between southern states and South American nations and highlighted the region's products to the rest of the nation and to Europe. Six states exhibited their industrial and agriculture offerings in individual buildings, and special units contained the accomplishments of women and Blacks. Those in attendance could view Lewis's work in the Negro Building. Dr. Johnson wrote, "I value the gift very highly; no money could compensate me for it, but in the interest of my race, and to add something to the success of the Negro exhibit of the Exposition, I will readily comply with the request."[347] The reporter who took Johnson's statement added, "In having one article of Miss Lewis sculpture, the negro exhibits score a victory."[348]

This positive assessment of a Lewis sculpture in Atlanta was not shared by all who viewed it. Another reporter said, "Edmonia Lewis, who now lives in Italy . . . has forgotten all about her African extraction. The negroes point to it proudly and say that 'anyway it was made when she was a negro.'"[349] At this late date in her career, Lewis and her reputation were nothing more than rapidly fading memories to many who recalled her only from old reports

in the Black press—a faceless "missing person" whom they saw as having turned her back on "the race" because of her long period of exile. This was obviously an unexpected price that Lewis had to pay to realize her dreams of becoming an internationally renowned sculptor.

Interestingly, Henry O. Tanner was exhibiting his *Bagpipe Lesson* at the same venue and had spent several years living in Paris. The verdict was still out on the level of his Blackness as gauged by the Atlanta fair attendees. The reporter noted, "Whether he has about forgotten that the blood of the African runs through his veins or not, the attendant at this exhibit was unable to say."[350]

Bishop Henry McNeal Turner, in an essay assessing the Cotton States Exposition, cited Lewis and her earlier triumph with *The Death of Cleopatra* but said that since her genius bloomed in Italy, "we can claim no credit for the recognition given her."[351] In Turner's mind, America in 1895 still failed to cultivate the talents of African American artists at home. Unfortunately and sadly, his words rang with an undeniable truth.

Lewis's brother, Samuel, died in Bozeman, Montana, in 1896 after a brief but painful illness. He left behind a widow, Melissa Bruce, the mother of five children from a previous marriage, and a son, Samuel E. Lewis (1886–1914), then twelve, that he fathered with her. His lengthy obituary acknowledged Edmonia but gave no information about his having a Native American past. There is no evidence that Edmonia attended his funeral, but Samuel did leave her a substantial sum of money. According to Harry and Albert Henderson, the will of Samuel Lewis, dated March 26, 1896, "bequeathed shares and deposits in a savings and loan society in San Francisco to my sister Edmonia Lewis, now residing in the city of Paris France." After settling fees and many claims against the estate, Melissa Lewis sent $8,142.75 to Edmonia on February 12, 1898.[352]

Lewis again made news in America when, at a charity ball held in Philadelphia in 1897 to aid the Frederick Douglass Memorial Hospital and Training School, the feature of the evening was the presentation of her bust of Charles Sumner by Reverend P. O'Connell and "its acceptance on behalf of the hospital by Rev. J. P. Sampson."[353] The following year Lewis returned to America, on September 17 aboard the steamship *Umbria*. The *New York Age* reported, "She returns to her American home for a few months and has brought several pieces of her art work. Miss Lewis is the guest of Professor and Mrs. Johnson, 769 Herkimer Street, Brooklyn."[354] As far as is known, this was her last visit to the land of her birth.

By 1901 Lewis was living in London. Perhaps she moved there to be close to Amelia B. Edwards, the English novelist whom Lewis once described as "one of my dearest friends."[355] While there Lewis joined a Catholic community in the Hammersmith area and remained there for the last years of her life. Experiencing a decline in her health, she composed her will. Harry and Albert Henderson said that it "called for a coffin of dark walnut and a service at Our Lady of Victories. She named a priest as her executor and main beneficiary. The huge Kensal Green Cemetery, which has a section for Roman Catholic burials, would be her final resting place."[356]

According to cultural historian Marilyn Richardson, Mary Edmonia Lewis died in obscurity in London, England, on September 17, 1907, at the Hammersmith Borough Infirmary.[357] Doctors diagnosed chronic Bright's disease as the cause of death. She was about sixty-three years old at her passing.

Unlike for Robert S. Duncanson and Edward Mitchell Bannister, there were no glowing tributes or lengthy obituaries offered. In the end, she was a forgotten expatriate buried in a foreign land. This would seem a sad conclusion to a life so triumphant in the art-spirit. Yet she proved to a skeptical world that people of color could aspire to the fine arts in sculpture and make significant contributions. Perhaps the greatest tribute to her came in 1871, just as she was making her mark in the art world. A reporter visiting her studio in Rome remarked:

> In her struggle to reach the goal of independence, she finds herself heavily weighted by her sex, and in addition to that burden, she has to bear also . . . the prejudices felt against color and race[;] she needs a vast amount of enthusiasm and courage to venture into the field at all.
>
> That enthusiasm and that courage Edmonia Lewis had, and the result has justified her dauntless faith in the power of a strong will, and an untiring patience to conquer all difficulties.
>
> And if ever a woman had a rough path to tread in her road to success, that woman was Edmonia Lewis.[358]

EPILOGUE

American Masters Reclaimed

Robert Seldon Duncanson, Edward Mitchell Bannister, and Mary Edmonia Lewis were exceptions in an age of oppressive racism. In their pursuit of cultural equality, they refused to become victims of societal restrictions and abandon their dreams of parity with celebrated white artists. They ultimately succeeded based on the quality of their work, which was, on many occasions, extraordinary.

As American art historians at the turn of the twentieth century reflected on the previous one hundred years of great advancements and glorified those who represented the country with distinction, Duncanson, Bannister, and Lewis were neglected, rejected, marginalized, and discarded from almost all written evaluations of the period, even though they were clearly exemplars in fortifying the country's national identity in the fine arts. In addition, despite their considerable accomplishments as nationally and internationally acclaimed artists, the lasting reputations of these artists suffered greatly when major American art museums excluded them from their collections. As a result, their works remained hidden largely in private homes or in storage for decades as memories of their greatness quickly faded.

Therefore, the legacies of Duncanson, Bannister, and Lewis disappeared from the collective art memory of the country for no other reason than their ethnic identities. Simply put, American art history, much like American society in the main, had no need to acknowledge any Black contributions that moved the "meter" of race relations positively, despite undeniable historical evidence.

It was only in the wake of the modern-day civil rights movement and the subsequent Black Power movement that these artists resurfaced nationally, as scholarly Afrocentric attempts to recover past glories proved fruitful.

This search was made easier thanks to the efforts of early historians like William Wells Brown, with *The Black Man: His Antecedents, His Genius, and His Achievements* (1863); Carter G. Woodson, with *The Negro in Our History* (1922); Alain Locke, with *Negro Art: Past and Present* (1936); and James A. Porter, with *Modern Negro Art* (1943), who valued and preserved the memories of artists like Duncanson, Bannister, and Lewis and thankfully ensconced their legacies within the African American community as a matter of immense racial pride.

Presently, much in the name of political correctness, Duncanson, Bannister, and Lewis enjoy secure places in leading museums, galleries, and private collections—deservedly so. But while many of their works have been recovered and appreciated, a detailed accounting of their personal lives remains elusive. What we know of them comes mostly from the press, and these artists understandably kept their intimate thoughts about race and racism to themselves, only rarely referencing their views on the impact it had on their careers. As such, we can never know them fully.

But we do know conclusively that Duncanson, Bannister, and Lewis sought an extraordinary form of personal liberation and creative freedom that led them to become widely accepted innovators within prevailing canons of contemporary art despite socially restrictive actions and the advantages of white privilege that worked against their chances of success. Perhaps the unnamed author of an article published in the journal *Opportunity* expressed the ultimate tragedy of this level of oppression: "Above all else the artist must be free. In an atmosphere permeated with the poisonous fume of racial prejudice, the sensitive soul is apt to be withered and the spirit crushed. This has ever been the tragedy of the Negro in America, and in the same measure, the tragedy of America. For America has lost heaven knows how much by the thoughtless disregard of the spiritual cost of racial prejudice and hate."[1] In this regard, Duncanson, Bannister and Lewis must be viewed not only as exceptionally "free" pioneers of African American art but also as resolute survivors who defied opposition from the dominant culture and triumphed.

Finally, this book has demonstrated that Duncanson, Bannister, and Lewis long ago deserved inclusion among their more illustrious and acclaimed peers—the historical record is extensive enough to verify that. They are, as much as any other distinguished artist of their era, a vital part of our proud collective heritage in the visual arts—true American masters.

NOTES

Introduction: The "Artistic Ancestors" of Henry O. Tanner

1. For a comprehensive account of Tanner's art and scholarly reactions to it, see Anna O. Marley, ed., *Henry O. Tanner: Modern Spirit* (Oakland: University of California Press, 2012). For the most recent biography of Tanner, see Naurice Frank Woods Jr., *Henry Ossawa Tanner: Art, Faith, Race, and Legacy* (London: Routledge, 2017).

2. Tanner's early struggles are elucidated in Henry O. Tanner, "The Story of an Artist's Life, I," *World's Work* 18 (June 1909).

3. For a detailed account of Eakins's method of instruction, see Charles Bregler, "Thomas Eakins as a Teacher," *Arts* 17 (March 1931): 383.

4. One episode of racism directed at Tanner at PAFA is detailed in Joseph Pennell, *The Adventures of an Illustrator Mostly in Following His Authors in America & Europe* (Boston: Little, Brown, 1925), 53.

5. For an examination of Tanner's time in Atlanta and his studies at Julian, see Woods, *Henry Ossawa Tanner*, chs. 2 and 3.

6. F. P. Noble, "The Chicago Congress on Africa," *Our Day* 12 (October 1893): 285.

7. Noble, "Chicago Congress on Africa," 285. Tanner also painted his highly celebrated *The Banjo Lesson* (1893) during this period.

8. See "Our Art Exhibition," *People's Advocate*, October 30, 1880, 2.

9. See Woods, *Henry Ossawa Tanner*, 52.

10. "Henry Ossawa Tanner," *Opportunity: Journal of Negro Life* 15 (July 1937): 197. The Urban League published this journal.

11. Tanner was the subject of a major exhibition at the Philadelphia Museum of Art in 1991. The exhibition catalogue, *Henry Ossawa Tanner*, advanced Tanner's biography significantly and paved the way, through its widespread availability, for the artist to gain greater acceptance in mainstream accounts of American art. In 2012 Philadelphia once more celebrated Tanner's legacy at PAFA with the exhibition *Henry Ossawa Tanner: Modern Spirit*, which again thrust Tanner to the forefront of nineteenth-century American artists. He has also been the subject of three biographies and numerous essays and book chapters.

12. Quoted in Theresa Vara-Dannen, *The African-American Experience in Nineteenth-Century Connecticut* (Lanham, MD: Lexington Books, 2014), 94.

13. Quoted in Olivia Clark, "It's Our Story: How Slaves and Slave Holders Helped Shape North Carolina," *Greensboro News and Record*, December 14, 2019, https://www.greensboro .com/news/state/it-s-our-story-how-slaves-and-slaveholders-have-shaped/article_47472e2e -4f52-5e84-a222-f5fd92ee315f.html?utm_source=WhatCountsEmail&utm_medium=NEWS %20-%20GSO%20PM%20News&utm_campaign=GSO%20Afternoon%20News.

Chapter One: Robert Seldon Duncanson (1821–1872)

1. Duncanson's middle name has long been listed as Scott due to an early misinformed account of the artist. Subsequently, many articles on Duncanson merely perpetuated the error. However, Julie Aronson, curator of American painting, sculpture, and drawings at the Cincinnati Art Museum, discovered that Seldon was correct based on an article she discovered entitled, "Artists and the Fine Arts among Colored People" in the January 1860 issue of *Repository of Religion and Literature*. See Jeanne Schinto, "What's in a Middle Name," Artist Biography & Facts, Robert Seldon Duncanson, askART. http://www.askart.com/artist_bio /artist/21368/artist.aspx#.

2. Misinformation of Duncanson's origin surfaced in early accounts of his life and career as he was rediscovered in the twentieth century. While it remains unclear as to the original source of these accounts, an article on the artist, "Robert S. Duncanson, a Cincinnatian Who Became World Famous as an Artist," published in the *Cincinnati Enquirer* on December 12, 1924, is a possible point of departure. James A. Porter, in his groundbreaking essay on Duncanson in 1951, also published some of the unsubstantiated claims, thus giving them greater credibility. See James A. Porter, "Robert S. Duncanson: Midwestern Romantic Realist," *Art in America* 39, no. 3 (October 1951): 99–154.

3. For information on Duncanson's ancestral line, see Joseph D. Ketner, *Robert S. Duncanson: "The Spiritual Striving of the Freedmen's Sons,"* Thomas Cole National Historic Site, reprinted at http://www.tfaoi.com/aa/9aa/9aa554.htm.

4. "A New Firm," *Monroe (MI) Gazette*, April 17, 1838.

5. "New Firm."

6. The events of Johnson's life are still obscure, and his precise racial heritage remained in question until a document surfaced dated July 25, 1782; it stated Johnson was the "son of a white man and a black slave woman owned by a William Wheeler, Sr." According to this source, George Johnson bought Joshua, then nineteen years of age, from William Wheeler, on October 6, 1764. The name of Joshua Johnson's mother remains unknown. After obtaining his freedom in 1782, he began his career as a limner or a portrait painter. The only published reference to Johnson's race is found in an 1817 Baltimore city directory, where he is described as a "Free Householder of Colour." See Carolyn Stiles Tuttle Colwill with Leroy Graham and Mary Ellen Hayward Weekley, *Joshua Johnson: Freeman and Early American Portrait Painter* (Baltimore: Maryland Historical Society, 1987).

7. Richard W. Pih, "Negro Self-Improvement Efforts in Ante-Bellum Cincinnati, 1836–1850," *Ohio History* 78 (Summer 1969): 180.

8. Pih, "Negro Self-Improvement Efforts," 180.

9. Pih, "Negro Self-Improvement Efforts," 182–83.

10. Leon F. Litwack, *North of Slavery: The Negro in the Free States, 1790–1860* (Chicago: University of Chicago Press, 1961), 279.

11. For an early history of African Americans in Cincinnati, see Wendell P. Dabney, *Cincinnati's Colored Citizens: Historical, Sociological and Biographical* (Cincinnati: Dabney, 1926).

12. Carter G. Woodson, "The Negroes of Cincinnati prior to the Civil War," *Journal of Negro History* 1, no. 1 (January 1916): 9.

13. Woodson, "Negroes of Cincinnati," 5.

14. William and Aimee Cheek, *John Mercer Langston and the Fight for Black Freedom, 1829–65* (Urbana: University of Illinois Press, 1989), 51.

15. Dabney, *Cincinnati's Colored Citizens*, 38.

16. Pih, "Negro Self-Improvement," 180.

17. Dabney, *Cincinnati's Colored Citizens*, 39–40.

18. Woodson, "Negroes of Cincinnati," 13–16.

19. "1836 Cincinnati Riots Couldn't Stop Anti-Slavery Newspaper," May 11, 2017, www.cincinnati.com/story/news/2017/05/11/1836-cincinnati-riots-couldnt-stop-anti-slavery-newspaper/101497562/.

20. Pih, "Negro Self-Improvement," 181.

21. Kathleen M. Dillon, "Painters and Patrons: The Fine Arts in Cincinnati, 1820–1860," *Ohio History* 96 (Winter–Spring 1987): 19.

22. *The Golden Age: Cincinnati Painters of the Nineteenth Century Represented in the Cincinnati Art Museum* (Cincinnati: Cincinnati Art Museum, 1979), 13.

23. Dillon, "Painters and Patrons," 19.

24. *Golden Age*, 15.

25. A limner was usually an itinerant painter who traveled throughout the early American colonies in search of commissions. For the most part, these artists were untrained and produced portraits of varying quality that often reflected their lack of training in rendering proper body proportions and perspective. Some limners, however, intuitively painted detailed and polished portraits that approached the level of academically trained artists.

26. Guy McElroy, *Robert Scott Duncanson: A Centennial Exhibition* (Cincinnati: Cincinnati Art Museum, 1972), 7.

27. Quoted in James Dallas Parks, *Robert S. Duncanson: 19th Century Black Romantic Painter* (Washington: Associated Publishers, 1980), 4.

28. I have not been able to ascertain whether Foster was an active member of Cincinnati's abolitionist community. However, his ability to construct scientific instruments was renowned, and some of his pieces are now housed at the Smithsonian.

29. Despite his as advancement as a portrait painter, there are, unfortunately, no known portraits of African Americans from Duncanson's hand.

30. Cedric Dover, *American Negro Art* (New London, CT: Studio Books and the New York Graphic Society, 1960), 25.

31. Quoted in Edward H. Dwight, "Robert Scott Duncanson," *Cincinnati Historical Society Bulletin* 13 (July 1955): 205.

32. See Erika Schneider, *The Representation of the Struggling Artist in America, 1800–1865* (Newark: University of Delaware Press, 2015), 137–40.

33. James A. Porter, "Robert S. Duncanson: Midwestern Romantic-Realist," *Art in America* 39, no. 3 (October 1951): 121.

34. Porter, "Robert S. Duncanson," 121.

35. "List of Premiums Awarded by the Michigan State Agricultural Society," *Michigan Farmer* 3, no. 19 (October 1, 1849): 295.

36. For an interesting account of Duncanson as a painter of fruit still lifes, see Shana Klein, "Cultivating Fruit and Equality: The Still-Life Paintings of Robert Duncanson," *American Art* 29, no. 2 (Summer 2015): 64–85.

37. Klein, "Cultivating Fruit and Equality." Klein states, "Between 1848 and 1849, Robert Duncanson painted seven still-life representations of fruit. This attention to fruit was natural given that Duncanson worked in Cincinnati, a hotbed for horticulture in the mid-nineteenth century. The artist's romance with fruit painting would have also been strategic given that art patrons in Cincinnati doubled as the city's leading fruit growers. These same patrons were abolitionists and supporters of greater equality for African Americans, thus deepening the interest in fruit paintings by an African American artist."

38. "Local Matters and Items: The State Fair," *Detroit Free Press*, September 27, 1849, 3. Quoted in Klein, "Cultivating Fruit and Equality," 68.

39. "Art Matters—General Mention," *Daily Cincinnati Gazette*, January 30, 1850, 2. Quoted in Klein, "Cultivating Fruit and Equality," 68.

40. *Bulletin of the America Art-Union*, December 1, 1850, vii.

41. "American Art Union," *Weekly Herald* (New York), December 28, 1850, 415.

42. The name Hudson River School was never used by the principal artists and it did not come into general use until the 1870s, at a time when their style was losing favor with the public. Art historians cannot agree on who coined the Hudson River School name, but it likely originated as a disparaging reference to perceived outdated works rapidly being replaced in public popularity by the plein air Barbizon School.

43. For a comprehensive study of Hudson River painters, see Linda S. Ferber, *The Hudson River School: Nature and the American Vision* (New York: Skira Rizzoli, 2009).

44. Letter, Robert S. Duncanson to Junius R. Sloan, August 21, 1854, Platt R. Spencer Collection, Newberry Library, Chicago, Illinois.

45. *Artists of Michigan* (Muskegon: Muskegon Museum of Art, 1987), 63.

46. *Frederick Douglass' Paper*, August 6, 1852.

47. "Negro Artist," *Boston Investigator*, October 13, 1852. Clarke was an influential white Unitarian minister and social reformer.

48. Peter Betjemann reads *The Garden of Eden* as a work that collates "multiple sources from multiple time periods. The *Garden of Eden* derives, with variations, from Cole's painting of the same; that work, in turn, sprang from lines in book 4 of Milton's *Paradise Lost*, itself a literary dramatization of the Bible." See Peter Betjemann, "The Ends of Time Abolition, Apocalypse, and Narrativity in Robert S. Duncanson's Literary Paintings," *American Art* 31, no. 3 (Fall 2017): 88.

49. "Artist's Union," *Daily Scioto Gazette*, March 28, 1851, no. 99.

50. "Artist's Union of Cincinnati," *Daily Scioto Gazette*, August 7, 1851, no. 210.

51. Abby S. Schwartz, "Nicholas Longworth: Art Patron of Cincinnati," *Queen City Heritage* 46 (Spring 1988): 19.

52. Dillon, "Painters and Patrons," 21.

53. "Artist's Union," March 28, 1851.

54. Dillon, "Painters and Patrons," 22.

55. Nancy Dustin Wall Moure, *William Louis Sonntag: Artist of the Ideal, 1822–1900* (Los Angeles: Goldfield Galleries, 1980), 19.

56. McElroy, *Robert Scott Duncanson*, 9.

57. *Artists of Michigan*, 63.

58. Lucinda Moore, "America's Forgotten Landscape Painter: Robert S. Duncanson," *Smithsonian Magazine*, October 18, 2011, http://www.smithsonianmag.com/arts-culture /americas-forgotten-landscape-painter-robert-s-duncanson-112952174/?page=2.

59. Multiple news items, *Daily Ohio Statesman*, June 27, 1851.

60. "Artists' Union of Cincinnati."

61. "Artists' Union of Cincinnati." In 1851 Charles Cist found Duncanson still transitioning to landscape painting and listed him as a painter of fruit, fancy and historical works, and landscapes. Cist also noted Duncanson's historical works as *Shylock and Jessica*, *Trial of Shakespeare*, *Ruins at Carthage*, *Battle Ground of the River Basin*, and *Western Hunters' Encampment*. All but the *Ruins at Carthage* are presumed lost. See Charles Cist, *Sketches and Statistics of Cincinnati in 1851* (Cincinnati: Wm. H. Moore, 1851), 126.

62. *Artists of Michigan*, 64.

63. *Artists of Michigan*, 64.

64. The Little Miami River is a tributary of the Ohio River east of Cincinnati.

65. "A Token of Gratitude," *Frederick Douglass' Paper*, August 6, 1852, 3. Republished from the *Anti-slavery Bugle*.

66. "Art, Artists, and Inventors," quoted in Silas Farmer, *The History of Detroit and Michigan* (Detroit: Silas Farmer, 1889), 359.

67. Dwight, "Robert Scott Duncanson," 206.

68. *American Paintings in the Detroit Institute of Art, Vol. I* (New York: Hudson Hills Press, 1991), 248.

69. *American Paintings in the Detroit Institute of Art, Vol. I*, 248.

70. Dabney, *Cincinnati's Colored Citizens*, 45.

71. Dabney, *Cincinnati's Colored Citizens*, 45, 72–73.

72. Denny Carter, "Nineteenth-Century Painters and Patrons in Cincinnati," *Magazine Antiques* (November 1979): 1156.

73. Kenneth R. Trapp, *Celebrate Cincinnati Art* (Cincinnati: Cincinnati Art Museum, 1981), 30.

74. Louis Leonard Tucker, "'Old Nick' Longworth, the Paradoxical Maecenas of Cincinnati," *Bulletin of the Cincinnati Historical Society* 25, no. 4 (1967): 259, library.cincymuseum .org/topics/1 /files/longworth/chsbull-v25-n4-old-246.pdf.

75. Tucker, "'Old Nick' Longworth," 33.

76. McElroy, *Robert Scott Duncanson*, 8–9.

77. Quoted in Moore, "America's Forgotten Landscape Painter."

78. Trapp, *Celebrate Cincinnati Art*, 34.

79. Lynda Roscoe Hartigan, *Sharing Traditions: Five Black Artists in Nineteenth-Century America* (Washington: Smithsonian Institution Press, 1985), 55.

80. Moure, *William Louis Sonntag*, 17–18.

81. *Frederick Douglass' Paper*, April 28, 1854, 2.

82. Richard Rudisill, *Mirror Image: The Influence of the Daguerreotype on American Society* (Albuquerque: University of New Mexico Press 1971), 201.

83. Beaumont Newhall, *The Daguerreotype in America* (New York: Dover, 1976), 68.

84. *Cincinnati Daily Enquirer*, August 29, 1857, 3.

85. Bridget Ford, *Bonds of Union: Religion, Race, and Politics in a Civil War Borderland* (Chapel Hill: University of North Carolina Press, 2016), 134.

86. *Cincinnati Daily Enquirer*, September 6, 1857, 3.

87. "Daguerrian Gallery of the West," *Frederick Douglass' Paper*, June 3, 1854, 1.

88. Romare Bearden and Arthur Henderson, *Six Black Masters of American Art* (New York: Doubleday, 1972), 31.

89. "J. P. Ball, African American Photographer: Success and Struggles in Cincinnati," Cincinnati History Library and Archives, http://library.cincymuseum.org/ball/jpball-cincy.htm.

90. See Afe Adogame and Andrew Lawrence, eds., *Africa in Scotland, Scotland in Africa: Historical Legacies and Contemporary Hybridities* (Boston: Brill, 2014), 183.

91. United States Census Bureau, 1860 census of Cincinnati, Ohio, 64.

92. James Presley Ball, *Ball's Splendid Mammoth Pictorial Tour of the United States . . .* (Cincinnati: A. Pugh, 1855), 10.

93. United States Census Bureau, 1860 census of Cincinnati, Hamilton County, Ohio, 255.

94. Mary Haverstock and Jeannette Mahoney Vance, *Artists in Ohio, 1787–1900: A Biographical Dictionary*, 3rd ed. (Kent, OH: Kent State University Press, 2000), 41–42.

95. Only one other painting attributed to Duncanson includes African Americans: *View of Cincinnati from Covington, Kentucky* (ca. 1851). Duncanson derived the scene, likely a commission, from an engraving that was published in the June 1848 issue of *Graham's Magazine*, with the picture credit stating it was copied from a daguerreotype. However, Duncanson chose to alter the race of a white man leaning on a rifle in the engraving to a Black man, presumably a slave, leaning on a scythe in the compositional center, in the presence of two white children. In the background, a Black woman hangs clothes beside a cabin. The expansive and detailed landscape contrasts rural Kentucky with sprawling, urban Cincinnati directly across the Ohio River; however, the painting appears to make no direct attempt at social or political commentary.

96. A. S. Cavallo, "Uncle Tom and Little Eva, A Painting by R. S. Duncanson," *Bulletin of the Detroit Institute of Arts* 30, no. 1 (1950–51): 21.

97. Cavallo, "Uncle Tom and Little Eva," 21.

98. Cavallo, "Uncle Tom and Little Eva," 23.

99. Cavallo, "Uncle Tom and Little Eva," 25.

100. *Detroit Free Press*, April 21, 1853, 2, which quotes the *Cincinnati Commercial*.

101. Quoted in *Artists of Michigan*, 64.

102. Moure, *William Louis Sonntag*, 20.

103. Letter, Robert Scott Duncanson to Junius R. Sloan, January 22, 1854, Platt R. Spencer Collection, Newberry Library, Chicago, Illinois.

104. Letter, Robert Scott Duncanson to Junius R. Sloan, January 22, 1854, Platt R. Spencer Collection, Newberry Library, Chicago, Illinois.

105. Letter, Robert Scott Duncanson to Junius R. Sloan, January 22, 1854, Platt R. Spencer Collection, Newberry Library, Chicago, Illinois.

106. Letter, William Miller to Isaac Strohm, April 10, 1854, in the collection of Cincinnati Historical Society.

107. Letter, Robert Scott Duncanson to Junius R. Sloan, August 21, 1854, Platt R. Spencer Collection, Newberry Library, Chicago, Illinois. This painting is likely *The Land of Beulah*, completed in 1856.

108. Letter, Robert Scott Duncanson to Junius R. Sloan, August 21, 1854, Platt R. Spencer Collection, Newberry Library, Chicago, Illinois.

109. Joseph D. Ketner, *The Emergence of the African-American Artist: Robert S. Duncanson, 1821–1872* (Columbia: University of Missouri Press, 1993), 87.

110. Apparently Phoebe's white father brought her to New Richmond, Ohio, to obtain an education. See "R.I.P. Joseph K and Robert D & viva Vanessa G!" Melville and Douglass in

2018 (blog), October 13, 2018,https://melvilleanddouglassin2018.wordpress.com/2018/10/13/r-i-p-joseph-k-and-robert-d-viva-vanessa-g/.

111. "A Recent Tour of Ohio," *The Liberator*, November 21, 1856, vol. 188, no. 47.

112. Ketner, *Emergence of the African American Artist*, 104–5.

113. Quoted in *Artists of Michigan*, 66.

114. Porter, "Robert S. Duncanson," 127.

115. Dillon, "Painters and Patrons," 16–17.

116. For an excellent account of Sarah Ernst's role in Cincinnati abolitionist circles, see Elizabeth J. Clapp and Julie Roy Jeffrey, eds., *Women, Dissent and Anti-Slavery in Britain and America, 1790–1865* (New York: Oxford University Press, 2011).

117. David A. Gerber, *Black Ohio and the Color Line, 1860–1915* (Champaign: University of Illinois Press, 1976), 23–24.

118. Wendy J. Katz, "Robert S. Duncanson: City and Hinterland," *Prospects* 25 (October) 2000: 313–14.

119. *Cincinnati Daily Press*, June 2, 1859, 3. It cannot be determined whether this painting was actually finished by Duncanson and now remains lost or if it was given another title because of misidentification.

120. "Art Matters: Duncanson's Last Picture," *Cincinnati Daily Press*, January 10, 1860, 3.

121. "New Picture by Duncanson," *Cincinnati Daily Press*, February 13, 1861, 3.

122. "New Picture by Duncanson," 3.

123. The Cincinnati Sketch Club, composed of the city's leading artists, was organized by Henry Worrall and William P. Noble and met for the first time on December 4, 1858. They continued to meet until 1864. At each session, held in an artist's home or studio, the participants, working in the medium of their choice, responded to a topic or theme chosen during the previous meeting by making sketches. The topics varied—hope, labor, liberty, and the seasons were choice—as well as specific works of literature. It is interesting to speculate whether Duncanson ever hosted the club in his home.

124. Ford, *Bonds of Union*, 134.

125. Duncanson apparently made another copy of *Lotos-Eaters*. While one version was known to be in Canada that later moved on to Europe, a copy loaned by a Dr. Knowlton to the Great Western Sanitary Fair (1864) was on exhibit. See *History of the Great Western Sanitary Fair* (C. V. Vent, 1864), 406.

126. Duncanson demonstrated a preference for British Romantic poets and novelists, including Alfred, Lord Tennyson, William Wordsworth, Walter Scott, and Thomas Moore, unlike many of his Hudson River contemporaries who preferred American authors such as Ralph Waldo Emerson, Henry David Thoreau, William Cullen Bryant, and James Fennimore Cooper.

127. Hinton Rowan Helper, *Nojoque; A Question for a Continent* (New York: George W. Carleton, 1897), 341.

128. *Daily Cincinnati Gazette*, May 30, 1861, 2.

129. *Daily Cincinnati Gazette*, June 3, 86, 2.

130. "Sketch Club," *Cincinnati Daily Press*, January 20, 1862, 3. The subject for the club's next meeting was Longfellow's poem "The Skeleton in Armor." According to Peter Betjemann, the Cincinnati Sketch Club (1858–64) "followed the model of its New York parent, using literature to inspire art, promoting a cosmopolitan range of reading, and tightly tying word to image. But the real interest of the Cincinnati Sketch Club lies in its vision of how art and literature informed one another in a cycle that invited circular and apparently endless remediation." See Betjemann, "Ends of Time."

131. Duncanson completed another version of *The Vale of Kashmir* while residing in Canada, Apparently the subject of the painting also struck a responsive chord with his patrons, who actively purchased at least two more versions.

132. Ketner, *Robert S. Duncanson*, 18.

133. Quoted in Katz, *Regionalism and Reform*, 135.

134. *Toronto Globe*, November 5, 1851, cited in Ketner, *Emergence of the African-American Artist*, 398.

135. Minnenopa is a Dakota word meaning "water falling twice," in reference to the dual waterfalls in the painting.

136. For a detailed account of Duncanson's time in Canada, see William Pringle, "Robert S. Duncanson in Montreal 1863–1865," *American Art Journal* (Autumn 1985): 28–50.

137. Dwight, "Robert Scott Duncanson," 209.

138. (London) *Art Journal* 3 (1864), 113, quoted in Pringle, 31.

139. William Notman was a Scottish photographer who came to Canada in 1856. His photography business grew to be the largest and most successful in the country. His personal and professional interest in art led Notman to associate closely with Montreal's most prominent painters, including the newly arrived Duncanson.

140. *Montreal Herald*, September 22, 1863.

141. Denis Reid wrote, "Most of the prominent artists of the period were, inevitably, immigrants. These included, as well as Notman and [Otto] Jacobi, the Germans Adolph Vogt and William Raphael, the Englishman C. J. Way, the American R. S. Duncanson, and the London-born Scot John A. Fraser. As their ranks grew and prospered, the interest they stimulated led to the foundation of the Society of Canadian Artists in 1867, the year of Confederation, and this new forum encouraged the native-born to take up the brush." See Dennis Reid, "Our Own Country Canada," *Vanguard* 8, no. 2 (March 1979).

142. *Photographic Selections by William Notman*. Text by Thomas D. King. Montreal: n.p., 1863, n.p.

143. Pringle, "Duncanson in Montreal," 42.

144. Pringle, "Duncanson in Montreal," 47.

145. Pringle, "Duncanson in Montreal," 49.

146. *Artists of Michigan*, 66.

147. Dwight, "Robert Scott Duncanson," 209.

148. "The Land of the Lotos Eaters. Painted by Robert S. Duncanson," *Art Journal* (London) 5, n.s., (1866): 95.

149. Moncure D. Conway, "A Cincinnati Colored Artist in England," *Cincinnati Gazette*, November 24, 1865, 2. Lord Tennyson addressed Duncanson as "one of my Canadian kinsmen." One has to speculate if Tennyson was aware that he shared a meal with a Black man.

150. Adogame and Lawrence, eds., *Africa in Scotland*, 198.

151. G. Frank Muller, "Cincinnati," *American Art News*, October 16, 1915, 5.

152. Dwight, "Robert Scott Duncanson," 210. Based on these prices, Duncanson's $500 paintings would be worth around $10,000 in 2018 with the rate of inflation factored in, thus ranking him among Cincinnati's wealthy elite.

153. Dabney, *Cincinnati's Colored Citizens*, 93.

154. See Ketner, *Emergence of the African-American Artist*, 177.

155. Dwight claimed, "During part of 1870 and 1871 he must have returned to Scotland. There is no other way of explaining the large landscapes of Scottish scenery painted during these years. They are among his best work." See Dwight, "Robert S. Duncanson," 210. Duncanson could have made these works from earlier sketches.

156. Loch Katrine is a freshwater loch in the district of Stirling, Scotland. It is the fictional setting of Sir Walter Scott's poem *The Lady of the Lake.*

157. *Detroit Free Press*, September 16, 1871, 1.

158. "Recollections of Charles Sumner: II. The Senator's Home and Pictures," *Scribner's Monthly: An Illustrated Magazine for the People*, November 1874, 113. Also see "Colored Businessmen: Important Factors in the Business Life of Cincinnati," *The Plaindealer* (Detroit), January 20, 1893, 1.

159. "Recollections of Charles Sumner," 113.

160. "Recollections of Charles Sumner," 113.

161. One wonders why, at this point in his career, Duncanson was once more focused on exhibiting regionally and not moving on to the major at centers of the East. He had earned the opportunity to advance. Was it by choice, or was his race preventing him from exhibiting nationally with more celebrated Hudson River painters? Clearly, Duncanson could have benefited financially from greater exposure in the lucrative art markets in the East. Unfortunately, the answers to these questions probably went to the grave with him.

162. *Cincinnati Daily Enquirer*, July 30, 1871, 8.

163. *Detroit Tribune*, December 26, 1872, 4.

164. *Cincinnati Daily Commercial*, December 27, 1872, 8, as quoted in Ketner, *Emergence of the African American Artist*, 182.

165. Dabney, *Cincinnati's Colored Citizens*, 93.

166. McElroy, *Robert Scott Duncanson*, 15.

167. "Colored Businessmen," 1.

168. Quoted in Parks, *Robert Scott Duncanson*, 32.

169. Ketner, *Emergence of the African-American Artist*, 183.

170. Ketner, *Emergence of the African-American Artist*, 184.

171. *Detroit Tribune*, December 26, 1872, 4.

172. *Cincinnati Inquirer*, December 31, 1872. See also Hartigan, *Sharing Traditions*, 68.

173. *Exhibition of Paintings, Engravings, Drawings, Aquarelles and Works of Household Art in the Cincinnati Industrial Exposition*, 1875, https://babel.hathitrust.org/cgi/pt?id=hvd.32044 108141805;view=1up;seq=14. "The Cincinnati Industrial Expositions were held in Cincinnati between 1870 and 1888 to showcase the products of Cincinnati business owners. . . . Over time, the expositions included displays from businesses across the Midwest and the rest of the United States. Artists displayed their works; musicians performed; and inventors and other businessmen displayed their wares. The Cincinnati Industrial Expositions illustrated Cincinnati's important contributions to culture and technology during the late 1800s." Quoted from *Cincinnati Industrial Expositions*, Ohio History Central, http://www.ohiohistory central.org/w/Cincinnati_Industrial_Expositions.

174. People with mental illness in the nineteenth century were often feared and shunned by the public because of a failure to understand the true nature of the condition. In Duncanson's case the stigma and negative stereotype attached to his sudden collapse may have also affected his immediate legacy and, consequently, severely devalued his reputation as a leading art figure in the region.

175. See the chapter "Reconstructing Duncanson," in David M. Lubin, *Picturing a Nation: Art and Social Change in Nineteenth-Century America* (New Haven: Yale Publications in the History of Art, 1994), 107–57.

176. Devries, *Race and Kinship*, 149.

177. Devries, *Race and Kinship*, 118.

178. Devries, *Race and Kinship*, 152.

179. The 1870 United States Census identified Duncanson as white. This is not, however, the "smoking gun" to prove that he deliberately crossed the color line at this time. Delineation of one's race often came through visual assessment by the census enumerator. In this case, it is understandable how the census taker could have mistaken Duncanson for white. His wife, previously recorded as a mulatto, also was listed as white in 1870. Still, the census record indicates that the Duncanson family was living in a white neighborhood. In addition this racial designation is close to the time when his son made the accusation of him passing and when he may have begun to experience mental health problems. It is possible that all these issues attributed to Duncanson's death. Unfortunately, because of a lack of more detailed information, it is impossible to understand fully his actions and motivations.

180. Parks, *Robert S. Duncanson*, 11.

181. Parks, *Robert S. Duncanson*, 11.

182. Lubin, *Picturing a Nation*, 122.

183. Buick, *Child of the Fire*, 41.

184. Letter, Longworth to Powers, June 20, 1852, quoted in Ketner, *Emergence of the African-American Artist*, 52.

185. Hartigan, *Sharing Traditions*, 51.

186. Hartigan, *Sharing Traditions*, 51.

187. Letter, Robert Duncanson to Reuben Duncanson, June 28, 1871. Quoted in Parks, *Robert S. Duncanson*, 30. At this time, Reuben was around twenty-seven years of age.

188. Robert Duncanson to Reuben Duncanson, June 28, 1871.

189. Joel Williamson, *New People: Miscegenation and Mulattoes in the United States* (New York: Free Press, 1980), 102.

190. See *Frederick Douglass' Paper*, August 6, 1852, 2. Douglass again cited Duncanson as "a colored artist of Cincinnati" in 1872. See "News Clippings," *New National Era* (Washington, DC), January 4, 1872, 1.

191. Kenneth Stamp, *The Peculiar Institution: Slavery in the Antebellum South* (New York: Vintage Books, 1984), 216–17.

192. Duncanson may have felt comfortable in knowing that the region was not as fixated on slave matters as the rest of the state. There were some slave owners in Asheville and surrounding counties, and slaves were advertised for sale in the city, but most "labored on small farms, in domestic service, hotels and inns, mines and foundries, and manufacturing plants." See David E. Whisnant, "Retrospective I: A Primer on the Sad Truths of Slavery in Asheville, Buncombe County and Western North Carolina," on August 29, 2015, accessed October 4, 2017, http://ashevillejunction.com/retrospective-i-a-primer-on-the-sad-truths-of-slavery-in -asheville-buncombe-county-and-western-north-carolina/

193. Moore was a noted book illustrator and publisher who produced a semimonthly agricultural publication, the *Ohio Cultivator*, in the 1850s.

194. See *Asheville Messenger*, August 14, 1850, 2.

195. *Asheville Messenger*, August 14, 1850, 2.

196. *Asheville Messenger*, August 14, 1850, 2.

197. John Preston Arthur identified the site of Duncanson's vantage point: "There was a woodcut reproduction of an oil painting of Asheville by F. S. Duncanson [*sic*], which was taken from Beaucatcher, and it appears that there were not more than twenty five residences in 1850 that were visible from that commanding eminence." See John Preston Arthur, *History of Western North Carolina, Chapter VIII: County History*, 1914, accessed from New River Notes, http://www.newrivernotes.com/topical_books_1914_historyofwestern_northcarolina.htm.

198. See Andrew James Brunk, "Robert Duncanson's *View of Asheville, North Carolina, 1850,*" in Robert S. Brunk, ed., *May We All Remember Well: A Journal of the History & Cultures of Western North Carolina* (Asheville: Robert Brunk Auction Services, 1997), 117.

199. Brunk, "Robert Duncanson's *View of Asheville, North Carolina, 1850.*"

200. Brunk, "Robert Duncanson's *View of Asheville, North Carolina, 1850.*" The Patton family maintained that Duncanson likely painted portraits of James W. Patton and Henrietta Patton at this time, but neither work appears stylistically to be by his hand.

201. Quoted from the *Daily Cincinnati Gazette,* June 18, 1851, 2.

202. See Bertha L. Heilbron, ed., *With Pen and Pencil on the Frontier in 1851, Diary of Frank Blackwell Mayer* (Saint Paul: Minnesota Historical Society, 1932).

203. Charles T. Webber, "Pioneer Art in Cincinnati," quoted in Henry Howe, *Historical Collections of Ohio in Two Volumes: An Encyclopedia of the State* (Norwalk, OH: Laning, 1898), 858.

204. Ketner, *Emergence of the African-American Artist,* 1.

205. Wendy J. Katz, "Robert S. Duncanson, Race, and Auguste Comte's Positivism in Cincinnati," *American Studies* 53, no. 1 (2014): 80.

206. Sharon F. Patton, *African American Art* (Oxford: Oxford University Press, 1998), 84–84. Both Lubin and Ketner also seem determined to read into Duncanson's landscapes a "hidden component" of race that somehow expresses the African American struggle for freedom and an affirmation of cultural identity, especially during the antebellum period. They wish to read "Blackness" into his paintings even though African American figures rarely appear because, for them, race "must" be embedded in the work of Black artists. Lubin states, "My response is that in America race cannot be left behind (Lubin, *Picturing a Nation,* 109)." There is simply not enough information to validate this point, so it remains interesting speculation at best. For a critique of their ideas of race and art see, Buick, *Child of the Fire.*

207. Margaret Rose Vendryes, "Race Identity/Identifying Race: Robert S. Duncanson and Nineteenth-Century American Painting," *Museum Studies* 27, no. 1 (2001): 87.

208. James W. Dawson, *Picturesque Cincinnati* (Cincinnati: John Shillito, 1883), 153.

209. G. Frank Muller, "Cincinnati," *American Art News,* October 16, 1915, 5.

Chapter Two: Edward Mitchell Bannister (1828–1901)

1. Oliver W. Larkin, *Art and Life in America* (New York: Rinehart, 1949), 240.

2. See Russell Lynes, *The Art Makers: An Informal History of Paintings, Sculpture and Architecture in the Nineteenth Century* (New York: Dover), 279.

3. Larkin, *Art and Life,* 242.

4. Draft from a tribute to Bannister by George Whitaker, n.d., Edward Mitchell Bannister Scrapbook. Archives of American Art, Washington, DC.

5. Carter G. Woodson, *Negro Makers of History* (Washington: Associated Publishers, 1942), 188.

6. Quoted in Lynda Roscoe Hartigan, *Sharing Traditions: Five Black Artists in Nineteenth-Century America* (Washington: Smithsonian Institution Press, 1985), 71.

7. Cedric Dover, *American Negro Art* (Greenwich, CT: New York Graphic Society, 1960), 27.

8. T. Thomas Fortune, "The Artist Bannister," *New York Sunday Sun,* November 8, 1893, in Edward Mitchell Bannister Scrapbook, Archives of American Art.

9. James Oliver Horton and Lois E. Horton, *Black Bostonians: Family Life and Community Struggle in the Antebellum North* (New York: Holmes & Meier, 1979), 92.

10. Horton and Horton, *Black Bostonians*, 67.

11. Woodson, *Negro Makers of History*, 189.

12. Fortune, "Artist Bannister."

13. James Horton, *Free People of Color* (Washington, DC: Smithsonian Institution Press, 1993), 29.

14. William Wells Brown, *The Black Man, His Antecedents, His Genius and His Achievements* (Boston: R. F. Wallcut, 1863), 215.

15. William J. Simmons, *Men of Mark: Eminent, Progressive and Rising* (Cleveland: Geo. M. Rewell, 1887), 1130.

16. Fortune, "Artist Bannister."

17. "Colored Genius," *The Liberator*, August 11, 1854, no. 32, 127.

18. John Van Surly DeGrasse (1825–1868) was a medical doctor who became the first African American to join a medical association in Massachusetts. He also served as the first African American medical officer in the US Army with the 35th Regiment of US Colored Infantry (the First Regiment, North Carolina, Colored Volunteers).

19. "Commemorative Meeting in Faneuil Hall," *The Liberator*, no. 9, February 26, 1858, 35. See also George Forbes, "E. M. Bannister with Sketch of Earlier Artists," Department of Rare Books and Manuscripts, Boston Public Library, Boston, Massachusetts, 8.

20. Forbes, "E. M. Bannister with Sketch of Earlier Artists," 8. According to Lynda Roscoe Hartigan, "Forbes was an assistant librarian at the Boston Public Library's West End branch from 1897 to 1913, a noted writer and editor, and Bannister's friend." See Hartigan, *Sharing Traditions*, 83, n. 8.

21. Hartigan, *Sharing Traditions*, 83, n. 8.

22. Hartigan, *Sharing Traditions*, 9.

23. "MARRIED—In this city, June 10, 1857 by Rev. Charles Mason, Edward M. Bannister and Christiana Carteaux," *The Liberator*, June 19, 1857, no. 25, 99. The Bannisters had no children.

24. Brown, *Black Man*, 215.

25. Christiana married Desiline Carteaux, a clothes dealer thought to have emigrated from the Caribbean, in the late 1840s.

26. Fortune, "Artist Bannister."

27. Glenn V. Laxton, *Hidden History of Rhode Island: Not-to-Be-Forgotten Tales of the Ocean State* (Charleston, SC: History Press, 2009).

28. "Oberlin Rescuers," *The Liberator*, no. 23, June 10, 1859, 90.

29. "Oberlin Rescuers," 90.

30. "Oberlin Rescuers," 90.

31. "New England Colored Citizens' Convention," *The Liberator*, August 19, 1859, no. 33, 132.

32. "Meeting of Colored Bostonians," *Pine and Palm* (Boston), February 13, 1862, 2.

33. "Association for the Relief of Destitute Contrabands," *The Liberator*, no. 41, October 10, 1862, 163.

34. W. Augustus Low and Virgil A. Clift, eds. *Encyclopedia of Black America* (New York: Da Capo Press, 1981), 65.

35. "Emancipation Day," *The Liberator*, December 25, 1863, no. 52, 207.

36. Brown, *Black Man*, 217.

37. "Twelfth Baptist Sunday School," *Boston Daily Advertiser*, January 16, 1865.

38. "Baptist Mission," *Christian Recorder*, July 21, 1866, 2.

39. "Baptist Mission," 2.

40. *The Liberator*, no. 3, January 20, 1860, 11.

41. *The Liberator*, no. 3, January 20, 1860, 11.

42. *Liberator*, October 1864.

43. Letter, Lydia Maria Child to Sarah Shaw, November 3, 1864, Houghton Library, Harvard University.

44. Letter, Lydia Maria Child to Sarah Shaw, November 3, 1864, Houghton Library, Harvard University.

45. Letter, Lydia Maria Child to Sarah Shaw, November 3, 1864, Houghton Library, Harvard University.

46. Lisa Tendrich Frank, ed., *Women in the Civil War*. Vol. 1 (Santa Barbara, CA: ABC-CLIO, 2008), 118, cited from *The Liberator*, May 22, 1863.

47. Juanita Holland, *The Life and Work of Edward Mitchell Bannister (1828–1901): A Research Chronology and Exhibition Record* (New York: Kenkeleba House, 1992), 8.

48. Holland, *Life and Work of Edward Mitchell Bannister*, 9.

49. Brown, *Black Man, His Antecedents, His Genius and His Achievements*, 216.

50. Brown, *Black Man, His Antecedents, His Genius and His Achievements*, 216.

51. Rimmer was born in Liverpool, England, and later immigrated to Nova Scotia before moving to Boston in 1826.

52. Jeffrey Weidman, Neil Harris, and Philip Cash, *William Rimmer: A Yankee Michelangelo* (Hanover, NH: University Press of New England, 1985), 9.

53. Fortune, "Artist Bannister."

54. John N. Arnold, "Edward M. Bannister: Reminiscences and Appreciative Tribute by a Fellow Artist," *Providence Daily Journal*, May 19, 1901, 17. John Nelson Arnold was born on June 4, 1834, in Masonville, Connecticut. He was noted for painting portraits. He was a member of the Providence, Rhode Island Art Club. He died on May 31, 1909 in Providence, Rhode Island.

55. Arnold, "Edward M. Bannister," 17.

56. Arnold, "Edward M. Bannister," 17.

57. Arnold, "Edward M. Bannister," 17.

58. Fortune, "Artist Bannister."

59. Corinne Jennings and Juanita Marie Holland, *Edward Mitchell Bannister* (New York: Kenkeleba House, 1992), 45.

60. Mary Armfield Hill, ed., *Endure: The Diaries of Charles Walter Stetson* (Philadelphia: Temple University Press, 1985), 11. Charles Walter Stetson was born in Tiverton Four Corners, Rhode Island, on March 25, 1858. He was a self-taught painter who opened his own studio in Providence, Rhode Island, at the age of twenty. Stetson was noted as one of America's finest colorists for his use of rich, vibrant colors in his ideal compositions. He was a member of the Providence Art Club. He died in Rome, Italy, in 1911.

61. Arnold, "Edward M. Bannister."

62. Arnold, "Edward M. Bannister"; Letter, Lydia Maria Child, to Sarah Shaw, November 3, 1864, Houghton Library, Harvard University.

63. Unidentified clipping, Providence *Sunday Journal*, November 17, 1895.

64. Unidentified clipping, Providence *Sunday Journal*, November 17, 1895.

65. George William Whitaker, "Edward Mitchell Bannister," undated typescript, Edward Mitchell Papers, Archives of American Art, Washington, DC, 6. Whitaker, a still-life and landscape painter, was regarded as the "Dean of the Providence Painters." He studied art in France under the artist De Paal. While in France, Whitaker was influenced heavily by the Barbizon painters of the Fontaineblue.

66. Arnold, "Edward Mitchell Bannister."

67. "Boston Artists' Picture Sale," *Daily Evening Transcript*, April 24, 1866.

68. Whitaker, "Edward Mitchell Bannister," 3.

69. Quoted in Simmons, *Men of Mark*, 1129.

70. Willard B. Gatewood, *Aristocrats of Color: The Black Elite, 1880–1920* (Bloomington: Indiana University Press, 1990), 110.

71. Guy C. McElroy, *Facing History: The Black Image in American Art, 1710–1940* (San Francisco: Bedford Arts, 1990), 73.

72. This fact was later learned by Henry Ossawa Tanner after his Black genre paintings, *The Banjo Lesson* (1893) and the *Thankful Poor* (1894), convinced him that he had no measurable Black audience.

73. Quoted in Sharon Kay Skeel, "A Black American in the Paris Salon," *American Heritage Magazine*, February/March 1991, vol. 42, no. 1.

74. Barbara J. Beeching, *Hopes and Expectations: The Origins of the Black Middle Class in Hartford* (Albany: State University of New York Press, 2017), 89.

75. Letter, Nelson Primus to Isabella Primus, January 27, 1867. Quoted in Beeching, *Hopes and Expectations*, 92.

76. George Forbes, "E. M. Bannister," 4.

77. Quoted in Beeching, *Hopes and Expectations*, 91.

78. Letter, Nelson Primus to his mother, July 10, 1865. Beeching, *Hopes and Expectations*, 92.

79. Beeching, *Hopes and Expectations*, 92.

80. *Hartford Courant*, January 16, 1877.

81. Primus painted Nehemiah Gibson in 1883; his son Charles Earl in 1881; and, in a third painting, likely Nehemiah's wife Lucy in 1883. Nehemiah Gibson was a highly successful Boston businessman, president and a director of the Maverick National Bank, and a politician who served as an alderman for the city of Boston and as a Massachusetts state representative. See Nehemiah Gibson of East Boston, http://nehemiahgibson.com/biography PrimusNelsonA.htm.

82. H. W. French, *Art and Artists of Connecticut* (Boston: Lee & Shepard, 1879), 155.

83. N. A. Primus advertisement, *East Boston Advocate*, April 29, 1882.

84. Letter, Nelson Primus to Isabella Primus, Hartford, January 27, 1867. Quoted in Beeching, *Hopes and Expectations*, 95.

85. Letter, Nelson Primus to Isabella Primus, Hartford, March 27, 1867. Quoted in Samella Lewis, *Art: African-American* (Fort Worth, TX: Harcourt College Publishers, 1978), 38.

86. Forbes, "E. M. Bannister," 4–5.

87. Forbes, "E. M. Bannister," 4–5.

88. "The New Negro at Our Show," *Atlanta Constitution*, July 28, 1895, 4.

89. Brown, *Black Man, His Antecedents, His Genius, and His Achievements*, 200–202.

90. Brown, *Black Man, His Antecedents, His Genius, and His Achievements*, 200.

91. "Commemorative Meeting in Faneuil Hall," 35.

92. Brown, *Black Man, His Antecedents, His Genius, and His Achievements*, 202.

93. Brown, *Black Man, His Antecedents, His Genius, and His Achievements*, 202.

94. Brown, *Black Man, His Antecedents, His Genius, and His Achievements*, 200.

95. Brown, *Black Man, His Antecedents, His Genius, and His Achievements*, 201.

96. Forbes, "E. M. Bannister," 3.

97. *Weekly Anglo-African* (New York), April 14, 1860, 1.

98. "Presentation to Governor Andrew," *Christian Recorder*, July 23, 1864, 1.

99. Forbes, "E. M. Bannister," 3.

100. Brown, *Black Man, His Antecedents, His Genius, and His Achievements*, 202. According to Forbes, Simpson left Boston for Chicago at the beginning of the 1870s and became involved in a romantic relationship that led him to commit suicide in 1872.

101. "E. M. Bannister, Portrait Painter," *The Liberator*, October 21, 1864, 171.

102. *Boston Directory* (Boston: Sampson & Murdock, 1868), 70.

103. *Boston Directory* (Boston: Sampson, Davenport, 1873), 462.

104. Rachel Keith, *The Barbizon School and the Nature of Landscape*, Mildred Lane Kemper Art Museum, 2008, 4, http://kemperartmuseum.wustl.edu/files/Barbizon.pdf.

105. Lynes, *Art-Makers*, 414.

106. Sally Webster, *William Morris Hunt* (Cambridge: Cambridge University Press, 1991), 68.

107. Quoted in Jennings and Holland, *Edward Mitchell Bannister*, 38.

108. Tonalism was a loosely framed movement, about 1880 to 1915, which derived from the French Barbizon style. It emphasized atmosphere, shadow, muted hues, and misty effects that harmonized nature with man. Tonalist painting expressed a sense of unity over diversity, tranquility over activity and the spiritual over the physical, thereby evoking a sense of emotionalism over reality. George Innes, an advocate of the style, said, "A work of art is not to instruct, not to edify, but to awaken an emotion" (quoted in John Charles Van Dyke, *American Painting and Its Tradition* [New York: Charles Scribner's Sons, 1919]), 24.

109. Arnold, "Edward Mitchell Bannister," 17.

110. Whitaker, "Edward Mitchell Bannister," 3.

111. Robert Workman, *The Eden of America: Rhode Island Landscapes, 1820–1920* (Providence: Rhode Island School of Design, 1986), 8.

112. Workman, *The Eden of America*, 9.

113. Whitaker, "Edward Mitchell Bannister," 2.

114. "Art and Artists: The Studios of Providence," *Providence Press*, October 26, 1869.

115. "Art and Artists."

116. "Biography of George Inness," George Inness: The Complete Works, https://www.georgeinness.org/.

117. Daniel Rosenfeld and Robert Workman, *The Spirit of Barbizon: France and America* (San Francisco: Art Museum Association of America, 1986), 50.

118. Forbes, "E. M. Bannister," 10.

119. *Providence Journal*, September 21, 1872.

120. "Personal Items," *Christian Recorder*, March 25, 1875. Lynch (1847–1939), was a prominent black Republican politician who served in the Mississippi state legislature and U.S. House of Representatives during Reconstruction.

121. "Art and Artists: The Centennial Exhibition," *Daily Evening Traveler*, April 6, 1876, 1, quoted in Jennings and Holland, *Edward Mitchell Bannister*, 29.

122. Whitaker, "Edward Mitchell Bannister," 4.

123. Forbes, "E. M. Bannister," 10.

124. *Frank Leslie's Illustrated Register*, 204, quoted in Hartigan, *Sharing Traditions*, 69.

125. Whitaker, "Edward Mitchell Bannister," 5.

126. Whitaker, "Edward Mitchell Bannister," 4.

127. John S. Brown, "Edward Mitchell Bannister," *The Crisis* 40 (November 1933): 248.

128. Henry McNeal Turner, "To Colored People," *Parsons Weekly Blade*, February 9, 1895, vol. 3 no. 28, 1.

129. Fannie Barrier Williams, "A Great Artist in Silhouette: E. M. Bannister's Notable Career," *Chicago Times,* August 18, 1895, 36.

130. "The Centennial Exhibition," *Christian Recorder,* October 26, 1876, 8.

131. *Christian Recorder,* October 8, 1876, 8.

132. Whitaker, "Edward Mitchell Bannister," 5.

133. Whitaker, "Edward Mitchell Bannister," 6.

134. George Whitaker, "One of Our Laureates," transcript of talk, December 3, 1891, Ann-Eliza Club Papers 1885–1937, Manuscripts Division, Rhode Island Historical Society, Providence.

135. Whitaker, "Edward M. Bannister," 1–6. For a discussion of Banister as an Idealist, see Traci Lee Costa, "Edward Mitchell Bannister and the Aesthetics of Idealism," master's thesis, Roger Williams University, February 2017, https://docs.rwu.edu/cgi/viewcontent.cgi?article =1000&context=aah_theses. While Costa makes a convincing argument as to how Idealism, particularly German Idealism, profoundly shaped Bannister's art creation, I suggest his work ethic and thought process was a hybrid formed by negotiating the real and the ideal through fundamental Christian principles and a deep love for capturing the aesthetic qualities of naturalism and realism found in picturesque scenic displays.

136. This information was furnished by the Providence Art Club.

137. Edward M. Bannister, "The Artist and His Critics," 1886, Ann-Eliza Club Manuscript Division, MSS# 26, Box 1, Folder 25, Rhode Island Historical Society, Providence.

138. *"Landscape and Transcendence," The Making of the Hudson River School,* online exhibition, Albany Institute of History and Art, https://www.albanyinstitute.org/landscape-and -transcendence.html.

139. Ralph Waldo Emerson, *Orations, Lectures and Essays* (London: Charles Griffin, 1866), 213.

140. Edward M. Bannister, "The Artist and His Critics," 1886, Ann-Eliza Club Manuscript Division, MSS# 26, Box 1, Folder 25, Rhode Island Historical Society, Providence.

141. Edward M. Bannister, "The Artist and His Critics," 1886, Ann-Eliza Club Manuscript Division, MSS# 26, Box 1, Folder 25, Rhode Island Historical Society, Providence.

142. Whitaker, "One of Our Laureates."

143. "Our Art Exhibition," *People's Advocate,* October 30, 1880, 2.

144. "Our Art Exhibition," 2.

145. "Notes and Comment," *New York Globe,* June 2, 1883, 2.

146. Hill, *Endure,* 11.

147. Hill, *Endure,* 16.

148. Hill, *Endure,* 231.

149. "Providence Studios," *Providence Sunday Journal,* April 17, 1887, 8. Bannister's choice of Edmund Spenser's *The Faerie Queene* as subject matter denotes, as do Duncanson's interpretations of famous works of literature, his gifts of intellect by rendering imaginative scenes based on elevated comprehension of popular literary forms. Bannister may have been drawn to this epic poem for its use of religious, moral, and political allegory as metaphors for his views on contemporary life.

150. W. Alden Brown, "Edward Mitchell Bannister," unpublished typescript, W. Alden Brown Papers, Manuscripts Division, Rhode Island Historical Society, Providence.

151. Hill, *Endure,* 16.

152. Hill, *Endure,* 327.

153. Bannister's lack of biblical paintings may be explained by the fact that the American art market at this time showed little interest in religious subjects. Therefore, American artists

rarely produced works inspired from the Bible because they catered to a small audience and were, consequently, largely unprofitable.

154. *Christian Recorder*, March 6, 1884, 3.

155. "Providence Driftings," *New York Freeman*, January 17, 1885, 4.

156. Forbes, "E. M. Bannister," 11.

157. Forbes, "E. M. Bannister," 11.

158. "Providence People: What They Are Doing in Their Societies and Churches—Obituary—Bannister's Picture," *New York Freeman*, November 27, 1886, 4.

159. Hill, *Endure*, 324–25.

160. "Rhode Island Doings," *New York Freeman*, August 20, 1887, 4.

161. "Easter in Providence: Baptizing in Benedict Pond—A Distinguished New England Painter," *New York Freeman*, April 28, 1887, 4.

162. "Easter in Providence," 4.

163. *First Annual Exhibition of American Art, September 8–June 27, 1891*, Detroit Museum of Art, exhibition catalog, http://www.dalnet.lib.mi.us/dia/collections/dma_exhibitions/1891–1.pdf.

164. "Newport Drowning Accident: Two Men Lose Their Lives off Bose Island–Ocean House Literary," *New York Age*, August 16, 1890, 1. William Clark Noble (1858–1938) was a sculptor who studied art in Boston and was best known for his Soldiers and Sailors Monument in Newport, Rhode Island, and statues of Napoleon Bonaparte and Thomas Jefferson.

165. "Died in Church," *Providence Daily Journal*, January 11, 1901, 8.

166. Arnold, "Art and Artists," 38.

167. *Providence Daily Journal*, January 10, 1901.

168. "A Great Painter: Rhode Island Honors the Great Colored Artist—the Bannister Memorial Exhibition," *Colored American* (Washington, DC), May 25, 1901, 6.

169. "Great Painter."

170. "Laid at Rest," *Providence Daily Journal*, undated clipping in the Bannister Scrapbook, Archives of American Art, Washington, DC.

171. "Bannister's Memorial," *Providence Daily Journal*, May 15, 1901.

172. From the unsigned introduction to the Edward Mitchell Bannister Memorial Exhibition, Providence Art Club, May 1901.

173. "Memorial to Mr. Bannister," undated and unidentified newspaper clipping in the Bannister Scrapbook, Archives of American Art, Washington, DC.

174. Forbes, "E. M. Bannister," 13.

175. Arnold, "Memorial to Mr. Bannister."

176. Whitaker, "Edward M. Bannister," 1–6.

177. Holland, *Life and Work of Edward Mitchell Bannister (1828–1901)*, 30–31.

178. *Providence Journal*, July 3, 1898.

179. Beth Comery, "Christiana Carteaux Bannister," *Providence Daily Dose*, February 15, 2015, https://providencedailydose.com/2015/02/14/christiana-carteaux-bannister/.

180. Simmons, *Men of Mark*, 1129.

Chapter Three: Mary Edmonia Lewis (ca. 1844–1907)

1. Edmonia Lewis gave several accounts of her date and place of birth to reporters and art critics during her most productive years. The reasons for these discrepancies are not

clear. At times she said she was born in 1843, 1844, 1845, and 1854 (an impossibility, since she enrolled at Oberlin College in 1859). She also gave Greenhigh, Ohio, and Greenbush, New York, opposite Albany, on the Hudson, as her birthplace. However, researcher Marilyn Richardson cites a sworn document by Lewis that gives 1844 in Albany as the correct information. See Marilyn Richardson, "Edmonia Lewis," *Harvard Magazine* 88, no. 4 (March/April 1986), 40.

2. Kirsten Pai Buick, *Child of the Fire: Mary Edmonia Lewis and the Problem of Art History's Black and Indian Subject* (Durham: Duke University Press, 2010), 4.

3. Buick, *Child of the Fire*, 4.

4. Buick, *Child of the Fire*, 4

5. Henry Wreford, "A Negro Sculptress," *Boston Athenaeum* (March 3, 1866), 302.

6. Wreford, "Negro Sculptress, 302." According to most accounts, Lewis was technically a mulatto of Black and Native American ancestry. As such, she is often described as an Afro-Indian or Black Indian. While these designations are correct, she is commonly identified as an African American artist. I acknowledge her biracial nature, but I include her in this study of African American artists based on her primary identification in many interviews as "Negro," her references to "the race" as her "people," and the trajectory of her career that often placed her in the sphere of Black influence and support.

7. Wreford, "Negro Sculptress."

8. Buick, *Child of the Fire*, 4.

9. The location of Samuel Lewis's birth varies in federal census records and in his obituary. For example, the 1870 United States federal census stated, "Lewis, Samuel—mulatto male age 37, barber, born Bermuda." His obituary from Bozeman, Montana, gives Haiti as his birthplace.

10. Unidentified source of a page headed by the title "Gallatin County," p. 1141, in the author's possession.

11. July 4 was a birthdate used by many African Americans, particularly former slaves, who had no knowledge of the actual day on which they were born.

12. "Biography of the 'The Bozeman Barber': Sam W. Lewis—His Remarkable Personal History—Life and Death of a Colored Pioneer Whose Friends Were Legion," *Avant-Courier*, April 6, 1896. Newspaper clipping in the collection of the author.

13. "Her Lineage," *The Elevator*, July 8, 1870, vol. 6, no. 14, 1.

14. "A Memorial Bust of John Brown," *New York Tribune*, December 27, 1878, 5. Garnet's statement seems credible, since at the time Edmonia was a child living in Greenbush, he was serving as pastor of the Liberty Street Presbyterian Church in nearby Troy, New York. Perhaps Garnet encountered her through missionary work, and she clearly made quite an impression.

15. Lewis claimed she lost both parents at the age of four. See "The Miscegen Sculptor," *Daily Graphic: An Illustrated Evening Newspaper* (New York), July 10, 1873, 58.

16. "Miscegen Sculptor," 58.

17. Unidentified source of a page headed by the title "Gallatin County," 1141, in the author's possession.

18. Wreford, "Negro Sculptress," 302.

19. "Miss Edmonia Lewis," *The Elevator*, August 30, 1873. Lewis's reference to "the black robes" suggests that she was instructed by nuns and possibly saw herself as Catholic at an early age.

20. Cited from Albert Henderson, "'I Was Declared to Be Wild.' Mary E. Lewis's Grades at New York Central College, McGrawville, NY," Edmonia Lewis (blog), March 1, 2013, http://www.edmonialewis.com/blog.htm Also, in a later interview, she claimed to be "extremely

fond of mathematics and made good progress in algebra and geometry" while at Oberlin. See "Miscegan Sculptor."

21. "Miss Edmonia Lewis," *The Elevator*.

22. Lynda Roscoe Hartigan, *Sharing Traditions: Five Black Artists in Nineteenth-Century America* (Washington, DC: Smithsonian Institution Press, 1985), 87.

23. Marcia Goldberg, "A Drawing by Edmonia Lewis," *American Art Journal* 9, no. 2 (November 1977): 104.

24. Lydia Maria Child, "Edmonia Lewis," *Broken Fetter* (March 3, 1865), 25.

25. John Mercer Langston, *From the Virginia Plantation to the National Capitol* (New York: Arno Press and the New York Times, 1969), 172.

26. Langston, *From the Virginia Plantation*, 174.

27. Geoffrey Blodgett, "John Mercer Langston and the Case of Edmonia Lewis, 1862," *Journal of Negro History*, July 1968, 206.

28. Langston later won a seat in the US House of Representatives in 1888, becoming the first African American to win a congressional election in the state of Virginia. His election was contested for nearly two years, and he eventually served in Congress from September 23, 1890, to March 3, 1891.

29. William Cheek and Aimee Lee Cheek, *John Mercer Langston and the Fight for Black Freedom, 1829–65* (Urbana: University of Illinois Press, 1989), 234.

30. Langston, *From the Virginia Plantation*, 176.

31. Langston, *From the Virginia Plantation*, 177.

32. *Lorain County News* (Ohio), February 19, 1862.

33. Blodgett, "John Mercer Langston," 211.

34. Cheek and Cheek, *John Mercer Langston*, 304.

35. Robert Samuel Fletcher, *A History of Oberlin College from Its Foundation through the Civil War* (New York: Arno Press and New York Times, 1971), 524.

36. Cheek and Cheek, *John Mercer Langston*, 304.

37. Clara Hale (?), "Dear Folks at Home," February 26, 1863, letter in Robert S. Fletcher Papers, Box 1, Oberlin Archives.

38. Clara Hale (?), "Dear Folks at Home," February 26, 1863, letter in Robert S. Fletcher Papers, box 1, Oberlin Archives.

39. *Lorain County News* (Ohio), May 6, 1863.

40. Some suggest that Frederick Douglass met with Lewis at this time, including Lewis historian Albert Henderson; see Henderson, Edmonia Lewis (blog).

41. "Miss Edmonia Lewis," *New National Era and Citizen*, September 25, 1873, 2.

42. Phebe A. Hanaford, *Daughters of America; or, Women of the Century* (Augusta, ME: True, 1882), 317.

43. Letter, Lydia Maria Child to *The Liberator*, February 19, 1864, 31. In this letter Child also indicated that Lewis's brother, Samuel, had died recently, leaving his sister destitute. However, Anne Whitney reported to her sister in 1869 that Lewis had returned to America and discovered that he had married. See Anne Whitney, letter to Sarah Whitney, December 12, 1869. Wellesley College Library, Wellesley, Massachusetts.

44. "Edmonia Lewis," *The Revolution* (April 20, 1871).

45. "Miscegan Sculptor."

46. "Miscegan Sculptor."

47. Hartigan, *Sharing Traditions*, 88.

48. "Edmonia Lewis," *St. Louis Globe-Democrat*, November 21, 1878, no. 184, 2.

49. "Medallion of John Brown," *The Liberator*, January 29, 1864, vol. 34, no. 5, 19.

50. Child, "Edmonia Lewis."

51. "The Thirteenth National," *The Liberator*, February 19, 1864, no. 8, 30.

52. "Thirteenth National."

53. In 1824 Child wrote a novel, *Hobomok, a Tale of Early Times,* in which a white woman marries a Native American and, after becoming a widow, attempts to raise their son in white society.

54. Letter, Lydia Maria Child, to Sarah Blake Sturgis Shaw, April 8, 1866, Shaw Family Correspondence, New York Public Library.

55. Letter, Lydia Maria Child, to Sarah Blake Sturgis Shaw, April 8, 1866, Shaw Family Correspondence, New York Public Library.

56. Hinton Rowan Helper, *Nojoque; A Question for a Continent* (New York: George W. Carleton, 1867), 339–41.

57. Helper, *Nojoque*, 339–41.

58. Letter, Lydia Maria Child to Sarah Blake Sturgis Shaw, April 8, 1866, Shaw Family Correspondence, New York Public Library.

59. Letter, Lydia Maria Child to Harriet Sewall, June 24,1868, Massachusetts Historical Society, Robie-Sewall Papers.

60. George M. Fredrickson, *The Arrogance of Race: Historical Perspectives on Slavery, Racism, and Social Equality* (Middletown, CT: Wesleyan University Press, 1988), 91.

61. Anne Whitney was an American sculptor who created life-size statues and portrait busts in the neoclassical style that often reflected her social and political beliefs. Like many American sculptors, Whitney moved to Rome in 1867, at age forty-six, and joined fellow Boston sculptors Hosmer and Lewis, who were already living there.

62. Lydia Maria Child, "Letter from L. Maria Child," *The Liberator*, February 19, 1864.

63. "A Chat with the Editor of the *Standard*," *The Liberator*, January 20, 1865, no. 3, 12.

64. Letter, Lydia Maria Child to Sarah Blake Sturgis Shaw, April 8, 1866, Shaw Family Correspondence, New York Public Library.

65. Henry T. Tuckerman, *Book of the Artists: American Artist Life* (New York: G. P. Putnam & Son, 1867), 603. According to Lewis scholar Harry Henderson, "Most historical references point to Nov. 11, 1864, as the date Edmonia Lewis's historic plaster bust of Col. Robert Gould Shaw launched her reputation as a portraitist at the Colored Soldiers' Fair in Boston. After all, the *Boston Transcript* raved about Lewis's work on that date. But the Colored Soldiers' Fair, which was organized by the wife of colored painter Edward M. Bannister, had occurred in mid-October. The story in the *Transcript* (and later in the *Liberator*) was about the National Sailors' Fair. On Nov. 14, the *Transcript* published a correction, noting that production problems had delayed its appearance."

66. John Greenleaf Whittier to Child, November 15, 1864, quoted in John Greenleaf Whittier and John B. Pickard, *The Letters of John Greenleaf Whittier* (Cambridge: Harvard University Press, 1975), 1036.

67. "From Boston," *New Orleans Tribune*, November 1, 1864, 4.

68. "The Thirty-First National Anti-Slavery Subscription Anniversary," *National Antislavery Standard*, March 4, 1865, 3.

69. "A Chat with the Editor of the *Standard*," *The Liberator*, January 20, 1865.

70. Letter, Lydia Maria Child to Sarah Blake Sturgis Shaw, November 3, 1864, Houghton Library, Harvard University.

71. Letter, Child to Shaw, April 8, 1866, Shaw Family Correspondence, Manuscript and Archives Division, The New York Public Library, Astor, Lenox, and Tilden Foundations.

72. Child, "Edmonia Lewis," 26.

73. *The Commonwealth* (Boston), February 4, 1865.

74. Albert Boime, *The Art of Exclusion: Representing Blacks in the Nineteenth Century* (Washington, DC: Smithsonian Institution Press, 1990), 162.

75. *The Liberator*, April 28, 1865, no. 17, 67.

76. "Miscegen Sculptor."

77. Letter, Anne Whitney to Abby Manning, August 9, 1864, Anne Whitney Papers, Wellesley College Archives, Margaret Clapp Library.

78. Letter, Anne Whitney to Abby Manning, August 9, 1864, Anne Whitney Papers, Wellesley College Archives, Margaret Clapp Library.

79. According to Kirsten Pai Buick, Howard was a member of an influential Black Boston family. She later became the principal of her own school in Washington, DC. See Kirsten Pai Buick, "Mary Edmonia Lewis, Representing and Representative," in Amy Helene Kirscke, ed., *Women Artists of the Harlem Renaissance* (Jackson: University Press of Mississippi, 2014), 43–44.

80. "From Richmond" (correspondence of the *New York Tribune*), *Boston Daily Advertiser*, August 9, 1865, no. 43.

81. "From Richmond."

82. *New Hampshire Statesman* (Concord, NH), Friday, September 1, 1865, no. 2309.

83. Passport application, National Archives and Records Administration, United States National Archives.

84. *The Commonwealth* (Boston), October 21, 1865.

85. "Miss Edmonia Lewis," *Lorain County News*, April 4, 1866, 3.

86. "From Richmond."

87. Quoted in Melissa Dabakis, *A Sisterhood of Sculptors: American Artists in Nineteenth-Century Rome* (University Park: Pennsylvania State University Press, 2014), 3.

88. John Wilmerding, Linda Ayres, and Earl A. Powell, *An American Perspective: Nineteenth Century Art from the Collection of Jo Ann & Julian Ganz, Jr.* (Washington, DC: National Gallery of Art, 1981), 34.

89. The reasons for this belief among some men are discussed later in the chapter.

90. Charlotte Saunders Cushman (1816–76, Boston) was a Boston native who became the most famous American actress of the nineteenth century. Her career encompassed four decades and spanned the United States and Europe. She enjoyed success with strong emotional performances. Her personal life centered on her community of female friends. Cushman lived in England and Italy from 1852 to 1870 where she used her fortune to advance the careers of female artists.

91. Henry James, *William Wetmore Story and His Friends* (New York: Grove Press, 1957), 257. In this case "marmorean" refers to marble.

92. Joseph Leach, "Harriet Hosmer: Feminist in Bronze and Marble," *Feminist Art Journal* (Summer 1976): 11.

93. Dolly Sherwood, *Harriet Hosmer: American Sculptor, 1830–1908* (Columbia: University of Missouri Press, 1991), 54–64.

94. Leach, "Harriet Hosmer," 11.

95. John Carlos Rowe, *New American Studies* (Minneapolis: University of Minnesota Press, 2002), 86.

96. Several LGBTQ sources have readily identified Lewis as a lesbian and celebrate her proudly as such. While some of these women sculptors were without question engaged in

same-sex relationships—Cushman, Hosmer, Stebbins, and Whitney in particular—there is no credible evidence that Lewis was. In fact, I uncovered several articles on Lewis written in America that stated that she was engaged or married. There is no documentation to support those claims, and they were likely written by reporters wishing to embellish their stories. Or perhaps Lewis purposefully supplied this information to deflect rumors concerning her sexuality. Added to this confusion were continued reports that she "often dressed like a man." Once more, there are no valid accounts or photographs to support this premise. See also Scott Trafton, *Egypt Land: Race and Nineteenth-Century American Egyptomania* (Durham, NC: Duke University Press, 2004), 212. Trafton seems to be forcing a lesbian identity upon Lewis, using her association with "the flock" as a leading cause for this assumption. He also cites "traces of Lewis's love" to imply possible relationships with Adeline T. Howard and Adelia Gales, a painter who accompanied Lewis to Naples with Fredrick Douglass and his wife during their visit to Italy. As with other attempts to define Lewis as a lesbian, Trafton offers no evidence to substantiate the claim.

97. Jacqueline Marie Musacchio, "Mapping the 'White, Marmorean Flock': Anne Whitney Abroad, 1867," *Nineteenth-Century Art Worldwide* 13, no. 2 (Autumn 2014), http://www.19thc-artworldwide.org/autumn14/musacchio-anne-whitney-abroad.

98. Letter, Lydia Maria Child to James Thomas Fields, October 13, 1865, James Thomas Fields Collection, Huntington Library, San Marino, California.

99. Letter, Lydia Maria Child to Annie Adams Fields, November 25, 1865, James Thomas Fields Collection, Huntington Library, San Marino, California.

100. Letter, Lydia Maria Child to Annie Adams Fields, November 25, 1865, James Thomas Fields Collection, Huntington Library, San Marino, California.

101. Letter, Lydia Maria Child to Annie Adams Fields, November 25, 1865, James Thomas Fields Collection, Huntington Library, San Marino, California.

102. "Miss Edmonia Lewis at Florence, *The Commonwealth*, December 9, 1865.

103. Child to James Fields, October 13, 1865.

104. Child to James Fields, October 13, 1865.

105. "Miscegan Sculptor."

106. Letter, Lydia Maria Child to James Thomas Fields, October 13, 1865, James Thomas Fields Collection, Huntington Library, San Marino, California.

107. Joseph Leach, *Bright Particular Star: The Life and Times of Charlotte Cushman* (New Haven: Yale University Press, 1970), 335.

108. In this regard Lewis joined the pioneering efforts of nineteenth-century feminists and therefore deserves a prominent place in historical discussions of the movement.

109. Sherwood, *Harriet Hosmer*, 259.

110. Quoted in Sherwood, *Harriet Hosmer*, 259.

111. Sherwood, *Harriet Hosmer*, 259.

112. "Miscegen Sculptor," 58.

113. "Edmonia Lewis," reprinted in the *South Carolina Leader*, May 12, 1866, 2.

114. "The Colored Genius at Rome," *Christian Recorder*, March 3, 1866.

115. "Edmonia Lewis," *St. Louis Globe-Democrat*, November 21, 1878, no. 184, 2.

116. "Miss Edmonia Lewis," *Christian Recorder*, October 26, 1867.

117. "Miscegan Sculptor."

118. Melissa Dabakis, *A Sisterhood of Sculptors: American Artists in Nineteenth-Century Rome.* (University Park: Penn State University Press; reprint ed., 2015), 169.

119. Wreford, "Negro Sculptress," 302.

120. Quoted in Hartigan, *Sharing Traditions*, 93.

121. "Miss Edmonia Lewis," *Lorain County News*, April 4, 1866, 3.

122. Letter, Child to Shaw, April 8, 1866, Shaw Family Correspondence, Manuscript and Archives Division, The New York Public Library, Astor, Lenox, and Tilden Foundations.

123. Letter, Child to Shaw, April 8, 1866, Shaw Family Correspondence, Manuscript and Archives Division, The New York Public Library, Astor, Lenox, and Tilden Foundations.

124. "Edmonia Lewis," *St. Louis Globe-Democrat*, November 21, 1878, no. 184, 2.

125. "American Sculptors in Italy," *Frank Leslie's Illustrated Newspaper*, July 20, 1867, no. 616, 275.

126. "Miss Edmonia Lewis, Sculptor," *Frank Leslie's Illustrated Newspaper*, August 1, 1868, no. 670, 316. It should be noted that all articles on Lewis following her time in Boston and through her time in Rome, especially those published in abolitionist literature, failed to mention her life at Oberlin. Apparently, the abolitionists wished to distance their promotion of Lewis as an exemplar of Black achievement from any connection to her scandals at Oberlin, even though her college education made her even more extraordinary. Thus, "Edmonia" replaced "Mary" to remove any remaining negative stigma associated with her developing notoriety.

127. Thayer Tolles, "American Neoclassical Sculptors Abroad," Metropolitan Museum of Art, 2004, https://www.metmuseum.org/toah/hd/ambl/hd_ambl.htm.

128. "A Colored Artist," *Lorain County News*, March 28, 1866.

129. Letter, Lydia Maria Child to Sarah Blake Sturgis Shaw, August 1870, Harvard University. Houghton Library.

130. Letter, Edmonia Lewis, Rome to Maria Weston Chapman, February 5, 1867, Letter/Correspondence Manuscripts, Boston Public Library, Anti-Slavery Collection.

131. Letter, Edmonia Lewis, Rome to Maria Weston Chapman, February 5, 1867, Letter/Correspondence Manuscripts, Boston Public Library, Anti-Slavery Collection.

132. Letter, Edmonia Lewis, Rome to Maria Weston Chapman, February 5, 1867, Letter/Correspondence Manuscripts, Boston Public Library, Anti-Slavery Collection.

133. Letter, Edmonia Lewis, Rome to Maria Weston Chapman, August 6, 1867, Letter/Correspondence Manuscripts, Boston Public Library, Anti-Slavery Collection.

134. Romare Bearden and Harry Henderson, *A History of African-American Artists from 1792 to the Present* (New York: Pantheon Books, 1993), 65.

135. Letter, Edmonia Lewis, Rome to Maria Weston Chapman, May 3, 1868, Letter/Correspondence Manuscripts, Boston Public Library, Anti-Slavery Collection.

136. Elizabeth Palmer Peabody, "Miss Edmonia Lewis' Works," *Commonwealth* (Boston), July 10, 1869.

137. Kirsten Pai Buick, "The Ideal Works of Edmonia Lewis," *American Art* 9, no. 2 (Summer 1995), 6.

138. Letter, Lydia Maria Child to Harriet Sewall, July 10, 1868, letter, Robie-Sewall Papers, Massachusetts Historical Society, Boston.

139. *The Song of Hiawatha* was Longfellow's most popular work and sold more than fifty thousand copies by 1860.

140. The writer mistakes Minnehaha's father for Hiawatha.

141. *The Revolution*, April 20, 1871. This reporter seems to have misjudged Lewis's interpretation of *The Wooing of Hiawatha*, mistaking Minnehaha's father for Hiawatha. The Smithsonian Museum of American Art owns two versions that are still entitled *The Old Arrow Maker* and are dated 1872. It is likely that Lewis later renamed the sculpture to avoid the confusion of the "missing Hiawatha."

142. "Statuary by Miss Lewis," *The Elevator*, June 6, 1867 3, no. 12, 2. Black journalist and abolitionist Philip Alexander Bell (1808–1886) founded the "weekly journal of progress" *The Elevator*, in 1865 in San Francisco with the slogan, "Equality Before the Law" printed on the masthead.

143. Rayford W. Logan and Michael R. Winston, eds., *Dictionary of American Negro Biography* (New York: W. W. Norton, 1982), 394.

144. "Miss Lewis, the Colored Sculptor," *The Elevator*, June 12, 1868, vol. 4, no. 1.

145. "Miss Lewis, the Colored Sculptor."

146. As previously mentioned, copies of *The Wooing* are located in the Smithsonian American Art Museum (1872), and in the Savannah College of Art and Design Museum of Art (1866 from Walter O. Evans), the Crystal Bridges Museum of American Art (1872), and Tuskegee University (1872). Extant copies of *The Marriage* are held by Bill Cosby (1866), Walter O. Evans (1868), the Montgomery Museum of Fine Art (1868), the Cincinnati Art Museum (1871), the Kalamazoo Institute of Arts (1872), and the Stark Museum of Art (1874).

147. "New Discovery: Three Indians in Battle by Edmonia Lewis," ARTFIXdaily (blog), December 30, 2010, http://www.artfixdaily.com/blogs/post/6906-new-edmonia-lewis-discovery.

148. Elizabeth Bolande, "Newly Discovered *Indian Combat* by American Artist Edmonia Lewis Acquired by the Cleveland Museum of Art," Cleveland Museum of Art, 2011, https://www.clevelandart.org/about/press/newly-discovered-indian-combat-american-artist-edmonia-lewis-acquired-cleveland-museum.

149. This version of *Hagar* is now believed lost. An extant version was shown in 1875. Therefore, any discussion of the sculpture is based on the presumption that both share stylistic similarities.

150. Letter, Lydia Maria Child to Sarah Blake Sturgis Shaw, August 1870, Harvard University. Houghton Library.

151. *The Revolution*, April 20, 1871.

152. "A Colored Sculptress," *Milwaukee Daily Sentinel*, April 14, 1869, no. 87.

153. "Colored Sculptress."

154. Letter, Anne Whitney to Sarah Whitney, February 7, 1869, Anne Whitney Papers, Wellesley College Archives, Margaret Clapp Library.

155. Wreford, "Negro Sculptress," 302.

156. Letter, Lydia Child to Harriet Sewall, July 10, 1869, Robie-Sewall Papers, Massachusetts Historical Society.

157. Letter, Lydia Child to Harriet Sewall, July 10, 1869, Robie-Sewall Papers, Massachusetts Historical Society.

158. Letter, Lydia Child to Harriet Sewall, July 10, 1869, Robie-Sewall Papers, Massachusetts Historical Society.

159. Letter, Lydia Child to Harriet Sewall, July 10, 1869, Robie-Sewall Papers, Massachusetts Historical Society.

160. Letter, Anne Whitney to Sarah Whitney, February 9, 1868, Whitney Papers, Wellesley College Archives.

161. Letter, Anne Whitney to Sarah Whitney, February 9, 1868, Whitney Papers, Wellesley College Archives.

162. Sherwood, *Harriet Hosmer*, 218.

163. *The Revolution*, April 20, 1871.

164. *Vermont Watchman and State Journal*, May 17, 1871, no. 30.

165. Letter, Anne Whitney to Sarah Whitney, February 7–18, 1869, Anne Whitney Papers, Wellesley College Archives, Margaret Clapp Library.

166. Letter, Anne Whitney to Sarah Whitney, February 7–18, 1869, Anne Whitney Papers, Wellesley College Archives, Margaret Clapp Library.

167. Personal," *The Elevator*, October 23, 1868, vol. 4, no. 30, 2.

168. "Colored Sculptress."

169. "Colored Sculptress."

170. "Colored Sculptress."

171. "Colored Sculptress."

172. Henry T. Tuckerman, *Book of the Artists: American Artist Life, Comprising the Biographical and Critical Sketches of American Artists* (New York: Putnam, 1867), 603–4.

173. Lillie Buffum Wyman and Arthur Crawford Wyman, *Elizabeth Buffum Chance* (Boston: W. B. Clarke, 1914), 37–38.

174. For a detailed account of the history of Hosmer's role in the monument's construction, see Kirk Savage, *Standing Soldiers, Kneeling Slaves: Race, War, and Monument in Nineteenth-Century America* (Princeton: Princeton University Press, 1999), 98–101.

175. M. G. W., "How Should Lincoln Be Memorialised?" *Boston Daily Advertiser*, Mar. 16, 1867: n. p.

176. M. G. W., "How Should Lincoln Be Memorialised?"

177. M. G. W., "How Should Lincoln Be Memorialised?"

178. M. G. W., "How Should Lincoln Be Memorialised?"

179. The culmination of Ball's statue grew from the desire of a freed slave named Charlotte Scott, of Virginia, to celebrate Lincoln's memory in a lasting monument. She donated her first five dollars earned in freedom on April 15, 1865, to begin the effort.

180. Buick, *Child of the Fire*, 65.

181. Buick, *Child of the Fire*, 22.

182. "Miss Edmonia Lewis," *The Elevator*, September 6, 1873, vol. 9, no. 222, 2.

183. "The Singeing Season," *St. Louis Globe-Democrat*, Jan. 3, 1881: n.p.

184. Born in a log cabin in Madison, Wisconsin, in 1847, Ream eventually studied sculpture with Clark Mills in his studio in Washington, DC. After honing her skills with portrait medallions and busts of well-known figures such as Thaddeus Stevens, George Armstrong Custer, and Horace Greeley, she received the honor of having President Lincoln pose for her while she was still a teenager.

185. See Gregory Tomso, "Lincoln's 'Unfathomable Sorrow': Vinnie Ream, Sculptural Realism, and the Cultural Work of Sympathy in Nineteenth-Century America," *European Journal of American Studies* 2 (April 5, 2011), http://ejas.revues.org/9139.

186. For more on this controversy, see Edward S. Cooper, *Vinnie Ream: An American Sculptor* (Chicago: Chicago Review Press, 2009).

187. "Miscegen Sculptor," 58.

188. "Miscegen Sculptor," 58.

189. "Miss Edmonia Lewis," *New National Era and Citizen*, 2.

190. "Miscegen Sculptor."

191. "Personal Gossip," *Boston Daily Advertiser*, May 25, 1872.

192. *The Revolution*, April 20, 1871.

193. *The Revolution*, April 20, 1871.

194. Miss Edmonia Lewis and the Marquis of Bute," *Boston Daily Advertiser*, May 21, 1870.

195. Logan and Winston, *Dictionary of American Negro Biography*, 395.

196. *The Revolution*, April 20, 1871.

197. "General and Personal," *St. Louis Globe-Democrat*, October 7, 1878, 2.

198. Letter, Anne Whitney to Sarah Whitney, February 9, 1868, Whitney Papers, Wellesley College Archives.

199. Boime, *Art of Exclusion*, 169.

200. *The Revolution*, April 20, 1871.

201. Henry James, *William Wetmore Story and His Friends*, 257.

202. Quoted in Harry Henderson and Albert Henderson, *The Indomitable Spirit of Edmonia Lewis: A Narrative Biography* (New York: Esquiline Hill Press, 2012). Her name was not mentioned.

203. Boime, *Art of Exclusion*, 169.

204. Letter, Anne Whitney to her family, February 21, 1869, Elizabeth Payne's unpublished manuscript, Anne Whitney Papers, Margaret Clapp Library, Wellesley College, Wellesley, Massachusetts.

205. "The Studios of Rome," *London Art Journal* 9 (March 1870): 77.

206. Charlotte Streifer Rubinstein, *American Women Artists from Early Indian Times to the Present* (Boston: G. K. Hall, 1982), 81.

207. "General News," *Mineral Point Tribune* (Mineral Point, WI), October 2, 1878, 2.

208. "About Artists," *Christian Register*, June 18, 1869, 4.

209. *Christian Register*, July 10, 1869, 3.

210. *Christian Register*, July 10, 1869, 3.

211. *Christian Register*, July 10, 1869, 3.

212. "Edmonia Lewis, Italy, Colonel Shaw," *The Elevator*, July 2, 1869, vol. 5, no. 13, 1.

213. "Edmonia Lewis," *Christian Register*, October 23, 1869, 2.

214. "Edmonia Lewis," 2.

215. "Memorials: Edmonia Lewis," *Christian Register*, October 23, 1869, 2.

216. "Testimonial to Miss Edmonia Lewis," *The Elevator*, December 3, 1869, vol. 5, no. 35, 1.

217. "Testimonial to Miss Edmonia Lewis," 1.

218. Letter, Lewis to Maria Weston Chapman, May 3, 1868, Boston Public Library, Anti-Slavery Collection, Rare Books and Manuscript Collection.

219. "Miss Edmonia Lewis Works," *The Elevator*, August 13, 1869, vol. 5, no. 19, 2 (reprinted from *The Commonwealth*).

220. Bearden and Henderson, *History of African-American Artists*, 68.

221. Quoted in Bearden and Henderson, *History of African-American Artists*, 65.

222. "All Sorts and Sizes," *Bangor Daily Whig & Courier*, April 22, 1872.

223. "Multiple News Items," *Lowell Daily Citizen and News* (Massachusetts), January 1, 1874.

224. "Dolly Varden Come to Grief," *The Elevator*, May 11, 1872, vol. 8, no. 6, 4.

225. "Items of Interest," *Weekly Clarion* (Jackson, Mississippi), September 2, 1869, 5. Lewis was likely in New York when she received this commission. It was here that the 1870 federal census identified her on June 24 as a female mulatto, twenty-four years of age, a sculptress born in New York, and possessing $20,000 worth of property. This astonishing amount was likely the value she placed on the sculptures she brought with her from Rome.

226. *The Revolution*, May 4, 1871.

227. Bearden and Henderson, *History of African-American Artists*, 69.

228. "Art Matters," *Milwaukee Sentinel*, January 13, 1871.

229. Letter, Anne Whitney to Sarah Whitney, January 14, 1871, Anne Whitney Papers, Wellesley College Archives.

230. Gwendolyn DuBois Shaw, *Portraits of a People: Picturing African Americans in the Nineteenth Century* (Seattle: University of Washington Press, 2006), 170.

231. "A Colored Sculptress," quoted from Rome correspondence, *New York Times* in, *Helena Weekly Herald*, June 26, 1873, 1.

232. "Colored Sculptress," 1.

233. "Colored Sculptress," 1.

234. See Congress of Religion, *Unity: Freedom, Fellowship, and Character in Religion*, vol. 75, no. 4 (March 25, 1915: 60.

235. Congress of Religion, *Unity: Freedom, Fellowship, and Character in Religion*, 60.

236. Congress of Religion, *Unity: Freedom, Fellowship, and Character in Religion*, 60.

237. Quoted in "Edmonia Lewis: The Famous Colored Sculptress in San Francisco," *San Francisco Chronicle*, August 26, 1873, 5.

238. "Miss Edmonia Lewis," *The Elevator*, August 30, 1873, vol. 9, no. 21, 2.

239. "Miss Edmonia Lewis," *The Elevator*, 2.

240. The reporter mistakenly identified the award-winning work as *Hiawatha's Wooing*. It was, in fact, *Asleep* that received the prize. Another work, *Love Caught in a Trap*, earned a certificate of excellence at the same venue. See Harry Henderson, "Biography—Chronology: Outline of Mary Edmonia Lewis's Life and Art," https://www.edmonialewis.com.

241. Quoted in Philip M. Montesano, "The Mystery of the San Jose Statues," *Urban West*, May/June 1968): 26.

242. "Miss Edmonia Lewis," *The Elevator*, 2.

243. "Miss Edmonia Lewis," *The Elevator*, 2.

244. Montesano, "Mystery of the San Jose Statues," 26.

245. "San Jose Invaded: First Day of the Santa Clara Valley Fair and Races," *San Francisco Chronicle*, October 2, 1873.

246. "Edmonia Lewis Sculptures (SJPL California Room)," accessed March 24, 2017, SJSU, King Library, Digital Collections, http://digitalcollections.sjlibrary.org/cdm/landingpage/collection/sjpl_edmon.

247. "Miss Edmonia Lewis," *New National Era and Citizen*, 2.

248. "Miss Edmonia Lewis," *New National Era and Citizen*, 2.

249. *How Edmonia Lewis Became an Artist* (Philadelphia: John Spencer, Printer, 1876), 5.

250. For a detailed account of the life of Thomas, see Loren Schweninger, ed., *From Tennessee Slave to St. Louis Entrepreneur: The Autobiography of James Peck Thomas* (Columbia: University of Missouri Press, 1984).

251. Cited in Cyprian Clamorgan, *The Colored Aristocracy of St. Louis*, ed. Judith Winch (Columbia: University of Missouri Press, 1999), 48–49.

252. *Edmonia Lewis vs. James P. Thomas and Antoinette Thomas*, St. Louis Circuit Court Case Files, Missouri State Archives–St. Louis, St. Louis, Missouri.

253. The marble bust of James Peck Thomas now resides in the Allen Memorial Art Museum, Oberlin College, Ohio. The fate of the bust of Antoinette Thomas, if completed, remains unresolved. Some scholars speculate that a work presently known as *Portrait of a Woman* (Saint Louis Art Museum) is of Mrs. Thomas, but its completion date of 1873 seems problematic if both works were finished and shipped back to America together. See Susan Crowe, "Visual Narratives and the Portrait Busts of Edmonia Lewis," master's thesis, University of Missouri–Kansas City, 2010.

254. "Edmonia Lewis," *Milwaukee Daily Sentinel* (from the *St. Louis Globe*, November 20), November 26, 1873, no. 281, 2.

255. "Edmonia Lewis," *Milwaukee Daily Sentinel*.

256. "Edmonia Lewis," *New National Era and Citizen*, February 12, 1874, 3.

257. "Edmonia Lewis," *New National Era and Citizen*, February 12, 1874, 3. This medal was likely the one she received for *Asleep* (as well as a certificate of excellence for *Love Caught in a Trap*) at the National Exposition of Paintings and Sculpture, Academy of Arts and Sciences, Naples in 1872.

258. "Edmonia Lewis," *New National Era and Citizen*, February 12, 1874, 3.

259. "Edmonia Lewis," *New National Era and Citizen*, February 12, 1874, 3.

260. "News and Notes," *Daily Graphic*, July 10, 1873, no. 110, 59.

261. "Mechanism and Art," *The Elevator*, September 6, 1873, vol. 9, no. 22, 2.

262. William Wells Brown, *The Rising Son: The Antecedents and Advancement of the Colored Race* (Boston: Boston: A. G. Brown, 1873).

263. "Miscegen Sculptor," 58.

264. Gail Schontzler, "Discovering Lizzie Williams and Bozeman's Lost Black History," *Bozeman Daily Chronicle*, February 15, 2017, accessed September 1, 2017, https://www.bozeman dailychronicle.com/news/discovering-lizzie-williams-and-bozeman-s-lost-black-history /article_75d9ded6-6a35-5747-883e-405b91d158a9.html.

265. Schontzler, "Discovering Lizzie Williams and Bozeman's Lost Black History."

266. The notion of Egypt and Egyptians as an easily understood metaphor for Black Africa and Black people in America is detailed later in this chapter.

267. Charmaine A. Nelson, *The Color Stone* (Minneapolis: University of Minnesota Press, 2007), 172.

268. "Persons and Things," *Weekly Louisianan*, July 24, 1875, 2.

269. William Henry Johnson, *The Autobiography of Dr. William Henry Johnson* (Albany: Argus, 1900), 166.

270. Johnson, *Autobiography of Dr. William Henry Johnson*, 166.

271. Johnson, *Autobiography of Dr. William Henry Johnson*, 166.

272. Johnson, *Autobiography of Dr. William Henry Johnson*, 169.

273. Johnson, *Autobiography of Dr. William Henry Johnson*, 169–70.

274. "Omaha; St. John's Chapel; Mr. E. R. Overall; C. D. Bell," *Weekly Louisianan*, September 11, 1875, 1.

275. "Indianapolis, Ind., Sept. 12th, 1875," *Christian Recorder*, September 23, 1875. There is no available information to gauge the impact of this effort.

276. "Centennial—Retrospectively," *Athens Messenger* (Ohio), August 27, 1876.

277. "Seeking Equality Abroad," *Milwaukee Daily Sentinel*, January 2, 1879, no. 2, 5. Reprinted from the *New York Times*, December 29, 1878.

278. William J. Clark, *Great American Sculptures* (Philadelphia: Gebbie and Barrie, 1878), 141. In reflection, Lewis's Cleopatra does not aesthetically or stylistically stray far from Thomas Ridgeway Gould's *Cleopatra* (1873) in its narrative of the queen's last moments. Like Lewis, Gould portrayed a seated monarch with eyes half-closed and one breast exposed, hovering between life and death. The only substantive difference between the two works is that Gould removed references to the asp and the wound it inflicted, thus bringing his work more in line with accepted neoclassical preferences of a "beautiful passing." However, this comparison demonstrates the fine line that existed between conventional idealized depictions and more realistic interpretations.

279. J. S. Ingram, *The Centennial Exposition, Described and Illustrated* (Philadelphia: Hubbard Bros., 1876), 372.

280. "American Sculptors," *Inter Ocean* (Chicago), October 7, 1876, no. 169, 6.

281. "The Exposition," *Inter Ocean*, September 26, 1878, no. 157, 4.

282. Scott Trafton, *Egypt Land: Race and Nineteenth Century American Egyptomania* (Durham, NC: Duke University Press, 2004), 178.

283. Trafton, *Egypt Land*, 177.

284. Henry William Herbert, "Antony and Cleopatra," *Graham's Magazine*, July 1852, vol. 41, 137.

285. "Centennial—Negro Mechanism—"Death of Cleopatra"—Negro Education," *People's Advocate*, July 22, 1876, 4.

286. Boime, *Art of Exclusion*, 121.

287. Henry Highland Garnet, "On the Past and Present Condition, Destiny of the Colored Race," *North Star*, June 16, 1848.

288. As stated earlier, Lewis studied with Edward Brackett for only a brief time, and how much she actually absorbed from him is not known. Brackett's interest in the subject of death, however, led him to create *Shipwrecked Mother and Child* (1850). The sculpture was not well received by the public. His figure proved to be too explicit for the times in both its "unbridled" nudity and its depressing theme of a dead woman and child washed ashore. The sentimentality generated by the victimization of figures like these was negated by its lost connection to an ancient Greek or Roman myth (thereby making the nudity more acceptable). Whether Lewis saw this work or had conversations with Brackett about it is not documented, but public reaction to the *Shipwrecked Mother and Child* seems strikingly similar to that surrounding *The Death of Cleopatra*.

289. For a detailed examination of Hosmer's creation of Zenobia, see Susan Waller, "The Artist, the Writer, and the Queen: Hosmer, Jameson, and Zenobia," *Woman's Art Journal* 4, no. 1 (1983): 21–28.

290. *Newport (RI) Daily News*, September 19, 1878, 4.

291. John P. Sampson, "Doing the Centennial," *Christian Recorder*, October 19, 1876, 8.

292. Cited in Bearden and Henderson, *History of African-American Artists*, 73.

293. "Facts and Fancies," *Milwaukee Daily Sentinel*, August 3, 1876, no. 185, 2.

294. Letter, Edmonia Lewis to Samuel C. Armstrong, September 11, 1876, Hampton University Archives.

295. *Memphis Daily Appeal*, "Local Paragraphs," October 19, 1876, 4.

296. "Items for Ladies," *True Northerner* (Paw Paw, Michigan), November 12, 1875, 8.

297. "Art Advancement," *Daily Globe* (St. Paul), July 15, 1883, 3.

298. "Art Advancement."

299. "Edmonia Lewis," *St. Louis Globe-Democrat* (from the *Indianapolis News*, November 18, 1878, vol. 9, no. 295, 4), November 21, 1878, no. 184, 2.

300. "Edmonia Lewis," *St. Louis Globe-Democrat*, 2.

301. "Edmonia Lewis," *St. Louis Globe-Democrat*, 2.

302. "Edmonia Lewis," *St. Louis Globe-Democrat*, 2.

303. "Edmonia Lewis," *St. Louis Globe-Democrat*, 2

304. "Edmonia Lewis," *St. Louis Globe-Democrat*, 2.

305. "Edmonia Lewis," *St. Louis Globe-Democrat*, 2.

306. "General and Personal," *St. Louis Globe-Democrat*, October 7, 1878, 2.

307. "Miss Edmonia Lewis," *Inter Ocean*, December 27, 1878, no. 236, 4.

308. "A Memorial Bust of John Brown," *New York Tribune*, December 27, 1878, 5.

309. "Seeking Equality Abroad: Why Miss Edmonia Lewis, the Colored Sculptor, Returns to Rome—Her Early Life and Struggles," *New York Times*, December 29, 1878.

310. "Seeking Equality Abroad."

311. "Seeking Equality Abroad."

312. "J. P. Thomas, Miss Edmonia Lewis, Judge Adams," *Weekly Louisianian*, February 8, 1879.

313. "The Courts," *St. Louis Globe-Democrat*, January 24, 1879, 7.

314. "Courts," 7.

315. "Courts," 7.

316. "Courts," 7.

317. "Courts," 7.

318. "The Courts," *St. Louis Globe-Democrat*, February 26, 1879, 8.

319. "The Courts," *St. Louis Globe-Democrat*, April 21, 1880, 7.

320. "Civil Courts," *St. Louis Globe-Democrat*, June 17, 1884, 10.

321. "Eve-Angelical Corner," *New North-West* (Deer Lodge, MT), October 31, 1879, 1.

322. "Edmonia Lewis, the Sculptress," *St. Louis Globe-Democrat*, November 2, 1879, no. 165.

323. "Edmonia Lewis, the Sculptress."

324. Melba Joyce Boyd, *Discarded Legacy: Politics and Poetics in the Life of Frances E. W. Harper, 1825–1911* (Detroit: Wayne State University Press, 1994), 214.

325. "J. H. Jones; Rev. J. W. Gazaway, Mrs. D. Washington," *Cleveland Gazette*, February 23, 1884, 3.

326. "Miss Edmonia Lewis; St Mary Chapel; Baltimore," *Cleveland Gazette*, February 23, 1886, 1.

327. "Evidence of Edmonia Lewis's Lost Work Found in Baltimore Church," February 4, 2011, ARTFIXdaily, http://www.artfixdaily.com/artwire/release/5021-evidence-of-edmonia -lewis%E2%80%99s-lost-work-found-in-baltimore-church.

328. "Brooklyn Notes," *New York Freeman*, June 19, 1886, 3.

329. "Brooklyn Notes," *New York Freeman*, October 2, 1886, 3.

330. Benjamin Quarles, *Frederick Douglass* (New York: Athenaeum, 1968), 310.

331. William S. McFeely, *Frederick Douglass* (New York: W. W. Norton, 1991), 329.

332. McFeely, *Frederick Douglass*.

333. Quoted in Richardson, "Edmonia Lewis," 40.

334. "Women of the Race: Their Practical and Creditable Progress," *Cleveland Gazette*, March 12, 1887, 1.

335. *Cleveland Gazette*, July 23, 1887, 1.

336. "News and Sentiment," *Huntsville Gazette*, February 2, 1889, vol. 10, no. 12, 2.

337. "A Statue of a Saint," *Milwaukee Daily Journal*, November 2, 1888.

338. "Chicago: The Orange Exhibition—Edmonia Lewis's' *Cleopatra*," *American Architect and Building News*, May 23, 1891, 120. The *Iowa State Bystander* (November 25, 1898) reported that *Cleopatra* was purchased by the International Art Association of Chicago. *Cleopatra* is now part of the Smithsonian American Art Museum. For her journey there, see Stephen May, "The Object at Hand," *Smithsonian* 27, no. 6 (September 1996): 20

339. "Miss Edmonia Lewis," *Cleveland Gazette*, March 11, 1893, 1.

340. Lewis remained in Paris until at least 1896. During this period, Henry O. Tanner was also residing there. Although Tanner was aware of Lewis and her career, there is no evidence that the two met in that city.

341. Tolles, "American Neoclassical Sculptors Abroad."

342. Tolles, "American Neoclassical Sculptors Abroad."

343. Tolles, "American Neoclassical Sculptors Abroad."

344. "Doings of the Race," *Cleveland Gazette*, January 21, 1893, 2.

345. "News and Sentiment," *Huntsville Gazette*, January 28, 1893, vol. 14, no. 9, 2.

346. *Official Directory of the World's Columbian Exposition*, ed. Moses Purnell Handy (Chicago: W. B. Conkey, 1893), 1059. Quoted in Henderson and Henderson, *Indomitable Spirit of Edmonia Lewis*, locs. 7459–7465.

347. "Negro States; International Exposition," *Savannah Tribune*, July 6, 1895, vol. 10, no, 39, 2.

348. "Negro States; International Exposition," 2.

349. "Atlanta's Exposition," *Hartford Herald*, November 6, 1895, 1.

350. "Atlanta's Exposition," 1.

351. Henry McNeal Turner, "To Colored People," *Parsons Weekly Blade*, February 9, 1895, vol. 3 no. 28, 1.

352. See Henderson and Henderson, *Indomitable Spirit of Edmonia Lewis*, locs. 11636–11639.

353. "The Great Charity Ball," *Washington Bee*, December 25, 1897, vol. 16, no. 30, 4.

354. "Race Echoes," *Iowa State Bystander*, November 25, 1898, 8.

355. "Miscegan Sculptor."

356. Henderson and Henderson, *Indomitable Spirit of Edmonia Lewis*, locs. 7701–705.

357. "Sculptor's Death Date Unearthed: Edmonia Lewis Died in London in 1907," ARTFIXdaily, January 9, 2011, http://www.artfixdaily.com/blogs/post/51-sculptors-death-unearthed-edmonia-lewis-died-in-london-in-1907.

358. *The Revolution*, April 20, 1871.

Epilogue: American Masters Reclaimed

1. "Henry Ossawa Tanner," *Opportunity: Journal of Negro Life* 15 (July 1937): 197.

BIBLIOGRAPHY

"1836 Cincinnati Riots Couldn't Stop Anti-slavery Newspaper," May 11, 2017, *The Enquirer*, www.cincinnati.com/story/news/2017/05/11/1836-cincinnati-riots-couldnt-stop-anti -slavery-newspaper/101497562/.

Adogame, Afe, and Andrew Lawrence, eds. *Africa in Scotland, Scotland in Africa: Historical Legacies and Contemporary Hybridities.* Boston: Brill, 2014.

American Paintings in the Detroit Institute of Art, Vol. I. New York: Hudson Hill Press, 1991.

Arthur, John Preston. *History of Western North Carolina, Chapter VIII: County History,* 1914, New River Notes, http://www.newrivernotes.com/topical_books_1914_historyofwestern _northcarolina.htm.

"Artists and the Fine Arts among Colored People," *Repository of Religion and Literature,* Indianapolis: Published for the Literary Societies under the Baltimore, Indiana, and Missouri Conferences of the African Methodist Episcopal Church, 1860.

Artists of Michigan. Muskegon: Muskegon Museum of Art, 1987.

Ater, Renée. *Remaking Race and History: The Sculpture of Meta Warrick Fuller.* Berkeley: University of California Press, 2011.

Bailey, Julius H. *Race Patriotism: Protest and Print Culture in the A.M.E. Church.* Knoxville: University of Tennessee Press, 2012.

Baker, Ray S. *Following the Color Line: Negro Citizenship in the Progressive Era.* New York: Harper & Row, 1964.

Baur, John I. *American Painting in the Nineteenth Century: Main Trends and Movements.* New York: Fredrick A. Praeger, 1953.

Bearden, Romare, and Harry Henderson. *A History of African-American Artists from 1792 to the Present.* New York: Pantheon Books, 1993.

Bearden, Romare, and Harry Henderson. *Six Black Masters of American Art.* New York: Doubleday, 1972.

Beeching, Barbara J. *Hopes and Expectations: The Origins of the Black Middle Class in Hartford.* State University of New York Press, 2017.

Berry, Mary Frances, and John W. Blassingame. *Long Memory: The Black Experience in America.* New York: Oxford University Press, 1982.

Betjemann, Peter. "The Ends of Time: Abolition, Apocalypse, and Narrativity in Robert S. Duncanson's Literary Paintings," *American Art* 31, no. 3 (Fall 2017): 80–109.

Black Art Ancestral Legacy: The African Impulse in African-American Art. Dallas: Dallas Museum of Art, 1989.

Blodgett, Geoffrey. "John Mercer Langston and the Case of Edmonia Lewis, 1862," *Journal of Negro History* (July 1968): 201–18.

Bloom, Harold. *The Harlem Renaissance.* New York: Chelsea House, 2004.

Boime, Albert. *The Art of Exclusion: Representing Blacks in the Nineteenth Century.* Washington, DC: Smithsonian Press, 1990.

Bontemps, Arna Alexander. *Forever Free: Art by Afro-American Women, 1862–1980.* Washington, DC: Stephenson, 1980.

Brawley, Benjamin. *The Negro in Literature and Art in the United States.* New York: Dodd, Mead, 1934.

Bregler, Charles, "Thomas Eakins as a Teacher," *Arts* 17 (March 1931): 379–86.

Bermingham, Peter. *American Art in the Barbizon Mood.* Washington, DC: Smithsonian Institution Press, 1975.

Bolande, Elizabeth. "Newly Discovered Indian Combat by American Artist Edmonia Lewis Acquired by the Cleveland Museum of Art," The Cleveland Museum of Art, 2011, https://www.clevelandart.org/about/press/newly-discovered-indian-combat-american-artist-edmonia-lewis-acquired-cleveland-museum.

Boston Directory. Boston: Sampspn & Murdock, 1868.

Boston Directory. Boston: Sampson, Davenport, 1873.

Brown, John S. "Edward Mitchell Bannister." *The Crisis,* November 1933, 248.

Brown, William Wells. *The Rising Son: The Antecedents and Advancement of the Colored Race.* Boston: A. G. Brown, 1874.

Brunk, Robert S., ed. *May We All Remember Well: A Journal of the History & Cultures of Western North Carolina.* Asheville, NC: Robert Brunk Auction Services, 1997.

Buick, Kirsten Pai. *Child of the Fire: Mary Edmonia Lewis and the Problem of Art History's Black and Indian Subject.* Durham, NC: Duke University Press, 2010.

Buick, Kirsten Pai. "The Ideal Works of Edmonia Lewis." *American Art* 9, no. 2 (Summer 1995): 4–19.

Burns, Sarah. *Pastoral Inventions: Rural Life in Nineteenth Century American Art and Culture. Philadelphia.* Philadelphia: Temple University Press, 1989.

Butcher, Margaret. *The Negro in American Culture.* New York: Alfred A. Knopf, 1971.

Cardoso, J. J. "Hinton Rowan Helper as a Racist in the Abolitionist Camp." *Journal of Negro History* (October 1970): 323–30.

Carter, Denny. "Nineteenth-Century Painters and Patrons in Cincinnati." *Magazine Antiques,* (November 30, 1979): 1153–58.

Cavallo, A. S. "Uncle Tom and Little Eva, a Painting by R. S. Duncanson." *Bulletin of the Detroit Institute of Arts* 30, no. 1 (1950–51): 21.

Chametzky, Jules and Sidney Kaplin, eds. *Black & White in American Culture: An Anthology from the Massachusetts Review.* Amherst: University of Massachusetts Press, 1969.

Chase, Judith W. *Afro-American Art and Craft.* New York: Van Nostrand Reinhold, 1971.

Cheek, William and Aimee. *John Mercer Langston and the Fight for Black Freedom, 1829–65.* Urbana: University of Illinois Press, 1989.

"Chicago: The Orange Exhibition—Edmonia Lewis's 'Cleopatra.'" *American Architect and Building News,* May 23, 1891, 120.

Cincinnati Industrial Expositions, Ohio History Central, https://ohiohistorycentral.org/w/Cincinnati_Industrial_Expositions.

Cist, Charles. *Sketches and Statistics of Cincinnati in 1851*. Cincinnati: Wm. H. Moore, 1851.

Clapp, Elizabeth J., and Julie Roy Jeffrey, eds. *Women, Dissent and Anti-Slavery in Britain and America, 1790–1865*. New York: Oxford University Press, 2011.

Clamorgan, Cyprian. *The Colored Aristocracy of St. Louis*. Columbia: University of Missouri Press, 1999.

Coen, Rena N. *Painting and Sculpture in Minnesota, 1820–1914*. Minneapolis: University of Minnesota Press, 1976.

Colwill, Stiles Tuttle, with Leroy Graham and Mary Ellen Hayward Weekly. *Joshua Johnson: Freeman and Early American Portrait Painter*. Baltimore: Maryland Historical Society, 1987.

Cone, James H. *God of the Oppressed*. Minneapolis: Seabury Press, 1975.

Congress of Religion. *Unity: Freedom, Fellowship, and Character in Religion*. March 25, 1915.

Cooks, Bridget R. *Exhibiting Blackness: African Americans and the American Art Museum*. Amherst: University of Massachusetts Press, 2011.

Cooper, Edward S. *Vinnie Ream: An American Sculptor*. Chicago: Chicago Review Press, 2009.

Costa, Traci Lee. "Edward Mitchell Bannister and the Aesthetics of Idealism." Master's thesis, Roger Williams University, February 2017. https://docs.rwu.edu/cgi/viewcontent.cgi?article =1000&context=aah_theses.

Crawford, John S. "The Classical Tradition in American Sculpture: Structure and Surface." *American Art Journal* (July 1979): 38–52.

Cureau, Harold G. "The Historic Roles of Black American Artists: A 'Profile of Struggle.'" *Black Scholar*, (November 9, 1977): 2–8.

Dabakis, Melissa. *A Sisterhood of Sculptors: American Artists in Nineteenth-Century Rome*. University Park: Penn State University Press. Reprint edition, 2015.

Dabney, Wendell P. *Cincinnati's Colored Citizens: Historical, Sociological and Biographical*. Cincinnati: Dabney, 1926.

Davie, Maurice R. *Negroes in American Society*. New York: McGraw-Hill Book, 1949.

Davis, James F. *Who Is Black? One Nation's Definition*. University Park: Penn State University Press, 1991.

Dawson, James W. *Picturesque Cincinnati*. Cincinnati: John Shillito, 1883.

"Dagnerrian Gallery of the West." *Frederick Douglass' Paper*, June 3, 1854, 1.

Devries, James E. *Race and Kinship in a Midwestern Town: The Black Experience in Monroe, Michigan*. Urbana: University of Illinois Press, 1984.

Dillon, Kathleen M. "Painters and Patrons: The Fine Arts in Cincinnati, 1820–1860." *Ohio History* 96 (Winter–Spring, 1987): 7–32.

Dover, Cedric. *American Negro Art*. Greenwich, CT: New York Graphic Society, 1969.

Dowd, Jerome. *The Negro in American Life*. New York: Century, 1926.

Douglass, Frederick, and Ida B. Wells, *The Reason Why the Colored American Is Not in the World's Columbian Exposition*. Chicago: n.p., 1893.

Driskell, David. *Hidden Heritage: Afro-American Art, 1800–1950*. San Francisco: Art Association of America, 1985.

Driskell, David. *Two Centuries of Black American Art*. New York: Los Angeles County Museum of Art, 1976.

Duberman, Martin, ed. *The Antislavery Vanguard: New Essays on the Abolitionists*. Princeton: Princeton University Press, 1965.

Du Bois, W.E.B. "Criteria of Negro Art," *The Crisis*, 32 (October 1926): 290–97.

Du Bois, W.E.B.. *The Negro Artisan*. Atlanta: Atlanta University Press, 1902.

Du Bois, W.E.B.. *The Philadelphia Negro*. New York: Benjamin Blom, Inc., 1967.

Du Bois, W.E.B. *The Souls of Black Folk*. Chicago: A. C. McClurg, 1903.

Dwight, Edward H. "Robert S. Duncanson." *Cincinnati Historical Society Bulletin* (July 1955): 43–45.

"Edmonia Lewis Sculptures (SJPL California Room)," accessed March 24, 2017, King Library Special Collections, http://digitalcollections.sjlibrary.org/cdm/landingpage/collection /sjpl_edmon.

Edwards, Lee M. *Domestic Bliss: Family Life in American Painting, 1840–1910*. Yonkers, NY: Hudson River Museum, 1986.

Emerson, Ralph Waldo. *Orations, Lectures and Essays*. London: Charles Griffin, 1866.

Ethnic Notions: Black Images in the White Mind. Berkeley, CA: Berkeley Art Center, 1982.

"Evidence of Edmonia Lewis's Lost Work Found in Baltimore Church." ARTFIXdaily, February 4, 2011. http://www.artfixdaily.com/artwire/release/5021-evidence-of-edmonia-lewis%E2 %80%99s-lost-work-found-in-baltimore-church.

Exhibition of Paintings, Engravings, Drawings, Aquarelles and Works of Household Art in the Cincinnati Industrial Exposition, 1875. https://babel.hathitrust.org/cgi/pt?id=hvd.320441081 41805;view=1up;seq=14.

Fabren, Geneviève, and Robert G. O'Meally. *History and Memory in African-American Culture*. New York: Oxford University Press, 1994.

Farmer, Silas. *The History of Detroit and Michigan*. Detroit: Silas Farmer, 1889.

Farrington, Lisa E. *Creating Their Own Image: The History of African-American Women Artists*. New York: Oxford University Press, 2011.

Ferber, Linda S. *The Hudson River School: Nature and the American Vision*. New York: Skira Rizzoli, 2009.

Fine, Elsa H. *The Afro-American Artist*. New York: Holt, Rinehart and Winston, 1973.

Fink, Lois Marie. *American Art at the Nineteenth Century Paris Salons*. New York: Cambridge University Press, 1990.

First Annual Exhibition of American Art, September 8–June 27, 1891. Detroit Museum of Art, exhibition catalog, http://www.dalnet.lib.mi.us/dia/collections/dma_exhibitions/1891–1.pdf.

Fletcher, Robert Samuel. *A History of Oberlin College from Its Foundation through the Civil War*. New York: Arno Press and the New York Times, 1971.

Ford, Bridget. *Bonds of Union: Religion, Race, and Politics in a Civil War Borderland*. Chapel Hill: University of North Carolina Press, 2016.

Fox, James Edward. "Iconography of the Black in American Art, 1710–1900." PhD dissertation, University of North Carolina at Chapel Hill, 1979.

Frank, Lisa Tendrich, ed. *Women in the Civil War*. Vol. 1. Santa Barbara, CA: ABC-CLIO, 2008. Cited from *The Liberator*, May 22, 1863.

Frazier, E. Franklin. *Black Bourgeoisie: The Rise of a New Middle Class in the United States*. New York: Collier Books, 1962.

Fredrickson, George M. *The Black Image in the White Mind: The Debate on Afro American Character and Destiny, 1817–1914*. Middletown, CT: Wesleyan University Press, 2008.

Fredrickson, George M. *The Arrogance of Race: Historical Perspectives on Slavery, Racism, and Social Equality*. Middletown, CT: Wesleyan University Press, 1988.

French, H. W. *Art and Artists of Connecticut*. Boston: Lee and Shepard, 1879.

Fusscas, Helen K. *Charles Ethan Porter*. Marlborough, CT: Connecticut Gallery, 1987.

Garret, Wendell D., Paul F. Norton, and Alan Gowans. *The Arts in America: The Nineteenth Century*. New York: Charles Scribner's Sons, 1969.

Gatewood, William B. *Aristocrats of Color: The Black Elite, 1880–1920*. Bloomington: Indiana University Press, 1990.

Gayle, Addison, Jr., ed. *The Black Aesthetic*. New York: Anchor Books, 1972.

"Biography of George Inness," George Inness: The Complete Works, https://www.georgeinness.org/.

Gerber, David A. *Black Ohio and the Color Line, 1860–1915*. Urbana: University of Illinois Press, 1976.

Goldberg, Marcia. "A Drawing by Edmonia Lewis." *American Art Journal* 9, no. 2 (November 1977), 104.

The Golden Age: Cincinnati Painters of the Nineteenth Century Represented in the Cincinnati Art Museum. Cincinnati: Cincinnati Art Museum, 1979.

Hanaford, Phebe A. *Daughters of America; or, Women of the Century*. Augusta, ME: True, 1882.

Handy, Moses Purnell, ed. *Official Directory of the World's Columbian Exposition*. Chicago: W. B. Conkey, 1893.

Harper, Michael, and Robert Stepto, eds. *Chant of Saints: A Gathering of Afro-American Literature, Art, and Scholarship*. Urbana: University of Illinois Press, 1979.

Hawthorne, Nathaniel. *The Marble Faun: or, the Romance of Monte Beni*. New York: Dell, 1860. Originally published 1859.

Hartigan, Lynda Roscoe. *Sharing Traditions: Five Black Artists in Nineteenth-Century America*. Smithsonian Institution Press, 1985.

Haverstock, Mary, and Jeannette Mahoney Vance. *Artists in Ohio, 1787–1900: A Biographical Dictionary*. Kent, OH: Kent State University Press; 2000.

Hazel, William A. "The Negro in Art." *A.M.E. Church Review*, 1897.

Heilbron, Bertha L., ed. *With Pen and Pencil on the Frontier in 1851: Diary of Frank Blackwell Mayer*. Saint Paul: Minnesota Historical Society, 1932.

Helper, Hinton Rowan. *Nojoque; A Question for a Continent*. New York: George W. Carleton, 1867.

Helper, Hinton Rowan. *The Negroes in Negroland: The Negroes in America*. New York: G. W. Carleton,, 1868.

Henderson, Albert. "'I Was Declared to Be Wild': Mary E. Lewis's Grades at New York Central College, McGrawville, NY," March 1, 2013, http://www.edmonialewis.com/blog.htm.

Henderson, Harry, and Albert Henderson. *The Indomitable Spirit of Edmonia Lewis: A Narrative Biography*. New York: Esquiline Hill Press, 2012. Kindle.

"Henry Ossawa Tanner," *Opportunity: Journal of Negro Life*" 15 (July 1937): 197.

Herbert, Henry William. "Antony and Cleopatra." *Graham's Magazine* (July 1852).

Hill, Mary A., ed. *Endure: The Diaries of Charles Walter Stetson*. Philadelphia: Temple University Press, 1985.

History of the Great Western Sanitary Fair. C. V. Vent, 1864.

Holland, Juanita. *The Life and Work of Edward Mitchell Bannister (1828–1901): A Research Chronology and Exhibition Record*. New York: Kenkeleba House, 1992.

Horton, James. *Free People of Color*. Washington, DC: Smithsonian Institution Press, 1993.

Horton, James Oliver, and Lois E. Horton. *Black Bostonians: Family Life and Community Struggle in the Antebellum North*. New York: Holmes & Meier, 1979.

How Edmonia Lewis Became an Artist. Philadelphia: John Spencer, Printer, 1876.

Igoe, Lynn M. *Two Hundred and Fifty Years of Afro-American Art: An Annotated Bibliography*. New York: R. R. Bowher, 1981.

Ingram, J. S. *The Centennial Exposition, Described and Illustrated*. Philadelphia: Hubbard Bros., 1876.

James, Henry. *William Wetmore Story and His Friends*. New York: Grove Press, 1957.

Jarrett, Gene Andrew. *Deans and Truants: Race and Realism in African American Literature*. Philadelphia: University of Pennsylvania Press, 2006.

Jennings, Corinne, and Juanita Marie Holland. *Edward Mitchell Bannister: 1828–1901*. New York: Kenkeleba House, 1992.

Johns, Elizabeth. *American Genre Painting: The Politics of Everyday Life*. New Haven: Yale University Press, 1991.

Johnson, William Henry. *The Autobiography of Dr. William Henry Johnson*. Albany: Argus Company, Printers, 1900.

Jordan, Winthrop D. *The White Man's Burden: Historical Origins of Racism in the United States*. London: Oxford University Press, 1974.

Jordan, Winthrop D. *White over Black: American Attitudes toward the Negro, 1550–1812*. Chapel Hill: University of North Carolina Press, 1968.

"J. P. Ball, African American Photographer: Success and Struggles in Cincinnati." Cincinnati History Library and Archives, http://library.cincymuseum.org/ball/jpball-cincy.htm.

"Joshua Johnson." Archives of Maryland (Biographical Series) MSA SC 3520–13555, http://msa .maryland.gov/megafile/msa/speccol/sc3500/sc3520/013500/013555/html/13555bio.html.

Kaplan, Sidney. *American Studies in Black and White: Selected Essays, 1949–1989*. Amherst: University of Massachusetts Press, 1991.

Karon, Bertram P. *The Negro Personality: A Rigorous Investigation of the Effects of Culture*. New York: Springer, 1958.

Kasson, Joy S. *Marble Queens and Captives: Women in Nineteenth-Century Sculpture*. New Haven: Yale University Press, 1990.

Katz, Wendy J. "Robert S. Duncanson, Race, and Auguste Comte's Positivism in Cincinnati." *American Studies* 53, no. 1 (2014): 79–115.

Katz, Wendy J. *Regionalism and Reform: Art and Class Formation in Antebellum Cincinnati*. Columbus: Ohio State University Press, 2002.

Katz, Wendy J. "Robert S. Duncanson: City and Hinterland." *Prospects* 25 (2000): 311–37.

Keith, Rachel. *The Barbizon School and the Nature of Landscape*. Mildred Lane Kemper Art Museum, 2008, 4. http://kemperartmuseum.wustl.edu/files/Barbizon.pdf.

Ketner, Joseph D. *The Emergence of the African-American Artist: Robert S. Duncanson, 1821–1872*. Columbia: University of Missouri Press, 1993.

Ketner, Joseph D. *Robert S. Duncanson: "The Spiritual Striving of the Freedmen's Sons."* Catskill, NY: Thomas Cole National Historic Site, 2011.

Ketner, Joseph D. "Struggles Many and Great: James P. Ball, Robert Duncanson, and Other Artists of Color in Antebellum Cincinnati." *Magazine Antiques*, Nov. 30, 2011. http://www .themagazineantiques.com/article/ketner-james-p-ball-robert-duncanson-antebellum -cinncinati/.

Kirscke, Helene, ed. *Women Artists of the Harlem Renaissance*. Jackson: University Press of Mississippi, 2014.

Klein, Shana. "Cultivating Fruit and Equality: The Still-Life Paintings of Robert Duncanson." *American Art* 29, no. 2 (Summer 2015): 64–85.

Klineberg, Otto. *Characteristics of the American Negro*. New York: Harper & Brothers, 1944.

Lacy, Dan. *The White Use of Blacks in America*. New York: Atheneum, 1972.

"The Land of the Lotus-Eaters. Painted by Robert S. Duncanson." *Art Journal* 5 (1866): 93.

"Landscape and Transcendence," *The Making of the Hudson River School*, online exhibition, Albany Institute of History and Art, https://www.albanyinstitute.org/landscape-and -transcendence.html.

Lane, Roger. *Roots of Violence in Black Philadelphia, 1860–1900*. Cambridge: Harvard University Press, 1986.

Lane, Roger. *William Dorsey's Philadelphia and Ours*. New York: Oxford Press, 1991.

Langston, John Mercer. *From the Virginia Plantation to the National Capitol*. New York: Arno Press and the New York Times, 1969.

Larkin, Oliver. *Art and Life in America*. New York: Rinehart, 1949.

Laxton, Glenn. *Hidden History of Rhode Island: Not-to-Be-Forgotten Tales of the Ocean State*. Charleston, SC: History Press, 2009.

Leach, Joseph. *Bright Particular Star: The Life and Times of Charlotte Cushman*. New Haven: Yale University Press, 1970.

Leach, Joseph. "Harriet Hosmer: Feminist in Bronze and Marble." *Feminist Art Journal* 5, no. 2 (Summer 1976): 9–13.

Leininger-Miller, Theresa. *New Negro Artists in Paris: African American Painters and Sculptors in the City of Light, 1922–1934*. New Brunswick, NJ: Rutgers University Press, 2001.

Lewis, Semella. *Art: African American*. New York: Harcourt Brace Jovanovich, 1978.

"List of Premiums Awarded by the Michigan State Agricultural Society." *Michigan Farmer* 3, no. 19 (October 1, 1849): 295, 299.

Litwack, Leon F. *North of Slavery: The Negro in the Free States, 1790–1860*. Chicago: University of Chicago Press, 1961.

Litwack, Leon, and August Meier, eds. *Black Leaders of the Nineteenth Century*. Urbana: University of Illinois Press, 1988.

Locke, Alain Leroy. *Negro Art: Past and Present*. Albany: Albany Historical Society, 1933.

Locke, Alain LeRoy. "The American Negro as Artist." *American Magazine of Art* 23, no. 3 (September 1931): 211–20.

Locke, Alain Leroy. "The Legacy of the Ancestral Arts." In *The New Negro: An Interpretation*. New York: A. and C. Boni, 1925.

Locke, Alain Leroy. "The Negro Artist Wins His Spurs." In *Negro Art: Past and Present*. Washington, DC: Association of Negro Folk Education, 1936.

Locke, Alain Leroy, and Charles Molesworth, eds. *The Works of Alain Locke*. New York: Oxford University Press, 2012.

Logan, Rayford W., and Michael R. Winston, eds. *Dictionary of American Negro Biography*. New York: W. W. Norton, 1982.

Low, Augustus W., and Virgil A. Clift, eds. *Encyclopedia of Black America*. New York: Da Capo Press, 1981.

Lowe, Henry. *Historical Collections of Ohio in Two Volumes: An Encyclopedia of the State*. Norwalk, OH: Laning Printing, 1898.

Lubin, David M. *Picturing a Nation: Art and Social Change in Nineteenth-Century America*. New Haven: Yale Publications in the History of Art, 1994.

Luker, Ralph E. *The Social Gospel in Black & White: American Racial Reform, 1885–1912*. Chapel Hill: University of North Carolina Press, 1991.

Lynes, Russell. *The Art-Makers: An Informal History of Paintings, Sculpture, and Architecture in the Nineteenth Century*. New York: Dover, 1970.

Marley, Anna O., ed. *Henry Ossawa Tanner: Modern Spirit*. Berkeley: University of California Press, 2012.

Martin, Francis. "The Image of Black People in American Illustration from 1825 to 1925." PhD diss., University of California, Los Angeles, 1986.

McElroy, Guy. *African-American Artists, 1880–1987*. Seattle: University of Washington Press, 1989.

McElroy, Guy. *Facing History: The Black Image in American Art, 1710–1940*. San Francisco: Bedford Arts, 1990.

McElroy, Guy. *Robert Scott Duncanson: A Centennial Exhibition*. Cincinnati: Cincinnati Art Museum, 1972.

McFeely, William S. *Frederick Douglass*. New York: W. W. Norton, 1991.

Meier, August. *Negro Thought in America, 1880–1915*. Ann Arbor: University of Michigan Press, 1963.

Mencke, John G. *Mulattoes and Race Mixture: American Attitudes and Images, 1865–1918*. Ann Arbor: UMI Research Press, 1979.

"Miss Edmonia Lewis, The Artist." *California Farmer and Journal of Useful Sciences* 39, no. 24, (September 1873): 188.

Montesano, Philip. "The Mystery of the San Jose Statues." *Urban West*, May/June 1968, 26.

Moore, Lucinda. "America's Forgotten Landscape Painter: Robert S. Duncanson." *Smithsonian Magazine*, October 18, 2011, http://www.smithsonianmag.com/arts-culture/americas -forgotten-landscape-painter-robert-s-duncanson-112952174/?page=2.

Mosby, Dewey F., and Darrel Sewell. *Henry Ossawa Tanner*. Philadelphia: Rizzoli International, 1991.

Moure, Nancy Wall. *American Narrative Painting*. Los Angeles: Los Angeles County Museum of Art, 1974.

Moure, Nancy Wall. *William Louis Sonntag: Artist of the Ideal 1822–1900*. Los Angeles: Goldfield Galleries, 1980.

Musacchio, Jacqueline Marie. "Mapping the 'White, Marmorean Flock': Anne Whitney Abroad, 1867." *Nineteenth-Century Art Worldwide* 13, no. 2 (Autumn 2014). http://www.19thc-art worldwide.org/autumn14/musacchio-anne-whitney-abroad.

Myrdal, Gunnar. *An American Dilemma: The Negro Problem and Modern Democracy*. New York: Harper & Brothers, 1944.

Nelson, Charmaine A. *The Color Stone*. Minneapolis: University of Minnesota Press, 2007.

"New Discovery: Three Indians in Battle by Edmonia Lewis." ARTFIXdaily, December 30, 2010. http://www.artfixdaily.com/blogs/post/6906-new-edmonia-lewis-discovery.

Newhall, Beaumont. *The Daguerreotype in America*. New York: Dover, 1976.

Nicolai, Richard R. *Centennial Philadelphia*. Bryn Mawr, PA: Bryn Mawr Press, 1976.

Nittle, Nadra Kareem. "How Is the 'Tragic Mulatto' Literary Trope Defined?" ThoughtCo. March 15, 2018. https://www.thoughtco.com/the-tragic-mulatto-literary-trope-defined-2834619.

Noble, F. P. "The Chicago Congress on Africa." *Our Day* 12 (October 1893): 279–300.

Nolen, Claude H. *The Negro's Image in the South: The Anatomy of White Supremacy*. Lexington: University of Kentucky Press, 1967.

Novak, Barbara. *American Painting of the Nineteenth Century: Realism, Idealism, and the American Experience*. New York: Harper & Row, 1979.

"Biography—Nelson A. Primus." Nehemiah Gibson of East Boston. http://nehemiahgibson. com/biographyPrimusNelsonA.htm.

Neuhaus, Eugen. *The History and Ideals of American Art*. Stanford: Stanford University Press, 1931.

Odum, Howard W. *Race and Rumors of Race*. Chapel Hill: University of North Carolina Press, 1943.

Parks, James Dallas. *Robert S. Duncanson: 19th Century Black Romantic Painter*. Washington: Associated, 1980.

Parry, Ellwood. *The Image of the Indian and the Black Man in American Art, 1590–1900*. New York: George Braziller, 1974.

Patton, Sharon F. *African American Art*. Oxford: Oxford University Press, 1998.

Pennell, Joseph. *The Adventures of an Illustrator Mostly in Following His Authors in America & Europe*. Boston: Little, Brown, 1925.

Perry, Regenia A. *Free within Ourselves: African-American Artists in the Collection of the National Museum of American Art*. San Francisco: Pomegranate Art Books, 1992.

Pih, Richard W. "Negro Self-Improvement Efforts in Ante-Bellum Cincinnati, 1836–1850." *Ohio History* 78 (Summer 1969): 179–87.

Pollock, Deborah C. *Visual Art and the Urban Evolution of the New South*. Columbia: University of South Carolina Press, 2015.

Porter, James A. "Four Problems in the History of Negro Art." *Journal of Negro History* 27, no. 1 (January 1942): 9–35.

Porter, James A. *Modern Negro Art*. New York: Dryden Press, 1943.

Porter, James A. "Robert S. Duncanson: Midwestern Romantic-Realist." *Art in America* 39, no. 3 (October 1951): 99–154.

Porter, James A. *Ten Afro-American Artists of the Nineteenth Century*. Washington, DC: H. K. Press, 1967.

Powell, Richard J. *Black Art: A Cultural History*. London: Thames & Hudson, 2003.

Pringle, William. "Robert S. Duncanson in Montreal, 1863–1865." *American Art Journal* 17, no. 4 (Autumn 1985): 28–50.

"Recollections of Charles Sumner: II. The Senator's Home and Pictures." *Scribner's Monthly: An Illustrated Magazine for the People* 9, no. 1 (November 1874): 101–14.

Reid, Dennis. "Our Own Country Canada." *Vanguard* 8, no. 2 (March 1979).

Reuter, Edward Byron. *The Mulatto in the United States*. New York: Johnson Reprint, 1970.

Revisiting the White City: American Art at the 1893 World's Fair. Washington, DC: National Museum of American Art and National Portrait Gallery, 1993.

Richardson, Marilyn. "Edmonia Lewis." *Harvard Magazine* 88, no. 4 (March/April 1986): 40.

"R.I.P. Joseph K and Robert D & viva Vanessa G!" Melville and Douglass (blog), October 13, 2018, https://melvilleanddouglassin2018.wordpress.com/2018/10/13/r-i-p-joseph-k-and-robert-d-viva-vanessa-g/.

Robinson, Malcolm. *The American Vision: Landscape Paintings of the United States*. New York: Portland House, 1988.

Rosenfeld, Daniel, and Robert Workman. *The Spirit of Barbizon: France and America*. San Francisco: Art Museum Association of America, 1986.

Rowe, John Carlos. *New American Studies*. Minneapolis: University of Minnesota Press, 2002.

Rubinstein, Charlotte Streifer. *American Women Artists from Early Indian Times to the Present*. Boston: G. K. Hall, 1982.

Rudisill, Richard. *Mirror Image: The Influence of the Daguerreotype on American Society*. Albuquerque: University of New Mexico Press, 1971.

Savage, Kirk. *Standing Soldiers, Kneeling Slaves: Race, War, and Monument in Nineteenth-Century America*. Princeton: Princeton University Press, 1999.

Schneider, Erika. *The Representation of the Struggling Artist in America, 1800–1865*. Newark: University of Delaware Press, 2015.

Schinto, Jeanne. "What's in a Middle Name." Artist Biography & Facts, Robert Seldon Duncanson, askART. http://www.askart.com/artist_bio/artist/21368/artist.aspx#.

Schontzler, Gail. "Discovering Lizzie Williams and Bozeman's Lost Black History." *Bozeman Daily Chronicle*, February 15, 2017. http://www.bozemandailychronicle.com/news/discovering-lizzie-williams-and-bozeman-s-lost-black-history/article_75d9ded6-6a35-5747-883e-405b91d158a9.html.

Schwain, Kristin. *Signs of Grace: Religion and American Art in the Gilded Age.* Ithaca, NY: Cornell University Press, 2007.

Schwartz, Abby S. "Nicholas Longworth: Art Patron of Cincinnati." *Queen City Heritage* 46, no. 1 (Spring 1988): 17–32.

"Sculptor's Death Date Unearthed: Edmonia Lewis Died in London in 1907." ARTFIXdaily, January 9, 2011. http://www.artfixdaily.com/blogs/post/51-sculptors-death-unearthed -edmonia-lewis-died-in-london-in-1907.

Sherwood, Dolly. *Harriet Hosmer, American Sculptor, 1830–1908.* Columbia: University of Missouri Press, 1991.

Simmons, William J. *Men of Mark: Eminent, Progressive and Rising.* Cleveland: Geo. M. Rewell, 1887.

Stamp, Kenneth. *The Peculiar Institution: Slavery in the Antebellum South.* New York: Vintage Books, 1984.

Stebbins, Theodore E. *The Lure of Italy: American Artists and the Italian Experience, 1760–1914.* Boston: Museum of Fine Arts, Boston, 1992.

Sterling, Dorothy, ed. *We Are Your Sisters: Black Women in the Nineteenth Century.* New York: W. W. Norton, 1985.

Sussman, Wald. *The Myth of Race: The Troubling Persistence of an Unscientific Idea.* Cambridge: Harvard University Press, 2014.

Terrain of Freedom: American Art and the Civil War. Chicago: Art Institute of Chicago Museum Studies, 2001.

Thomas, James P. *From Tennessee Slave to St. Louis Entrepreneur: The Autobiography of James Thomas.* Edited by Loren Schweninger. Columbia: University of Missouri Press, 1984.

Tolles, Thayer. "American Neoclassical Sculptors Abroad." American Wing, Metropolitan Museum of Art, October 2004. https://www.metmuseum.org/toah/hd/ambl/hd_ambl.htm.

Tomso, Gregory. "Lincoln's 'Unfathomable Sorrow': Vinnie Ream, Sculptural Realism, and the Cultural Work of Sympathy in Nineteenth-Century America," *European Journal of American Studies* 2 (April 5, 2011), http://ejas.revues.org/9139.

Trafton, Scott. *Egypt Land: Race and Nineteenth-Century American Egyptomania.* Durham: Duke University Press, 2004.

Trapp, Kenneth R. *Celebrate Cincinnati Art.* Cincinnati: Cincinnati Art Museum, 1981.

Tucker, Louis Leonard. "Old Nick" Longworth, the Paradoxical Maecenas of Cincinnati." *Bulletin of the Cincinnati Historical Society* 25, no. 4 (1967): 246–59.

Tuckerman, Henry T. *Book of the Artists: American Artist Life, Comprising the Biographical and Critical Sketches of American Artists.* New York: Putnam, 1867.

Turner, Jonathan, Royce Singleton, and David Musick. *Oppression: A Socio-history of Black–White Relations in America.* Chicago: Nelson Hall, 1984.

Van Dyke, John Charles. *American Painting and Its Tradition.* New York: Charles Scribner's Sons, 1919.

Vara-Dannen, Theresa. *The African-American Experience in Nineteenth-Century Connecticut.* Lanham, MD: Lexington Books, 2014.

Vendryes, Margaret Rose. "Race Identity/Identifying Race: Robert S. Duncanson and Nineteenth-Century American Painting." *Museum Studies* 27, no. 1 (2001): 82–104.

"Vinnie Ream." Historic Missourians. State Historical Society of Missouri. https://shsmo.org /historicmissourians/name/r/ream/#references.

Waller, Susan. "The Artist, the Writer, and the Queen: Hosmer, Jameson, and Zenobia." *Woman's Art Journal*, no. 1 (1983): 21–28.

Washington, Joseph R. *Marriage in Black and White*. Boston: Beacon Press, 1970.

Webster, Sally. *William Morris Hunt*. Cambridge: Cambridge University Press, 1991.

Weidman, Jeffrey, Neil Harris, and Philip Cash. *William Rimmer: A Yankee Michelangelo*. Hanover, NH: University Press of New England, 1985.

Wesley, Charles H. "The Concept of Negro Inferiority in American Art." *Journal of Negro History* 25 (October 1940): 540–60.

Whisnant, David E. "Retrospective I: A Primer on the Sad Truths of Slavery in Asheville, Buncombe County and Western North Carolina," August 29, 2015, accessed October 4, 2017 http://ashevillejunction.com/retrospective-i-a-primer-on-the-sad-truths-of-slavery -in-asheville-buncombe-county-and-western-north-carolina/.

Whitter, John Greenleaf, and John B. Pickard. *The Letters of John Greenleaf Whittier*. Cambridge: Harvard University Press, 1975.

Williamson, Joel. *New People: Miscegenation and Mulattoes in the United States*. New York: Free Press, 1980.

Wilmerding, John. *American Views: Essays on American Art*. Princeton: Princeton University Press, 1991.

Wilmerding, John, Linda Ayres, and Earl A. Powell. *An American Perspective: Nineteenth Century Art from the Collection of Jo Ann & Julian Ganz, Jr*. Washington, DC: National Gallery of Art, 1981.

Woods, Naurice Frank, Jr. *Henry Ossawa Tanner: Art, Faith, Race, and Legacy*. London: Routledge, 2017.

Woodson, Carter G. *Negro Makers of History*. Washington, DC: Associated, 1942.

Woodson, Carter G. "The Negroes of Cincinnati prior to the Civil War." *Journal of Negro History* 1, no. 1 (January 1916): 1–22.

Workman, Robert. *The Eden of America: Rhode Island Landscapes, 1820–1920*. Providence: Rhode Island School of Design, 1986.

Wyman, Lillie Buffum, and Arthur Crawford Wyman. *Elizabeth Buffum Chance*. Boston: W. B. Clarke, 1914.

Zurski, Ken. "The Frankenstein That Created a Monster Painting." Unremembered: A History of the Famously Interesting and Mostly Forgotten. April 12, 2016. https://unremembered history.com/2016/04/12/the-frankenstein-that-created-a-monster-painting/.

Newspapers

The following newspapers were consulted. See the endnotes for specific references:

American Citizen (Kansas City, Kansas)

Athenaeum (London)

Anti-slavery Bugle (New Lisbon, Ohio)

Asheville Messenger (North Carolina)

Atchison Daily Globe (Atchison, Kansas)

Atlanta Constitution

Baltimore Herald

Bangor Daily Whig & Courier (Bangor, Maine)

Boston Daily Advertiser

Boston Herald

Boston Investigator
Bozeman Avant Courier
Broad Ax (Salt Lake City and Chicago)
Brooklyn Daily Eagle
Charleston (WV) Advocate
Chicago Times
Christian Recorder (Philadelphia)
Christian Register (Boston)
Cincinnati Daily Commercial
Cincinnati Daily Enquirer
Cincinnati Daily Press
Cincinnati Inquirer
Cleveland Gazette
Colored American (Washington, DC)
Commonwealth (Boston)
Daily Cincinnati Gazette
Daily Evening Telegraph (Philadelphia)
Daily Evening Transcript (Boston)
Daily Globe (St. Paul)
Daily Graphic: An Illustrated Evening Newspaper (New York)
Daily Ohio Statesman
Daily Scioto Gazette (Chillicothe, Ohio)
Detroit Free Press
Detroit Tribune
East Boston Advocate
El Paso Herald
The Elevator (San Francisco)
Frederick Douglass' Paper (Rochester, New York)
The Freedman (Indianapolis)
The Gazette (Raleigh)
Hartford Courant
Hartford Herald
Helena Weekly Herald
Huntsville Gazette
Indianapolis News
Inter Ocean (Chicago)
Iowa State Bystander (Des Moines)
Kansas City Journal
Liberator (Boston)
London Art Journal
Lorain County News (Ohio)
Los Angeles Times
Lowell Daily Citizen and News (Lowell, Massachusetts)
Negro Star (Wichita)
New National Era and Citizen
New North-West (Deer Lodge, MT)

New York Age
New York Daily Journal
New York Freeman
New York Globe
New York Sunday Sun
News and Citizen (Morrisville, VT)
Memphis Daily Appeal
Milwaukee Daily Journal
Milwaukee Daily Sentinel
Mineral Point Tribune (Mineral Point, WI)
Monroe Gazette (Michigan)
New Hampshire Statesman (Concord, NH)
New Orleans Tribune
Newport (RI) Daily News
New York Age
New York Freeman
New York Herald
New York Times
New York Tribune
North Star (Rochester, NY)
Oakland Sunshine (Oakland, CA)
Parsons Weekly Blade (Parsons, KS)
People's Advocate (Washington, DC)
Philadelphia Enquirer
Philadelphia Tribune
Pine and Palm (Boston)
Plaindealer (Detroit and Topeka)
Providence Journal
Providence Press
Providence Sunday Journal,
Recorder (Indianapolis)
Revolution (New York)
San Francisco Chronicle
Savannah Tribune
St. Louis Globe-Democrat
South Carolina Leader
Times (Scranton, PA)
Topeka Plaindealer
True Northerner (Paw Paw, Michigan)
Vermont Watchman and State Journal
Washington Bee
Washington Times
Weekly Clarion (Jackson, MI)
Weekly Herald (New York)
Weekly Louisianan
Wyandotte Echo (Kansas City, KS)

Archives

Ann-Eliza Club Papers 1885–1937, Manuscripts Division, Rhode Island Historical Society, Providence, Rhode Island.

Anne Whitney Papers, Wellesley College Archives, Margaret Clapp Library.

Boston Public Library, Anti-Slavery Collection, Rare Books and Manuscript Collection.

Cincinnati Historical Society.

Edward Mitchell Papers. Archives of American Art, Washington, DC.

Edward M. Bannister Scrapbook, Archives of American Art, Washington, DC.

Hampton University Archives.

Letters to Sarah Blake Sturgis Shaw from various correspondents, Houghton Library, Harvard University.

James Thomas Fields Collection, Huntington Library, San Marino, California.

Platt R. Spencer Collection. Newberry Library, Chicago, Illinois.

Robie-Sewall Papers, Massachusetts Historical Society, Boston, Massachusetts.

Shaw Family Correspondence, Manuscript and Archives Division, the New York Public Library, Astor, Lenox, and Tilden Foundations.

Primus Family Papers, 1853–1924, Ms 44012, Connecticut Historical Society, Hartford, Connecticut.

V. Alden Brown Papers, Manuscripts Division, Rhode Island Historical Society, Providence, Rhode Island.

INDEX

ABOUT THE AUTHOR

Naurice Frank Woods Jr. is an associate professor of African American stud-
ies at the University of North Carolina at Greensboro. As an art historian, he
examines the impact of race and racism on the lives and careers of pioneering
African American artists. He has authored several books, including *Henry
Ossawa Tanner: Art, Faith, Race, and Legacy* and *African American Pioneers
in Art, Film, and Music.*

Made in United States
Troutdale, OR
06/30/2023

10884163R00171